This item must be returned on or before

Alice Neel

Painter of Modern Life

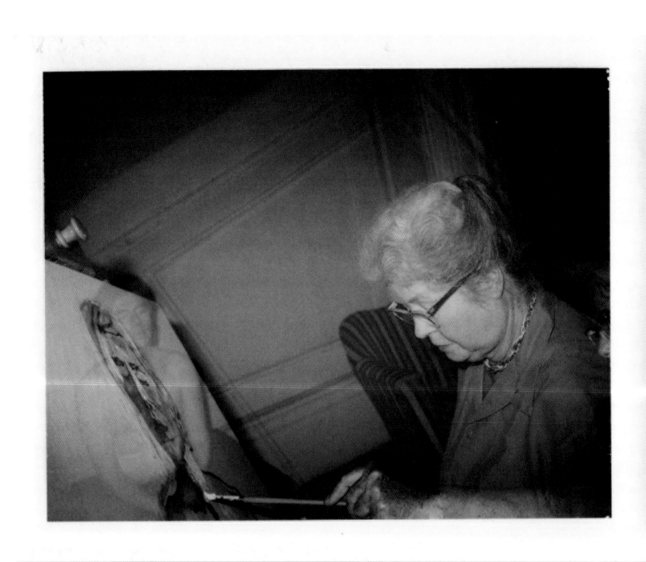

Alice Neel
Painter of Modern Life

Edited by
Jeremy Lewison

With contributions by
Bice Curiger
Petra Gördüren
Jeremy Lewison
Laura Stamps
Annamari Vänskä

MERCATORFONDS
ATENEUM ART MUSEUM, FINNISH NATIONAL GALLERY, HELSINKI
DISTRIBUTED BY YALE UNIVERSITY PRESS, NEW HAVEN AND LONDON

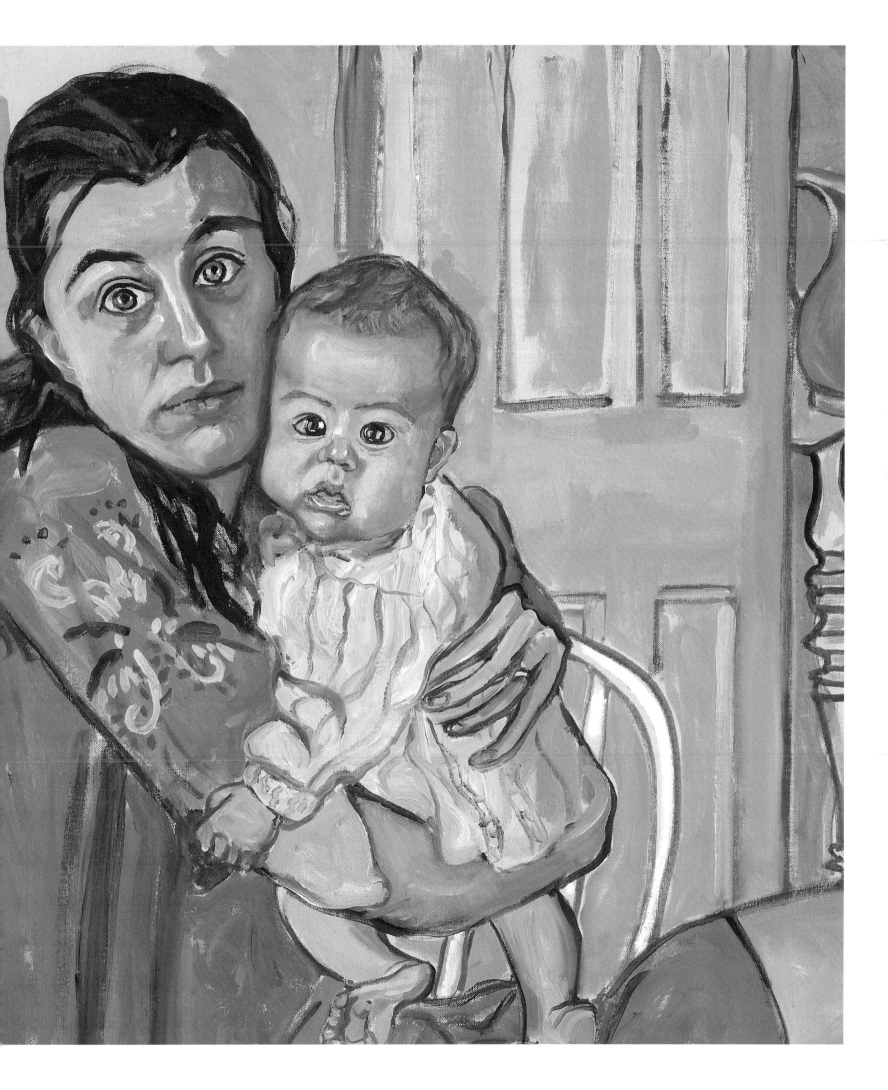

Acknowledgements

This book was published on the occasion of the exhibition
Alice Neel. Painter of Modern Life

Ateneum Art Museum, Finnish National Gallery, Helsinki
10 June – 2 October 2016

Gemeentemuseum Den Haag
5 November 2016 – 12 February 2017

Fondation Vincent van Gogh Arles
4 March – 17 September 2017

Deichtorhallen Hamburg
13 October 2017 – 14 January 2018

Chief Curator
Jeremy Lewison

Curators
Bice Curiger, Fondation Vincent van Gogh Arles
Sointu Fritze, Ateneum Art Museum, Helsinki
Dirk Luckow, Deichtorhallen Hamburg
Laura Stamps, Gemeentemuseum Den Haag

Exhibition Coordinator
Anna Pirkkalainen, Finnish National Gallery

The authors of this book and the curators of the exhibition would like to express their deepest gratitude to the museum professionals and all those who have contributed to the realization of the exhibition and the catalogue for the exhibition.

We would also like to thank all the museum professionals in each of the organizing museums for their cooperation in this project. Special thanks are due to the editors of the various different language versions of the book: to Laura Stamps for the Dutch version, to Delphine Ménage for the French version and to Basil Blösche, Sabine Seidel and Annette Sievert for the German version.

Ann Mestdag and Bernard Steyaert of Mercatorfonds in Brussels and Barbara Costermans at Tijdsbeeld & Pièce Montée in Ghent have coordinated the production of this book and each of its five language versions and we extend our thanks to them.

We warmly acknowledge the museums, galleries, foundations and collectors, and all those wishing to remain anonymous, who have generously lent their works:

Brand Family Collection
Charlotte Feng Ford Collection
Cheim & Read, New York
Cleveland Museum of Art
Defares Collection
Diane and David Goldsmith Collection
The Estate of Alice Neel
Foundation for Women Artists, Antwerp
Hirshhorn Museum and Sculpture Garden, Smithsonian Institution, Washington, D.C.
Honolulu Museum of Art
The Institute of Contemporary Art, Boston
The Jewish Museum, New York
John Cheim Collection
Kim Manocherian Collection
Locks Foundation, Philadelphia
The Metropolitan Museum of Art, New York
Moderna Museet, Stockholm
Museum of Fine Arts, Boston
The Museum of Fine Arts, Houston
The Museum of Modern Art, New York
National Gallery of Art, Washington, D.C.
National Museum of Women in the Arts, Washington, D.C.
The National Portrait Gallery, Smithsonian Institution, Washington, D.C.
Oklahoma City Museum of Art
Philadelphia Museum of Art
Smithsonian American Art Museum, Washington, D.C.
Tate, London
Victoria and Warren Miro Collection
Whitney Museum of American Art, New York

Alice Neel and
the Human Image
Foreword

Depicting people has been a central theme throughout art history, from Cycladic figurines to contemporary interpretations. A work is always linked to its time, historical context, artistic genre and artistic intention. Artists often depict themselves and those close to them. They interpret the world, portraying it through human figures and the lives they live.

Portraits by American artist Alice Neel (1900-1984) have an exceptional, startling power. Sometimes the subject looks straight at the viewer, seeming to come extremely close. At other times the gaze is inward, rejecting and excluding the viewer. These images tell and reveal: through them we can easily see feelings and thoughts, but also narratives. Time and again, Neel's psychologically-keen eye and virtuosic painting skills capture something essential about the person and his or her surroundings.

Some of the individuals portrayed in Neel's works, such as US colleagues Robert Smithson and Andy Warhol, are familiar for their artistic achievements, others as political figures or celebrities. Some are members of Neel's family and close circle of friends or just people she encountered by chance. These portraits open up Neel's unusually rich, multi-faceted life, an account of which could fill many books. The urban landscapes chosen for the exhibition also reinforce the experience of Neel's ability to see her environment in a precise, experiential way.

Museums today have an ever-greater responsibility – and duty – to pause beside the endless stream of images and information and to make considered choices. Creating an exhibition requires the commitment of a great number of experts in various roles. At the same time it is a promise to our audience: we have something to show and tell.

The Ateneum Art Museum / the Finnish National Gallery is extremely proud to be able to present this Alice Neel exhibition in partnership with the Gemeentemuseum Den Haag, Fondation Vincent van Gogh (Arles) and

Deichtorhallen (Hamburg). Assembling the show would not have been possible without the willing participation of the Estate of Alice Neel and private and public lenders. We have a particular gratitude to Alice Neel's family, especially her sons, Richard and Hartley Neel. Her grandson, Andrew Neel, has also been generous in allowing us to show his insightful film about Alice Neel. We would also like to thank the representatives of the Estate of Alice Neel, Xavier Hufkens, Victoria Miro, Aurel Scheibler and David Zwirner, who have been supportive throughout the organisation of this exhibition.

We would like to express our deepest gratitude to the exhibition's principal curator, Jeremy Lewison, who has worked with the Ateneum's Sointu Fritze, for his persistent, expert and uncompromising work. Thanks are also due to Franz Kaiser, Director of Exhibitions and Laura Stamps, Curator of Modern Art in Gemeentemuseum Den Haag and all of the writers of this publication, whose essays open up new perspectives on Neel's art, as well as to Ateneum curator Anu Utriainen for coordinating the catalogue project.

Through exhibition and book, we hope that as many people as possible will have time to concentrate on Neel's art – as perceptively and boldly as Neel herself painted her subjects. Time to stop amid the stream of images and stimuli, time to look and to think.

Susanna Pettersson
Museum Director
The Ateneum Art Museum / The Finnish National Gallery, Helsinki

Benno Tempel
Director
Gemeentemuseum Den Haag

Bice Curiger
Artistic Director
Fondation Vincent van Gogh Arles

Dirk Luckow
General Director
Deichtorhallen Hamburg

Alice Neel:
Painter of Modern Life
An Introduction

by Jeremy Lewison

On the 26 and 29 November and 3 December 1863 *Le Figaro* published "Le Peintre de la vie moderne", an essay in three parts by the poet and critic Charles Baudelaire. He began working on it in 1859 but it took four years to come to light. Baudelaire had been to Eugène Delacroix what John Ruskin was to J. M. W. Turner, a champion from the younger generation. Indeed Baudelaire's long valedictory article on the great French Romantic painter appeared in three instalments in *l'Opinion nationale* on 2, 14 and 22 November 1863, just before the publication of "Le Peintre de la vie moderne". "Le Peintre de la vie moderne" thus testified to a shift in his interest and attitude to painting. Delacroix was already the past.

Ostensibly an essay about an anonymous illustrator and draughtsman, although the initials C. G. were a light disguise for Constantin Guys, "The Painter of Modern Life" amounted to a manifesto of modern painting that had a far-reaching impact. The *Salon des Refusés* had opened in May 1863 with, as its star attraction, Edouard Manet's *Le Déjeuner sur l'herbe* (1863). Manet's work, now considered as marking the birth of the modern, was greeted with howls of derision, laughter and shock in equal measure, yet Baudelaire's writing, if not its date of publication, anticipated Manet's approach to painting. Baudelaire advocated an art that would represent the painting of "present-day attitudes"[1] whose pleasure would "derive not simply from its beauty ... but also from its essential quality of presentness".[2] He pleaded for paintings of city life, not of Ancient Greeks and Romans that the academic followers of Jacques-Louis David continued to paint at the halfway point of the century, nor even of the episodes from medieval history that Delacroix and his followers had painted. Baudelaire demanded a painting that depicted neither togas, nor late eighteenth century costume, but contemporary dress, evidence of the "morals and aesthetics of the present".[3]

Man's beauty, he declared, was to be found in his poise, his dress, his gestures and the features of his face, and these were inseparable from the epoch in which he lived.

"Beauty", according to the poet, "consists [on the one hand] of an eternal and invariable element, of which the proportion is extremely difficult to determine, and [on the other hand] a relative element, circumstantial, which will be, if one likes, in turn or all together, the epoch, the fashion, the principles and the passion. Without this second element, which is like the amusing envelope, a titillating aperitif of the divine cake, the first element would be indigestible, impossible to appreciate, neither adapted for nor appropriate to human nature."[4] Beauty in Baudelaire's view is both universal and contingent, eternal and ephemeral, derived from the past and the present. The evanescent element is found in fashion. The artist "must bring out from fashion the poetic content of its historical aspect, to extract the eternal from the transitory."[5] Contemporary fashion on its own, therefore, does not constitute beauty. The artist has to explore it, pare it down until he finds what is enduring in the fleeting. Baudelaire decries the way in which artists who are his contemporaries denigrate present-day fashion. "Modernity", he repeats, is precisely the opposite. It is "the transitory, the fugitive, the contingent, one half of art, of which the other half is the eternal and the immutable."[6] While approving of artists who painted costume appropriate to the period of their subjects, he considered it a betrayal to paint contemporary portraits in anything other than contemporary clothing. In essence Baudelaire was arguing for a portraiture that represented the *zeitgeist*.

The clothing a sitter wore would influence every aspect of his bearing; the gestures he made, the expression he bore and the way in which he sat. "Every epoch had its carriage, its look, its gesture."[7] As for a nude, "If a patient and meticulous painter, but with a mediocre imagination, had to paint a present day

courtesan and was *inspired* by (that is the established word) a courtesan [painted] by Titian or Raphael, it is infinitely probable that he will make a fake, ambiguous and obscure work. The study of a masterpiece from those times and of that kind will not teach him the attitude, the look, the grimace nor the essential appearance of these creatures the dictionary of fashion has successively classified under the coarse or playful designation of *unchaste*, of *kept women*, of *mistresses* and *sweethearts*."[8] Who could Baudelaire be thinking of but Jean-Auguste-Dominique Ingres, whose *Great Odalisque* of 1814, *Odalisque with Slave* of 1842 and *The Turkish Bath* painted in 1862, represented everything that Baudelaire detested in the anachronistic approach to the contemporary? And how strongly Ingres' *The Turkish Bath*, an orgy of naked women posing like goddesses or Madonnas off duty, contrasted with the contemporary look of Manet's naked lady sitting with her clothed male companions in the Bois de Boulogne. Even if the *Pastoral Concert* (c. 1509, Musée du Louvre), at that time attributed to Giorgione but now given to Titian, and other Venetian paintings inspired Manet he did not make slavish copies. Rather he used precedent to make an entirely modern looking painting, turning a poetic allegory in Arcadia into a contemporary picnic in the Bois de Boulogne. For medieval costume he substituted the ubiquitous black jacket and grey trousers, and perhaps most shocking and modern of all, instead of the characters ignoring the viewer of the painting, the naked Victorine Meurent, a modern day woman and a painter in her own right, directly confronts him. There is no sense of shame but rather a pose for the camera. Baudelaire did not object to the study of past masters but not at the expense of dispensing with the look of the present. The problem with Ingres and his followers was that their paintings did not present the look or the morals of the present day but of some exotic place in a far away time.

Fast forward now to Alice Neel. Here was an artist who from the outset was interested in the look of her times. Born with the century, as it progressed the appearance of her work changed. But how? Her paintings reflect changes in fashion, in attitudes to gender and race, in make-up or lack of it. They both anticipate and reflect the recasting of modes of representation. They see gesture as intimately associated with clothing and posture, and posture as relating to class, attitude, conformity, rebellion and defiance. The "unfinished" look of many of Neel's later works was a characteristic of the paintings of his contemporaries that Baudelaire described affirmatively as "barbarous", that "may lead some people to believe that we are concerned here with a few formless drawings that only the spectator's imagination knows how to transform into perfect things." [9] Baudelaire encourages artists to lay down the principal lines and contours, to paint from memory not from nature, and "establish a duel between the desire to see everything and forget nothing, and the faculty of memory which has got the habit of vividly absorbing general colour and the silhouette, the arabesque of contour."[10] What could be closer to a description of Neel's painting of Michel Auder (1980, cat. 67) than that, with his scrolling knees that wear the air of "unfinish" so eloquently, in contrast to the highly detailed study of his head? If Neel's early, licentious paintings bear the hallmarks of Baudelaire's lyric poetry, her late paintings, from the sixties onwards, rely on the sort of competition Baudelaire describes, between the observed and the felt, the scrutinized and the imagined, the discerned and the projected, the studied and the glimpsed, and the in-focus and out-of-focus. "Finish" becomes a variable term in Neel's hands. As Baudelaire says of Guys: "Every drawing has the look of being sufficiently finished."[11] This melding of the finished and the unfinished is embodied in the fine line Neel often walked between the abstract and the representational.

Meyer Schapiro described the work of Paul Cézanne, an admirer of Baudelaire and one of Neel's heroes, as lying "between the old kind of picture, faithful to a striking or beautiful object, and the modern 'abstract' kind of painting, a moving harmony of coloured touches representing nothing. ... The visible world is not simply represented ... It is re-created through the strokes of colour among which are many we cannot identify with an object and yet are necessary for the harmony of the whole."[12] What better description could there be of Hartley's T-shirt in *Hartley* (1966, cat. 43) or indeed of Schapiro's face in Neel's late-life painting of him (cat. 71)?

And what of Neel's actual knowledge of Baudelaire's key text? Well, it is not known whether she read it but in 1929 she painted a watercolour of Nadya Olyanova called *La Fleur du Mal (Nadya)*, in itself a homage to Baudelaire's anguished poems which, at the time of their publication, were considered decadent and obscene. So might she have gone on to read his celebrated essay? Even if she did not speak French, Baudelaire's article was translated into English by the British art critic, P. G. [Paul] Konody, and published in 1930[13]. And if by chance she failed to read that, then she might have got hold of another translation in 1950, this time by Norman Cameron[14], or the 1964 translation by Jonathan Mayne[15]. But if she failed to read any of these, which seems unlikely for someone so engaged with the look of the modern, then Robert Henri's *The Art Spirit*, a key text for Neel, is permeated with Baudelaire's ideas.[16] Henri, who spent time in Paris in 1888 and stayed in France till 1891, could not have avoided it. For an admirer of Impressionism like Henri, Baudelaire's essay would have been required reading.

Neel made a number of statements that resonated with Baudelaire's view of modernity, none more striking than in a doctoral address given at Moore College of Art & Design in 1971: "My choices were perhaps not always conscious, but I have felt people's images reflect the era in a way nothing else could. When portraits are good art they reflect the culture, the time and many other things".[17] A modern woman herself, a flapper, a single mother, opinionated, outspoken, standing up for rights, Neel was the painter of her modern life.

Painting Crisis

by Jeremy Lewison

The biography of Alice Neel has often intruded on the examination and interpretation of her paintings. Certainly her life experiences must have played an important part in her choice of subjects and the attitudes she struck in her paintings. For example, the death of an infant, and the loss of custody of another two years later, could not but have had a profound impact on her psyche. The fact that she painted in a figurative idiom has allowed writers (including the present author) to make connections between these life events and her work,[1] but had she worked abstractly such interpretations might have been harder to establish. A figurative painter is always likely to offer opportunities for biographical links, and they are certainly not irrelevant, but a painting, whether abstract or figurative, is a collection of marks on a support, the paint being a medium through which the painter communicates thoughts, impressions, instincts and observations, making strategic decisions to arrive at a solution to the problem of representation. The conscious and subconscious come into play whatever the idiom. So in looking at Alice Neel's paintings, it is helpful to resist the urge simply to explain them in terms of her life and the social context in which she was working – whether the Communist milieu, second-wave feminism or her living conditions for example – but rather to examine the nature of her art and its physical manifestation, exploring in what ways the manner in which she painted, the actual marks she made, determine what is represented. One of the questions to ask is does the way in which she applied paint amplify or even represent some of these biographical and social factors?

Throughout Neel's oeuvre there is a tension between the realistic and the expressive, or to put it another way, between the naturalistic and the distorted. There is also a dialogue between the mark as material and as a signifier. There was nothing unusual in these dualities. In Cubist painting the play between the mark and the sign was a central construct.

Similarly, Neel's interest in a certain kind of realism was perfectly in accord not only with the precedent set by the Ashcan artists, but even with the European "return to order" in the aftermath of the First World War. But it is the operation of these dual modes of painting, the real and the distorted, and the negotiation between material autonomy and service to narrative, that allowed Neel to move beyond the naturalistic to expose what lay beneath, or at least to give that impression.

While the Ashcan artists sometimes rebelled against the bourgeois milieus depicted in Impressionist painting in their adoption of low life subjects, their work was still essentially Impressionist in its facture, and they continued to adopt a number of Impressionist themes and strategies, not least its voyeuristic tendencies. They held aloft Edgar Degas, and his precursor, Honoré Daumier, as exemplary artists. Like the Impressionists, the Ashcan artists tended to see low life through a somewhat romantic lens. There was something of this in such early works by Neel as *Beggars, Havana, Cuba* (1926, Estate of Alice Neel, fig. 1), although, from her retrospective pronouncements, there can be no doubting Neel's empathy with the subjects.[2]

This kind of voyeuristic approach was not sustainable if Neel was to achieve the hallmark of authenticity. Her interest in realism, or "the truth" as she put it on a number of occasions, required her to live and breathe the life she portrayed. So in the late twenties and early thirties she painted her own world, whether in watercolour or oils, because that was what was authentically and immediately available to her: her impressions of a birthing clinic, her experience sitting on the beach at Belmar, New Jersey with her child, or her naked studio mates, Ethel Ashton and Rhoda Myers. These were things she lived and people she knew.

Already in *Ethel Ashton* (1930, fig. 2, cat. 5) Neel manifests an interest in the material nature of paint and its ability to act as both sign and mark. The lick of yellow ochre beneath

Ashton's left breast[3] has no narrative function, or at least the only narrative function is really quite improbable, namely that there was a gap between the breast and overflowing stomach that allowed Neel, from her position towering above Ashton, to observe the wall behind. The elongated yellow form is there to interrupt the folds of flesh, to accentuate the extended shape of the breast, giving it definition, and to mould the body into a writhing mass that is an index of Ashton's embarrassment and shame. The head that rhymes with the breasts, with eyes turned upwards in apparent supplication, reveals the dominance, some might say callousness, of the artist.

The portraits of Ashton and Myers are testimonies to a desire to move beyond the conventions of the nude, the preserve of male artists who traditionally idealized the female nude into an unthreatening but nevertheless erotic, contained form. In Neel's paintings the naked female is a living, breathing being, with emotions, feelings and concerns and above all with an unidealised body. Neel does not shy away from abjection nor does she create a pure illusion, whether the illusion of flesh or the illusion of the ideal; paint is itself as well as a means to create an illusion, paint as flesh and flesh as paint. Observe the area to the right of Ashton's navel where a dirty patch of grey appears to have been smeared on thinly, bounded by a black curve. While the curve indicates shadow, the grey area has no descriptive function since this fold of flesh is in direct light. It is simply a passage of paint, and while the colours applied to her left thigh are blended to an approximate flesh colour, the paint is laid on in broad, visible strokes. Similarly the passage of black between her legs, two triangles touching at their apexes, conflates pudenda and shadow, although it cannot be regarded as depicting either. It is first an area of paint and then susceptible to interpretation.

In *Rhoda Myers with Blue Hat* (1930, cat. 4) Myers's pubic hair is broadly described in a series of horizontal brushstrokes of black and brown, where the colours are simply applied on top of each other with no attempt to make an illusionistic blend. These characteristics would become part of de Kooning's signature style in 1950, where paint is both autonomous and descriptive.

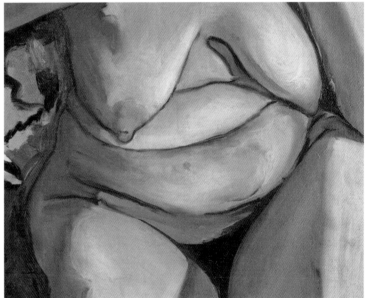

1 **Alice Neel,** *Beggars, Havana, Cuba,* **1926**
 Oil on canvas, 50.8 x 45.7 cm. Estate of Alice
 Neel.

2 **Alice Neel,** *Ethel Ashton,* **1930 (detail)**
 Oil on canvas, 61 x 55.9 cm. Tate, London.

Neither of these nudes are in the tradition of the neutral portrayal of the studio model, but extend Édouard Manet's approach in endowing the model with both recognisable function (*Olympia* as a courtesan) and personality (*Olympia* as insouciant). If the scale of Manet's courtesan was one of the most shocking elements of his painting, the scale of Neel's two "modern" women is equally confrontational, compressed as they are within the confines of the canvas and looking directly at the viewer. Neel's subjects are not models but friends, fellow artists, whose personalities she lays bare, Ashton's shame and embarrassment and Myers's indifference. She took the same approach to *Joe Gould* (1933, cat. 8) where Gould's devilish eccentricity lifts him out of the role of model to become a Greenwich Village character.

Here again there is a tension between the descriptive and material functions of paint. There is no narrative role for the orange, horizontal stripe beneath the stool. Similarly while the patch of grey beneath the legs of the torso on the left may denote shadow, it is first and foremost a series of marks, while the distressed nature of the surface where Neel has scraped back the paint, for example in the top left corner, has no apparent significance, although perhaps it is emblematic of Gould's slovenliness. A dirty patch may be a sign for dirt but there is no illusion here, simply paint operating as paint. However, the viewer may extrapolate from it something the artist may or may not have intended. Perhaps Neel wanted *Joe Gould* to resemble a mythological creature in a peeling, Roman fresco, examples of which were on view in the Metropolitan Museum. In those wall paintings, particularly from Boscoreale in the Bay of Naples, vermillion was often the background colour. The sculptural nature of Gould's hair is not dissimilar from a number of Roman or Greek busts of emperors, gods and mythological figures. As portrayed by Neel, Gould becomes chimerical.

A painterly approach was not one that Neel always adhered to. In her first portrait of *Max White* (1935, cat. 11), which may or may not manifest the impact of the German artists of the *Neue Sachlichkeit* (New Objectivity),[4] Neel dilutes the paint

so that it becomes a smooth, thin paste. The only anarchic feature of this cool-toned painting is the little spot of green between his lips and his nose that echoes the colour of his iris, thus drawing the attention of the viewer's gaze from the eyes to the complementary red lips and vice-verse. A more dilute patch of this colour is integrated into the flesh tones below his lips, where it represents a token of shadow as well as a means to unify the face. The mid grey area between his legs is presumably the seat of the chair or stool on which he is perched (although one wonders whether Neel took license with the colour), but it has a greater structural than descriptive role in that it represents an interruption to a solid dark blue across the bottom of the painting and a link to the lighter tones above.

The backgrounds of Neel's paintings at this point suggested an interest in geometric abstraction. They were generalised, perhaps generic, and sometimes incorporated passages of paint that anticipate the later work of Mark Rothko. The combination of a scumbled purple and a dusky pink-grey in *Max White* is not that dissimilar to the background of Rothko's *Underground Fantasy* (c.1940, National Gallery of Art, Washington, fig. 3), while the striking contrasts of the background of *Elenka* (1936, cat. 18) point to an interest in geometric abstraction, although after a while it becomes clear that Elenka is sitting at night before a window, with a blind drawn down to just over the half way point. The light comes from an internal electric lamp unseen up and to the left, her left cheek, closest to the window, lying in shadow. But even when the context has been deciphered what remains is a passage of pure painting: the extraordinarily textured area on the left, a mass of brush strokes of grey-black and, at its lower edge, a thin, serpentine line of green that kisses her right shoulder and opens up a space between her blouse and the wall. This green line has no descriptive function since the blouse is white and parts company with it. Then there is the polarity of the black and gold horizontal bands of paint whose horizontality is in fact an illusion, consisting as they do of quite a number

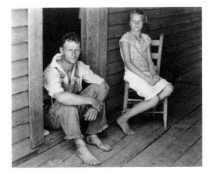

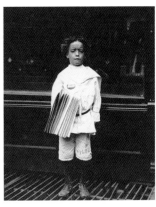

of vertical and diagonal brush marks. And intruding into this glorious background are two stray, curling locks of hair (the same happens on the other side of her head) where Neel enlivens the surface by breaking up the horizontal dynamic and relieves the square form of Elenka's head. Finally, Elenka's white blouse is in fact an accumulation of whites, greys, light brown and unpainted but primed canvas, where Neel suggests not only her experience of painting watercolours but of looking at the "unfinished" paintings of Paul Cézanne. The blouse consists of a series of wiggly, vertical passages of white paint, mostly applied quite thickly, knitted together by thinned, darker grey, sometimes applied with a dryish brush. Neel is not looking for verisimilitude here; she allows the paint to do the talking as these various elements coalesce before the viewer's eyes. The face is another area where Neel is beginning to understand that colour and materials can have a life of their own. Although some of the flesh tones are blended, other areas of the face are decidedly unnaturalistic, the abundance of yellow tones linking it to the background and recurring in the ring on her finger. The golden tones of this portrait make it one of Neel's warmest.

During the mid-thirties Neel painted friends, Communist political activists and the bohemian characters of Greenwich Village. If her style varied between the expressive (*Elenka*) and the so-to-speak photographic (*Max White*) it was because Neel was perhaps torn between her Robert Henri inspired training in Philadelphia, and her own discovery of photography, European and American, that must have occurred around this time. Henri's *The Art Spirit* (first published in 1923) was something of a bible to Neel, whose paintings would continue, perhaps increasingly, to reflect the absorption of his teachings. Henri's belief in spontaneity, in the primacy of the brush stroke and its ability to transmit the state of the artist, in the need for speedy execution and painting from memory, in the depiction of the background as just air, in the power of the look of the unfinished over the finished, were all to play a key role in Neel's work, although she was also to observe these characteristics in the paintings of some of the artists she most valued, Cézanne,

3 **Mark Rothko,** *Underground Fantasy,*
 c. 1940
 Oil on canvas, 87.3 x 118.2 cm. National Gallery
 of Art, Washington D.C., Gift of the Mark
 Rothko Foundation, Inc., 1986.43.130.

4 **Walker Evans,** *Floyd and Lucille*
 Burroughs on Porch, **Hale County**
 Alabama, 1936
 Gelatin silver print, 18.9 x 23.7 cm.
 Metropolitan Museum of Art, New York,
 Purchase, Marlene Nathan Meyerson Family
 Foundation Gift, in memory of David Nathan
 Meyerson; and Pat and John Rosenwald and
 Lila Acheson Wallace Gifts, 1999,
 199.237.4.

5 **Lewis Wickes Hine,** *Jo Lehman, a 7 year*
 old newsboy. 824 Third Ave., N.Y. City, **July**
 1910
 "He was selling in this Saloon. I asked him
 about the badge he was wearing. "Oh! Dat's
 me bruder's," he said.", gelatin silver print,
 11.6 x 9.5 cm. Metropolitan Museum of Art,
 New York, Gilman Collection, Purchase,
 The Howard Gilman Foundation Gift, 2005,
 2005.338.

Edvard Munch and Vincent Van Gogh.[5] But on the other hand there was the increasing visibility of photography and her greater exposure to it once she met the photographer and filmmaker, Sam Brody, who was to become her partner for just over 18 years from 1939.

It was the year before this meeting, while still living with José Santiago Negrón and pregnant with his child, that Neel moved from the bohemian quarter of Greenwich Village, to the gritty, immigrant neighbourhood of Spanish Harlem. Although an overwhelmingly African-American district of Manhattan, Harlem had pockets where different nationalities would congregate, forming ghetto-like conurbations. Spanish Harlem, later to be called El Barrio, was the Eastern enclave populated predominantly by Puerto Ricans and Latin Americans. While Neel moved there to be closer to Negrón's family, cutting herself off from Bohemia, it was not as much a removal from the cultural world as some writers have suggested, for Harlem underwent a "renaissance" of African-American culture in the twenties and thirties.[6] Neel undoubtedly had contact with some of its protagonists. Nevertheless, the principal motive for her departure from the Village, she announced retrospectively, was to seek out the "truth", and in that sentiment she echoed the words of the pioneer American photographers.

In his article "The Reappearance of Photography", published in 1931,[7] Walker Evans described a reawakened interest in "simple" and "honest" photography and an abandonment of the romantic aestheticism of Alfred Stieglitz. Evans and his contemporaries introduced a new aesthetic that foregrounded decay, hardship, obduracy and pathos and that, in the context of the Great Depression, became an index of truth. Their portraits of tenant farmers, the unemployed, the starving and the desperate did much to refocus the minds of city dwellers, and demonstrated more than anything else that America had no single identity but was a nation of many parts (fig. 4). This interest in documenting America and focusing on ordinary people and their harsh lives was consistent with the views of Neel's Communist friend, Mike Gold, who advocated a proletarian realism, a functional art concerned with facts. His rejection of bohemianism, as Andrew Hemingway has explained,[8] was commonplace among Communist Party members. For another Communist like Brody, films and photography were weapons in the class struggle.

Photography was considered at the time to be a measure of authenticity. Ostensibly objective, often published anonymously, it became a tool of social reformers and a means to communicate honest truths. The public gave little thought to the means by which photographers could actually shape their intentions by editing, lighting and cropping. Neel was, therefore, among a number of artists and photographers who came to realise, as an anonymous writer opined in the programme notes for the Film and Photo League (a slightly later incarnation of the Workers' Film and Photo League of which Brody was a founder member in 1930), that "the only honest approach to art is TRUTH".[9]

Three paintings of the middle of the decade, *Max White*, *Elenka* and *Kenneth Fearing* (1935, cat. 12) suggest that Neel was at a crossroads. If *Max White* had a high focus, almost photographic quality, and *Elenka* was to a certain degree expressionistic, the portrait of Fearing was to a large extent allegorical, consistent with such works as *Futility of Effort* (1930, private collection, fig. 31), *Degenerate Madonna* (1930, cat. 3) and *Symbols (Doll and Apple)* (c. 1933, cat. 7). The fact that she chose to pursue the line set by *Elenka* suggests that for Neel "truth" was more than naturalism, more than being faithful to appearance and required greater restraint than the fantasy required to create allegory. Although she was a great admirer of the allegorical, didactic and propagandistic murals of Diego Rivera, David Siqueiros and José Clemente Orozco (she regarded Orozco as the greatest of the three),[10] and seemed to nod in the direction of Rivera in her depiction of *Pat Whalen* (1935, Whitney Museum of American Art, fig. 6),[11] she must have felt that the complexity of their works, replicated to some extent in *Kenneth Fearing*, was too illustrational, too much in the service of narrative and maybe too impure in painting

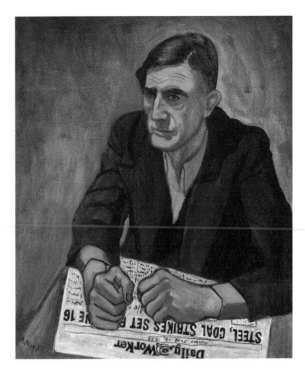

terms, for rarely in their mural work was paint allowed to remain paint. Theirs was essentially a graphic, almost comic strip art, that deferred to the models set by *trecento* and *quattrocento* Italian religious painters for recounting holy narratives.

Neel's move to Spanish Harlem precipitated not so much a change of subjects as additions to the range. She continued to paint left wing activists, but they included members of the African-American and Hispanic population that she would not have encountered in Greenwich Village, and she expanded her repertoire to embrace immigrant neighbours. Very few of her sitters, if any, would have been widely known.

The way in which Neel addressed her new subjects, the young Georgie Arce, for example, or the anonymous Hispanic and black children, echoed the approach of Lewis Hine (fig. 5). Hine photographed immigrants at Ellis Island and street children in the style of social documentary that was later taken up by Jerome Liebling, a member of the Film and Photo League, who began his career in the late 1940s. Hine's photographs were shown in a retrospective at the Riverside Museum, New York in 1939, the year after Neel moved to Spanish Harlem.[12] The authenticity of Hine's photographs and the innocence of children in the harsh urban environment pervade Neel's depictions of her downtrodden neighbours. Like that other Harlem street photographer, Helen Levitt, who had a one-person show at the Museum of Modern Art, New York in 1943, her subjects were not citizens of the new streamlined, mechanised city but of the poor districts that modernisation passed by. This was closely observed New York, not the idealised vision presented in architectural models at the New York World Fair in 1939, where people were shown as encumbrances in an impersonal, Corbusian environment dominated by highways, skyscrapers and cars.[13]

It is not clear how much Neel looked at photography before meeting Brody, but she was an admirer of the great French nineteenth century pioneer, Félix Nadar (Gaspard-Félix Tournachon), whose work was bought and shown as early as 1931 by Julien Levy. "Nadar took photographs that were

6 **Alice Neel,** *Pat Whalen,* **1935**
Oil, ink, and newspaper on canvas, 68.9 x 58.7 cm. Whitney Museum of American Art, New York, Gift of Dr. Hartley Neel, 81.12.

7 **Photographer unknown. Daguerreotype of Honoré de Balzac owned by Nadar.**

8 **Nadar,** *Champfleury,* **c. 1877.**
Musée d'Orsay, Paris.

9 **Alexander Rodchenko,** *Vladimir Mayakovsky,* **1924**
Gelatin silver print, 10.7 x 7.5 cm. Metropolitan Museum of Art, New York. Gilman Collection, Purchase, Ann Tenenbaum and Thomas H. Lee Gift, 2005. 2005.100.346.

10 **August Sander,** *Art Historian Wilhelm Schäfer,* **1928**
Gelatin silver print, 21.6 x 15.9 cm. The J. Paul Getty Museum, Los Angeles.

better than paintings", she told Jonathan Brand. "His picture of Balzac (fig. 7)[14] couldn't have been outdone. And Nadar made a photograph of [Joseph] Conrad that is just one of the greatest things I have ever seen. He looks like a lion."[15] What Neel must have admired in Nadar's work was the characterisation of the sitter, the power of the pose and the sense of intimacy that differentiated his work from routine photography (fig. 8). Nadar's methods of obtaining the pose were pretty much Neel's. Describing one of his late photographs of Adolphe Crémieux he wrote: "One sits down, one chats, one laughs, all the while readying the lens; and when [he] is in place, well positioned and drawn out for the decisive moment, radiating all his natural benevolence, warmed by the affection with which he feels himself surrounded" the shutter is released.[16] Nadar, like Neel, was after an intimate moment when the sitter revealed his innermost character. She would talk constantly to sitters while painting, lulling them into finding a pose that would reveal what she regarded as their inner self.

Unlike the ornate interiors that formed the backdrop of the photographic work of many of his contemporaries, Nadar's photographs were austere, rarely full length, and with plain backgrounds. He seldom encouraged his sitters to express emotion, and a large number of his works portrayed people facing straight to camera or in three quarters pose. Neel adopted similar strategies in her portraits of the 1930s. Max White, for example, sits impassively staring straight at the artist (cat. 11). His clothes are plain and loose, muffling his body so as not to draw attention from his head, a strategy also employed by Nadar whose male sitters tended to wear black outfits so that their faces appeared as highlights. Like a Nadar photograph, Neel's painting is severe and intense with all concentration directed towards White's head. But the close-cropped hair, the chiselled features, the plain worker's suit and neutral background also bring to mind Alexander Rodchenko's portraits of Vladimir Mayakovsky of 1924 (fig. 9). Whether Neel knew these Soviet photographs or not, what she creates is a look associated with the proletarian thinker and writer.

Elenka also mimics Nadar's compositions; again an impassive look, a compressed space, but also the use of the arm of a chair to maintain a pose (cat. 18). There appears to be no conversation taking place, the sitter concentrating on keeping still, unlike in Neel's late portraits which could be restless. In Nadar's day taking a photograph needed such a long exposure that the sitter required props to maintain poses. Similarly the strong contrast between the light and dark sides of Elenka's face are a feature of Nadar's photographs, for early on in his career Nadar photographed his sitters outside in full sunlight with the sitter placed so that one side of the face was more brightly lit than the other. Neel regularly adopted this strategy, nowhere more memorably than in the second portrait of Max White (1961, cat. 37) where the dark side of the face suggests infirmity attendant upon old age and reeks of mortality. The chiaroscuro portrait also became a familiar theme in the work of the photographic portraitist Irving Penn, but he used it for dramatic effect rather than to suggest any metaphoric reading. Penn, who spent time in Paris, was clearly influenced by Nadar as well.

The way in which Neel cropped her paintings also has a close relation to photography. Cropping came to play an increasingly important role in her oeuvre, and it can be no coincidence that it did so the more she looked at photography. "I lived with a man for many years who was a great photographer," she told Henry Geldzahler in reference to Brody, "and through him I had an interest in photography."[17] Neel also had an involvement with *Aperture*, a photographic magazine founded in 1952. Clearly she realised she could choose how to frame an image. In *Richard at Age Five* (1945, cat. 25) the edge of the canvas slices off Richard's right elbow as it does Art Shields's in the eponymous portrait of 1951 (cat. 28). Shields's head of hair is also truncated so that the viewer concentrates more on his facial features. John Perreault's right elbow is omitted from his nude portrait of 1972 (cat. 59), and the arms of Don Perlis in the late *Don Perlis and Jonathan* (1982, cat. 70) are similarly cut off. These deliberate

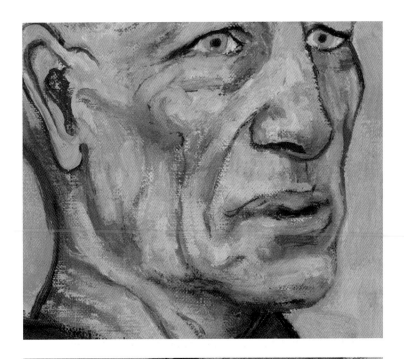

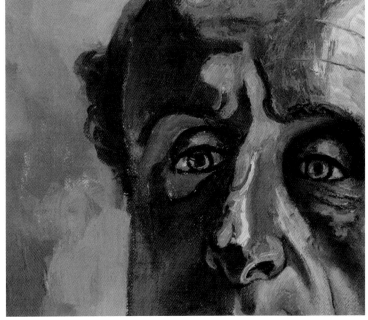

crops compress the image and give it greater informality, immediacy and tension.

For an artist interested in portraiture of a realistic nature, photography was an obvious source of interest. Neel confessed to an interest in Hine, Margaret Bourke-White and the German photographer August Sander (fig. 10). In the interview with Brand Neel referred to an exhibition of Bourke-White's photographs at "the Russian embassy in the thirties" and reproductions of her work in *Life*. She judged Hine to be "magnificent" and Sander as someone whose work she "loved".[18] Sander's typological project has certain parallels to Neel's self-proclaimed purpose of creating an equivalent to Honoré de Balzac's *Comédie humaine*.

If there are parallels in themes, compositions and approaches to subjects between Neel and various photographers past and contemporaneous, her address was substantially different, for a painting is a composite image built over time from hand-applied material, in her case leaving evidence of its build through brush strokes, *pentimenti*, changes of mind, and subjective choices of colour. Painting is ultimately a fiction, an imaginative creation, where brush strokes are to the final image as words are to a book. It is their accumulation that endows them with meaning. Neel's paintings are no more nor less real than the work of any abstract painter. They are constructs. *Daily Worker* journalist Art Shields's face, far from smooth, is a craggy massing of short brush strokes interspersed with bare, primed canvas suggesting the dry skin of a man who cared little for his personal appearance or retaining youthful skin (fig. 11). His ruggedness seems to underpin his steadfast belief in the integrity of left wing causes, evinced in his piercing, blue eyes staring at a distant vision of justice for all, redolent of Soviet photographs of pioneers. The severe portrait of Sam, executed around the time of his definitive break from Neel in 1958,[19] contains painterly passages, for example on his nose and forehead, which in themselves are a series of semi-autonomous abstract marks but cumulatively make a convincing form (fig. 12, cat. 31). The bulbous shape down the left side of the bridge, the

11 **Alice Neel,** *Art Shields,* **1951 (detail)**
Oil on canvas, 81.3 x 55.9 cm. Private Collection.

12 **Alice Neel,** *Sam,* **1958 (detail)**
Oil on canvas, 81.3 x 56.2 cm. Estate of Alice Neel.

ragged maroon patch diagonally down from it (reprised on his chin) and the trail of white that snakes its way up the bridge like some kind of protozoan discharge, coalesce into a convincing nose that reflects light and creates shade, but as a piece of pure painting is as abstract as the background that clearly mimics the prevailing tendencies in Abstract Expressionist painting Neel would have seen in the galleries and heard about on her attendance at meetings of the Club.[20] In painting such backdrops, also seen for example in *Georgie Arce* (1959, cat. 33), Neel was domesticating Abstract Expressionism, feminising it, emasculating it even, suggesting, perhaps, it was no more than decorative. Abstraction, Neel seemed to be saying, should be placed in the service of figuration; it was not an end in itself.

It was no more purposefully employed than in the double portrait *Rita and Hubert* (1954, cat. 30). Hubert Satterfield, like Alvin Simon (cat. 34), was one of a number of black writers Neel painted, here with his white girlfriend Rita. The stark contrast between Rita's bright flesh and Satterfield's blackness, exacerbated by the freely brushed, maroon background which, behind him, is darker still and into which he sinks, conspires to make him less visible. Moreover, the bright and intricate pattern of his shirt distracts the viewer's eye from his face, which, but for the highlights on his nose, cheeks, lips and chin and the whites of his eyes would otherwise fade into the unlit world of the second class citizen. Visibility was the primary theme of a number of black writers in this period, not least the prize winning author Ralph Ellison whose exposition of racism and black activism, *Invisible Man*, published in 1952, took the American literary scene by storm. The black narrator, who is neither described nor named in his first person account, establishes at the beginning of the book that in spite of being "a man of substance, of flesh and bone, fiber and liquids … I am invisible … simply because people refuse to see me."[21] Neel translates this injustice in American society in the most vividly visual and painterly way, while at the same time not fearing to paint what was considered in this era of prejudice a

transgressive relationship between a black and a white. Neel saw people like Satterfield and Alvin Simon as equals.

The backgrounds to Neel's portraits in this period, while embracing the prevailing idioms of Abstract Expressionism, were not merely expertly wrought passages of pure painting, but could also be pointed parodies. In the last portrait of Max White (1961, cat. 37) Neel paints a helmet of marks around his head, as though referencing her description of her first portrait of White as an Olmec head.[22] Yet clearly she used these marks to cover up a shift in the contour of his cranium that she balanced by the spiralling, gestural marks on the upper left of the painting, probably pools of light, that call to mind, if not the swirling breasts on many of de Kooning's *Woman* paintings of the previous decade, then Ellie Poindexter's ample bosoms in Neel's acerbic portrait, painted from memory, the following year (cat. 39). Neel seems knowingly to be mimicking de Kooning, reclaiming these marks in her portrait of a withered, arthritic man and uneroticising the mammaries of a powerful, female art dealer she disliked on acquaintance.

The dismantling of the erotic, which may be regarded as an assault on de Kooning and other male painters of the nude, was surely one of the intentions behind the frank portrayal of *Ruth Nude* (1964, cat. 41), who parades her genitals in a gesture of defiance without a hint of seduction. Like Ethel Ashton, Ruth is corpulent, but unlike the former, bears no shame. This is the sixties, the era of sexual liberation, of growing feminist bravura and pride, when women fought back against male domination. *Ruth Nude* is emblematic of this moment, a riposte to the traditional subservience of the relationship of the female model to the male artist, which, in the mind of the male viewer, conjured ideas of coition after the painting session was over. Ruth is not available; she is formidable.

Ruth Nude comprises long, flowing brush strokes defined by strong contours. The green areas around her body suggest grass, the yellow and blue gestural marks to her left denote sun and sky. Perhaps this was executed with a memory of Spring Lake or maybe in front of a window, since the shadow on the

left evinces an interior wall. The ambiguity of the setting arises from the paint that refuses to be wholeheartedly descriptive, but remains equally simply material and colour. If there is a touch of a parody of the women de Kooning depicted in a landscape environment, there is nonetheless a serious assertion that the female body is not a sex object but a source of female pride and demands respect.

The background in *Ruth Nude* is much less complete than in paintings of earlier periods. Neel was progressively abandoning the need to fill the canvas with paint and to achieve a high degree of finish. Henri had advocated sketchiness, although he himself was not as audacious as Neel. For example, the features of the room in *Hartley* (1966, cat. 43) are delineated in the most rudimentary way, the paint scrubbed on swiftly to denote shadow and three simple lines turning the corner to mark out the dado. All attention is focused on the figure whose troubled look Neel signifies by the green tones that cloud his face and expression. She was later to employ green to indicate the anguish and sickness of her daughter-in-law, Nancy, in *Pregnant Woman* (1971, cat. 55).

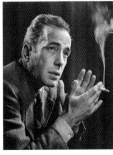

The "unfinished" look of the backgrounds of these portraits soon migrated to the figures themselves, where sometimes faces were complete but torsos merely outlined. If Henri's theories might have prompted this "sketchiness" Neel may also have embraced it for a number of other reasons. By 1960 she was sixty years old with a strong sense of her mortality. With time running out she became more impatient and concerned to get on to the next idea. So, having established the essentials she felt she could move on. Furthermore she may have also regarded the "unfinished" portrait as being more suggestive, drawing the viewer into a collaboration to complete it. In this respect her approach was very much of the moment, since it was in 1962 that the Italian philosopher, Umberto Eco, published his essay *Opera aperta* (The Open Work), which analyses the role of ambiguity and incompleteness in drawing the viewer into the work of art.[23] Neel would not have known Eco's writing but she was serendipitously demonstrating its validity. Lack of

13 Alice Neel, *Hartley*, 1966 (detail)
Oil on canvas, 127 x 91.5 cm. National Gallery of Art, Washington D.C., Gift of Arthur M. Bullowa, in Honor of the 50th Anniversary of the National Gallery of Art, 1991.143.2.

14 Yousuf Karsh, *Humphrey Bogart*, 1946

15 Alice Neel, *Sherry Speeth*, 1964
Oil on canvas, 106.7 x 71 cm.
Private Collection.

"finish" was also a way of counteracting the singular moment characteristic of realist or photographic portraiture. The "unfinished" portrait was in a constant state of becoming.

Neel's portraits were also becoming less static and incorporated gesture and movement. Whereas her portraits had been like set pieces up until the late fifties, by the sixties she veered towards greater informality and photographers took the same trajectory. Yousuf Karsh's active 1946 portrait of Humphrey Bogart (fig. 14) and Richard Avedon's 1958 portrait of Marcel Duchamp make interesting comparisons with Neel's *Sherry Speeth* (1964, fig. 15). The dynamics of the portraits, not to mention their psychological intensity, are derived as much from the gestures as the face. In his *Simon and Garfunkel*, used on the cover of their 1968 album *Bookends,* Avedon employs gestures in a similar way to Neel. The angle of their heads, Garfunkel's raised hand and arm cut off at the elbow create movement, flow and tension in what is ultimately an eccentric image.

Backdrops to photographs also changed. Irving Penn, presumably influenced by Sander, developed a taxonomy of manual trades in the early fifties and a signature style of variegated backdrops that seemed to reflect an awareness of the inflected surfaces of Abstract Expressionism, just as Neel's painterly backgrounds did. By the sixties that look was over as Avedon, among others, introduced the brilliant white studio shot where the subject was pinned against an unremittingly bright wall of paper. Neel seemed to take cognizance of this new look in a number of portraits – for example *Andy Warhol* (1970, cat. 51) and more especially *Victoria and the Cat* (1980, cat. 68) – where the vulnerability and exposure of her granddaughter, in a blast of bright light, makes for uncomfortable viewing. By dropping out the background she intensifies the viewer's gaze on the awkward child and stresses her vulnerability. Victoria had been captured in this pose in a photograph earlier that year (her father recounts she often held the cat like this),[24] and although Neel did not paint the work from the photograph she might have had it in mind. In fact, the painting was largely painted from memory since a child of this age would be unlikely to hold a cat in this pose for a long period.

Vulnerability is one of the themes of Neel's portraiture. She and Avedon both portrayed the inmates of Warhol's Factory and made representations of his scarred body (fig. 16), but whereas Avedon's shot portrays Warhol's swagger and bravado, wearing his wounds like a fashion garment, Neel's quieter depiction gets under his carapace to reveal an introspective Warhol who, in his exposure, betrays exhaustion, perhaps serenity or even shame, since shame derives from being seen by the other. By closing his eyes Warhol resists the penetrating gaze. Similarly both Neel and Avedon portrayed sitters in old age with a lack of sentiment but with painful honesty, highlighting the process of decay as well as a depth of humanity. Avedon's portraits of his ailing father echo Neel's earlier portrait of her mother, *Last Sickness* (1953, cat. 29), and her double portrait of *The Soyer Brothers* (1973, cat. 61).

Andy Warhol (cat. 51) is a reprise of *Ethel Ashton*, his sagging breasts recalling the shape of hers, his overflowing folds of flesh held in check by a corset. How ironic that Neel should portray this iconic male artist like the forgotten female artist once her friend. But now the painterly address is totally different. The paint is brushed on broadly, the stitches of his wounds are crude dabs of paint, his face an accumulation of fauvist patches, the blue under his left eye not some effeminate eye shadow but simply a link to the bright blue background, just as the green yellow patches on his forehead are scarcely credible reflections of his hair. Paint and colour operate autonomously, contributing to the dynamics of the composition as much as having a descriptive function. Neel took liberties with the appearance of her subject to create an image that was psychologically penetrative and compositionally taut. Warhol sits like a modern martyr against a pure blue background attached to him like wings, recalling paintings by Piero della Francesca. A weighty presence barely anchored in the world, Warhol is materially present but psychologically absent.

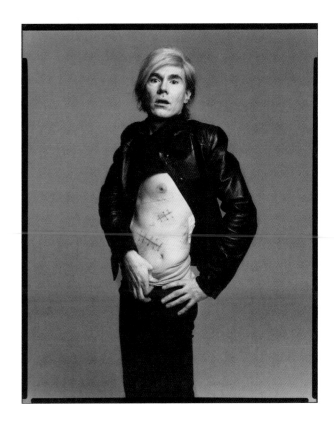

Neel's experience of painting backgrounds that manifested the history of their painting through open brushwork now found its way into the central elements of the painting itself. Her treatment of Hartley's T-shirt in the portrait of 1966 (fig. 13) recalls Elenka's blouse but is much more fluid and gestural, a rich combination of whites, greys, pinks and hints of blue, with serpentine and diagonal marks evincing folds and creases. It is a sophisticated passage of painting of which any abstract artist would have been proud, but which is less redolent of the paintings of Robert Ryman, who had already settled on an exploration of white and the medium of oil paint, than of Manet, who really set the precedent for this kind of painterly address, whose visible brushwork swept away the demand for a high degree of finish and supplanted it with a broken surface of marks of multiple colours that would cohere on the retina as a pleated or rippling light-catching, monochrome fabric (fig. 18). If Neel had previously lavished attention on garments, for example Hubert's shirt in *Rita and Hubert*, or her mother's threadbare dressing gown in *Last Sickness*, these were generally patterned. But in *Hartley* the T-shirt was neutral, like Elenka's blouse supposedly a single colour, which in previous paintings she would have painted broadly and with little inflection (see for example *Art Shields,* cat. 28). Here, however, the T-shirt becomes a living, breathing membrane, a matrix of cast shadows, highlights and mid tones that separates itself from its contours on his right shoulder, and down his right side, and refuses to be fixed. As a large expanse of brilliant light it throws into relief the gloom of Hartley's face, the obverse to Nadar's practice.

Hartley is the culmination of a long line of portraits Neel painted during a period of growing interest in Existentialism that preoccupied American intellectuals after the war. Her youngest son, a medical student at Tufts, sits pondering his future, allegedly disturbed by his obligation to dissect corpses, particularly at a time when his contemporaries were dying on the killing fields of Vietnam.[25] His delicate good looks, his face, the majority of it cast in shadow, a masquerade in the tradition

16 Richard Avedon, *Andy Warhol, Artist*, New York City, April 5, 1969
17 Richard Avedon, *Willem de Kooning, Painter*, Springs, Long Island, August 18, 1969.

of female *maquillage*, present a man in crisis. Neel represents here what it means to be in a funk.

Neel's project to create a *comédie humaine,* a collection of types, coincided with a debate about what literary historian Mark Greif calls "the crisis of man" that, in the USA, began in the thirties and became particularly emphatic in the early forties, finally commuting into existentialist rhetoric in the late forties and fifties.[26] Greif convincingly argues that in the thirties it was feared that human nature was being forcibly changed, that not only were fascist regimes, and in particular the Nazi regime, attempting to pervert human nature and manufacture it anew, but that technology, created by man, was now beyond his control and being used against him. As Neel's Communist friend Mike Gold argued in the introduction to the catalogue of her 1951 exhibition at New Playwrights Theatre: "Alice Neel has never allowed them to dehumanize her. This is heroic in American painting, where for the past fifteen years Humanity has been rejected, its place given to the mechanical perversions, patent-leather nightmares and other sick symbols of a dying order."[27] For Gold capitalism was a dehumanising force leading to massification. Neel echoed Gold, pinning the blame on technics, when she wrote in 1974: "Man in our present society cannot compete with the forces against which he is pitted, so he technologizes himself and denies his own humanity. He cannot control the technological forces created by his intellect and therefore seeks to ape the lack of feeling of his own inventions, not realizing that without him they would be mere empty shells."[28] This is classic "crisis of man" rhetoric.

Greif has described the context for such writings: "Man became at mid-century the figure everyone agreed must be addressed, recognized, helped, rescued, made the centre, the measure, the 'root', and released for 'what was in' him".[29] Numerous books were published that attempted to answer or opened with the question "what is man?".[30] Human nature that had previously been regarded as permanent now appeared to be malleable, giving rise to an increase in social anxiety. There was a sense that mankind had returned to a state of barbarism through over-civilization, or as sociologist Lewis Mumford, who had previously expressed optimism about technological progress, put it in 1944: "Modern man is the victim of the very instruments he values most".[31] The impact of the atomic bomb and the revelation of the concentration camps only strengthened the sense of danger posed by technology and man's ability to destroy himself. *Film noir* simultaneously presented man as out of control, threatened by his ever-increasing weakness, caught in a spiralling web of conflict, confusion, indecision and powerlessness, with woman perceived as dangerous and threatening. The "crisis of man" was essentially a masculine concern that the rising tide of feminism did nothing to assuage and which ignored issues pertaining to racism and women.

In the immediate aftermath of war the debate was disseminated by means of the discussion of French Existentialism in such small circulation magazines as *Tiger's Eye* and *Partisan Review*, the latter formerly a Trotskyite magazine but read by artists, writers and politicians alike. Jean-Paul Sartre's take on Existentialism emphasized individual action, instinct, personal responsibility and freedom and had an enormous impact on left leaning intellectuals as well as artists, particularly the Abstract Expressionists and their supporters. But Sartre's influence was soon to be superseded by Albert Camus' universalism. Lectures at the Club frequently made reference to existential thought. Neel's intense scrutiny of men and women can be seen as her own way of entering the debate and seeking answers to the question "what is man", of asserting the importance of the idiosyncratic nature of the individual over the uniformity of a "barbaric" world where people are manipulated, pacified and placed in the service of capital, so ably satirised by, among others, Aldous Huxley in *Brave New World* (1932). "I love to paint people mutilated and beaten up by the rat race in New York", Neel reflected in an interview with Judith Higgins published in 1984, indicating her view of the inhumanity of city life in the Capitalist era.[32]

The novel was also in crisis. In the early part of the century modernism brought about what the philosopher, José Ortega

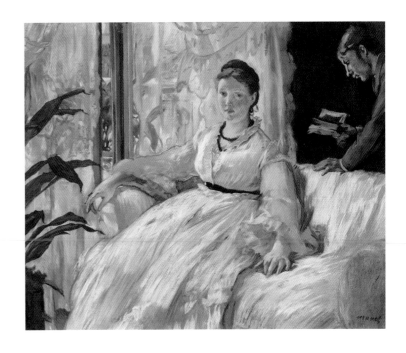

y Gasset, referred to as the dehumanization of art.[33] After the Second World War novelists sought to restore a strong belief in the value of humanism in the face of mechanisation and charted a course parallel to Neel's. The critical view of William Faulkner was transformed from nihilist to humanist, and he came to be regarded as a writer who could rescue the novel from its social irrelevance. The critic, Robert Penn Warren, suggested that Faulkner saw modernism as "the enemy of the human, as abstraction, as mechanism."[34] If in the literary sphere humanism and modernism were polar opposites, in the visual arts Abstract Expressionist painting, which embraced Existentialism, was perceived as, to a certain degree, humanistic in that it provided an index of the artist's feelings as an individual. As Michael Leja has argued, Abstract Expressionism was a manifestation of "modern man's" new idea of self.[35]

The well-known literary critic, Lionel Trilling, who considered abstraction and modernism, or novels that were obsessed with form, were now exhausted and that novelists had to return to "humanness", prompted Warren's point of view.[36] To the extent that their work was abstract, artists like Jackson Pollock and Mark Rothko were somewhat out of step, although their insistence on the tragic and timeless as subjects fit for art was well in line. In spite of the fact that they invested their art obliquely with humanity, their refusal to engage with the figure in their mature work (Pollock's black "pourings" aside) suggested the obliteration of man or at best a focus on internal feelings. Faulkner, in accepting the Nobel Prize for literature in 1950, took the opposite point of view: "I decline to accept the end of man ... I believe that man will not merely endure; he will prevail. He is immortal, not because he alone among creatures has an inexhaustible voice, but because he has a soul, a spirit capable of compassion and sacrifice and endurance."[37] There are echoes of Faulkner's much read address in Neel's statement in *The Hasty Papers. A One Shot Review*, a beat anthology with articles by Jack Kerouac, Allan Ginsberg, Gregory Corso and Frank O'Hara among others and photographs by Robert Frank. It also contained an article

18 Edouard Manet, *La Lecture*
(The Reading), **c. 1848–83**
Oil on canvas, 61 x 73,2 cm.
Musée d'Orsay, Paris.

by Sartre. "When I go to a show of modern work" Neel wrote, "I feel that my world has been swept away — and yet I do not think it can be so that the human creature will be forever verboten. Thou shalt make no graven images."[38]

At this point the question arises as to what was the most radical position among visual artists; to continue on the modernist trajectory like Pollock, Rothko and Newman or, like Neel, to reject modernist abstraction as somewhat meaningless and *passé*, and maintain a position outside the mainstream by reengaging with the humanistic. After all, by the late 1950s, Abstract Expressionism had become the new academy. If photography was perceived to have been the death of painting, as the *juste milieu* painter Paul Delaroche is alleged to have remarked in 1839 on the invention of the Daguerreotype, was it more or less adventurous to engage with it, as Neel did? It has taken the work of Gerhard Richter, among others, to show that photography, and indeed realism, has a fundamental relationship to painting. If abstraction was one way of delaying that death, of turning away from the real and developing a language that focused on the inner world, a new humanism was another way of maintaining or developing painting's relevance post photography. Whether in the work of Frank Auerbach, Francis Bacon, Jean Dubuffet, Jean Fautrier, Lucian Freud, Alberto Giacometti, Pablo Picasso or Alice Neel, artists found ways to engage with the realities of the post-war era without renouncing the figure. There were more ways than Abstract Expressionism to represent the "crisis of man" and "modern man's" fault lines, each of them inventive and radical in their own way.

The discussion of the "crisis of man" helps to situate *Hartley* and such earlier paintings as *Rita and Hubert* (cat. 30), *Sam* (cat. 31), and *Sam (How Like the Winter)* (1945, cat. 24), with its troubling representation of mental demons, as manifestations of an acute and urgent debate. Neel continually represented the psychic disturbance, insecurities and agonies central to the "crisis of man" discourse, especially in paintings of Sam who, at times, had such a disturbing presence in the family as Neel

showed in a dramatic way in *Minotaur* (1940, Estate of Alice Neel, fig. 19).

Issues of identity were also crucial elements in the crisis and in Neel's art: homosexuality and gender in, for example, *Jackie Curtis and Ritta Redd* (1970, cat. 52), *Jackie Curtis as a Boy* (1972, cat. 57) and *David Bourdon and Gregory Battcock* (1970, The University of Texas at Austin), and even professional identity in *Richard in the Era of Corporation* (1979, Estate of Alice Neel, fig. 42). Selfhood appears as a shifting and troubling concept. As she did in *Hartley*, Neel signifies Richard's bewilderment and depression by a sickly, green cast smeared onto his face like make-up. She captures his uncertainty, as she does in the half naked standing portrait *Richard* (1973, Estate of Alice Neel), where he poses awkwardly, self-consciously and perhaps angrily in the garden at Spring Lake. Other portraits that capture a sense of *ennui*, such as *Hartley* (1978, Estate of Alice Neel), *Nancy and the Rubber Plant* (1975, The Toledo Museum of Art, Ohio) and even the elderly *Soyer Brothers* (1973, cat. 61), manifest the continuing legacy of the "crisis of man" deep into the final half of the century, while issues pertaining to gender surface not only in the aforementioned paintings of Warhol and his acolytes, but in the brazen pose of *Marxist Girl (Irene Peslikis)* (1972, private collection, fig. 39)[39] with her unashamed display of axillary hair, the effeminate-looking artist *Robbie Tillotson* (1973, Museum of Contemporary Art, Los Angeles) and even Julia in *The Family (John Gruen, Jane Wilson and Julia)* (1970, Museum of Fine Arts Houston, cat. 53), where the awkward feelings of early pubescence are captured by Neel in a pose that echoes Munch's painting *Puberty* (1894–95, National Gallery Oslo). In pose, choice of tones and colours, facture and painterly address Neel describes the flaws and rifts of the century.

To the end of her life Neel continued to manipulate paint so that it was both mark and signifier. In *Don Perlis and Jonathan* (1982, cat. 70) Perlis's face is a mask of depression, his deep-set, hollow eyes and grimacing mouth expressing the pain of having a son with cerebral palsy. Jonathan, all

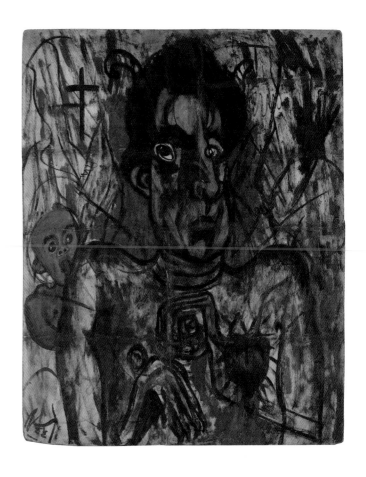

innocence, is depicted in light tones, while Perlis is sombre, his dark mood accentuated by the stark, light background. Neel paints his face with coarse brush strokes that retain their individuality as marks and clash in all directions like a metaphor for internal conflict. Perlis's pain found its expression in Neel's crude brush work through a process of the transference. Colours which might be justified as shadow – the black and brown patches to the left of his nose for example – provide sculptural relief to a face otherwise painted in flat, more or less horizontal marks. It is a gash that penetrates his deathly façade. The face works in inexplicable ways. A surface that is so "unfinished" and coarse ought not to read with such clarity and coherence, but it does. And what of the pink and yellow marks rising above Perlis's shoulder between his and Jonathan's head? There is no logical explanation in terms of narrative. They sit like a flame, a flare of light indicating a space behind but also a brilliant counterpoint to Perlis's jet black hair and gloom, perhaps a ray of hope for the future of his son.

Neel did not make marks for their own sake; they always had a purpose whether structural or allusive. As modernism increasingly turned away from the illusion of the real and photography occupied the vacant ground, Neel employed the means of abstraction, the literal mark, to create an art predicated on realism, recognizing that the real was a characteristic of the mark itself as much as what was depicted. Painting represents the act of looking and thinking over a sustained period. The image, necessarily a fictional construct, is an accumulation of experiences distilled into a single image, of marks applied independently which, cohering into a whole, become analogies for things seen. There can be a logic to mark making beyond the narrative requirement, where a mark is required for structural rather than depictive purposes, where the mark can undermine or sustain the realist project. In making her paintings Neel achieved a fine balance between the two.

19 Alice Neel, *Minotaur*, 1940
Oil on canvas, 76.6 x 61 cm.
Estate of Alice Neel.

Emotional Values
Alice Neel and the American Reception of German Art

by Petra Gördüren

On 8 November 2005, a painting by the American artist Alice Neel was auctioned in New York (fig. 20).[1] It was a haunting painting with a clear message: *Nazis Murder Jews* is the work's title, quoted from the text of a sign in the compositional focal point of this work from 1936. A man in dark, workers' clothes, with a peak cap on his head and the placard in his balled fist, leads a long protest march together with two companions. The demonstrators are flanked by mounted police; with torches in their hands, they march – rank after rank – through New York's night-time streets lined with tall buildings. Three prominently placed red banners featuring a hammer and sickle identify it as a Communist-supported demonstration against the German Nazi regime. Neel has stated that she and other fellow artists from the Works Progress Administration (WPA) participated in the rally.[2]

During its first exhibition, at the ACA Gallery, New York, the painting aroused substantial – and critical – attention.[3] On 12 September 1936, the *New York World-Telegram* wrote: "Alice Neel brandishes aloft the torch which she and the members of the Artists Union along with her hope will eventually lead to enlightenment and the destruction of Fascism. One, depicting a workers' parade, would be an excellent picture from the point of view of colour, design and emotional significance if the big bold black-and-white sign carried by one of the marchers at the head of the parade, didn't throw the rest of the composition completely out of gear by serving to tear a visual hole in the canvas."[4] The criticism applied to the rather propagandistic way Neel directs the viewer's gaze to the placard, whose light value stood out before the darkly depicted demonstration. By adopting a high viewpoint, Neel has also succeeded in capturing the procession in its entire length and thus solved the problem of depicting crowds. In its uncompromising application of

perspective, it goes substantially further than the procession in James Ensor's famous painting *Christ's Entry into Brussels in 1889* (1888, J. Paul Getty Museum, Los Angeles).[5] Painted with a raw directness and featuring figures whose faces and bodies have been simplified and depersonalised in the manner of a woodcut, Neel undoubtedly wanted to create a startling image. Years later, she commented upon the remark of the *New York World-Telegram*'s art critic: "But if they had noticed that sign, thousands of Jews might have been saved."[6]

It is known that Neel attended meetings of the Communist Party and that she sympathised with its cause. According to her biographer she was herself a party member from 1935.[7] In the thirties, she became one of the first artists to draw attention to the persecution of Jews in the "Third Reich". Painted four years before the beginning of the systematic genocide carried out by the Nazis, the painting appears prophetic from today's perspective. However, the American press had already been reporting on the situation of the Jewish population of Germany since Hitler had seized power – often doing so in connection with demonstrations against the Nazi regime in many American cities.[8] In 1936, there were increasing signs of the murders to come. On 20 June 1936, for example, the *New York Times* quoted Georg Bernhard, a German emigrant and the editor-in-chief of the Parisian exile newspaper *Pariser Tageblatt*: "Consequently […] the entire German Jewry is now exposed to torture and slavery. It is the fate of these masses the civilized world should be worried about."[9]

If Neel's knowledge of contemporary events in Germany can thus be considered certain from the evidence of the painting, this raises the question of whether the artist was interested only in German politics or also in German art. More than a few works from her early *oeuvre* have led viewers to assume

this, and particularly the paintings of the late twenties and the thirties display an astonishing affinity with those created by German and Northern European artists around the same time. For instance, the ghost-like mourners of her watercolour *Requiem* (1928, private collection, fig. 22) resemble the gloomy figures of Edvard Munch's images. However, in her memoirs she would later write: "But Munch I never saw in the beginning. I did a painting, and you'll swear that I was influenced by Munch, but I hadn't even heard of him yet."[10] The dressed-up *Two Women* (private collection, fig. 21) in a 1936 watercolour recall Rudolf Schlichter's cocottes with their garish make-up; the bony, mannerist hands holding the cigarette in Neel's *Man with Rose* (private collection, fig. 24) of the same year display a strange resemblance to a similar motif in Otto Dix's 1926 portrait of the German writer Sylvia von Harden (1926, Musée National d'Art Moderne, Paris, fig. 25) – and, in particular, the pose of Ed Meschi (Estate of Alice Neel, New York, fig. 23) sunk into an armchair in Neel's 1933 portrait calls to mind the cramped pose of the poet Max Herrmann-Neiße as depicted by George Grosz in 1927 (Museum of Modern Art, New York, fig. 27).[11] Other paintings may remind the viewer who is familiar with the art of German Expressionism and the *Neue Sachlichkeit* [New Objectivity] of works by Oskar Kokoschka and Max Beckmann. The list of potential models could easily be continued, but – in the manner of a bizarre double image – the impression derived from examining the motifs and style of Neel's paintings oscillates between an art shaped by the European avant-garde and a completely independent artistic concept.

Particularly in regard to Neel's expressive early work, art critics have repeatedly drawn comparisons with European artists. The founding figures of modern art – Vincent van Gogh, Munch and Oskar Kokoschka – are primarily cited in this context, artists who, like Neel, understood painting as the expression of subjective sensations and did not hesitate to explore the depths of the human psyche.[12] Neel herself rarely talked about other artists and only at a relatively late

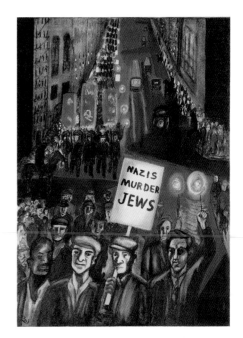

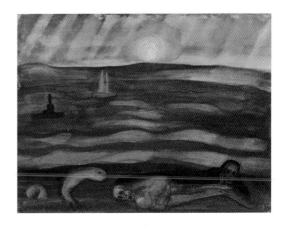

20 Alice Neel, *Nazis Murder Jews***, 1936**
Oil on canvas, 106.7 x 76.2 cm.
Private Collection.

21 Alice Neel, *Two Women***, 1936**
Watercolor on paper, 50.8 x 42.5 cm.
Private Collection.

22 Alice Neel, *Requiem***, 1928**
Watercolor on paper, 22.9 x 30.5 cm.
Private Collection.

point in her life. She evidently deliberately formulated her appreciation for Francisco de Goya, Munch or Chaïm Soutine, for example, in quite vague terms; concrete references to possible influences from European art are veiled.[13] She described her own artistic position as "a combination of realism and expressionism".[14]

Expressive Realism in Alice Neel's Early Work

It was during her education in Philadelphia that Neel came in contact with American Realism. She extended its tradition and surely also redefined it for twentieth-century art. Neel enrolled at the Philadelphia School of Design for Women (now the Moore College of Art & Design) in 1921. While it was considered a conventional school for upper-class daughters at that time, it looked back with pride on the years in which Robert Henri – the founder of New York's Ashcan School and the leading protagonist of American Realism since the 1910s – served as a teacher there. In retrospect, Neel resolutely declared that she preferred her studies at the School of Design to the well-established Pennsylvania Academy of the Fine Arts in Philadelphia, the oldest art academy in the US.[15] While the latter had opened itself to modern developments in art around 1920,[16] it also cherished the memory of two internationally successful artists from Philadelphia, the Impressionist Mary Cassatt and the fashionable portrait painter Cecilia Beaux – both of them served as negative "role models", so to speak, from whom Neel programmatically distanced herself with her less accommodating works: "I didn't want to be taught Impressionism […]", was the reason the artist gave for the choice of her place of education; "I didn't see life as a *Picnic on the Grass*. I wasn't happy like Renoir."[17] And she added in further explanation: "I didn't want to be taught a formal form."[18] Neel thus criticised Impressionism as a formalist art, as a highly aestheticised art form that did not deal with the darker

aspects of human life. Depicting these was, however, the declared intention of the artist, who saw painting primarily as a medium of expressing one's opinion and accordingly even as a "philosophy about life".[19]

The European avant-gardes, including Expressionism and the *Neue Sachlichkeit*, had pursued similar goals in the first decades of the twentieth century: Expressionism, with its turning to an artistic statement defined by inner worlds, and the *Neue Sachlichkeit*, with its critique of the social and political reality of the interwar period. While Neel's links to the tradition of American Realism cannot be denied, her work nonetheless – in a manner that is entirely characteristic of the social realism of American painting in the twenties and thirties – certainly raises the question of a possible reception of European developments in art. German and Scandinavian positions, in particular, must have aroused her attention, for they were seen as less formalistic and, above all, as the expression of subjective feelings in comparison to the dominant French art.

Still, the existing sources make it largely impossible to determine when Neel first came in contact with German avant-garde art. She had, however, already had some contact with German culture early on in her life. The artist grew up near Philadelphia, a city strongly influenced by German immigrants and their descendants. Two of her professors were also born in Germany. Without mentioning his name, she describes one of them as "very dogmatic", but she was very enthusiastic about the other, her drawing teacher – the portrait painter and glass artist Paula Himmelsbach Balano, who had come from Leipzig to the US with her family in 1879, while still a child.[20]

Neel's first known works are dated 1926, when she was living in Havana, recently married to the Cuban painter Carlos Enríquez. Although they are executed with a coarser brushstroke and a gesture that is clearly more expressive, paintings like *Beggars, Havana, Cuba* (Estate of Alice Neel, fig. 1), the portrait *Carlos Enríquez* (cat. 1) and *Mother and Child, Havana* (cat. 2) display a clear affinity with the art of

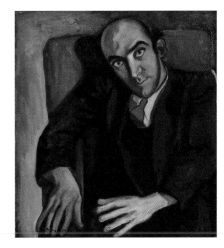

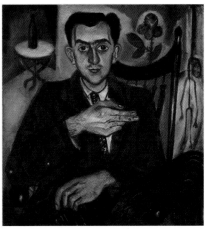

Robert Henri – both in their dark palette and the choice to depict underprivileged social classes.[21] His book *The Art Spirit* was indubitably also of great significance for Neel, as it was for other artists of her generation.[22] Henri propagated a painting that was to lead out of the academies and to turn to everyday life with a subjective, but open-minded gaze: "What we need is more sense of the wonder of life and less of this business of making a picture."[23] And he demanded that artists develop "a fresh new concern for everyday objects and an awareness of new trends in painting".[24]

As a student Neel was well-read and, in Havana, she moved within the circles of Cuba's artistic avant-garde. Their organ was the journal *revista de avance*. The first issue appeared in March 1927 and Enríquez was a regular contributor.[25] It certainly paid attention to developments in Europe, but in this regard its interest was primarily in Cubism, Futurism, and Surrealism. Nonetheless, there was a debate specifically of German literature and philosophy: Leibniz and Hegel were discussed, as were Nietzsche and Husserl. The few traces of German and Austrian avant-garde art that can be tracked down in the journal naturally include scattered illustrations by Max Ernst, George Grosz, and Egon Schiele, whose familiarity can thus be assumed.[26]

The American Perspective on a "Serious" Art

After just over a year in Cuba, Neel returned to America with her daughter in May 1927, her husband following them in the autumn. She settled in New York, where she encountered an art scene in which German and Northern European art was increasingly acquiring traction. Until the beginning of the century, the artistic exchange with Germany had taken place through immigration, journeys abroad for study and also developing institutionalised support; after being broken off during the First World War, critics, gallery owners and museum professionals systematically promoted contact with the young

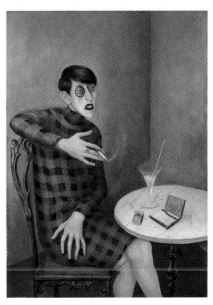

23 Alice Neel, *Ed Meschi,* 1933
Oil on canvas, 66 x 61 cm.
Estate of Alice Neel.

24 Alice Neel, *Man with Rose,* 1936
Oil on canvas, 66 x 61 cm.
Private Collection.

25 Otto Dix, *Bildnis der Journalistin Sylvia von Harden (Portrait of the Journalist Sylvia von Harden),* 1926
Oil and tempera on wood, 121 x 89 cm.
Centre Pompidou - Musée national d'art moderne - Centre de création industrielle, Paris.

German avant-garde.[27] A few of the exhibitions that were important for the reception of German art took place early on. The Société Anonyme, which was founded by the German-American artist and collector Katherine Sophie Dreier in 1920, and in which Marcel Duchamp was also active, presented Kurt Schwitters to the American public in 1920, Wassily Kandinsky in 1923 and Paul Klee in 1924. In 1926/1927, it organised the highly successful *International Exhibition of Modern Art* at the Brooklyn Museum, which had 52,000 visitors.[28] With artists like Kurt Schwitters and Wassily Kandinsky, Max Ernst, Paul Klee, Franz Marc, Gabriele Münter, Heinrich Hoerle and Carl Buchheister, the focus in German art was on Expressionist, Dadaist and Constructivist tendencies. This catalogue was to become a reference point as a canon for modern art was established in the succeeding years.

Expressionist art, on the other hand, was promoted with dedication by the German art historian William R. Valentiner, who came to the US in 1921. He was initially employed as a curator and then, from 1924 onward, as director at the Detroit Institute of Arts.[29] In collaboration with the Berlin gallery owner Ferdinand Möller, who was looking for new overseas markets for the modern German art represented by his gallery, Valentiner organised the 1923 exhibition *Modern German Art* at New York's Anderson Galleries. Among others, it was artists of the Brücke and the Bauhaus whose works were exhibited – but also that of Emil Nolde, Christian Rohlfs and Franz Radziwill as well as Lyonel Feininger, who was born in New York, but hardly known in the US at that time.[30] More recent art was represented by two of George Grosz's drawings, "an unpleasant surprise" in the judgment of the *New York Times*.[31] While the discussion of the exhibition was not necessarily favourable, it certainly drew attention and was thus considered a success by Valentiner.[32]

One of Valentiner's fundamental aims was to establish a distinction between German art, as an art of inner expression, and French Impressionism and Post-Impressionism: "But there is also an art that is life itself", he wrote in the introduction

of the catalogue, "that rises out of the depth like a cry, and it carries the deepest expression of humanity".[33] Valentiner presented Expressionist art as the expression of a tormented soul and characterised it as a German phenomenon – ignoring the fact that the term "Expressionism" had been coined at the beginning of the century with reference to international (including French) avant-garde tendencies.[34] The interest in Expressionism in the US had already begun in the early 1920s, and before the fine art of this movement entered the scene, Expressionist film, literature, and music had already made an impression on the American public.[35]

Another protagonist who successfully dedicated himself to the presentation of German art in the US was the art dealer J. B. Neumann, who opened his New York gallery in 1924 and began to show German artists in 1927.[36] In April 1927, shortly before Neel's arrival in the metropolis, Max Beckmann's first solo exhibition in America could be seen there.[37] The show was not a financial success, but the 15 exhibited paintings aroused substantial attention in the press. With a single stroke, Beckmann became known as an "unquestionably strong painter",[38] his work understood as a "selective mirror of life in post-war Central Europe".[39] That same year, the largely conservative Homer Saint-Gaudens, director of the Carnegie Institute in Pittsburgh, announced after returning from a trip to Europe: "The greatest change in the art situation in Europe today has taken place in Germany. [...] In Germany art has become completely modernist."[40]

The interest in artistic developments in Germany was reflected in the daily press from the mid-1920s onward, but also in articles on German art in scholarly journals. Oskar Kokoschka and Max Pechstein, Max Ernst and Paul Klee were well-known names; Karl Schmidt-Rottluff, Emil Nolde, and Käthe Kollwitz were highly esteemed. George Grosz was known both for his caricature-like, cynical works on paper and for the blasphemy trial of 1928. Otto Dix was another German artist who began to draw increasing attention from 1927 onward. Dix's first solo exhibition was held in 1923 at the

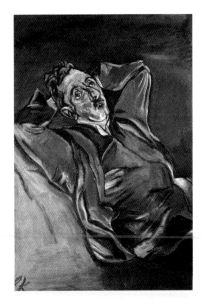

gallery of Neumann's partner in Berlin, Karl Nierendorf; Dix was included in Neumann's program and, along with Kokoschka, Pechstein, Willy Jaeckel and Anton Faistauer, he had been represented since the fall of 1927 by several works at the *Carnegie International*, which began in Pittsburgh and toured to Brooklyn and San Francisco.[41]

As was the case every year, the *Carnegie International* – which was presumably the largest regularly-occurring exhibition of international contemporary art at that time – enjoyed a substantial resonance in the press. Among the artists from German-speaking countries, it was particularly Dix and Kokoschka who were discussed. The *New York Times* reproduced Kokoschka's *Portrait of Albert Ehrenstein* (1914, National Gallery, Prague, fig. 26) and praised the psychological insight of its depiction, and the paper also occupied itself extensively with the portrait *Hugo Erfurth with Dog* (1926, Museo Thyssen-Bornemisza, Madrid, fig. 28), which is one of Dix's most important likenesses and could be seen there for the first time in the US.[42] It is possible that Neel, who lived in New York at that time, was among the visitors to the exhibition in Brooklyn. Constantly in rebellion against established artistic positions, she must have had a vital interest in an art that the critic Helen Appleton Read assessed in her review of 15 January, 1928, printed in the *Brooklyn Daily Eagle*: "The German section is in interesting contrast to the French and British. German painters care little for charm, but there is an earnestness [...] and always the psychological twist which gives their art a distinctive personality and interest. [...] Painting does not mean decoration or merely aesthetic satisfaction to the German. It is and always has been a *Weltanschauung* (attitude toward life)."[43] Read, who had also studied with Robert Henri and supported American Realism, emphasised the uncompromising interiority and the forceful psychological expression of German art – aspects which were repeatedly used to characterise it in American art criticism of the 1920s – and thus legitimised its apparent ugliness.[44]

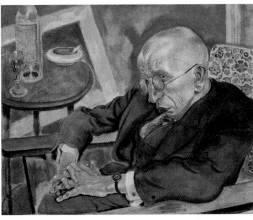

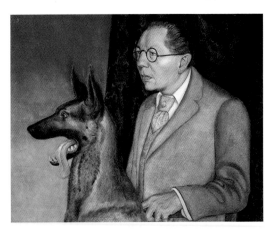

26 Oskar Kokoschka, *Portrait of Albert Ehrenstein*, **1914**
Oil on canvas, 120.7 x 80 cm, National Gallery, Prague.

27 George Grosz, *The Poet Max Herrmann-Neiße*, **1927**
Oil on canvas, 59.4 x 74 cm, Museum of Modern Art (MoMA), New York, Purchase, 49.1952.

28 Otto Dix, *Hugo Erfurth with Dog*, **1926**
Tempera and oil on panel, 80 x 100 cm. Museo Thyssen-Bornemisza, Madrid.

Encounters with Modern German Art

Art as an expression of "life itself" (Valentiner) or as a "*Weltanschauung*" (Read): Such characterisations of the German art of the 1920s display a remarkable affinity with Neel's understanding of art as a "philosophy of life", so that the existence of a comparable mental attitude may be assumed, regardless of the contentious question about a direct reception of German tendencies in art in her work. In addition – to the extent that this can be documented on the basis of the few preserved early paintings and watercolours – there is a clear shift in Neel's work after 1927. While the underprivileged social classes stood in the focal point of her early work as an artist, in works like *The Family* (fig. 30), she redirects her attention to her own life with a clear-sighted and startlingly open analysis of the situation in her parents' home. She unflinchingly deals with her personal suffering, for example, the death of her first daughter Santillana in late 1927, her traumatic separation from Enríquez in May 1930, her financial worries, and the lack of family support: a personal suffering expressed in deeply disturbing, painted compositions and that finally led to the artist's nervous breakdown.

At the same time, German art was achieving increasing acceptance and prominence in the US. Even before its conclusive breakthrough with Alfred H. Barr's *German Painting and Sculpture* in 1931 at the still-new Museum of Modern Art, there were constant reports on exhibition events dealing with German art. The *New York Times* alone provided extensive coverage of individual artists of the *Neue Sachlichkeit*: on the occasion of the June 1928 exhibition *Deutsche Kunst* (German art) in Düsseldorf; in the autumn, Grosz's trial for blasphemy was one of its daily topics.[45] In early 1929, the paper commented upon Alfred Kuhn's contribution in the special issue of the journal *Survey Graphic* dedicated to Germany: this text provided an extensive overview of contemporary German art and presented Dix, Georg Scholz, George Grosz, and Rudolf Schlichter, among others.[46] In the spring of 1929, Max Beckmann and Karl Hofer were declared to have established themselves on the international market, and it was simultaneously noted that Grosz wanted to secure his presence in the US.[47] Only a few months later, the *New York Times* announced the first purchases of German art for the Art Institute of Detroit and the Art Institute of Chicago.[48] In May of 1930, the newspaper finally pointed out that some considered Nolde the "greatest living German painter", and in August of that year, it praised and prominently reproduced Dix's 1927 painting *Liegende auf Leopardenfell* (*Woman Reclining on a Leopard Skin*; Ithaca, Cornell University, Herbert F. Johnson Museum of Art) on the occasion of the Venice Biennale.[49]

The reception of German art in the US in 1931 was defined above all by the exhibition *German Painting and Sculpture*.[50] Neel certainly did not see the show: at that time, she had been hospitalised for treatment following her attempted suicide. However, on the basis of her professional interest, we can nonetheless assume that she knew about the exhibition and its accompanying catalogue; indeed, several portraits of the 1930s, for example, *Max White* (1935, cat. 11) and *Elenka* (1936, cat. 18), clearly recall the *Neue Sachlichkeit*. Finally, in 1933, she also exhibited together with three of the artists presented in *German Painting and Sculpture*: Pechstein, Beckmann, and Klee. It was the second group show in the US for Neel, who had moved to New York's Greenwich Village – which was popular among intellectuals – in early 1932, following her recovery.

The *Living Art Exhibition*, which J. B. Neumann organised at the Mellon Galleries in Philadelphia after his own gallery went bankrupt, seems to be the only documented direct contact between Neel and the German avant-garde.[51] However, the effects of this encounter were – judging by the sparse source material – of moderate intensity. In this group exhibition, Neumann gathered American, Mexican, and European artists. With five works, Beckmann was the most extensively represented artist. According to the exhibition flyer, Neel presented two works, *Red Houses* and *Snow*; however, it has not yet been possible to identify these with

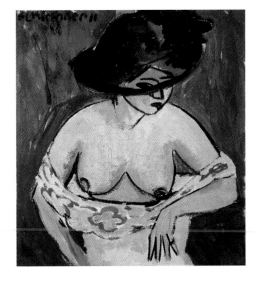

complete certainty, and they may also have fallen victim to the destructive rage of a jealous lover in 1934.[52] Following the exhibition, there was one further meeting with Neumann, who visited the artist in her studio.[53] However, the paintings that Neel showed to the dealer on this occasion, among them the portrait of Joe Gould (1933, cat. 8) – practically a precursor to Martin Kippenberger's "bad painting" – surely represented the most radical position but did not lead to a further business relationship.

The notion that an increasing awareness of German art also contributed to the artistic break in Neel's work after 1927 can perhaps be best illustrated through a direct comparison of two works. We do not know whether the artist saw Ernst Ludwig Kirchner's 1911 painting *Weiblicher Halbakt mit Hut* (*Female Half-Length Nude with a Hat*, Museum Ludwig, Köln, fig. 29), for example, in person or as a reproduction, but the thematic and stylistic similarities with the 1930 portrait *Rhoda Myers with Blue Hat* (cat. 4), as well as with the nude portrait *Ethel Ashton* (1930, cat. 5) from the same year are distinctive. In the formative years of her career, Neel absorbed many influences from various artists and then developed these into an independent position. The expressive force of German Expressionism, but also the relentlessness of the *Neue Sachlichkeit*, must have represented a link to American Realist positions in her eyes, and they were surely among the inspiring pictorial worlds within the visual cosmos of an artist who, like every self-assured artist, rigorously rejected imitative quotations of the works that served her as models.[54]

Spiritual Affinity

Neel's work of the 1930s is characterised by experimentation, both in terms of the works' thematic diversity and her struggle to achieve her own distinctive artistic style. Such portraits as *Max White*, *Gerhard Yensch* (c. 1935, cat. 14), or the slightly later *Mr. Greene* (1938, cat. 19) display a clear affinity with

29 **Ernst Ludwig Kirchner,**
Female Half-Length Nude with Hat, **1911**
Oil on canvas, 76 x 70 cm. Museum Ludwig, Köln.

30 **Alice Neel,** *The Family*, **1927**
Watercolor on paper, 36.8 x 24.8 cm.
Private Collection.

the *Neue Sachlichkeit*'s detached concept of the portrait, as represented by Dix or Schlichter, for example. At the same time, the likeness of the activist and labour leader *Pat Whalen* (1935, Whitney Museum of American Art, New York, fig. 6) stands for a political and propagandistic realism. A nude like the one Neel painted of her fellow student Ethel Ashton is equally reminiscent of similar motifs by Kirchner and Pablo Picasso, though they have been substantially transformed stylistically. In addition to this, through her scenes reflecting the sombre reality of the Depression years around 1930, Neel established herself as a painter of the very personally felt social realism that dominated American painting of the late 1920s and the 1930s.[55] She also created singular, radical works, for example *Futility of Effort* (1930, private collection, fig. 31), which is situated between realism and abstraction and which Neel, in her later years, still referred to as one of her best works.[56] The links to artistic tendencies are diverse, and – alongside the German influences – her oeuvre from this period also displays clear formal links to works by American and Mexican artists. In these early years of her career, Neel was stylistically and compositionally operating within a contradictory constellation between expression and analytical gaze, between depersonalization and unflinching character study, between cool surface and raw gesture.

In spite of all their formal heterogeneity, Neel's works are linked by an artistic attitude that emerges from every single painting, an attitude that does not follow the rules of a formalist aesthetic, but instead understands the artwork as the record and expression of a subjective understanding of the world: "I didn't want to be taught a formal form." Neel repeatedly described the absolute necessity of visualising an inner sensation, an inner reality, as the motivation for her tireless productivity as an artist. And it is precisely in this respect – not, for example, in the borrowing of quoted motifs – that her approach to art intersects with an understanding of German Expressionism of the kind that was often propagated in the 1920s. "Expressionism escapes any such limitation of

technique or method", writes Sheldon Cheney in *A Primer of Modern Art* in 1924: "It is distinguished only by a difference in approach to art." And he goes on to explain that Expressionism is characterised by a "shift from impressionistic surface values to emotional values, from imitation to expression".[57] Thus, for the 1920s, an "American" definition of Expressionism has been found, even though authors like Valentiner or Barr would soon link this art with German cultural heritage, in order strategically to enhance its value relative to the dominant French art.

Neel's development as an artist began with the aesthetic ideas of Robert Henri, who demanded an impartial perspective on the world. Her early rebellion as an artist against bourgeois society indubitably placed her in proximity to avant-garde tendencies in art – in the proximity of Expressionism and socially committed realism on both sides of the Atlantic, which were initially rigorously rejected by a broad public in American society on account of their lack of charm. It is thus less the reception of individual works or motifs that shaped Neel's work in its decisive early phase than a deeply felt spiritual affinity to an artistic attitude that was not just a calculating artistic scheme but, above all, one thing: an attitude toward life.

31 Alice Neel, *Futility of Effort*, 1930
Oil on canvas, 68.6 x 63.5 cm. Private
Collection.

Alice Neel, a Marxist Girl on Capitalism

by Laura Stamps

"If a story is not about the hearer he will not listen. And here I make a rule - a great and interesting story is about everyone or it will not last."

John Steinbeck, *East of Eden*, 1952

The reason given for the art world's failure to acknowledge Alice Neel's work for many years is always the same. Neel was entirely out of keeping with the spirit of the times. Her whole life, she painted – mainly portraits – in a quasi-realist style. For a large part of the twentieth century Modernists regarded a realist style of painting as backward, a reversion to the nineteenth century. The dominant style of painting in the 1940s and 50s was the Abstract Expressionism of such artists as Jackson Pollock (fig. 32) and Willem de Kooning. Indeed, painting was pronounced dead in the early 1960s.[1] Furthermore, Neel was a woman in an art world that, until the 1970s, was still almost entirely dominated by men. Add to this the fact that she was a Communist sympathiser in Cold-War America, and it starts to seem like a miracle that she ever managed to amass a body of work.[2]

Though this summing up does not contain a single untrue word, it does not tell the entire story. The media are too ready to reduce Neel's story to an American fairytale about a woman driven to paint portraits of her friends and family who, though her style was not "in" at the time, stuck to what she believed in and was eventually rewarded with recognition once times changed. This narrative ascribes Neel's popularity entirely to changing circumstances, emphasising the personal aspect of her work. It disregards the fact that Neel's intention in making art was only properly revealed later in her career. In this essay I should therefore like to argue that it was a combination of factors that eventually led to her recognition, recognition that she deserves not merely because of her purely personal perspective.

La Víbora, Havana, Cuba

Neel's ideas about art were formed in Havana (Cuba), where she and her Cuban husband Carlos Enríquez (1900–1957, fig. 33) lived from January 1926 to May 1927. The dictatorship of Gerardo Machado y Morales was under pressure, and Cuba was experiencing turbulent times. Although the couple lived with Enríquez's parents in a very prosperous suburb for the first few months, they regularly went into the city to paint portraits of people from the lowest social classes. Both painted in a realist style, though Enríquez's work was more romantic than Neel's. After several months they moved to La Víbora, a deprived neighbourhood where many left-leaning writers and artists had made their home. During this heyday of Cuban literature Neel met writers like Nicolás Guillén (1902–1989), Marcelo Pogolotti (1902–1988) and Alejo Carpentier (1904–1980), and became familiar with the methods they used to depict a society in process of change. She discovered, partly thanks to them, that art could be a political act. In their books they described the impact of American Imperialism on ordinary people's lives in Latin America. Neel shared their anti-American sentiments. In the years that followed, her own personal life was unsettled. She gave birth to a daughter who died at the age of one, and then she and Enríquez separated, one of the consequences being that their second daughter was raised by his family in Cuba. All these events led Neel to suffer a nervous breakdown and she was admitted to a psychiatric hospital for treatment. At that time, her work was mainly autobiographical.[3]

Greenwich Village, New York

By 1931 the tide appeared to have turned, and she moved to Greenwich Village. It was an interesting time to move to this part of New York. In response to the Great Depression, the artists, intellectuals and writers who lived there had become interested in Marxism, and many also became politically active. It was in Greenwich Village that Neel, who became a member of the Communist Party herself in 1935, started producing "revolutionary paintings". She developed her characteristic style, tending on the one hand towards Expressionism, and yet also towards the documentary, as propagandised in leftist circles.[4] Although Neel produced a number of paintings there with explicitly political subjects, the majority of her work clearly consisted of portraits – a striking number of them of leading Communist figures. As in La Víbora, her artistic friends and acquaintances included many journalists, writers and poets. Thus she produced a fine group of portraits of proletarian writers, including Sam Putnam, Joe Gould and Max White. The most striking of these was Joe Gould (1889–1957), a phenomenon in Greenwich Village. He was constantly hanging around drunk in bars and restaurants, working every day on a book he called "An Oral History of Our Time", an idea that came to him in 1917 when he was working as a reporter for the *New York Evening Mail*. "What we used to think was history – kings and queens, treaties, inventions, big battles...is only formal history and largely false. I'll put down the informal history of the shirt-sleeved multitude," he said.[5] Gould was supported in his endeavour by certain private individuals and by the Federal Writers Project.[6] His "Oral History" would never see the light of day, however.[7]

Alice Neel painted two portraits of Gould in 1933 (cat. 8). By far the best known shows a grinning male nude standing before us, legs apart, knees slightly bent. Gould's genitals appear not only between his legs. Another penis and scrotum can be seen beneath his navel, and yet another "set" appears from beneath the stool. The genitals of two men standing either side of him can also be seen. Could these be echoes

32 Hans Namuth, *Jackson Pollock*, 1950
National Portrait Gallery / Smithsonian Institution, Washington DC.

33 Alice Neel, Carlos Enríquez and Marcelo Pogolotti, c. 1926–27.

41

of his delusions of grandeur? He was after all engaged in "the greatest literary project of all time", the completion of which was already in doubt, given his drink problem and his psychological instability. It was known that Neel sympathised with the eccentric Gould. She remained concerned for him long after his patrons had dropped him. So why did she make him look so ridiculous? Did Gould's "Oral History of Our Time" give Neel the idea of creating a "visual history of her time" by portraying people from all levels of society? This is at any rate the ideal way of reconciling the genre of the portrait – which left-wingers generally associated with personal glorification – with Communist ideals. Neel may have painted this grotesque portrait of Gould to convince herself that Gould, the kindred spirit, was actually her opposite. The portrait of Gould as a spectre, was a constant reminder to convince herself that, though it might take many sacrifices and a lot of patience, her "Visual History" would one day see the light of day. The fact is that no other portrait by Neel is known to include the name of the subject alongside and the same size as her surname, which serves as her signature.[8] It looks very much like Neel not only found her own style of painting in Greenwich Village, but also an all-embracing artistic concept which allowed her to reconcile her personal ambitions as an artist with the collective goals of Communism.

Spanish Harlem, New York

In 1938 Neel moved to Spanish Harlem, a much poorer New York neighbourhood, where she would continue to live until 1962, working steadily on her "Visual History". She portrayed people from the street, alongside her portraits of Communist activists. She probably identified with people like Art Shields, a reporter for the *Daily Worker*, and Ford union organiser Bill McKie (fig. 34), who remained faithful to the party's ideals at a time when it was simply not done to be Communist in America. The use of colour, the lack of a clearly defined background and the emphasis on external characteristics in these portraits from 1951 (cat. 28) and 1953 (fig. 34) conjure associations with Van Gogh's paintings from his Arles period. He used intensely contrasting colours to portray normal life, as in his portraits of an old woman, a pipe-smoking farmer and a postman. With this reference to Van Gogh (fig. 35), Neel was paying tribute both to the leading Communists and to the artist whose Humanist art was admired within the Party. Thus, she once more underlined the fact that she was working on something that, though it clearly concerned herself, also transcended the personal.[9]

Spanish Harlem is also the place where Neel gave birth to sons Richard (b. 1939) and Hartley (b. 1941), whose fathers were José Santiago Negrón and Sam Brody respectively. Neel's relationship with Brody, a photographer, documentary maker and a founder of the "Workers' Film and Photo League", would last for almost 20 years. She regularly portrayed Sam, Richard and Hartley during this period. This not only gives us a view of the different stages of their lives, and their different moods, it also shows how the world around them was changing, as reflected in the clothes they wore, for example. Although she painted only her sons and lovers repeatedly, and later her daughters-in-law and grandchildren, she also produced several paintings of a few other people. For instance, between 1950 and 1959 she regularly painted Georgie Arce of Spanish Harlem (1959, fig. 36 and cat. 33). In one she would emphasise his childlike innocence or playfulness, while in another his intense look would dominate the picture. However, the most striking thing about this series of portraits is his growing tendency to strike the pose of a Puerto Rican gangster (complete with knife!). Was Arce adopting this attitude because it reflected some internal development in him, or because it was expected of him in the social milieu of Spanish Harlem? Was he living up to the preconceived ideas of the white ruling classes as to how a poor Puerto Rican would develop? Whatever the answer, we cannot help but relate to Arce when looking at Neel's portraits of him. During Neel's time in Spanish Harlem issues of

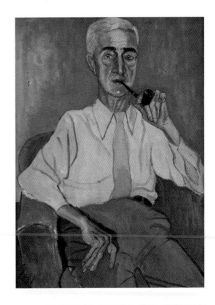

race and discrimination were high on the Communist Party's agenda. Neel reveals this in all its complexity in her portraits of Arce. For whom or what do we actually see in this series? Arce himself, Neel's representation of him, our own views, or all these things at once, in some kind of "blur"?[10]

Beginning in 1955 Neel began to attend meetings of the Club, an artists' discussion group founded by non-representational gestural painters and sculptors who had broken with academic idioms. In doing so she slowly seemed to find a context for her work away from the Communist circle, although some of the Club attendees were undoubtedly also Communist sympathisers. In 1959 Neel acted alongside Allen Ginsberg in the film *Pull My Daisy* (based on a play by Jack Kerouac). Writers Ginsberg and Kerouac belonged to the Beats, a group to which Neel was also attracted, because it so clearly opposed American bourgeois morality. The movement was soon annexed by the media, which coined the term "beatnik" (based on the Russian word "sputnik").[11] The term signified an archetypal intellectual with a beard and a roll-neck sweater, to whom American youngsters who wanted nothing to do with "superficial" pop music and motorcycle culture could relate. Aspects of beat culture were adopted by the hippy movement in the 1960s, at a time when countercultures were no longer actively opposed, or ignored, but actually acquired cult status.[12] Neel was well aware that this was her moment. Making a "visual history of your time" was one thing, but it would only be "read" if the "writer" was famous. Neel was 60 by now, and if she was not to end up like Joe Gould she would have to act fast.

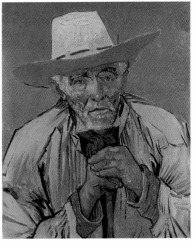

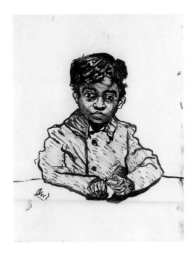

Upper West Side, New York

The steps Neel would take in the 1960s, however, were vital to her efforts to achieve her goals on more than one level. Encouraged by her psychotherapist, she actively sought possibilities to win a place in the canon of American art history.

34 Alice Neel, *Bill McKie,* **1953**
Oil on canvas, 81.3 x 58.4 cm. Estate of Alice Neel.

35 Vincent van Gogh, *Portrait of Patience Escalier,* **1888**
Oil on canvas, 60 x 45 cm. Private collection.

36 Alice Neel, *Georgie Arce,* **1952**
Ink and gouache on paper, 35.5 x 27.9 cm. Private Collection.

She started portraying leading figures in the art world, like poet and Museum of Modern Art curator Frank O'Hara (cat. 35), and the leading gallery owner, Ellie Poindexter (cat. 39), in the hope that they might give her or include her in exhibitions. She even portrayed the daughter of Clement Greenberg, who was – like O'Hara and Poindexter – one of the leading promoters of abstract (expressionist) art. However, she failed to make an impression on them. Neel's 1960 portrait of O'Hara did appear that same year in an article about him in the influential *ARTnews*, thus giving her exposure.[13]

At this time Neel started cleverly to combine her attempt at commercial success with reaching for her ultimate artistic goal. Until then she had concentrated mainly on portraits of leading Communists, proletarians, the oppressed, the poor and her own family. For a true and "complete" visual history, it was high time she also showed the other side of the coin. She began making portraits of the cultural elite, and became a full-time participant in the "rat race" of the New York art scene.[14] Completely in line with Marxist dialectics – which sought the truth in contradictions – Neel declared "I wanted to see all things and their opposites".[15]

In 1962, wanting to repossess her apartment, her landlord offered Neel the possibility to move to the more prosperous Upper West Side of New York, culturally the place to be. There she was able to find plenty of opposites of the subjects of her earlier portraits. For example, she made a portrait of art critic John Gruen, ex-model and painter Jane Wilson and their daughter Julia, titled *The Family* (1970, cat. 53) – successful "beautiful people", who were part of the art scene and had already been portrayed by such photographers as Diane Arbus (1923–1971, fig. 37) and Richard Avedon (1923–2004). When she came in and settled down to paint Neel is said to have declared "Oh how wonderful! You are all wearing patent-leather shoes!".[16] In 1943 Neel had painted *The Spanish Family* (cat. 22) under radically different circumstances; a woman with three children, no man around, who would never wear patent-leather shoes. At the same time, we see in the faces of Gruen,

Wilson and Julia the same exhaustion and tension as in the faces of the nameless Spanish Family. Nothing in this portrait suggests that wealth and the cult of the individual have really liberated them. In the same way, Communism failed to liberate *The Spanish Family* from their financial troubles.

It was also on the Upper West Side, in 1963, that Neel met Andy Warhol (1928–1987, fig. 38), the figurehead of Pop Art. Warhol asked her to be in one of his films, and to paint his portrait, something she would not eventually do until 1970 (cat. 51 and frontispiece, p. 2).[17] His desire for a portrait by Neel is interesting. Both he and his work were "camp", a term aptly defined by Susan Sontag as "love of the unnatural: of artifice and exaggeration".[18] Yet Neel's portrait emphasises his human, vulnerable side. Warhol sits on a bed, his torso bare, revealing his flabby male breasts, the corset he wore and the scars of the attempt on his life in 1968. His hands folded in his lap and his eyes cast down, he in no way resembles the ingeniously constructed celebrity artist of his public persona. "As a camp-dandy who had publicly renounced all personal feeling, Neel made Warhol appear to have made the ultimate sacrifice for his art"[19] – himself.

Neel in fact placed a great deal of emphasis on personal feeling in her work. She wanted to capture her subjects psychologically and socially, and would therefore ask them to pose several times. "They unconsciously assume their most characteristic pose, which in a way involves all their character and social standing – what the world has done to them and their retaliation."[20] Neel also deliberately projected her own desires and fears onto her subjects. She in fact chose portraiture in order to enter into dialogue with "the other". Every portrait therefore has its own dynamic which, together with all the other portraits, reflects the dynamics of an era. At first glance Warhol symbolises everything that Neel is not. He produced portraits based on Polaroid photographs of such stars as Marilyn Monroe and Liz Taylor, which he converted into silkscreen prints. He was not interested in them as people, but as the icons they had become. His impersonal portraits

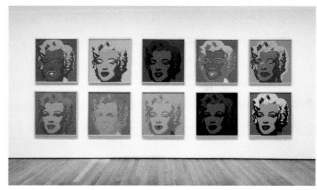

showed how people became commodified in the 1960s. Thus, though different in all other respects, like Neel's portraits they bear witness to a social reality. Given the way he allowed Neel to portray him, it could be that Warhol was aware of this similarity in their work.[21] Furthermore, the advent of Pop Art – aptly described in Germany as 'Capitalist Realism' – signified the end of Abstract Expressionism, ironically enough giving artists with Communist roots, like Alice Neel, a platform again for the first time in decades. Might Neel's relationship to Warhol have made her realise that the Cold War between Russia and America had also brought the Communist and Capitalist political systems to depend on each other for their identity?

At the time of the Warhol portrait, the Women's Liberation Movement was actively campaigning for equality between men and women. Although Neel never joined the women's movement, her ideas had most in common with the "Redstockings".[22] They believed that, for women to be liberated, the entire political system must change. One of the members of the movement was Irene Peslikis (1943–2002), whose portrait Neel painted in 1972, calling it *Marxist Girl (Irene Peslikis,* fig. 39).[23] In that same year, Peslikis founded the *Feminist Art Journal,* along with Cindy Nemser (born 1937). The first edition published the famous Whitney petition demanding "the admission of Alice Neel into the Whitney Painting Annual".[24] Neel painted Peslikis wearing dark trousers, vest and laced shoes, and with unshaven armpits. She sits on her chair, her body quite deliberately occupying much of the space; she looks every inch a feminist. But there is something forced in her posture. What sacrifices has this "Marxist girl" had to make for her "liberation"? The portrait of Linda Nochlin and her young daughter Daisy, painted in 1973 (fig. 40), may provide the answer. A portrait of a slightly older, tense-looking mother and a playful child which reflects the dual existence of a woman bearing intellectual as well as full parental responsibility, a tension with which Neel was familiar in her own life.[25]

37 Diane Arbus, John Gruen and Jane Wilson, N.Y.C., 1965.

38 Installation view of the exhibition *Andy Warhol: Campbell's Soup Cans and Other Works, 1953-1967*
April 25, 2015 through October 12, 2015, Museum of Modern Art (MoMA), New York. Photographed by Jonathan Muzikar, The Museum of Modern Art, New York.

45

Neel's method also allowed her, during her Upper West Side period, to show the effects of Capitalism on individual lives. For instance, while in 1963 she portrayed her son Richard as a thoughtful and idealistic youngster wearing a loose sweater and trousers (fig. 41), by 1979, in *Richard in the Era of Corporation* (fig. 42), he is an adult, absorbed by the suit and corporate culture. Whereas Neel had previously portrayed the heroes of Communism, Neel shows us here the "corporate hero" of American Capitalism – one of whom she is proud, in spite of her Communist sympathies. She also learned something from the methods of Capitalists. In the early 1960s she compiled a slideshow of her work and took every opportunity to show it at universities and museums, injecting a lighter note into the proceedings with her amusing anecdotes and pithy comments about her subjects. She worked hard to promote the Alice Neel brand – and with success.[26]

A visual history of our time

It was at the time of her slideshows that Neel began to compare her work with Honoré de Balzac's (1799–1850) *La Comédie humaine* ('The Human Comedy'): more than 90 novels and novellas charting all levels of society in post-Napoleonic France. Balzac's work is a collection of stories about love, ambition and desire that are interrelated in all kinds of ways, and in which the main characters constantly reappear at different stages of their lives; stories that sharply criticise the Capitalist system.[27] By the final stages of her life Neel had painted a body of work, consisting mainly of portraits, which together present a cross-section of American society from roughly the end of the 1920s. And, just as Balzac's entire *Comédie humaine* is regarded as his masterpiece, rather than a single novel, so Neel's greatest achievement lies in her entire oeuvre in which many combinations of portraits can be identified, and that tell different stories about her personal life, minor subcultures, and also large parts of humanity. Because a

"Visual History of Our Time" depends entirely on the diversity of social narratives that can be compiled from its parts, it was only at a late stage that Neel's work could be interpreted and understood as such. On the Upper West Side, Neel was able to add various groups of "opposites" to her "Visual History", in a period when the spirit of the times was more favourably disposed towards her and her work. As soon as Neel acquired a platform, she took to it with alacrity, with a body of work that she could also present as an impressive *Gesamtkunstwerk*. It is this combination of factors that has elicited glowing reviews, not merely the change in the spirit of the times.

Alice Neel once said that, for her, painting was a way of reducing the distance between herself and others, and the world around her. At the same time, painting other people's portraits also gave her a way to understand herself better. Since Neel was in search of the truth through opposites, it is not so strange that portraits of two such antithetical artists as Gould and Warhol appear to tell us most about her as an artist. Whereas the portrait of Gould exposed her artistic ambition early in her career, the picture of Warhol emphasised the importance of the dynamic between the self and the other in her portraits. Furthermore, it illustrates how the Communist identity depended on the Capitalist identity in the Cold War. *Self-Portrait* (1980, cat. 66), the only obviously recognisable one she ever painted, was her last big statement. Here, she painted herself as she saw herself in the mirror. "Neel, who was left-handed, holds the brush in her right hand in the reflected image. This is a portrait of the self as 'other'."[28] Here, Neel appears to be choosing not to take sides. The truth is not to be found at either end of the spectrum, but in opposition itself. Without the individual there is no society, without the personal there can be no political, without Communism there can be no Capitalism. Neel's body of work, her visual history, reflects this, in the profound realisation that no belief, not even that of Marxist Girl Neel, is sacred.

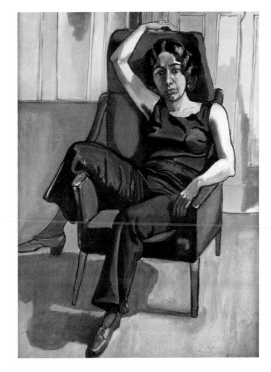

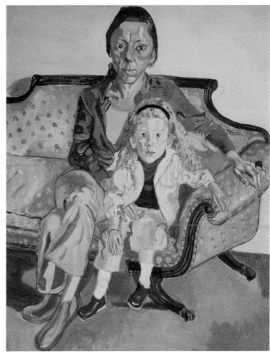

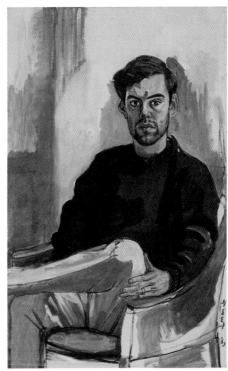

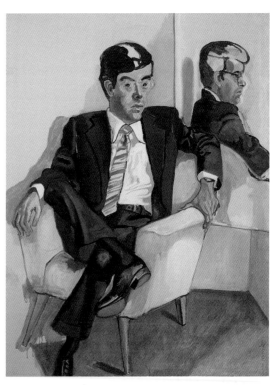

39 Alice Neel, *Marxist Girl (Irene Peslikis),*
1972
Oil on canvas, 151.8 x 106.7 cm.
Private Collection.

40 Alice Neel, *Linda Nochlin and Daisy,* **1973**
Oil on canvas, 141.9 x 111.8 cm. Museum of Fine
Arts, Boston, Seth K. Sweester Fund.

41 Alice Neel, *Richard,* **1963**
Oil on canvas, 121.9 x 76.2 cm. Estate of Alice
Neel.

42 Alice Neel, *Richard in the Era of*
Corporation, **1979**
Oil on canvas, 152.4 x 114.3 cm. Estate of Alice
Neel.

"I hate the use of the word *portrait*."[1]

by Bice Curiger

Alice Neel knew that she could only say what she had to say through painting. The medium was an existential necessity for her and it is the unerring ability to hone in on essentials in her paintings of people that accounts for the extraordinary quality of this oeuvre. The likenesses of her twentieth-century colleagues may seem too polished by comparison, bogged down by convention or by an emphasis on form so wrought that the immediacy of the human encounter is attenuated.

Alice Neel's paintings show a great rightness of means in rendering straightforward events that oscillate between accident and destiny. Palpable in these pictures is the contribution the sitters make to the emergence of their likenesses through the intensity of their presence, so much so that Robert Storr was motivated to comment, "You see time happen."[2]

It is astonishing and telling that, given her unconventional temperament, Neel chose to dedicate herself to portrait art, which was more or less written off in the 20th century as one of the most conventional of genres! Her declared antipathy to the word "portrait" must also be assessed in this context, especially since she painted people who "sat" for her, as classical art terminology has it.

What is more, it is impossible to overlook the patently attentive, alert presence and wordless communication of Neel's sitters. The people she portrays are "centred", both relaxed and mindful, wearing no armour metaphorically speaking, although they do occasionally reveal the way in which they garner support from their protective shells, i.e. their clothing but also gestural crutches and prostheses. "If there are very liberated people, I in turn feel very liberated and can paint them in a more liberated way," she said.[3]

In 1967, at the height of conceptual art, Giulio Paolini reproduced in black-and-white the Renaissance likeness of a young man painted in 1505 by Lorenzo Lotto. By calling it *Giovane che guarda Lorenzo Lotto* (*Young Man Looking at Lorenzo Lotto,* fig. 43), Paolini highlighted the facts that some five hundred years ago a young man directed his gaze at the artist while the latter painted him – and that we, as viewers of the image, now take the place of the artist in the act of painting.

Foregrounding the gaze, drawing attention to the meta-level of a likeness: Neel is not a conceptual artist but her paintings once again confirm the assertion that good art is conceptual by definition. Her paintings represent the art of the portrait *in actu*. Through her commitment to figurative painting, she courageously defied the ideology that dominated the art scene in New York as the uncontested centre of post-war abstraction – which meant even more determined and vigilant consideration of her contribution within the larger context.

Almost in passing, Neel once remarked that "My painting always includes the frame as part of the composition," as opposed to Russian painter Chaïm Soutine, who "is just like Rembrandt, inside the frame."[4]

These statements draw attention to the somewhat curious way in which her sitters often fill the space of her compositions. Neel establishes tension in the picture plane by wildly cropping the figures and zooming in, not only on the face but also the body. In her grandson's film, we see the artist checking the framing by looking at the picture through the rectangle formed by her thumbs and index fingers, a frequent gesture, according to her sons (fig. 44).[5]

Neel's sitters take a bold and innovative stance when modelling for her.[6] Neel claimed that she did not pose or

arrange them, adding, in the same breath, that she observes how people sit down when she is talking to them. "They unconsciously assume their most characteristic pose, which in a way involves all their character and social standing – what the world has done to them and their retaliation. And then I compose something around that."[7]

In the film, we also learn that she occasionally suggested that her models undress and pose in their underwear because their clothing – a three-piece suit, for example – did not match her painting. In some cases they actually ended up naked on a bed or a couch. A case in point: *Cindy Nemser and Chuck* (1975, fig. 45), who seem to express this very circumstance with every fibre of their being. Seeking protection, they have retired to a corner of the spacious couch, their serious but trusting gaze directed toward the painter.

Fortunately for posterity, some of Neel's sitters were interviewed for the 2007 film, including Julie from the painting *Pregnant Julie and Algis* (1967, cat. 47). Julie speaks of the incredibly powerful and electrifying energy of an intense nonverbal dialogue; subjected to Alice's laser gaze, she finds that she is staring at herself.[8]

Julie faces us, looking out at the world with confidence, her decisive attitude as a pregnant woman is tangible in the panorama format of that painting that pictures her lying stretched out on the bed. Her partner, still fully clothed, seems to protect her although he is almost hiding behind her. The lively pattern of the red blanket underneath captures some of the tension of the moment, while Neel's characteristically blue contours outline the woman's body with masterful cogency, like a tender arabesque of liberty. "There is a new freedom for women to be themselves, to find out what they really are."[9]

It has become so commonplace that we hardly notice anymore how fundamentally cultural change over the past hundred years has altered the way we look at and relate to our bodies. This brings us back to Neel's technique of

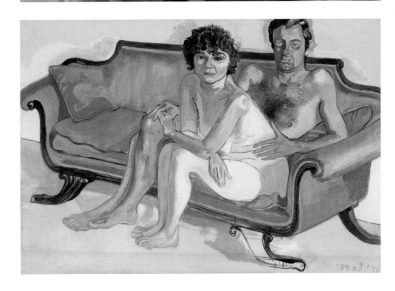

43 Giulio Paolini, *Giovane che guarda Lorenzo Lotto (Young Man Looking at Lorenzo Lotto)*, 1967
Photo emulsion on canvas, 30 x 24 cm.
Sammlung FER, Ulm.

44 Still from the film *Alice Neel* by Andrew Neel: Alice building a "viewer" with her fingers.

45 Alice Neel, *Cindy Nemser and Chuck*, 1975
Oil on canvas, 105.4 x 151.8 cm.
Private Collection

including the frame in her compositions, by which she probably also meant the *zeitgeist*, "the feel of an era", to which she so often referred.

In 1968, a year after she had painted naked, pregnant Julie and her partner, the picture appeared on the cover of the then tone-setting *Village Voice*. It must have struck like a bombshell, breaking taboos in more than one way. For one thing, the self-confident, perfectly natural image, an extremely unusual motif in painting, quite literally embodied the raging battle against the puritanism of bourgeois culture and society. For another, pregnancy was a taboo subject for feminists for fear that it could be enlisted as an argument "to send women back to their suburban prisons".[10]

Formally, Neel's painting of *John Perreault* (1972, cat. 59),[11] is the naked male counterpart to Julie. Stretched out, he lies there with legs bent, quiet and pensive, his genitalia unabashedly exposed.

There is nothing laboured about the profound intimacy of Neel's paintings. "Psychological" is a term repeatedly invoked by writers and critics but what does that actually mean? Her work records a readiness to trust and confide. It reveals an awareness of others that unfolds in thrilling repose, leading to an encounter of a special order that takes time and allows for an unusual, communicative exchange.

In *The Family (Algis, Julie and Bailey)* (cat. 48), Neel painted the same couple again a year later in 1968, now with their baby; the lackadaisical nonchalance of their pose is staggering. Algis, centred in the composition, casually holds the child with one hand, the thumb of his other hand hooked into the pocket of his jeans (fig. 46). Their faces are questioning, serious and open, lending the painting a near existential urgency. But in the final analysis, the urgency lies in the very fact that these people are painted!

In the early days of photography, models had to stand immobile for minutes at a time and, as a rule, the pictures portray rigid, buttoned-up people, decked out in their Sunday best. Now that snapshot photography has become

an omnipresent, all-embracing documentary companion in every life situation, Neel deliberately cultivates an entirely different ritual when she captures her images. She imposes a wilfully prolonged investment of time on her sitters, beginning with the extended journey they have to take in order to reach her studio – which is her apartment.

Brigid Berlin recounts that Andy Warhol asked her "to go with him to Alice Neel's because he was afraid to go to Harlem by himself. I couldn't believe we were going all the way up there."[12] In Neel's 1970 painting of him, Warhol is seen facing front, seated and naked to the waist, exposing his invasive scars and assaulted body (cat. 51). The vulnerability is palpable in the artist's gentle, tender brushstrokes. Avoiding her gaze, Warhol has his eyes introspectively averted. We are reminded of his secrets: Andy the Catholic, the churchgoer, his closely guarded inner life. Although he is wearing a corset, his hips seem to bulge and overflow, underscoring the feminine aspect. There is even something girlish about the way he is sitting with his legs and narrow feet so straight and close together. There is a touching, astonishing intimacy in the likeness of this inscrutable, provocatively indifferent figure that dominated twentieth-century art.

An important detail catches the eye in Warhol's portrait: his very small hands. He is holding a cloth or his undershirt. Hands in Neel's pictures are important indicators of character but they are also formal anchors for the figure in the composition and often appear variously distorted, sometimes scaled-down, as in *Henry Geldzahler* (1967, cat. 44); emphasized with mannered positions of the fingers, as in *Sherry Speeth* (1964, fig. 15); holding hands in an exchange of strength and warmth among couples; or resembling the claws of a bird, as in *Mother and Child (Nancy & Olivia)* (1967, cat. 46).

Not only did Neel occasionally stylize her models' hands, their arms may also be explicitly emphasized, almost like overlong sausages, and yet, within the context as a whole, it is these elements that lend the compositions cogency,

speed and even a wilful nonchalance. Rudimentary planes of colour around the figures morph into portions that are not completely "coloured in" so that we still see patches of primed canvas. Warhol is sitting on a bed, drawn in subtle contours that appear to have been pushed into the painting from the left, almost like a little wooden perch for a canary. Sparing, light-blue brushstrokes around his torso fan out above his right shoulder into the shape of a wing, reinforcing the birdlike implications or, in fact, actually transforming Andy into an angel. Neel frequently consolidates her figures by framing them in bold brushstrokes, thereby also underscoring the autonomy and vibrancy of the colouring and flow of her paintings.

Returning once again to Neel's declared treatment of the frame as part of her compositions, one cannot overlook how important it is for her to break down the homogeneity of the picture plane. To that end, she introduces an interplay between sophisticated staging and the importance of a sitter's facial traits. The rectangle of the canvas remains visually porous with *non finito* portions (for instance, Warhol's trousers) and intentionally visible *pentimenti*, made manifest by linking detailed, slow and contemplative areas with rapidly, yet firmly painted portions of the canvas. This sophisticated orchestration is often full of surprises and set off against other symbolically charged elements of the composition, such as clothing, furniture, plants, textile patterns and the many semiotically iridescent factors that abound in these paintings.

There is always movement in the work of Alice Neel. It comes from seeking a balance between the wish to achieve maximum verisimilitude in rendering what she sees and the resulting emotions, the desire for formally impulsive release and resolute disavowal of "slavish mimesis". Vincent Van Gogh also had to see reality in order to chart its formal hyperbole in his paintings. The portrait *Robert Smithson* (1962, cat. 38), transmits a glint of sparkling movement, great tempo and a drive that communicates the singular

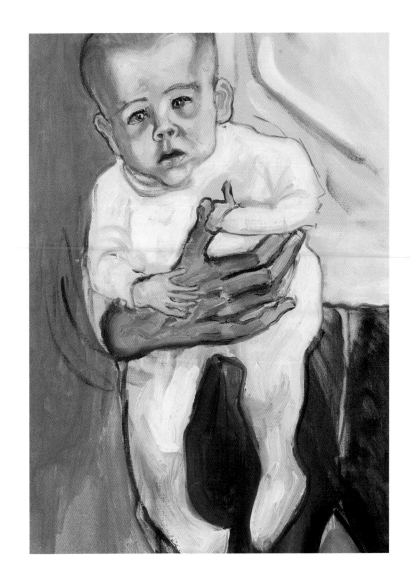

46 Alice Neel, *The Family (Algis, Julie and Bailey)*, 1968 (detail)
Oil on canvas, 152.1 x 87 cm. Charlotte Feng Ford Collection.

51

intelligence and revolutionary energy of the young artist.

Time and again, Neel leaves traces in her paintings of the extemporaneous, signs of spontaneous, amused inspiration that emerge in the process of looking and painting. In *Michel Auder* (1980, cat. 67), the model's knee is rendered as three concentric circles or a conspicuous disc – as if it were a commentary on the slight torque of the arms and legs in the composition. One is reminded of the large disc in *Max White* (1961, fig. 47, cat. 37), arching behind the model's bald head and lending the background of the portrait movement and tone. It is an additionally energetic flash in the painting, especially in the case of White, who appears so tense and constrained in the armchair.

The five penises in the notorious, grotesque portrait of *Joe Gould* (1933, cat. 8), may well also be indebted to inspiration of a similar nature – the impulsive response to a sudden observation. And what a response! In this picture, the then 33-year-old painter takes an unmistakable stand as an observing, reacting woman and woman artist. The statement that she posited in time and in art is nothing short of incredible. A whimsical act: that eccentric, obviously slightly macho Gould wanted to be painted and he got what he wanted.[13] That was her explanation but the actual recipient of this lovingly and elaborately painted congregation of male organs is art history, in compensation for centuries of unilateral fixation on female nudity.

The act of painting is based on a mimetic impulse; it is a physical act. When we speak about the body language of Neel's sitters, the term also applies to the artist's own physical commitment. Fiercely consistent and fiercely free, Neel inscribed the act of painting into every work she ever created.

Her much-quoted remark that she was entirely exhausted after a painting session must be seen in this light: "I get so identified when I paint them, when they go home I feel frightful. I have no self – I've gone into this other person. And by doing that, there's a kind of something I get that other

artists don't get." In response to being accused of making no distinction between life and art, she declares, "That's right. It's my way of overcoming alienation. It's my ticket to reality."[14]

Neel's art communicates a compelling sense of community. Wild and uninhibited it may be, but it is the unruffled relaxation and trust that strikes a chord. The work embraces all walks of life, all levels of society. In great and indeed pointed openness she shows a readiness to commit to any "exemplar" that happens to be washed up in front of her easel.

She has also been criticized for her supposedly anachronistic use of the easel; like the revolutionary artist David Alfaro Siqueiros, she ought to be painting the masses and not just individuals. Her response: "One plus one plus one is a crowd."[15]

She is four weeks younger than the century in which she lives, Neel said in her grandson's film. What a fitting coincidence for an artist who has left behind such an empathetic, important panorama of iridescent humankind over the course of a century. A panoptic of historical slices: the Depression in the late 20s, the war years and post-war years and the cultural, revolutionary upheavals of the 60s and 70s. These historical slices can be grasped in the specificity of their times and equally represent the *basso continuo* of a remarkably easy-going, alert relationship to the body, exhibited as much by the sitters as by the painting protagonist.

Unmistakable as well is the reference to subcultures, a category that has become all but obsolete, while in Neel's day it was among the prime movers of upheaval and opposition to entrenched structures across the board. At various times, Neel sympathized and, indeed, identified with a variety of subcultures, starting with her affinity for an ethnic subculture through her marriage with a Cuban and the many years that she lived in Spanish Harlem. She was part of a left-wing political, literary subculture, had a long-standing liaison with the communist photographer and documentary

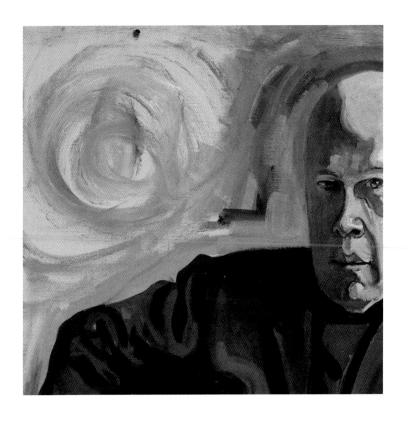

filmmaker Sam Brody and had many friends among the Beat generation in the literary world of Greenwich Village (fig. 48).[16] She also showed an impartial interest in the homosexual and transgender scene. Above all, in relation to the New York art establishment of her day, Neel felt she belonged to an artistic subculture (comparable to Alex Katz, who also paints figuratively).

The artist Marlene Dumas has commented on Neel's courage to paint people fully dressed and even wearing fashionable clothes.[17] But clothing is a vital element in the particular micro universe that Neel captures and creates in each of her paintings. Compared to photography in those days, her paintings might actually be said to be even more candid and open. It seems paradoxical that painted pictures emphasize a detachment to the more ephemeral aspects of their specific time, particularly due to the traditionally "timeless" connotation of the medium, while, in a deeper sense, also rendering the specificity of their time all the more authentically. Above all, Neel's work communicates the determination for every single chequered pattern, every tie and every ruffled blouse to resonate with the will to record visual elements for viewers that transcend the moment, fashions and anecdote.

In 1956, Erving Goffman published his trailblazing sociological study, *The Presentation of Self in Everyday Life* as a story of everyday culture and the performative body. The issues he discusses did not become a subject of debate in art until much later with the advent of, for instance, Cindy Sherman, Robert Gober, Marlene Dumas and Matthew Barney. The late response to Louise Bourgeois is also a consequence of the fact the body as subject matter did not acquire widespread currency until the 1980s.[18]

Significantly, however, it was Andy Warhol who produced *Flesh* in 1968, the first part of Paul Morrissey's underground trilogy. The films made by the Factory corralled international notoriety with their blatantly manifest anarchistic trajectory and a new body consciousness that marks, in the words

47 Alice Neel, *Max White*, 1961 (detail)
Oil on canvas, 101.9 x 71.6 cm.
Collection Kim Manocherian.

of Klaus Theweleit, the "transition from the formed body to an individually vibrating one; endangered by drugs, hedonistic, sexualized, infected by art, semi-tolerant, free of responsibility."[19]

At the Lucerne Museum of Art in 1974, Jean-Christophe Ammann organized what may well be the first-ever gender-oriented exhibition to be mounted in a museum: "*Transformer: Aspekte der Travestie*."[20] The title comes from Lou Reed's record released two years earlier with the hit of the century, "Walk on the Wild Side". The line, "Jackie is just speeding away, thought she was James Dean for a day," refers to man-woman Jackie Curtis, who features in two portraits by Neel.

In 1970, two years before Reed's song came out, Neel painted *Jackie Curtis and Ritta Redd* (fig. 49, cat. 52) and in 1972, *Jackie Curtis as a Boy* (cat. 57). Neither portrait underscores the frivolous, trashy nature of the Factory superstar; both are refreshingly understated. Jackie sitting next to Ritta has her leg bent as if she might dash off any minute, while she lovingly caresses her partner's foot. Details like the jaunty toe peeking out of the hole in her tights subtly emphasize the ordinariness of the moment. The ambiguity of the look is undoubtedly present. Jackie is facing us head-on with her makeup, as if boldly challenging the artist: paint me, this is what I want to look like!

Perhaps she intuited what inspired Neel at such moments: "No matter what the rules are, when one is painting one creates one's own world."[21]

48 John Cohen, Alice Neel on the set of *Pull My Daisy* by Robert Franck, with Allen Ginsberg and Peter Orlovsky, 1959.

49 Neel with Jackie Curtis and Ritta Redd at the opening of her exhibition in Moore College, Philadelphia, January 1971.

A Modern Woman's Social Conscience

by Annamari Vänskä

A direct, challenging gaze. Long, dark hair. A man's white collared shirt and red-and-white striped trousers. Leaning slightly forward, the figure looks as she might rise at any moment and attack the viewer.

The subject of Alice Neel's 1970 painting was the radical feminist Kate Millett, an icon of second-wave feminism. The portrait was commissioned by *Time* magazine that year, around the time Millett published *Sexual Politics*, which went on to become a classic of feminist literature. The book immediately gained cult status owing to its harsh critique of the patriarchal social system. Literary scholar Millett argued that such major figures of twentieth-century Western literature as American writers Norman Mailer and Henry Miller, as well as English author D. H. Lawrence, demonstrated in their works a social system based on machismo and hatred of women and homosexuals.

Although *Sexual Politics* met with a mixed reception, it soon became the bible of the feminist movement as Millett became its figurehead. When *Time* wanted to personify the movement on its "Women's Lib" cover, it was no wonder that the magazine chose Millett as the subject. To portray her, it hired Alice Neel, an American painter who was establishing her status as a major female artist. The writer did not like the idea, however. She refused to pose, telling Neel that no single individual could personify a broad social movement. As a result Neel had to resort to using photographs of Millett to create her painting. This may also lie behind the picture's alleged angriness. Although the portrait undoubtedly symbolises the feminist movement's anger, it may also represent Neel's dissatisfaction at the model's refusal to cooperate.

No matter how it is interpreted, the commission for *Time* speaks to Neel's status in the American art world. Neel did become more broadly known and recognised through the feminist movement. In the same way that Millett criticised Western literature's failure to recognise women, feminist art criticism lashed the art world for its androcentrism. The early seventies was the era when women began to gain a higher profile as artists. Another American feminist art historian, and a soon-to-become friend of Neel's, Linda Nochlin, published her well-known essay "Why Have There Been No Great Women Artists?" in *ARTnews* in 1971. The 40-year-old Nochlin asked simply why the art history canon did not recognise any great female artistic geniuses. This influential, polemical essay questioned the white-male-dominated history of art and demonstrated that its concept of "genius" was completely masculine. Nochlin also claimed that women had not made it into the art world because their status was both socially and societally weaker than that of men and because art schools did not admit them as students. Nochlin laid the blame on the "romantic, elitist, individual-glorifying and monograph-producing substructure upon which the profession of art history is based."[1] Thus she accused all the players in the art world, from researchers to museum curators, who favoured and exhibited male artists.

Nochlin's critical essay set into motion a feminist art revolution that previously remained under the surface, and that benefited Neel among others. Many feminist art publications and activist groups popped up on the American art scene, including Women Artists in Revolution (WAR), the Los Angeles Council of Women Artists (LACMA)[2], the Ad Hoc Women Artists' Group, Women in the Arts (WIA) and the Women's Caucus for Art (WCA). In 1979, Neel was one of five artists honoured by the latter group with its first Lifetime Achievement Awards.

Neel may well be considered an example of how the rise of feminist art criticism began to raise "forgotten" women

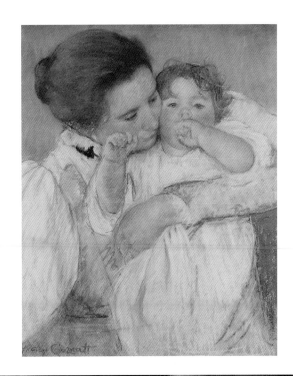

out of the depths of history and onto pedestals. The feminist movement made room for women artists who are now both globally known and recognised, as well as for a generation of feminist art historians who have carried on a critical analysis of the art historical canon, adding female artists to it until the present day. Neel was one of the first living female artists to enjoy the fruits of this change. In spite of this, she had an ambivalent attitude towards feminism. While she conceded that she was discriminated against as an artist because of her gender, she also said that she had always respected men more than women. "Women terrified me. I thought they were stupid because all they did was keep children and dogs in order," Neel's biographer Phoebe Hoban quotes her as saying.[3]

Regardless of Neel's personal view of women, feminism and the movement's relationship to herself, it is clear that her career as an artist is a powerful example of a social change set in motion by feminism, and an affirmation of it. When Neel was born on 28 January 1900 into an ordinary lower-middle-class family in Pennsylvania, a middle-class woman's opportunities to pursue a career – not to mention an artistic career – were close to nil. By the time she died on 13 October 1984, women had become some of the central figures in the art world as researchers, critics and artists. Neel is known to have said: "I am the century."[4] Even though she was referring to her age, Neel's life and work exemplify how radically the position of women artists changed socially in fewer than one hundred years.

Neel was born in the Victorian era, characterised by strict customs, class structure and categorical separation of the sexes. She died in an era when that social system was history and women had attained many of the privileges previously reserved for men. Neel came of age in the heyday of the suffragette movement during the First World War. She was past middle age by the time she experienced the second wave of the feminist movement and the sexual revolution in the sixties.

All of this can be seen in Neel's work. Unlike most nineteenth-century female artists, she did not content herself

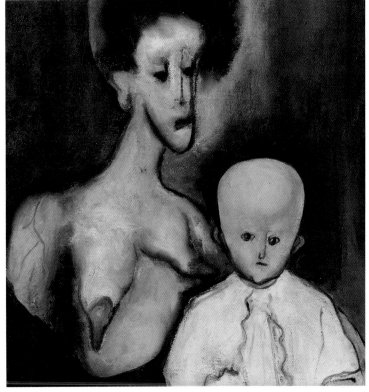

50 Mary Cassatt, *Mother and Child*, 1897
Pastel on paper, 53 x 45 cm. Musée d'Orsay, Paris.

51 Alice Neel, *Degenerate Madonna*, 1930 (detail)
Oil on canvas, 78.9 x 61.3 cm. Estate of Alice Neel.

with depicting the domestic and private realm. Neel painted her friends, homeless street people, public spaces and famous individuals. Her human figures do not fit the traditional gender roles: the men do not look heroic or the women weak. Nor did Neel shy away from subjects that were considered improper for women, such as nudity. In her portraits people are often naked, regardless of their gender, age or status, without cultural status symbols. Her subjects' nudity is not idealised, either. Every fold of skin, wrinkle or other body form is exaggerated. For Neel, the body was material to be shaped and stripped of hierarchies linked to various values. This can also be seen in the gallery of individuals represented in her portraits. Posing in these works are members of the intelligentsia and the cream of society along with those marginalised by society in various ways: New York's Latinos, African-Americans, gays and drag queens. Indeed the driving theme of Neel's output is her social consciousness. This was most likely shaped by her own status as a female artist in the male-dominated art world, her political convictions as a member of the Communist Party and the changes in women's societal rights that she experienced.

In her youth Neel witnessed the rise of the suffragette movement and how the radical National Women's Party (NWP) harshly criticised President Woodrow Wilson over his failure to allow universal suffrage in the second decade of the century. This led to the imprisonment of members of the movement in 1917, and eventually to women gaining the vote in 1920. Although Neel is not known to have taken part in the suffragette movement, she began her university studies in 1921, right after women gained the right to vote. She chose to study at the largest US women's art school, the Philadelphia School of Design for Women. Established in 1848, its aim was rather feminist and even revolutionary: to teach women a profession. It was also known as a place where female artists were allowed to draw nude models, unlike nearly all other art schools.

Neel could well be described as a "modern woman", the kind who for the first time in Western history had an opportunity to fulfil herself by working outside of her home.

Neel was a tomboy, a flapper or a *garçonne* – which was considered to be "the new breed of women".[5] Neel dressed tomboyishly in trousers or skirts that showed her legs and she was sexually liberated. She disregarded traditional codes of decency or behaviour expected of women. She personified the ideal of the emancipated modern woman who had experienced the First World War and the manner in which the most destructive war in history had paradoxically improved her social and societal visibility. When the men were away at war, women had to take responsibility on the home front. No wonder Neel could go off to study. She enjoyed freedoms that had been denied to the previous generation of women. The works she painted for public spaces also testified to this: women could now go anywhere without chaperones and do whatever today's women take for granted.

According to Neel, she chose the Philadelphia School of Design for Women for its freedom: "I didn't want to be taught a formal form. At least where I went it wasn't too organised, but you had freedom. You could do as you wanted, which was the most important thing in my life."[6] Neel's desire for freedom also aroused bewilderment. As she put it, this was because she "didn't want to pour tea" or to wear "fluffy dresses",[7] in other words to be a polite, obedient girl who would return home after art school to start a traditional family. Unlike many of her classmates, Neel was highly class-conscious and saw art as an arena for social criticism: "I worked so hard…not for my own family, but for all the poor in the world. Because when I'd go into the school, the scrubwomen would be coming back from scrubbing office floors all night. It killed me that these old gray-headed women had to scrub floors, and I was going in there to draw Greek statues."[8]

Constructing this dramatic polarisation between working-class women and art school students is revealing of Neel's character of course, but also of her efforts to depict reality in a critical, unvarnished way. For instance, she had a sceptical view of Impressionism, saying that she "didn't see life as *Picnic on the Grass*" and that she "wasn't happy like Renoir".[9] Neel

dismissed the portraits of women and children by the leading American female painter, Mary Cassatt, calling them overly polished and conservative (fig. 50). As Neel sought to paint realistically, warts and all, she was considered too direct in her own time. It is precisely that directness that speaks to today's generations, which have grown up in the era of photography. Neel's works are fresh and timely.

Some of Neel's paintings, such as the mother-and-child image, *Degenerate Madonna*, from 1930 (fig. 51, cat. 3), which combine symbolism and gritty realism, are far from her contemporary female artists' portrayals of idyllic bourgeois family life. Unlike, say, Cassatt's pastel warmth and paintings suffused with maternal love, Neel's vision of motherhood is downright oppressive. There is no warmth, only death and loss: the woman's and child's proportions are distorted, the woman's face is like a mask, the child's skull is shaped like that of an alien, and both have corpse-like skin that is waxy and white. Another difference from Cassatt is that Neel's works depict her own experiences, unlike Cassatt, who never married or had children. Although the maternal model for *Degenerate Madonna* was Neel's close friend Nadya Olyanova, the painting may also be seen as a self-portrait. Neel created it just before her committal to a mental hospital, where she was treated for a year following a nervous breakdown. At the same time, her life was overshadowed by other concerns. Neel had fallen in love with Cuban artist Carlos Enríquez, with whom she had her first daughter, Santillana, who died in 1927 of diphtheria, before reaching her first birthday. Neel was soon pregnant again and gave birth to another daughter, Isabetta, in 1928. Two years later, she lost this child too when Enríquez took her to be raised by relatives in Cuba without asking Neel's permission. The tragic nature of the painting can be seen as questioning the norms of motherhood, which was not appreciated by her contemporaries. When the work was exhibited at the *First Washington Square Outdoor Art Exhibit* in New York in 1932, it stirred condemnation probably because of its blasphemous title, and was censored following a protest by the Catholic

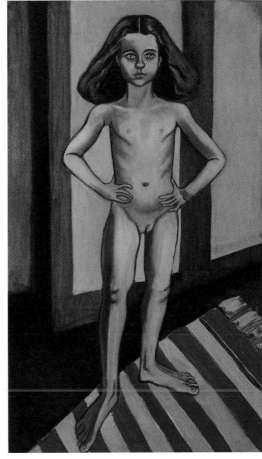

52 Robert Mapplethorpe, *Rosie*, 1976.

53 Alice Neel, *Isabetta*, 1934, repainted 1935
Oil on canvas, 109.2 x 66 cm. Private Collection.

Church. Triggering such a furore makes Neel seem like an utterly contemporary artist.

One could even argue that shocking and breaking down the conventions of academic painting were key elements of Neel's artistic output. Another example is her self-portrait from 1980 (cat. 66). In this sketch-like work, the 80-year-old artist poses nude, seated in an armchair, wearing glasses and holding a paintbrush. The artist's gaze is penetrating and aimed directly at the viewer. The ageing woman's body is shown with sagging cheeks, breasts and belly. Neel does not hide or show shame over her deteriorating body but rather challenges us to consider the charged relationship between old age and nudity. Why do we not want to see the ageing body? Why do we only worship youth?

Neel painted similarly provocative nude pictures in the thirties, an era when nudity was taboo and inappropriate for a female artist as the combination of nakedness and old age is in our own time. The nature of the nudity taboo can be seen in the fact that when Neel was young, it was not considered appropriate for proper women to wear trousers. They were believed to emphasize the legs and their sexual power, and it was unseemly for virtuous Victorian women to draw attention to their corporeality, not to mention their sexuality. Nor were men completely beyond the discussion of nudity. For instance Frank Capra's 1934 film, *It Happened One Night*, caused a sensation because of the scene where Clark Gable takes off his button-down shirt. Underneath it the film star was bare-chested, rather than wearing an undershirt according to the expectations of the day. This immediately spurred a trend, with sales of undershirts reportedly dropping by more than 40 percent.

In the context of her time, the nudity that pervades Neel's art was revolutionary, although she herself considered it to be the most natural thing in the world. She created nude portraits of her friends, but also painted children with the same realistic approach. One of her most powerful nude portraits may be her painting of Isabetta, done in 1934, repainted 1935 (fig. 53,

cat. 10). The work is startling in its modernity: how it challenges the nineteenth century's romantic idea of childhood as an age that is radically different from adulthood and is therefore visualised differently.[10] The painting does not contain a trace of the bourgeois innocence that was established by such eighteenth century British artists as Sir Joshua Reynolds (fig. 54), Thomas Gainsborough, Thomas Lawrence, Sir Henry Raeburn and John Hoppner, and which Cassatt carried on in her works. They portrayed children sentimentally as soft, round big-eyed tots whose bodies were overwhelmed by concealing attire. The romantic childhood is bodiless and the child rarely seems aware of the outside world. The gaze is turned inward and the child is depicted as being immersed in his or her own world.

Neel's painting of Isabetta is utterly different. The girl is shown naked, seen from directly in front, with her genitalia clearly visible. The child does not seem to be ashamed of her nudity, however. On the contrary, she stands in a turning position with her hands on her hips quite self-confidently, staring at the viewer with her green eyes blazing and her brown hair defiantly swept out. This painting, too, lacks the expected sentimental maternal warmth. In a documentary film about Neel, Isabetta's daughter disapproves of the frankness of the picture: "I think it's disgusting. I mean, I'm conservative, but, I'm not, you know, fuddy-duddy. And I would never have my children, naked, like that, standing for a photograph or a painting. I, I just don't think it's correct. All that genitalia, you know... [laughs nervously] and it was very pronounced in that picture... I, I think it's ugly."[11] The detached, analytical scrutiny suggested by the painting has been attributed to the fact that Isabetta did not live with Neel. It has been argued that the lack of a mother-daughter relationship made Neel into an objective observer of girlhood.[12]

This may of course be true. At the same time one must understand, however, that Neel was not in general interested in depiction according to norms. Her paintings show that there is not a single way to portray childhood, motherhood

or the mother-child relationship. The painting effectively summons up the norms governing childhood and shows how they can be broken. The figure of Isabetta does not seem to be connected to the history of innocent childhood that Reynolds immortalised in his 1788 painting *The Age of Innocence* (Tate, London), Hoppner in his *The Sackville Children* from 1796 (Metropolitan Museum of Art, New York) or Cassatt in her *Little Girl in a Blue Armchair* (1878, National Gallery of Art, Washington DC). Instead, to a contemporary eye, the painting inevitably brings to mind unconventional depictions of children by artists after Neel: Robert Mapplethorpe's 1976 photographs of Jesse McBride and Rosie Bowdrey (fig. 52) and Sally Mann's photographs of her own children from the 1980s. The painting also has much in common with – and perhaps drew from – Lewis Carroll's photographs of Alice Liddell in the 1850s and Julia Margaret Cameron's sensual photographs of children from the 1860s (fig. 55). These works, like Neel's painting, depict the "Other" of innocence: an erotic, sexual child.

This is not strange when one considers the period when the painting was made. The early twentieth century was a time when sexology, the new scientific research into sexuality, and Freudian psychoanalysis were cementing their position in defining sexuality. The figure of the child held a central place in this situation. The child became a lens through which the question of the origin of sexuality was examined. On one hand, the subject was studied from the standpoint of innocence, which was a product of eighteenth-century Enlightenment philosophy. The child was considered to be an oblivious semi-human, or a savage to be raised into humanity and enlightened adulthood. During the course of the nineteenth century, the question of sexual innocence also became an essential part of innocence. The question of how sexuality arose in a person emerged. The attempts to answer this shaped the histories of both the innocent child and the sexual child. The notion of a child's innocence formed the modern "grand narrative" of childhood. This was differentiated from the story of childhood

54 Sir Joshua Reynolds,
The Age of Innocence, **1788**
Oil on canvas, 76.5 x 63.8 cm (support).
Tate, London.

55 Julia Margaret Cameron,
Paul and Virginia, **1864**
Albumen print from wet collodion negative,
26.6 cm x 21.5 cm. Victoria & Albert Museum,
London.

sexuality, which was transformed into something negative and problematic. For instance a masturbating child was considered a problem, while working-class children were designated from the start as sexually bold, petty-criminal problem children. The idea of childhood innocence is indeed a product of the middle-class imagination.

In the early twentieth century, however, the tone changed as Sigmund Freud appeared on the scientific stage. He sought to describe sexuality in an analytical, objective manner. He did not consider sexuality to be a problem in itself. On the contrary, it was clear to him that every child is born sexual – that sexuality was an inborn characteristic. This idea was revolutionary, as it meant that childhood might not after all be a time of such innocence as the conventional wisdom would have one believe. Freud also stressed that the form of one's eventual sexuality was dependent on culture and upbringing. There are parallels in Neel's way of depicting her pre-pubescent daughter. She did not make any particular claims about Isabetta's sexuality, yet at the same time she seemed to be saying that girlhood could not be placed outside any category of sexuality either.

In Neel's youth, the new sexological research also ushered homosexuality and lesbianism into the centre of scientific and popular debate – and these themes can also be seen in Neel's output. Homosexuality was not however defined as just a person's internal trait but as one that could at times be seen externally in the form of cross-dressing. In Neel's hometown of New York, the homosexual subculture was visible. In the fifties and sixties members of sexual subcultures gathered at Lower Manhattan bars such as the Stonewall Inn. The Stonewall was the scene of one of the key events in gay and lesbian history: a riot in which the police clashed with members of sexual subcultures, which led to the establishment of the gay and lesbian liberation movement in 1969. One of the movement's main ideological goals was to take over urban spaces and to encourage people to express their sexuality openly.

This history can be seen in Neel's paintings, for instance

in the portraits *Jackie Curtis and Ritta Redd* (1970, cat. 52) and *Jackie Curtis as a Boy* (1972, fig. 56, cat. 57). Curtis was an actor, writer and singer, whose trademark look included garish makeup, glitter and ripped women's clothing. He was also one of the "Superstars" of Pop artist Andy Warhol's Factory, an array of social outcasts whom Warhol turned into celebrities through his films. In Neel's double portrait, Curtis appears in drag, along with his androgynous lover Ritta Redd, who is dressed in jeans and a striped top. The painting puts the spotlight on Curtis, a member of a sexual minority, and his lover, while it emphasises gender ambivalence and the role of clothing and make-up in constructing gender. Neel seems to be indicating that gender is not an inborn fact but rather a characteristic that can be shaped through clothing and body styling, one known in contemporary terminology as performative. Today the notion of gender performativity has become familiar, but in Neel's time the idea of gender as drag was still unfamiliar. Curtis's gender ambivalence is also emphasised in Neel's second portrait: *Jackie Curtis as a Boy*, from 1972. Unlike the earlier portrait, here the viewer faces an unflinchingly androgynous figure with short red hair, who is revealed to be a man through the reddish stubble around his mouth. Through this pair of portraits Neel underlines the notion that gender is like a work of art or a collage. It is possible to vary the ratio between masculine and feminine signs, and in so doing even produce opposing interpretations of gender.

Like her Curtis figures, Neel's portrait of Warhol from 1970 also stresses gender ambivalence. In this work, the central pioneer of Pop Art is stripped of his trademark drag attire. Beneath this surface, the painting reveals a soft-muscled, feminine figure sitting on the edge of a couch with eyes closed and breasts sagging. At the centre of the picture is the corset around his waist and a scar stretching across his stomach. This is not a vestige of giving birth, but a brutal reminder of an attack by feminist Valerie Solanas, just two years earlier on 3 June 1968. The incident stemmed from Solanas's play *Up Your Ass*. She believed that Warhol had agreed to produce the play,

but that he broke his promise and made matters worse by losing Solanas's script. Solanas responded to this humiliation by shooting Warhol three times, nearly killing him. The scar shown in the painting is a reminder of indiscriminate violence, while also turning gender roles upside down. Warhol is shown as the victim of violence while conjuring up an image of Solanas as a masculine killer. In Neel's hands, Warhol becomes a contemporary St Sebastian, the patron saint of marginalised people and a martyr *par excellence*.

Neel's oeuvre opens up a fascinating perspective on gender, female artistry and art's status as a portrayer of twentieth-century social reality. Her social conscience and her unique ability to look unsentimentally at the margins of society make her perhaps more contemporary now than ever.

56 Alice Neel, *Jackie Curtis as a Boy,* **1972 (detail)**
Oil on canvas, 111.8 x 76.2 cm.
Collection John Cheim.

Catalogue
of Works

by Jeremy Lewison

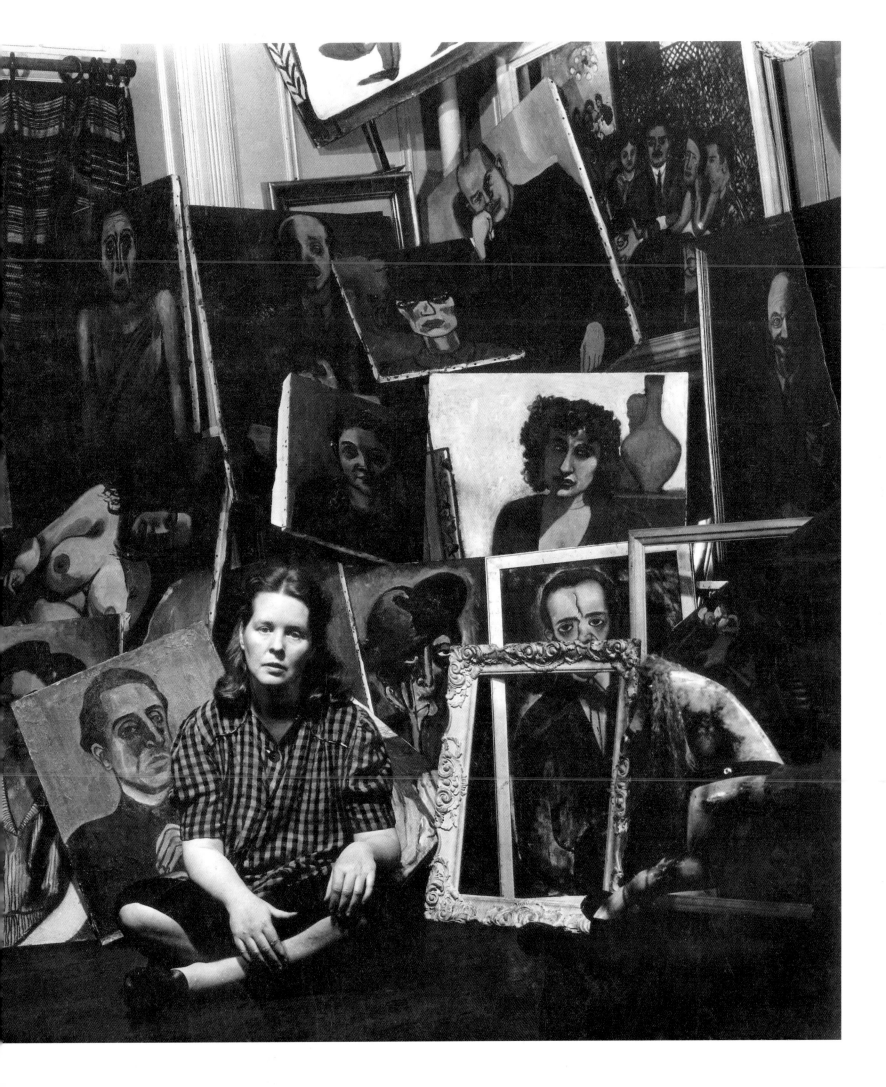

Havana, Cuba

Shortly after graduating from Philadelphia School of Design for Women, Neel married fellow painter Carlos Enríquez. Enríquez returned to Cuba and began to mix with members of the Cuban avant-garde but Neel stayed in the Philadelphia area and was invited to work with her fellow artists, Rhoda Myers and Ethel Ashton. In 1926, however, Enríquez persuaded Neel to travel to Cuba, where they stayed with his middle-class parents in El Vedado, close to the centre of Havana, later on moving out into independent accommodation. Enríquez's family was wealthy and Neel was uncomfortable with the disparity between their standard of living and those of the poor whom she enjoyed painting and drawing. Cuba generated considerable wealth and Havana in particular enjoyed a substantial construction programme.

A strong and cohesive avant-garde emerged in this time and Neel associated with it, exhibiting at the *XII Salón de Bellas Artes* in 1927 and having work reproduced in *revista de avance* that same year. Most of the members of that grouping had visited Europe and had knowledge of the Mexican muralists. Although Neel only stayed there for a year, the impact on her of the visit was considerable. This was her first trip outside the USA and to an exotic location with a sense of history, bright light and strong colour. Surrounded by servants in the Enríquez household, Neel was also witness to a lifestyle beyond her experience, while in Havana itself, then regarded as the Paris of the Caribbean, she was surrounded by nightclubs and bars. Havana was becoming a playground for wealthy Americans. But it was the particularly Latin quality that left its lifelong mark on Neel. She and Enríquez spent time with members of the Cuban avant-garde, for example Marcelo Pogolotti, painting portraits and landscapes. In December 1926 Neel gave birth to Santillana but by May 1927 things were not going well for her and she returned with her child to Colwyn, Pennsylvania, leaving Enríquez behind.

‹ Neel and Carlos Enríquez in Cuba, 1926.

Carlos Enríquez, 1926

Oil on canvas, 76.5 cm x 61.3 cm,
Estate of Alice Neel.

Born in 1900, the same year as Neel, Carlos
Enríquez, a Cuban, came to the USA in 1920 to
study at the Curtis Business School, Philadelphia.
After completing his course he enrolled at the
Pennsylvania Academy of the Fine Arts, where
he met Neel. They married in 1925 and moved
to Cuba staying with his parents. They returned
to New York in 1927, where Enríquez worked as
an illustrator for a Cuban magazine, *revista de
avance*. Following the death of their first child,
Santillana, and the birth of their second, Isabetta,
Enríquez returned to Cuba in 1930, taking Isabetta
with him and abandoning Neel. As a painter, he
adopted a surrealist outlook tempered with a
dreamy romanticism. He died in Havana in 1957.

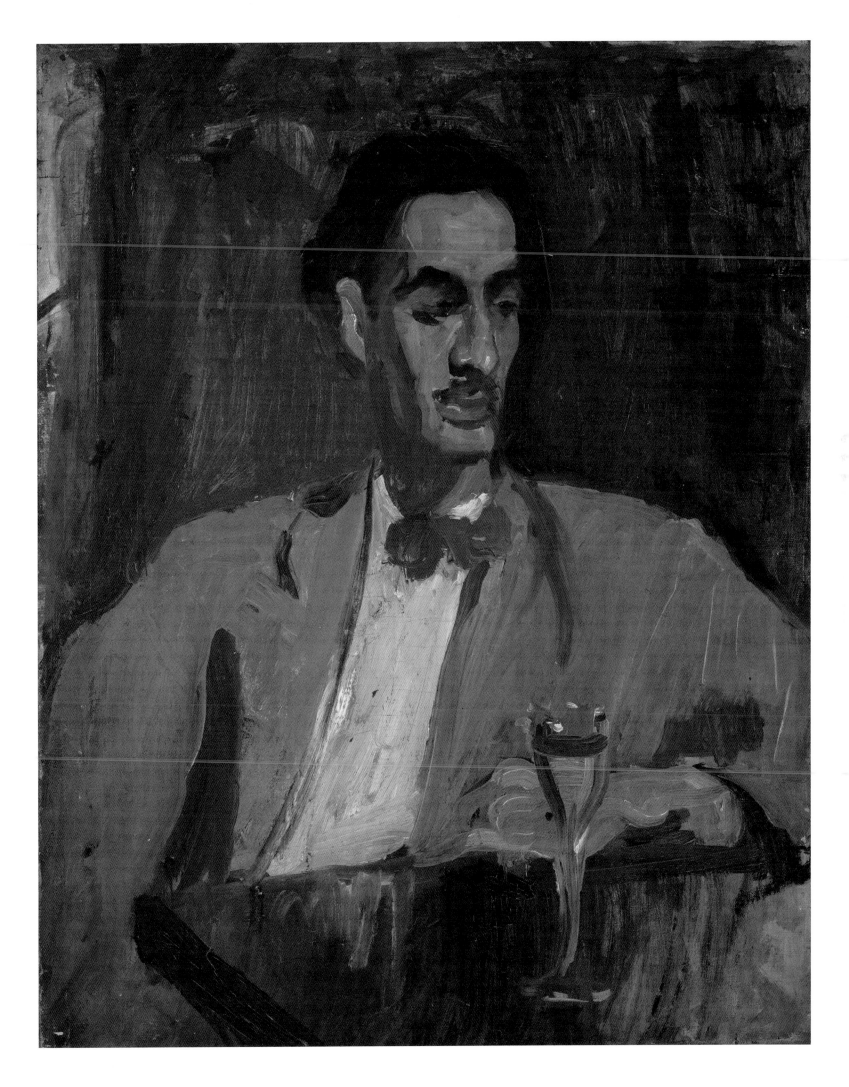

Mother and Child (Havana), 1926

Oil on canvas, 65.7 cm x 45.9 cm,
Estate of Alice Neel.

One of Neel's earliest portraits, it announces her lifelong interest in depicting mothers with their children. Neel and Enríquez lived in bourgeois luxury with his parents but would visit the poorer districts and observe people in less fortunate circumstances. Already at this early stage Neel showed great empathy for the disadvantaged. Neel applied the paint in broad, broken brush strokes with a narrow tonal range, showing an evident pleasure in the nature of the materials themselves. She implies a sense of movement through the rotating posture of the mother and the child's gesture. Neel arrived in Havana with copies of Ashcan painter Robert Henri's *The Art Spirit*, which she showed to local painters. This painting is very close in style, facture and sombre tone to Henri's work.

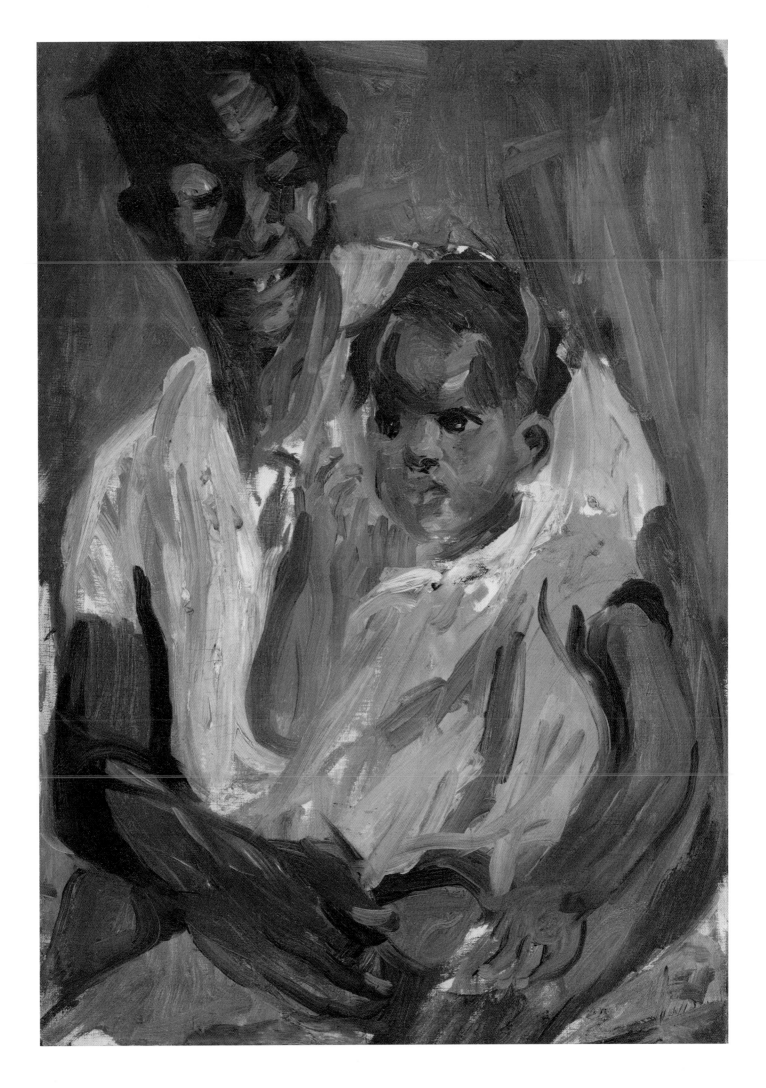

New York and Philadelphia

When Enríquez finally came to the USA in the autumn of 1927, he and Neel moved to a room on the Upper West Side of Manhattan with shared bathing facilities. The Upper West Side was then a slum area. Neel found a job in a bookstore in Greenwich Village while Enríquez worked as an illustrator and reporter for the *revista de avance*. Neel mostly painted watercolours, often depicting the conditions in which they were living, but also some oils. Finding life expensive with a child, they moved further out to Sedgwick Avenue in the Bronx, close to the Harlem River and the highway, north of the Washington Bridge. With the expansion of the subway and the elevated railways, the Bronx had become heavily populated by immigrants and Jewish Americans, although the Jewish Americans left the south and west parts when the Hispanic and African-American people moved in. Though far from the centre of Manhattan, it was well connected by public transport. That was essential because Neel knew no-one in the area. That winter, Santillana died of diphtheria. Neel became pregnant again fairly soon after and gave birth to Isabella (known as Isabetta) in November 1928. Neel must have made day trips to Coney Island and to the beach at Belmar, New Jersey with Isabetta, as she recorded them in paintings and watercolours. There were signs of some happiness but always lurking in the background was overwhelming sadness and disorientation. Two years later, on the pretext of taking Isabetta to stay with his parents while he and Alice would travel to Paris, Enríquez left Neel, never to live with her again. Neel returned to her parents and began, again, to share a studio with Ashton and Myers in Philadelphia. The paintings Neel made there show clear signs of psychological trouble and by August 1930 she suffered a nervous breakdown. She was eventually hospitalised in October.

If New York had been a locus of excitement, by the end of her time there it had become a site of tragedy. Neel would not return for two years.

< Neel with Santillana outside her house in Sedgwick Avenue in the Bronx, 1927.

Degenerate Madonna, 1930

Oil on canvas, 78.9 cm x 61.3 cm,
Estate of Alice Neel.

In the early years of her career Neel painted a number of works that could be described as allegorical. In *Degenerate Madonna* she depicts her friend, Nadya Olyanova, a Ukrainian émigré, with a fictitious child on her lap. The profile of another child in a garden is glimpsed through a window. The ghostly figures of the children, their grey flesh, swollen heads and stick legs, infer sickness and may allude to the death of Neel's first child and the spiriting away of her second with a certain gallows humour. The gothic nature of the painting recalls such works as *Mother with Child* (1921) by Otto Dix but there are also interesting echoes of Francisco de Goya's *The Countess of Altamira with her Daughter Maria Agustina* (1787-88) which was in the Lehman Collection in New York and is now in the Metropolitan Museum. The painting was reproduced in Walter Cook's article, "Spanish and French Paintings in the Lehman Collection", published in *The Art Bulletin* in December 1924, which Neel could have seen in the library of the Philadelphia School of Design for Women. It was also reproduced in *Goya. An Account of His Life and Works* by Albert Calvert, published in 1908 by John Lane, London and New York, which was probably more widely available.[1] For Neel, who was immersed in Hispanic culture, Goya must have been of enormous interest. Goya's sitters are pallid, the legs of the child, sitting on her mother's lap, project like those of Neel's infant, and the countess's hair is a frizzy halo similar to Olyanova's. Olyanova, born Edna Meisner (or possibly Ethel Neidish) was a graphologist who became a psychologist in the thirties. She was twice widowed and had no children. She died in 1991. *Degenerate Madonna* was exhibited at the *First Washington Square Outdoor Exhibit* in 1932 but had to be withdrawn after protests from the Catholic Church, presumably because of its title.

Note

1 Information kindly provided by Debra Jackson, curator of the Lehman Collection, Metropolitan Museum of Art, New York.

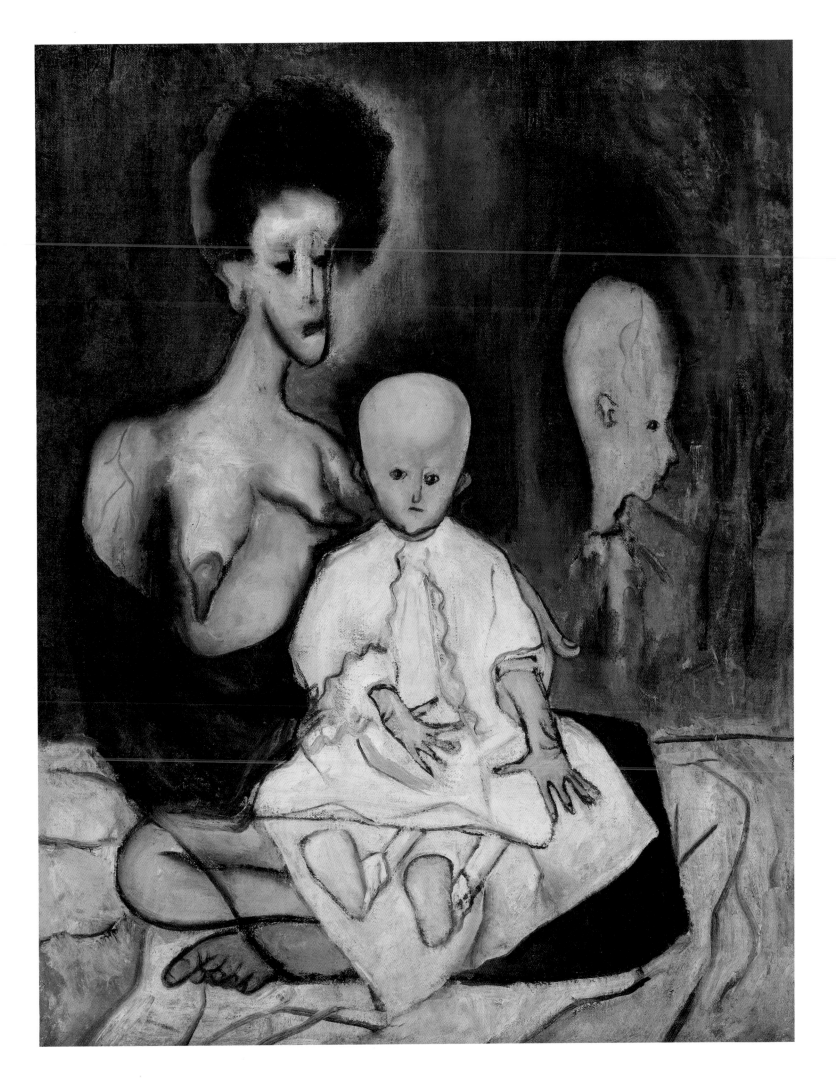

Rhoda Myers with Blue Hat, 1930

Oil on canvas, 69.9 cm x 59.1 cm,
Private Collection.

In 1930, before Neel's breakdown, she painted a
number of nudes in the company of her friends
Rhoda Myers (1902-1991) and Ethel Ashton,
sharing a studio with them in Washington Square,
Philadelphia. Neel reclaimed the subject from
the control of male artists, scrutinising the female
body in a manner that divests it of any erotic
charge. Myers's body is abject and the spectator
is confronted with her corporeal reality rather
than an idealised image. Neel does not spare her
dignity, painting her as though she has a body
beyond her years and transforming the shadow
between her legs into an intimation of pubic
hair. Myers's expression is indifferent, however.
Wearing a broad rim hat that slices through space,
she faces the painter with glazed eyes resisting
Neel's penetrating gaze. Seated directly facing
the viewer on a yellow, floral patterned chair, this
painting has echoes (probably serendipitous since
it was still in private hands) of *Madame Cézanne
in a Red Dress* (1888-90) by Paul Cézanne.

Ethel Ashton, 1930

Oil on canvas, 61 x 55.9 cm.
Tate, London.

Ethel Ashton (1896-1975) was an aspiring artist but
with a career limited to exhibiting in Philadelphia,
where her day job was librarian at the Pennsylvania
Academy of the Fine Arts. She had been a student
one year ahead of Neel at the Philadelphia School
of Design for Women and met Neel and Myers at
the Graphic Sketch Club, where free life classes
took place on Sundays. Neel first shared Ashton
and Myers's Washington Square studio briefly in
1925 and Ashton had already painted a portrait of
Neel in 1924. Neel's candid early portrait, painted
during the second period she shared Ashton's
and Myers's studio, was an embarrassment to
Ashton and suggests a degree of control that
Neel exercised over her. Not having money to
hire models Ashton, Neel and Myers painted
each other but Neel was the only one to strike
an original note in her depiction of the nude.
The frankness of her approach may suggest a
familiarity with artists of the *Neue Sachlichkeit*
and anticipates the work of a number of artists,
among them British artists Stanley Spencer and
Lucian Freud. Only the abstractly covered bed
cover that angles out of the painting on the left
relieves the intensity of the painting, exacerbated
by the plunging view. Photographs of Ashton
reveal that her head was as egg shaped and her
body as corpulent as Neel portrayed them.

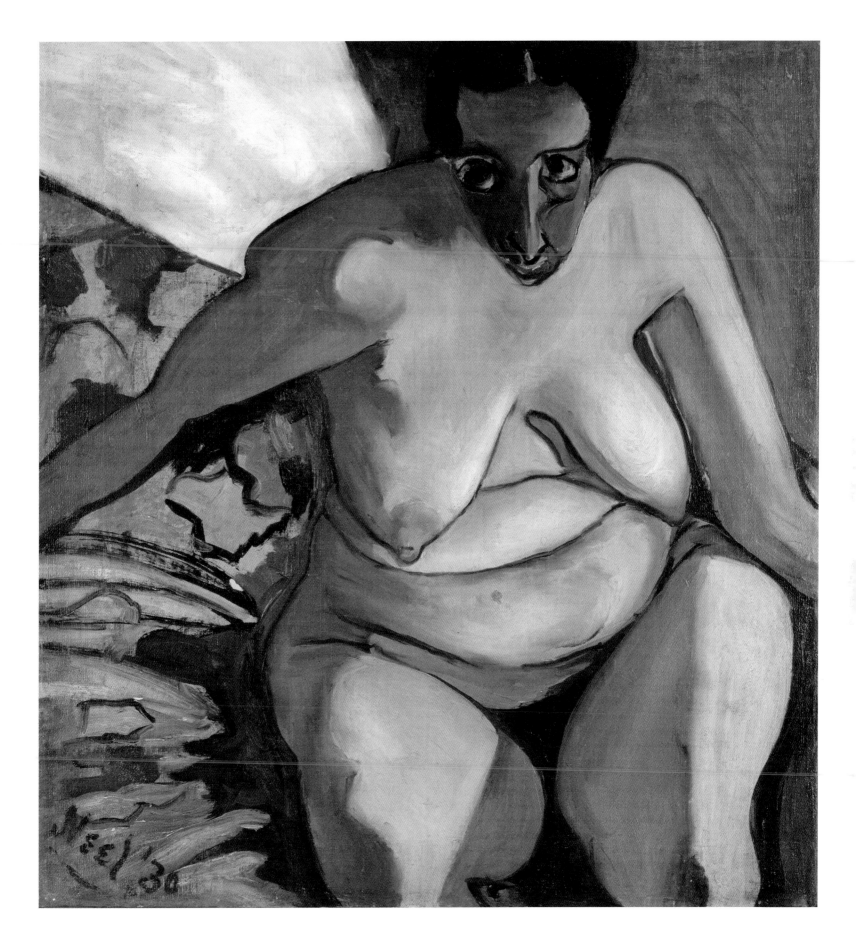

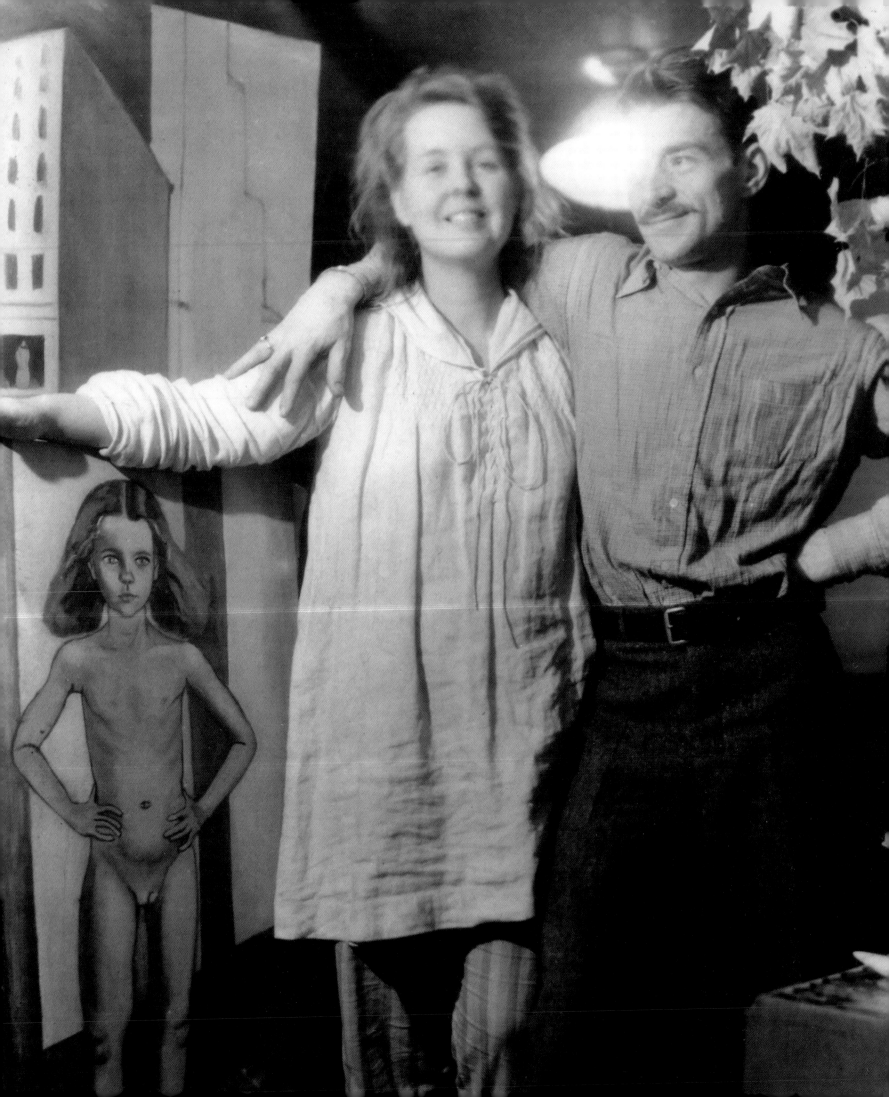

Greenwich Village

Early in 1932, having been discharged from hospital and having met Kenneth Doolittle, Neel moved with him into a flat in a carriage house at 33½ Cornelia Street in Greenwich Village. It was set back from the street, between Bleecker and West 4th Streets. In those days Greenwich Village was regarded as the heart of Bohemia, populated by writers, artists, photographers and intellectuals. It had a well-known theatre, the Cherry Lane Theatre, and Gertrude Vanderbilt Whitney established the Whitney Studio Club that evolved into the Whitney Museum of American Art on West 8th Street, three blocks away from Cornelia Street, the year before Neel moved in. The buildings were low-rise Victorian houses and decrepit "row houses" (terraced houses) that were turned into flats for artists. The area in general had a reasonably ethnically diverse population, although it was predominantly white. It was known for its non-conformism and radicalism. Neel met artists and writers who became the subjects of her paintings but she also painted cityscapes from her window. But these were the Depression years and she witnessed extreme poverty and hardship, strikes and protests, which she translated into drawings, watercolours and paintings.

Doolittle was a sailor with pretensions to being a photographer but he was also a dope smoker. This was unexceptional in Greenwich Village. Doolittle was also a Communist and, according to Phoebe Hoban, it was through him that Neel began to meet other members of the Party and dockworkers.[2] Doolittle remained an activist throughout his life, even volunteering to fight in Spain during the civil war. It was in the Village that Neel also met the Soyer brothers, who would be lifelong colleagues and friends. Although she exhibited in a handful of group exhibitions, her work had little visibility.

Neel's relationship with Doolittle ended abruptly when he found out she was having an affair with John Rothschild. In anger he burned many of her watercolours and slashed many paintings, including *Isabetta*. Neel moved out of Cornelia Street to a hotel at Rothschild's expense. "When I left Cornelia Street, I left a life," she told Jonathan Brand in 1969.[3] After enrolling in the Works Progress Administration (WPA) programme in September 1935, she could afford to rent an apartment and found one at 347½ West 17s Street in Chelsea. Chelsea was also a cultural district with many theatres. As a WPA artist, Neel painted many urban landscapes, including the 9th Avenue El at the intersection of Hudson Street and 9th Avenue, which was just two blocks south of her apartment. Her sojourn in Chelsea came to an end after she met José Santiago Negrón, a musician and singer, and they moved to Spanish Harlem.

‹ Neel and Kenneth Doolittle at their apartment at 33 ½ Cornelia Street with the first *Isabetta* (1934), and *Synthesis of New York, The Great Depression* (1933) behind, 1934.

Notes

1 Phoebe Hoban, *Alice Neel: The Art of Not Sitting Pretty*, (New York, 2010), 88.

2 Jonathan Brand, "Fire and Alice", unpublished typescript, 1969.

Martin Jay, 1932

Oil on canvas, 64.1 x 51.4 cm.
Estate of Alice Neel.

Painted not long after Neel was discharged from
hospital and had settled with Kenneth Doolittle in
Greenwich Village, *Martin Jay* represents a new
departure for Neel in her approach to painting.
With the exception of *Rhoda Myers with Blue Hat*
(cat. 4), this is one of the first paintings by Neel in
which the sitter sits directly facing the artist, rather
than turned in three-quarter pose or slightly at
an angle. The confrontational aspect of the pose
is matched by the intensity of Jay's expression.
There is no admission to his psyche. Jay stares
down the artist, his lips clamped shut. The single
colour background differs from the patterned
props in Neel's 1930 nudes and reinforces the
starkness of the painting. No information is known
about the sitter.

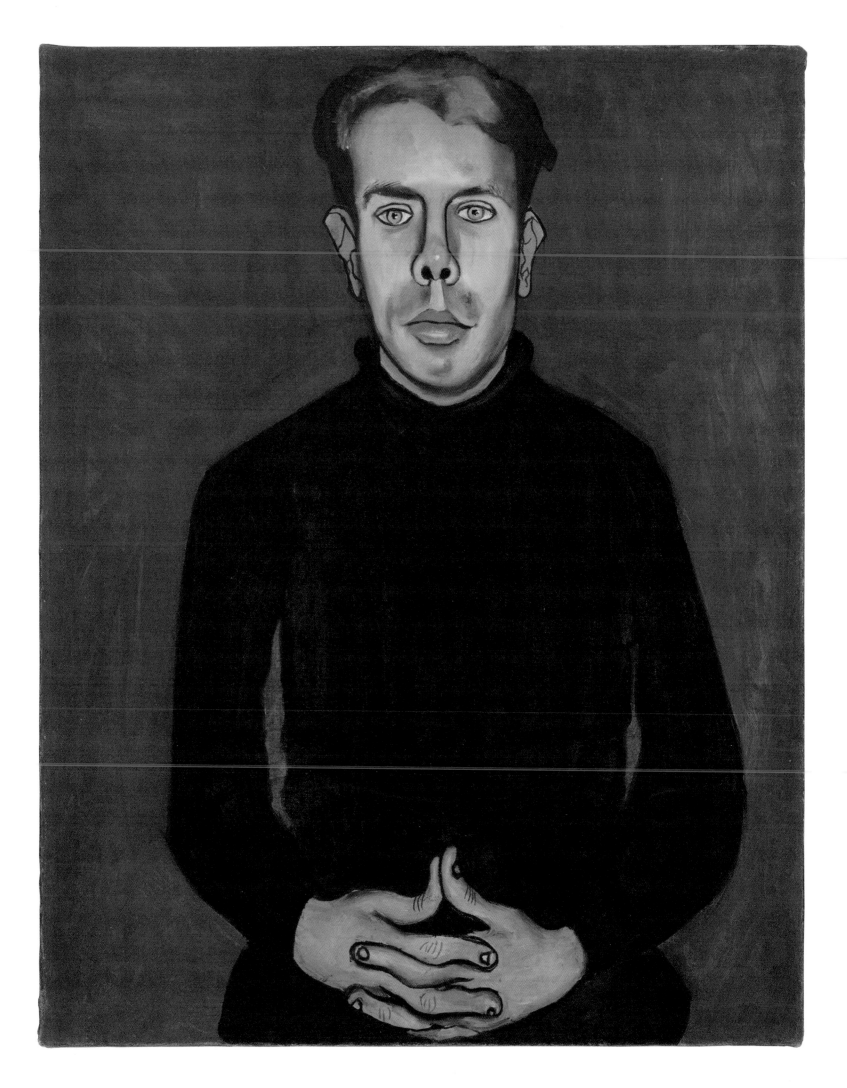

Symbols (Doll and Apple), 1932

Oil on canvas, 62.2 x 71.1 cm.
Museum of Fine Arts, Boston,
Gift of Barbara Lee, 2015.3330.

Although *Symbols* is one of the most overtly allegorical of Neel's paintings, it is one of the most enigmatic. Painted not long after her discharge from hospital following her suicide attempts, it depicts the child as a mannequin, a theme Hans Bellmer began to address simultaneously in Berlin, although he presented the mannequin as a composite of fragments. In Neel's painting the child is sickly and undernourished, the source of nourishment blocking up her vaginal passage. The apples may make reference to the myth of Adam and Eve. By eating the fruit of the tree of knowledge mankind developed an evil inclination. Blocking the vagina the apple becomes the fruit of the womb, the product of sex and procreation. The green apples and the large orange glove possibly refer to Giorgio de Chirico's *The Song of Love* (1914) where objects are assembled with a similar sense of incongruity. Notwithstanding the references to Latin American devotional images, this painting proposes the possibility of Neel's interest in European surrealism and manifests a strong interest in developing a symbolic language.

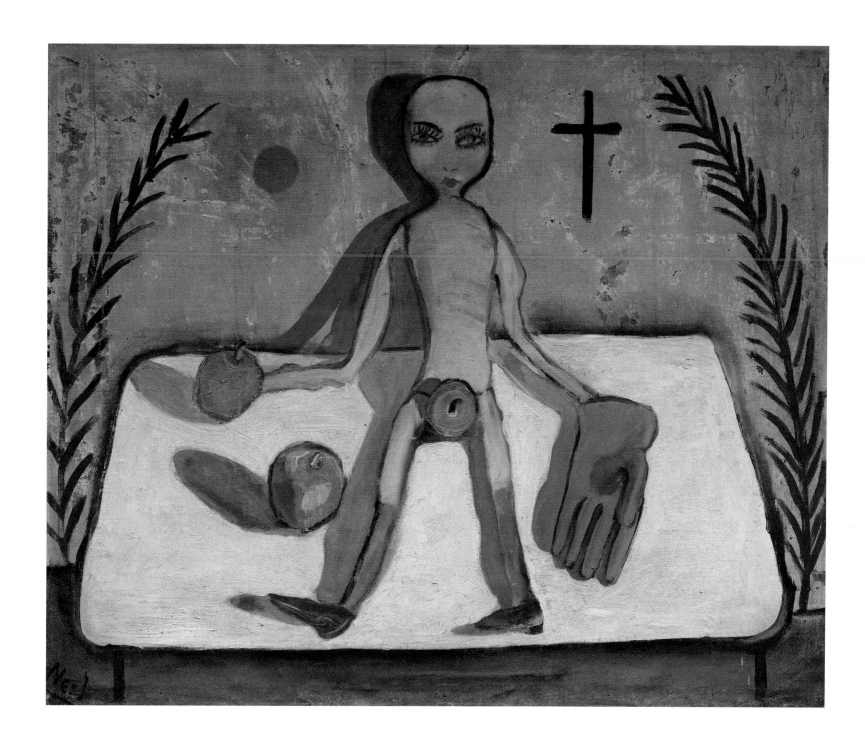

Joe Gould, 1933

Oil on canvas, 99.2 x 79.1 cm.
Estate of Alice Neel.

Joe Gould (1889-1957) was an eccentric, possibly autistic, inhabitant of Greenwich Village. He had an interrupted period of study at Harvard University but finally graduated in anthropology in 1916. Some time after that, he was admitted to Manhattan State Hospital for the Insane. On his release Malcolm Cowley hired him as a regular reviewer for the *New Republic* and through this work he met many modernist writers. Gould claimed to be writing "An Oral History of New York" but it was never completed. One chapter was published in 1923 in *Broom: An International Magazine of the Arts*. Neel depicts Gould as a Village simpleton and mocks his exhibitionist nature. There is a suggestion that either Gould was aroused by sitting for Neel or that sexual relations took place, since one rendering of his penis, on the right, is engorged. Depicting Gould in three different poses and three different states in one image alludes to the passage of time, but it is also an ironic variation on the theme of the Three Graces. Neel's use of vermillion, and the distressed nature of the paint surface raise the possibility she may have been thinking of Pompeian wall paintings, which were often licentious.

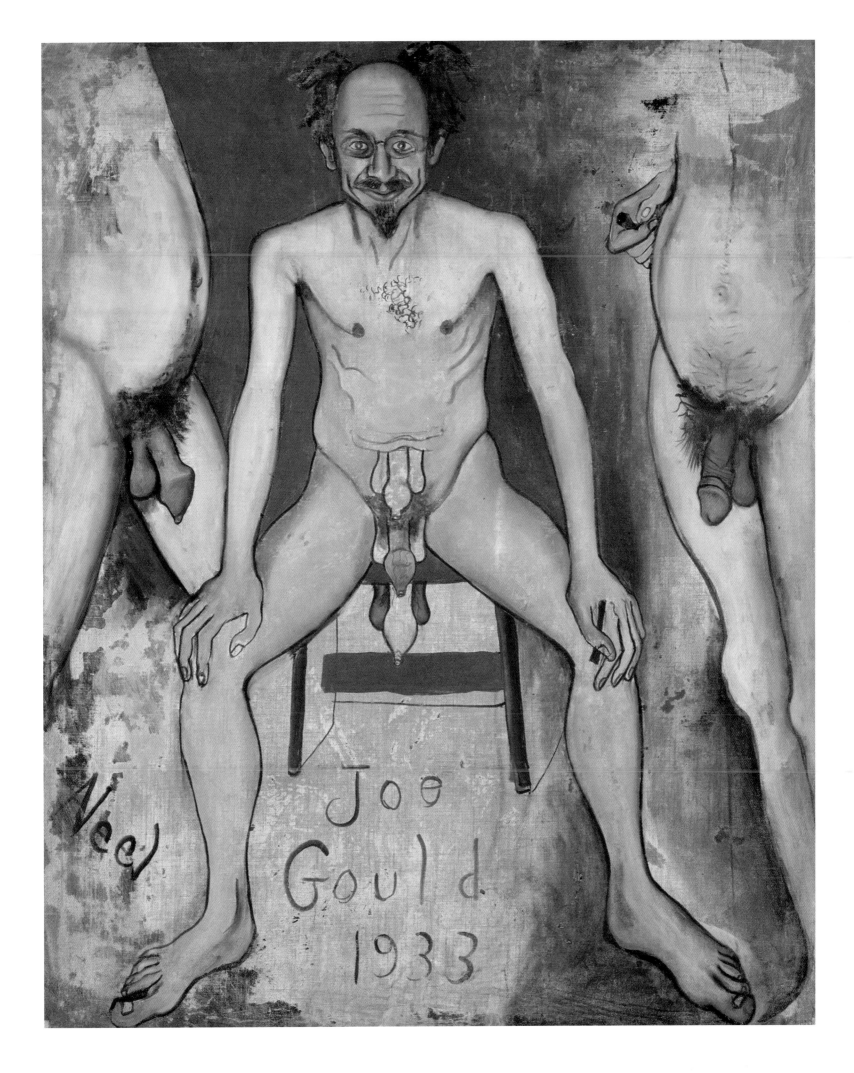

Nee

Joe
Gould
1933

Nadya and Nona, 1933

Oil on canvas, 66 x 90.2 cm.
Lieve Van Gorp Foundation, Antwerp.

Nadya Olyanova (1900-1991), the model for *Degenerate Madonna* (cat. 3), lies on a bed with a companion, Nona (about whom nothing is known). Neel addresses the tradition of the double female nude, for example Gustav Courbet's *The Sleepers* (1866), but removes any hint of the erotic from the encounter between the women and between the spectator and the models. Although Nadya turns her genital area towards the spectator there is no sense of invitation. Her grim expression and Nona's icy stare refuse any engagement. In 1929 Neel had painted a watercolour of Olyanova titled *La Fleur du Mal (Nadya)*, clearly referring to an interest in Baudelaire's poems published in 1857. The atmosphere in *Nadya and Nona* is essentially Baudelairean too, with its mood of lassitude, the *ennui* clearly sensed by Nadya, the wan moon and the air of decadence that permeates the scene. Among the many poems that describe something of the atmosphere in Neel's painting is "J'aime le souvenir de ces époques nues" ("I love to think of those naked times"), where Baudelaire writes by way of contrast to the uninhibited manner in which he imagined the Ancients regarded nudity:

"Today the poet, when he wants to visualise
Those ancient grandeurs, in the places where
Man and woman revealed their nakedness,
Feels a shadowy coldness envelop his soul
Before this black picture full of dread.
O monstrosities lamenting their clothing!
O ridiculous torsos! Physiques worthy of masks!
O poor twisted bodies, thin, potbellied or flabby,
That the God of Utility, implacable and serene,
As children wrapped up in blankets of bronze!
And you women, alas! Pale as candles,
Gnawed and nourished by debauchery, and you, virgins
Dragging behind you the heritage of maternal vice,
And all the hideousness of fecundity!"[1]

Le Poète aujourd'hui, quand il veut concevoir
Ces natives grandeurs, aux lieux où se font voir
La nudité de l'homme et celle de la femme,
Sent un froid ténébreux envelopper son âme
Devant ce noir tableau plein d'épouvantement.
Ô monstruosités pleurant leur vêtement!
Ô ridicules troncs! torses dignes des masques!
Ô pauvres corps tordus, maigres, ventrus ou flasques,
Que le dieu de l'Utile, implacable et serein,
Enfants, emmaillota dans ses langes d'airain!
Et vous, femmes, hélas! pâles comme des cierges,
Que ronge et que nourrit la débauche, et vous, vierges,
Du vice maternel traînant l'hérédité
Et toutes les hideurs de la fécondité!

Before the publication of his poems Baudelaire announced on a number of occasions that he would call the collection *Les Lesbiennes* (the lesbians). For Baudelaire lesbianism was in some respects a representation of modernity. In the event only three poems in *Les Fleurs du mal* were on this theme. Olyanova was certainly no lesbian so the painting is a staging of a scene. In a rather bathetic way, Neel nicknamed the painting "Two Little Tarts". Because it was considered indecent, it was not shown until Neel's Whitney Museum retrospective in 1974.

Note

1 Present author's translation.

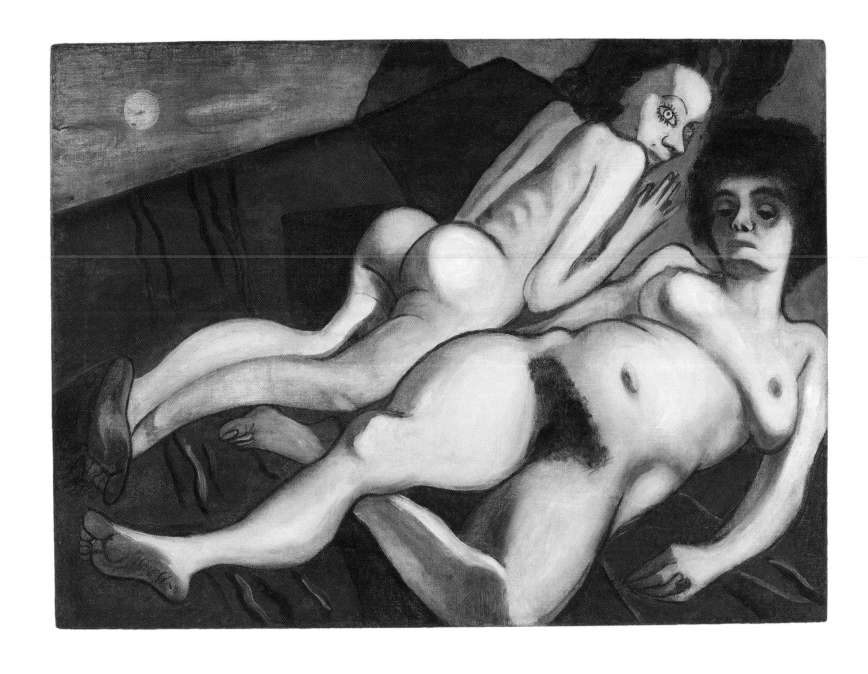

Isabetta, 1934, repainted 1935

Oil on canvas, 109.2 x 66 cm.
Private Collection.

Neel painted Isabetta, her second, but estranged, daughter when Isabetta stayed with her in New Jersey in 1934. Neel's parents were also present during this visit, presumably as chaperones and to provide supplementary childcare, not to mention to become acquainted with their granddaughter. The painting proposes the ambivalence of the relationship between mother and child. While Isabetta stands in a confrontational pose, her nakedness implies intimacy and trust. The pose is similar to Cézanne's *The Bather* (c.1885), which had recently been acquired by the Museum of Modern Art, New York and was exhibited in 1934 in Philadelphia. Of the tendency to expose their naked bodies, Sigmund Freud wrote in *Three Essays on the Theory of Sexuality* (1905): "Small children are essentially without shame, and at some periods of their earliest years show an unmistakable satisfaction in exposing their bodies, with special emphasis on the sexual parts." It is perfectly plausible, on a hot summer's day, that Isabetta, at age four years six months, was running around naked, rather than Neel asking her to strip to be painted. Kenneth Doolittle destroyed the first version of this painting but it was so important to Neel that she repainted it immediately. Even when she sold it she made another copy of it. Although the South African born artist, Marlene Dumas, suggests that Neel's *Andy Warhol* (1970, cat 51) influenced her own painting, *The Painter* (1994), also a picture of a naked female child, *Isabetta* seems close to it too. In the context of the history of portraits of children, Neel's *Isabetta* is radical, unconventional and iconoclastic.

Max White, 1935

Oil on canvas, 91.4 x 66 cm.
Smithsonian American Art Museum,
Washington D.C., Museum purchase, 1989.14.

Max White was the *nom de plume* of Charles William White, born in 1906. His books tended to be set in the artistic milieu and included *Anna Becker* (1937), the poorly selling *Tiger Tiger* (1940), a story of a fictitious painter in Paris, John Martin, and *In the Blazing Light* (1945), about Goya, one of Neel's favourite artists. Gertrude Stein admired White. Neel painted White in 1935, 1939 and 1961. Other than members of her family, partners and the early naked portraits of Nadya and Rhoda, Neel painted no other person so frequently. In this, the earliest of the portraits, White is portrayed as a proletariat intellectual, his mien resembling Rodchenko's photographs of the poet Vladimir Mayakovsky, although she may not have known them. White, however, has the look. Neel likened White's appearance to Olmec sculpture that she would have seen in the Metropolitan Museum and imparts a strong sculptural quality to her painting. In a generally even toned composition, Neel makes his sensuous, red lips a strong focal point.

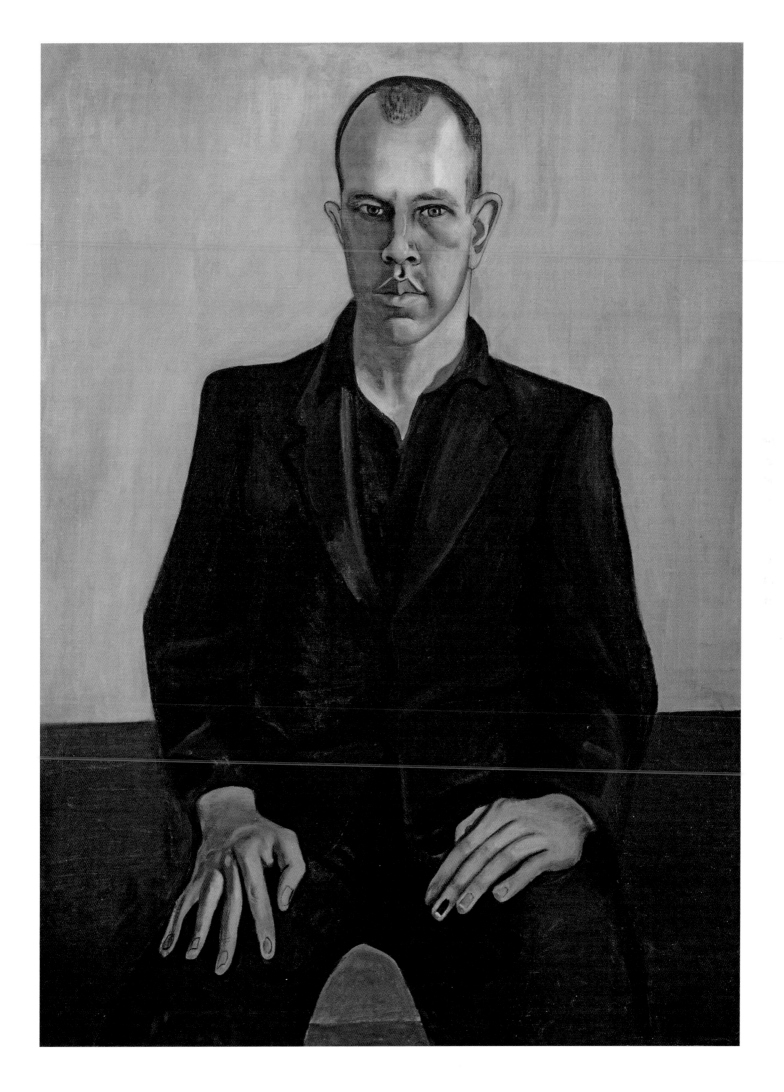

Kenneth Fearing, 1935

Oil on canvas, 76.5 x 66 cm.
Museum of Modern Art (MoMA), New York,
Gift of Hartley S. Neel and Richard Neel,
28.1988.

Kenneth Fearing (1902-1961) was considered one
of the leading poets of his generation in the 1930s,
although his reputation has since diminished.
A man of the left, his work was published in
the Communist journals *Masses & Mainstream*
and *New Masses*. He also published in the
New Yorker and in 1934 helped to found *Partisan
Review*, at that time a Communist cultural and
political magazine. Fearing was a proponent of
proletarian literature. In 1935, when Neel painted
this portrait, Fearing's wife, Rachel Meltzer, had
just given birth to a boy, Bruce, depicted on the
table in front of the poet. Neel recounted how
Fearing would visit her every week in Greenwich
Village. She claimed to have depicted the material
for Fearing's poetry. The subject of his poems
was the violent, urban atmosphere and vernacular
of the Depression years.

Ninth Avenue El, 1935

Oil on canvas, 61 x 76.2 cm.
Cheim & Read, New York.

Neel depicted the Ninth Avenue El where
Hudson Street intersects with Fourteenth Street.
The subway was rapidly replacing the elevated
railway and by the time Neel depicted the latter,
the Interborough Rapid Transit Company that
owned it had gone into receivership. The Ninth
Avenue El, which was the first elevated railway
to have opened in 1868, finally closed in 1940.
Neel's painting, probably executed while she was
working for the WPA, is painted in a faux naïve
style but is spatially highly complex with multiple
vanishing points. Only public transportation
is visible in the painting and the people have
a burdened, cadaverous look. This is a proletarian
vision of the city devoid of private luxury or the
presence of wealth, painted in the middle of
the Great Depression. But it is also somewhat
nostalgic, recording a technology that was in
the process of being superseded. Furthermore,
it is likely to have been a railway that Neel herself
took downtown when earlier she lived on the
Upper West Side, so it would have had a personal
association. The figures in the painting are
reminiscent of the works of James Ensor.

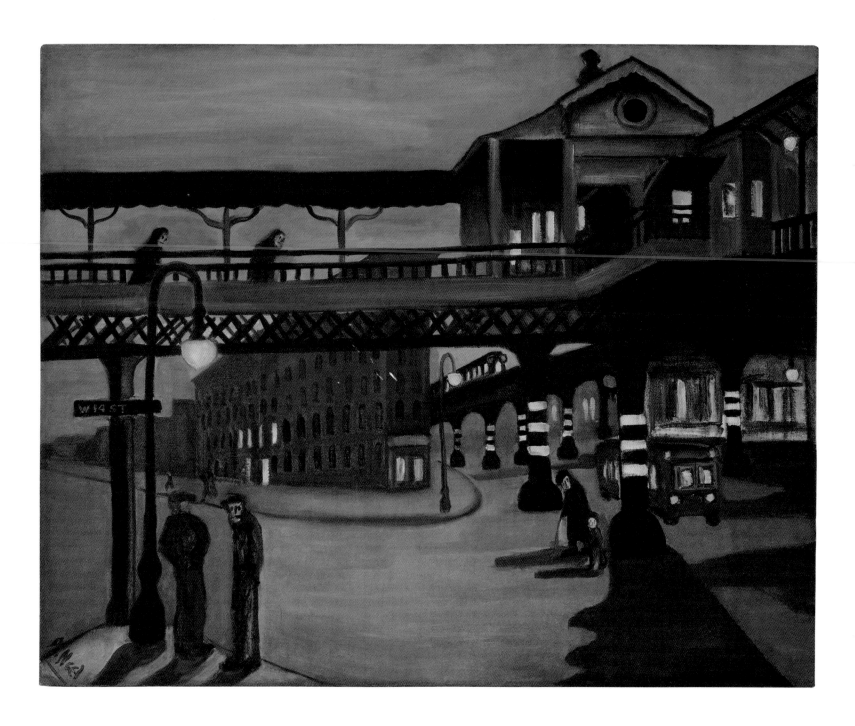

Gerhard Yensch, c.1935

Oil on canvas, 81.3 x 54.3 cm.
Estate of Alice Neel.

Like Max White, Neel painted Gerhard Yensch
face-on. Yensch is dressed rather formally in
a pinstriped suit and sits in a reserved way,
revealing no expression. There is a Germanic air
to this painting, which is in keeping with a sitter of
German origin. The frontal composition is similar
to portraits by Otto Dix and Max Beckmann, for
example. There is no indication as to Yensch's
occupation but Neel highlights his elegance not
simply through his clothing but his refined looks,
elongated hands and gemstone ring. Perhaps
Neel had been looking at Mannerist portraiture,
for example El Greco or Bronzino.

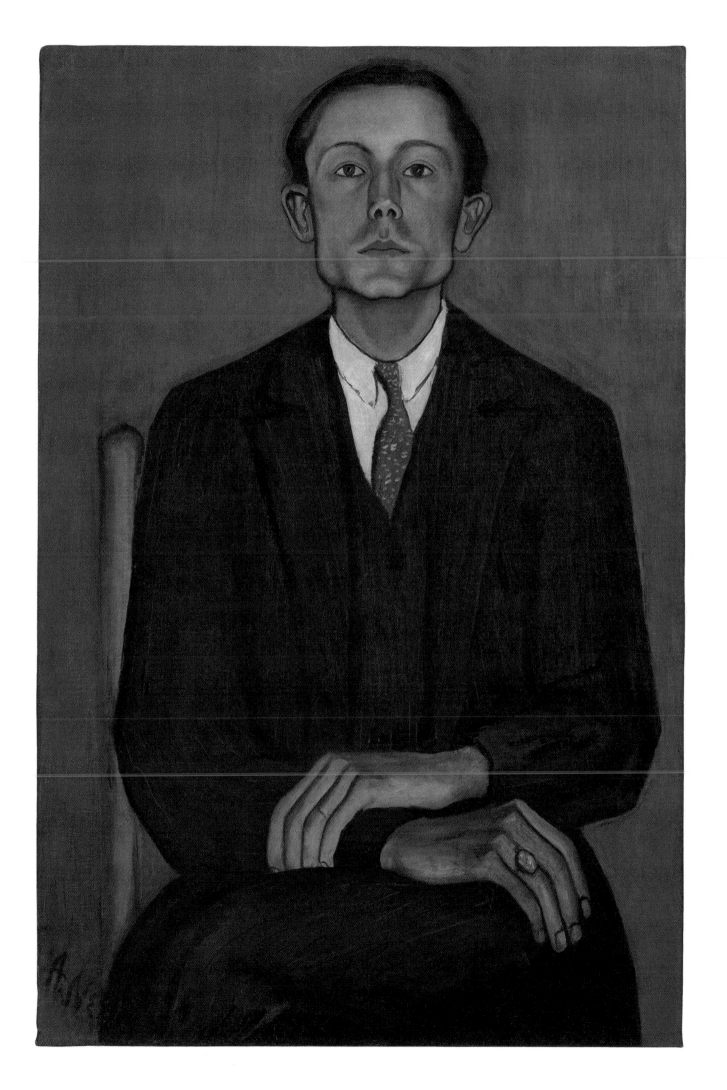

Mother and Child, c.1936

Oil on canvas, 61 x 55.9 cm.
Collection Victoria and Warren Miro.

The sitters have recently been identified as José
Santiago Negrón's first wife, Molly (née Smith),
and their daughter Sheila. Sheila was born in 1935.
Neel had painted a series of works depicting a
mother and child in 1930, so this was a reprise of
an earlier theme. The work is suffused with an
air of melancholy, the realisation, perhaps, that
Neel had supplanted Molly in Negrón's affections.
His abandonment of mother and young child
would be repeated shortly after Neel gave birth
to Richard in 1939. The composition resembles
many Renaissance paintings of the Madonna
and Child and replicates the custom whereby
both protagonists face forwards, thus not
communicating with each other. But there is also
a strong similarity to the treatment of this theme
by German artists of the *Neue Sachlichkeit*.
The simple colour scheme is based on the
complementary colours, red and green, all other
tones, apart from flecks of blue, being neutral.
It is clear from *pentimenti* that Neel altered
the composition, narrowing the mother's proper
right arm, dropping her right shoulder and altering
the shape of her hair.

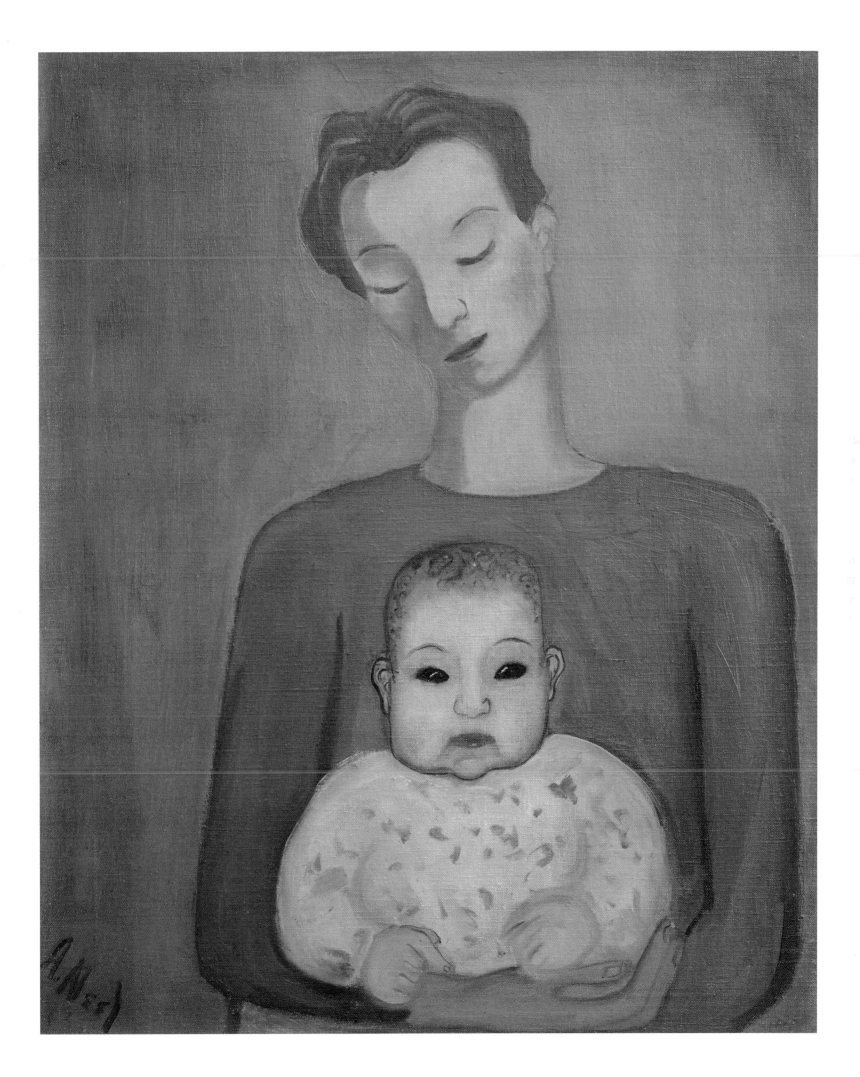

José, 1936

Oil on canvas, 58.4 x 46 cm.
Estate of Alice Neel.

José Santiago Negrón (1910-1992) was a musician
and nightclub singer Neel met towards the end
of 1935, not long after her break up with Kenneth
Doolittle. Negrón was married and had a daughter,
Sheila, but he left his family to move in with Neel.
For Neel, who never really recovered from her
split with Carlos Enríquez (they did not divorce),
Negrón was a Latin substitute. Here she depicts
the dreamy, romantic side of Negrón wearing
striped pyjamas. The pose is close to being a
mirror version of a drawing of the same year, with
José leaning on one elbow in three-quarter profile,
although differently attired. Neel documented
their four-year relationship in a number of
paintings and drawings as well as portraying
Negrón playing his guitar and singing. Here she
moved away from the full frontal composition
to something more gentle and subtle.

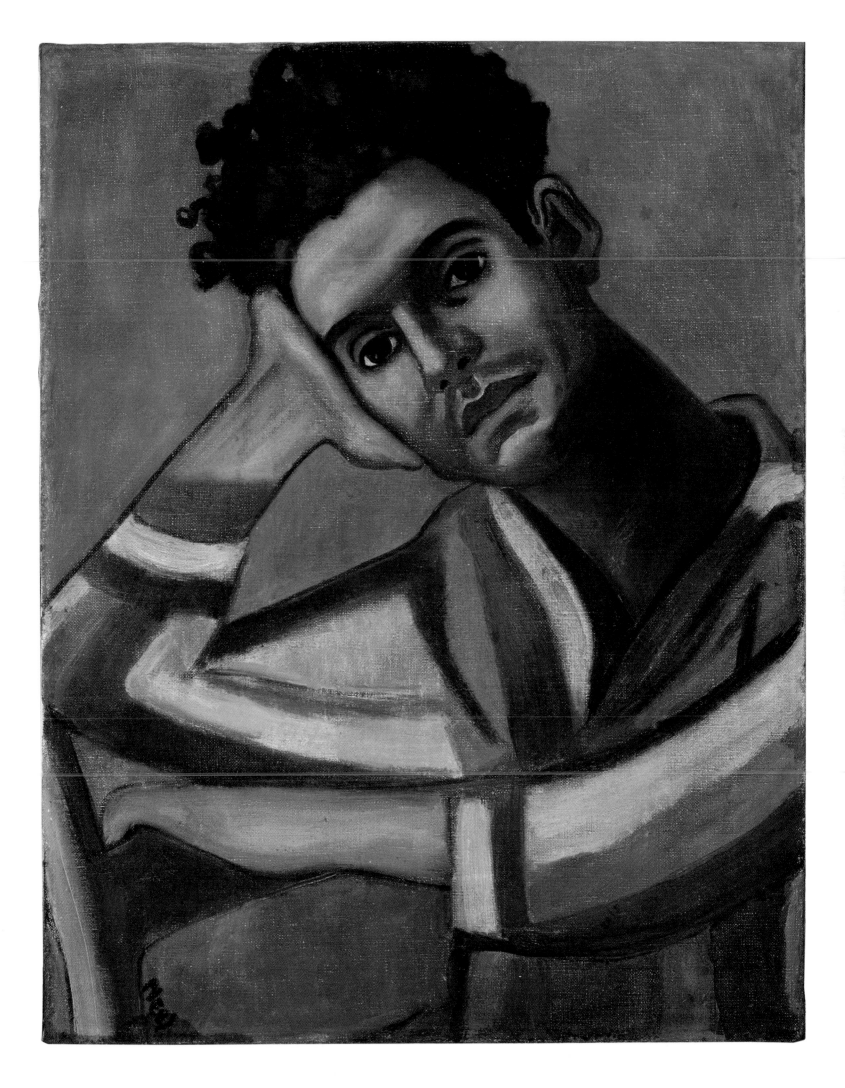

José, 1936

Oil on canvas, 71.1 x 64.
Estate of Alice Neel.

Neel depicts her new-found lover, José Santiago Negrón, in a stylised manner, almost like an Aztec or Mayan god, with chiselled facial features, hollow sockets for eyes and almost rigid, upstanding hair fanning around his head like a crown. His hands are flat as though carved from stone or wood. Where the portrait of José in pyjamas is soft and dreamy, this is tough and powerful. Negrón sang at La Casita in Greenwich Village, and not long after they met he moved into Neel's apartment at 347½ West 17th Street. Within a year she would have a miscarriage and José abandoned her, running back to his wife Molly. Neel was devastated, as she wrote in a poem: "But now I see you in a baser light | A rat who scuttles off the ship that's going down". José returned and in 1939 he and Neel had a son, Neel (later called Richard), but within three months José abandoned her for good, moving in with Ruth Lovett, a young saleswoman at Lord and Taylor's department store, the first to open on Fifth Avenue.

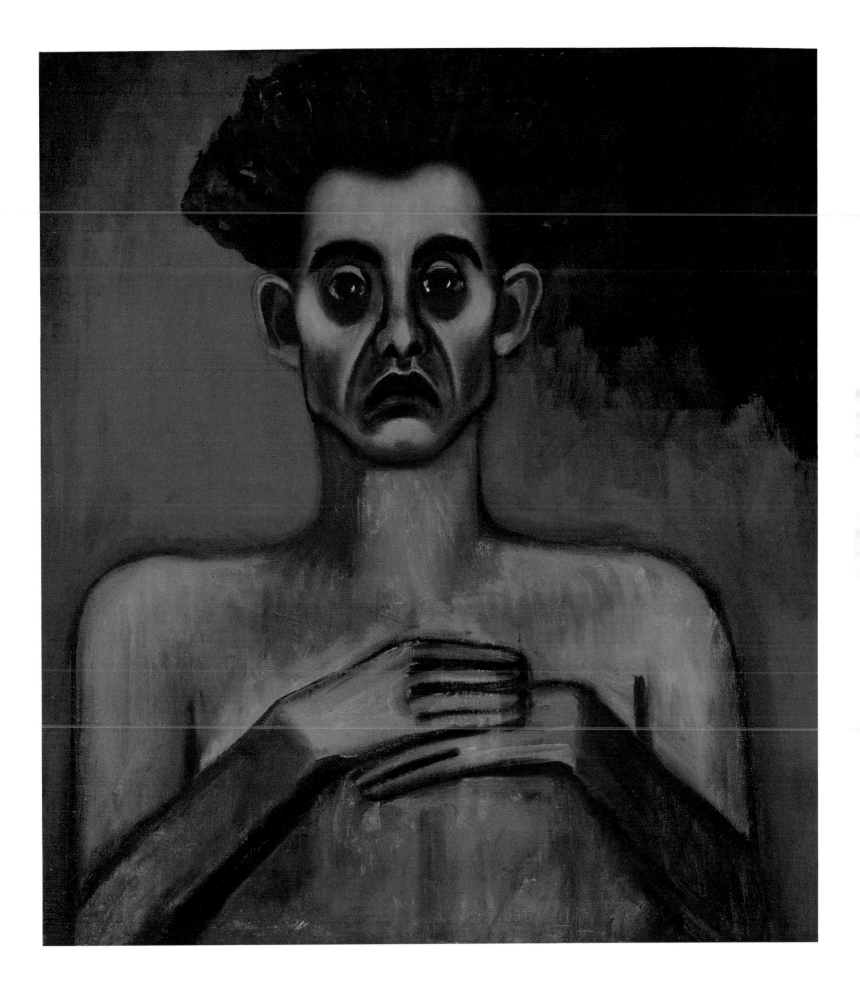

Elenka, 1936

Oil on canvas, 61 x 50.8 cm.
Metropolitan Museum of Art, New York,
Gift of Richard Neel and Hartley S. Neel 1987,
1987.376.

The sitter's name suggests she was of Russian or Eastern European origin but nothing is known about her. Painted in lambent tones, this is one of Neel's warmest paintings. Neel professed to liking "dividing up the canvas". The composition is tightly constructed around a series of vertical and horizontal passages with the diagonal arm of the chair opening up what would otherwise be flattened space, thereby softening the confrontation with the viewer. There is an emphasis on asymmetry: Elenka's eyes are at different levels, her hairline rises up towards her right and her proper right shoulder is cut off at the edge of the canvas. In this painting, more perhaps than any of her previous works, Neel uses primed but unpainted canvas as a tone, in much the same way that Cézanne and even Goya had done. The depiction of the white blouse includes raw canvas, pink, grey and white as well as calligraphic lines in black. As a whole it is a convincing image of a blouse under electric light and its concomitant shadows. Before a window, a blind half drawn down, Elenka sits like a goddess, her hair, with its stray but solid locks, invoking the work of Ancient Greek and Roman sculptors and echoing the shapes of her fingers. This was a sitter whose beauty Neel undoubtedly admired.

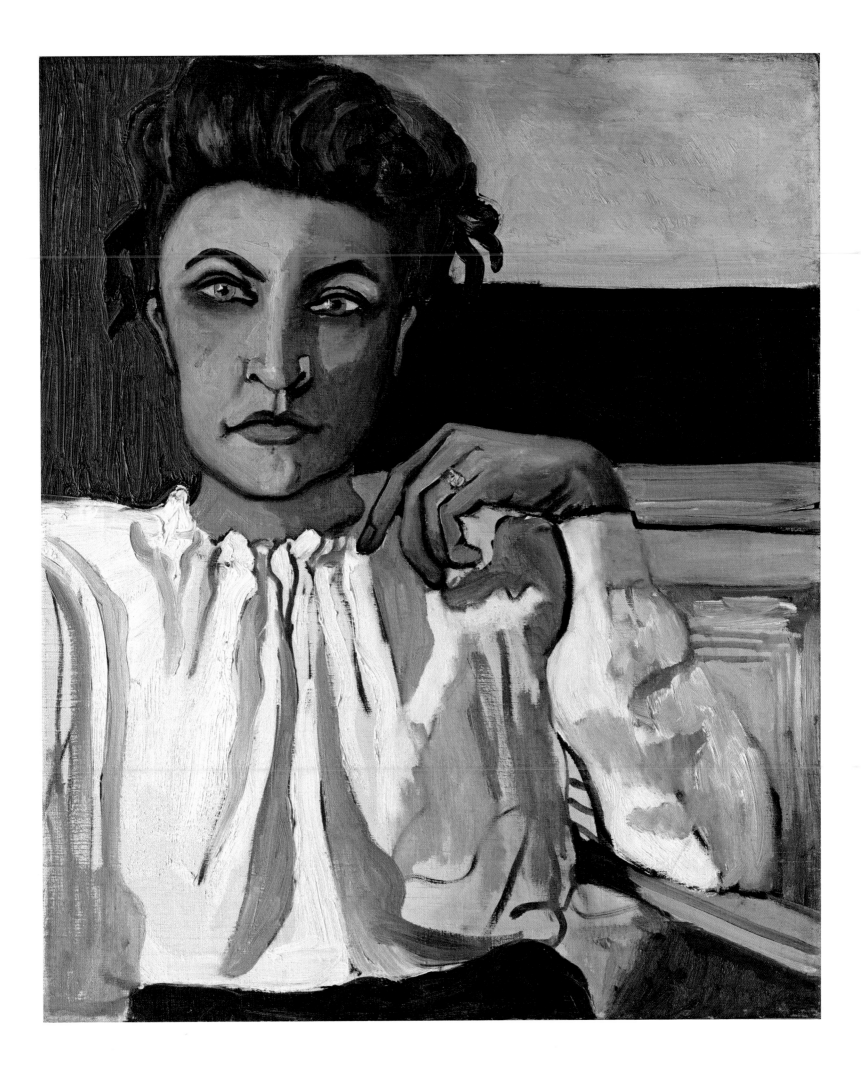

Mr Greene, 1938

Oil on canvas, 76.2 x 60.9 cm.
Moderna Museet, Stockholm, Donation in 2009
from Hartley and Richard Neel via The American
Friends of the Moderna Museet Inc.

Edward Pinkney Greene, according to Hartley Neel, was an intellectual friend of Neel, who, after she moved to Spanish Harlem, would read the Grimm brothers' *Fairy Tales* to her two sons when visiting. He was more than likely an inhabitant of Greenwich Village. The portrait is one of the most Germanic-looking of Neel's paintings, although it is uncertain how familiar she was with the work of Otto Dix and other artists of the *Neue Sachlichkeit*. El Greco might also have been on her mind, perhaps his *Cardinal Fernando Niño de Guevara,* which entered the collection of the Metropolitan Museum in 1929. The cardinal, wearing spectacles, faces the same direction as Greene and sits in an upright chair, his left hand curled around the end of the arm like a claw, his right hand slightly elongated and drooping downwards. If Neel did not see it in the Metropolitan Museum, she definitely viewed it in the *Exhibition of Spanish Painting* at the Brooklyn Museum in 1935. Greene's delicate, tentacular fingers are disturbing, although this is counteracted by his open demeanour, cigarette in hand, legs crossed in a relaxed pose. The simple form of the chair is emphasised far more in this painting than in *Elenka*. This was either one of the last paintings Neel made in Greenwich Village or one of the first she executed in Spanish Harlem, since she moved there from Greenwich Village that year. In 1946 Neel painted a picture consisting of Greene's hands, indicating her general interest in hands and Greene's in particular. Neel's viewpoint in this painting was from above, with

Greene's right hand crossed over his left, which was positioned flat on a spotted fabric draped over his grey trousers just above the knee.

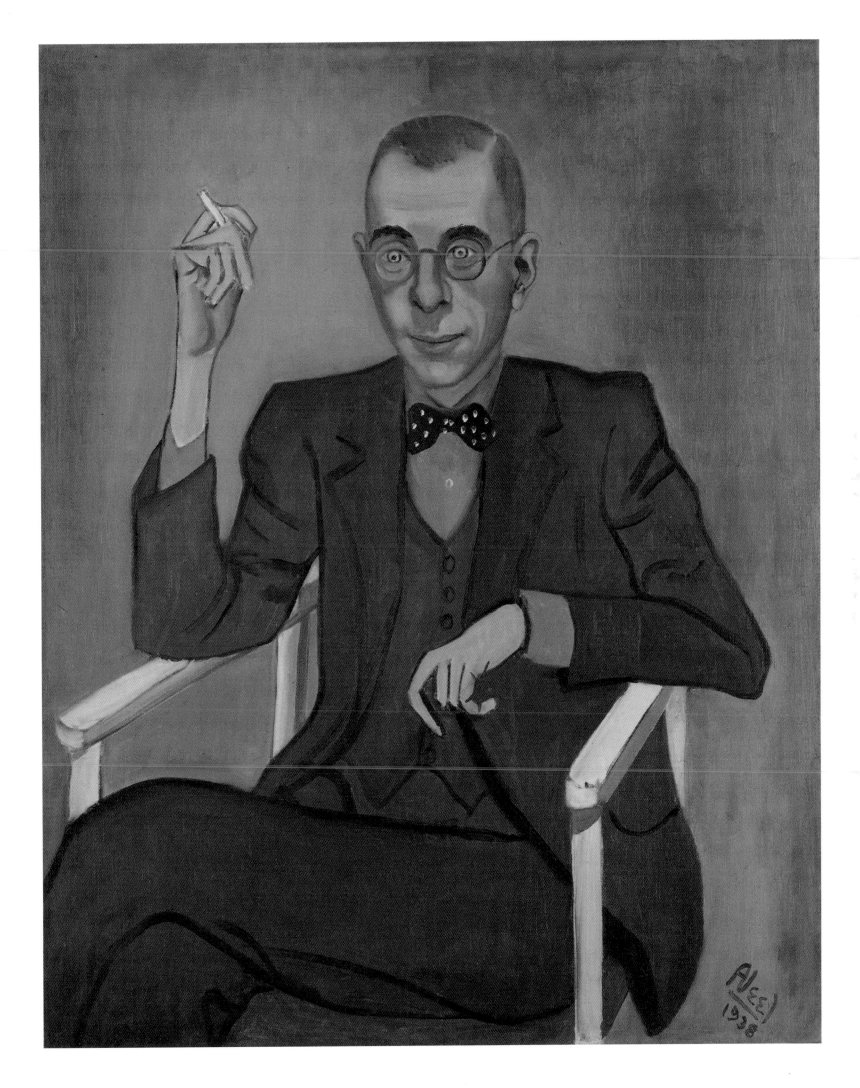

Spanish Harlem

Spanish Harlem is the eastern district of Harlem later known as El Barrio, although it is often not considered to be Harlem proper. After the First World War it became the focus for Latin American immigrants and Puerto Ricans and gradually they displaced the Italians who had arrived there after Italian Unification in 1870. A market under the railway tracks between 111th and 116th Streets, La Marqueta, opened in 1936 and there was a local fish market Neel painted. The wider district of Harlem, home to an extensive African-American population, was also a cultural district, the source of the Harlem Renaissance that had flowered from the end of the First World War to the mid-thirties. If Neel arrived too late to be a part of it, she was certainly able to meet people who themselves were influenced by it as well as those who had participated in it.

Neel left Chelsea when she was heavily pregnant with Richard. While she liked to relate that she moved to Spanish Harlem in 1938, into 8 East 107th Street, to get away from the falsity of bohemian life, the other reason was to be near Negrón's family for support. The move allowed her to meet a different class of person, more immigrant children, people living in poverty, black writers and activists, and social workers; in essence people living real lives, and this had an impact on her work. Here she bore her two children, Richard and Hartley, who were brought up in straitened circumstances.

In 1941 she moved again, this time to 10 East 107th Street and finally, the following year, to a "railroad" apartment on the third floor at 21 East 108th Street near Central Park. The rooms led one into the other, thus privacy was hard to achieve. The sitting room doubled as her studio, and to access it visitors had to walk through Richard and Hartley's as well as Neel's bedrooms. So when Neel was entertaining at night, visitors would disturb the children when they were in bed. She chose it to work in because it had two windows and thus the best light, but even so it was quite dark. It was also the largest room. The smell of oil paint in the bedrooms must have been overpowering. Neel's bedroom also doubled as a paintings store with racks along one side. Further back was an open playroom with a piano and a television, a small bathroom and a bedroom occupied, for a few months before she died, by Neel's mother, which had previously been a closet. The bathroom and Neel's mother's room were the only ones with a door.

Her liking for Spanish Harlem was another manifestation of her love of all things Latin. She only left it, in 1962, because her landlord wanted to repossess the building to develop it.

‹ Alice Neel with *Still Life*, c. 1945

T.B. Harlem, 1940

Oil on canvas, 76.2 x 76.2 cm.
National Museum of Women in the Arts,
Washington D.C., Gift of Wallace and
Wilhelmina Holladay, 1983.24.

In *T.B. Harlem* Neel returned to the allegorical
portrait. Negrón's brother Carlos suffered from
tuberculosis, which was rife in the poorer districts
of New York, no more so than in Harlem. Before
the discovery of penicillin the treatment involved
accessing the lungs by breaking the ribs and
then collapsing them. The BCG vaccine did not
achieve widespread acceptance in the US until
after the Second World War. Neel depicts Carlos
as a Christian martyr, undoubtedly referencing the
work of El Greco and Goya. Taking liberties with
his anatomy in stretching his neck, Neel described
the work as a "crucifixion", no doubt alluding to the
cruciform white bandage, but the painting is more
suggestive of a deposition. The soiled sheets, the
dirty wall and the sombre tones create a sense
of adversity experienced by the poor in a period
of high capitalism. In a poem about Harlem Neel
wrote of "All the wear and worry | Of struggle on
their faces" and of "... the rich deep vein | Of human
feeling buried | Under your fire engines, | Your
poverty and your loves." T.B Harlem evinces these
feelings about the district. Neel stayed in touch
with Negrón's family long after he abandoned her.

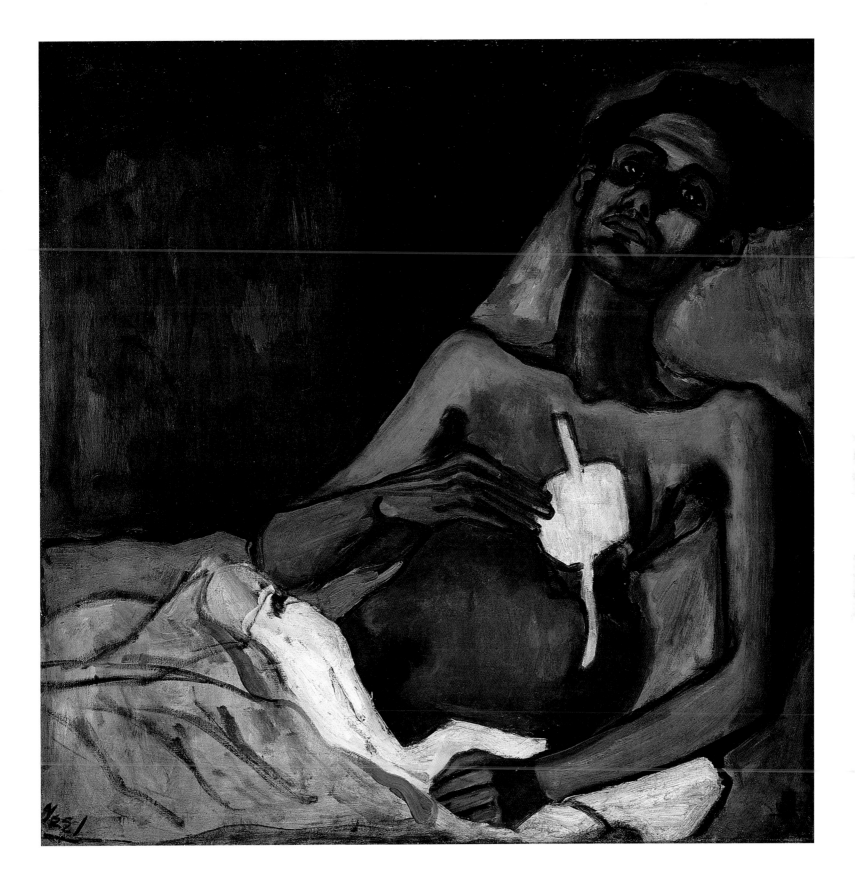

Audrey McMahon, 1940

Oil on canvas, 60.3 x 45.4 cm.
Estate of Alice Neel.

Audrey McMahon (1890-1981) was installed as Director of the New York division of the Works Progress Administration's Federal Art Project in 1935. An unpopular figure, her appointment provoked a mass protest by members of the Artists Union, of which Neel was a member. The Federal Art Project was a means of relieving hardship for artists during the Depression. Neel joined the WPA in 1935 and her pay was continually adjusted downwards by McMahon, until eventually she was discharged in August 1939. She was reassigned to it in October that year, was terminated again in February 1941, reassigned in March and finally terminated in 1943 when Congress brought the scheme to an end. Her depiction of McMahon, painted from memory, evidences Neel's poor opinion of this harridan, with claw-like hand, toothless mouth and shifty eyes. Neel's painting recalls Picasso's *Weeping Woman*, shown at the end of 1939 at the Museum of Modern Art in *Picasso Forty Years of his Art*, which is no more nor less a portrait of Dora Maar than Neel's painting is a portrait of McMahon. First and foremost they are paintings suggestive of a time and a complex of emotions.

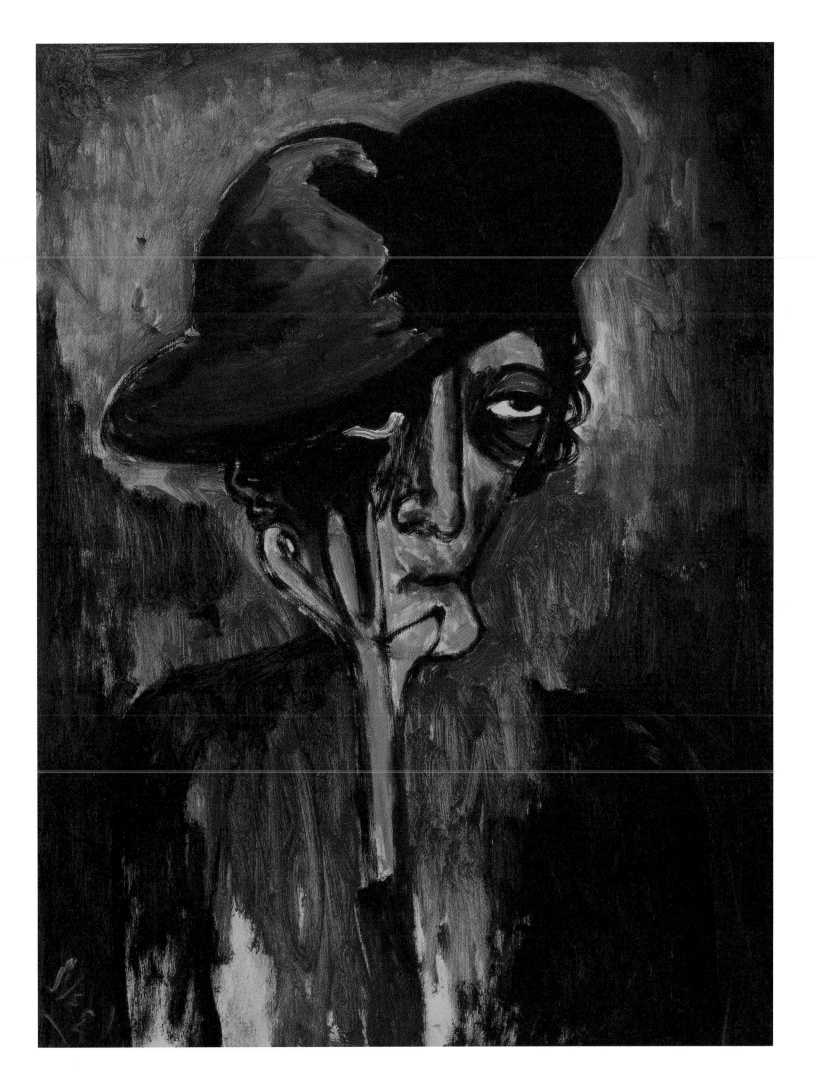

The Spanish Family, 1943

Oil on canvas, 86.4 x 71.1 cm.
Estate of Alice Neel.

In *The Spanish Family* Neel depicted Margarita, the wife of Negrón's brother Carlos, with her three children. Carlos, whom she painted in *T. B. Harlem*, is absent. Carlos and Margarita lived in the neighbourhood and Neel kept in touch with them after her separation from Negrón. Seated in front of iron railings, the family are seen as though captured by a casual camera shot. The shoulder and arm of the daughter, also called Margarita, touch one edge of the canvas, while the son, named Carlos after his father, is sliced off by the other edge. Margarita junior is distracted by something off to the side, while Carlos looks directly at the painter. Staring ahead the mother does not appear to be present while her baby, Tommy, whom she clasps firmly, struggles on her lap. The painting memorialises the sadness and difficulty of life in Harlem with the mother extending a hand as though begging for money. Three paintings probably well known to Neel in reproduction, if not in the flesh, that featured prominent railings were Manet's *The Balcony* (1868) and *The Railroad* (1872-73), and Goya's *Majas on the Balcony* (c.1800-10), a variant of which entered the Metropolitan Museum in 1929. Railings represent a boundary, an instrument of exclusion or a separator between social classes. The curlicues of the railings in Neel's painting rhyme with the stray lock of hair on the mother's proper right. Goya's and Manet's railings were less ornate. Tommy's diaper or nappy has a crease down the middle that appears to suggest the child was a girl. Assuming Neel knew Tommy was a boy perhaps she used the opportunity to create something of a fiction. In this way *The Spanish Family* becomes more than simply a painting of Margarita and her children, but a more general statement, as its unspecific title implies, on the poverty and destitution of immigrants in New York.

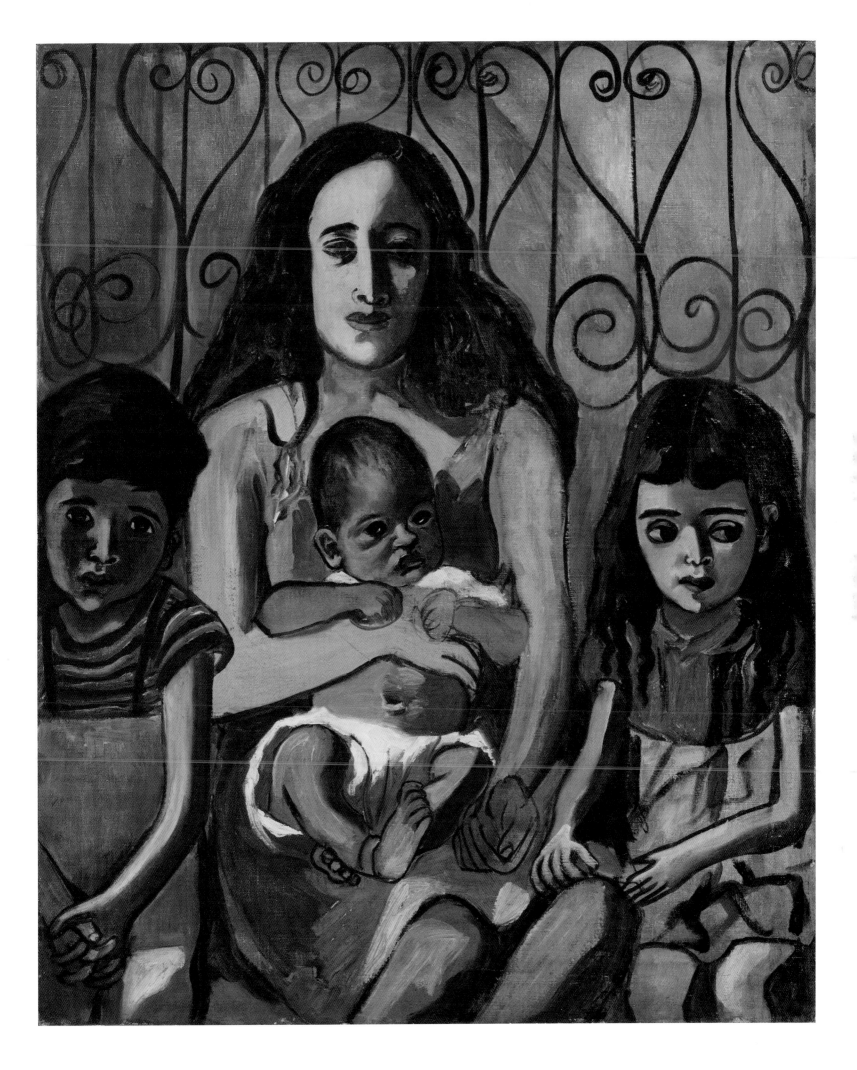

Hartley on the Rocking Horse, 1943

Oil on canvas, 76.4 x 86.4 cm.
Estate of Alice Neel.

Depicting Neel's youngest son Hartley (born 1941)
the painting is an indication of how Neel coped
simultaneously with child care and pursuing her
career. By painting him she could ensure that she
was simultaneously working and caring for him.
The rocking horse was salvaged from the street
and normally kept in the playroom but Neel
must have brought it into her front room where
the light was better. Unusually the sitter is set in
an apparently deep space with a self-portrait
reflected in the mirror at the back, making light
reference to Diego Velázquez's *Las Meninas*
(1656), where the artist depicts himself facing out
of the picture with the King and Queen of Spain,
whom he is notionally portraying, reflected in
the mirror in the background. Neel is standing
between the two windows on the front façade
with Hartley interposed between her and her
bedroom, which had a small window at the back
on the right. Dividing the sitting room from her
bedroom is a curtain. The contrast between the
deep space on the left and the reduced space on
the right, interrupted by a curtain, recalls Titian's
Venus of Urbino (1538). It seems likely that Neel
sought inspiration from the masters for a number
of her paintings.

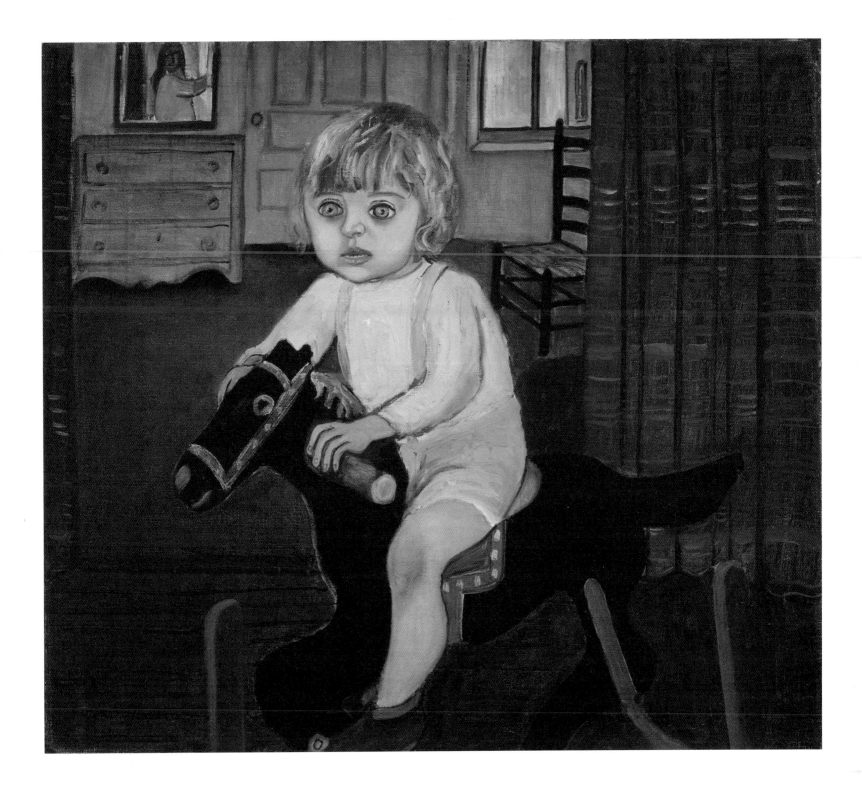

Cat. 24

Sam, Snow (How Like the Winter), 1945

Oil on canvas, 76 x 61 cm.
Private Collection.

Sam Brody (1907-1987), Hartley's father and Neel's partner, was born in London as Samuel Brodetsky to his Russian Jewish immigrant parents in the district of Whitechapel. In 1912 the family emigrated to Paris but in 1920, fearful of the strong anti-Semitism in France, they moved on to New York. In 1927 Brody resolved to become a film-maker and that year married Claire Gebiner with whom he would have two children, Julian and Mady. Briefly studying at the Sorbonne in Paris, Brody returned to New York in 1929 to live in the Bronx. He worked as a film critic for the Communist *Daily Worker* and helped to found the Workers' Film and Photo League in 1931, for which he wrote theoretical texts. He then worked as a photographer, in particular for the WPA. It was at a meeting of the WPA in January 1940 that he met Neel. In this painting he sits reading a newspaper inscribed with the letters "VIC", probably a reference to Victory in Europe, which was proclaimed on 8 May 1945. A profile is rare in Neel's oeuvre but it accentuates Brody's noble features, as it would Frank O'Hara's irregular face when he sat for her the first time in 1960 (cat. 35). The snow mentioned in the title alludes to the dusting of white on Brody's black hair, collar and the arm of the chair. He had been absent for some time in Los Angeles taking Hartley with him on account of his asthma, leaving Neel with memories of her separation from Isabetta. The subtitle of the painting, "How Like the Winter", is an adaptation of the first line of Shakespeare's Sonnet 97. Neel clearly selected it to represent her feelings:

How like a winter hath my absence been
From thee, the pleasure of the fleeting year!
What freezings have I felt, what dark days seen,
What old December's bareness everywhere!

In the background are various objects including a female profile, possibly Neel's, and a bird's head, which may refer to the line of the sonnet: "And thou, away, the very birds are mute". This background is possibly a projection of Neel's troubled state of mind, which contrasts with Brody's detached calm.

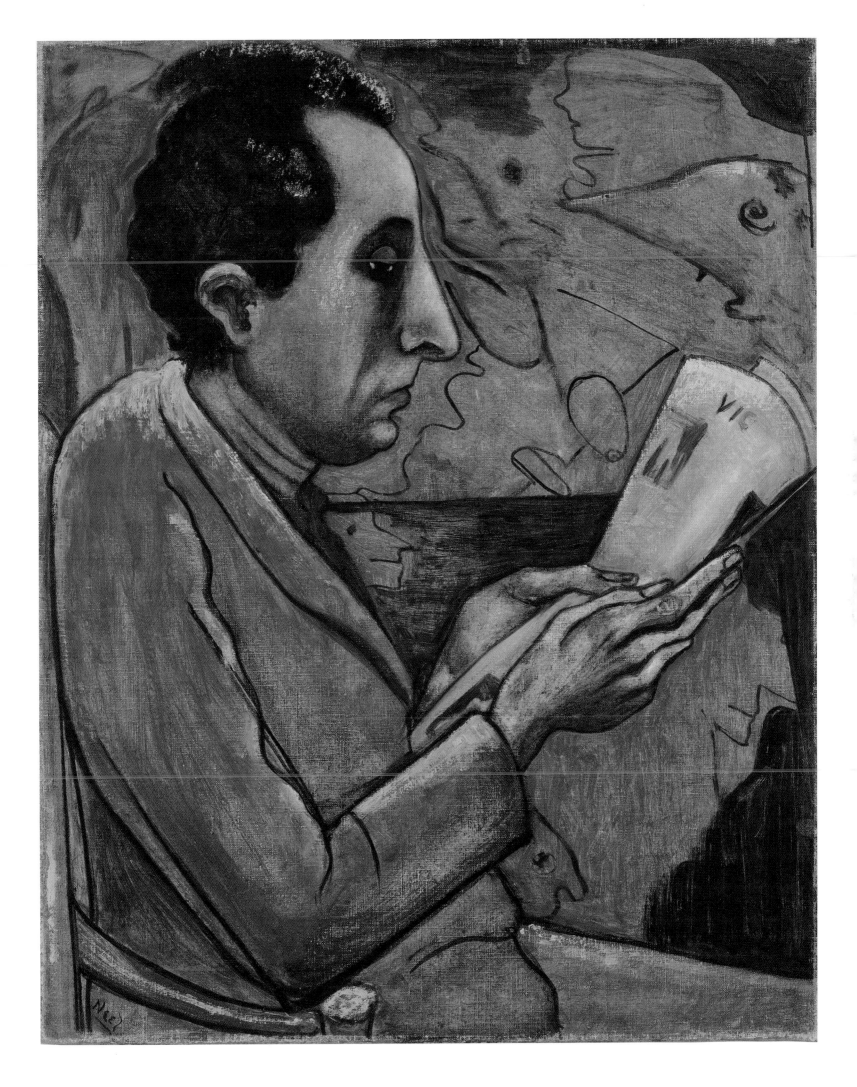

Richard at Age Five, 1945

Oil on canvas, 66.2 cm x 35.9 cm.
Estate of Alice Neel.

Neel's oldest son Richard (named Neel Neel at
birth in 1939 and fathered by Negrón) sits in a
wooden chair directly facing the artist. Richard
was registered as blind and Neel depicts
his eyes as black sockets with the faintest
reflections indicating some residual life in his
vision. An arm hooked around the chair appears
to prevent him from sliding to the floor. The
painting is constructed on a strong diagonal from
Richard's proper left hand up to his elbow, cut
off by the edge of the painting. The intensity
of his stare and his audacious expression bear
comparison with the earlier *Isabetta* (cat. 10).
Neel's paintings of her own children had nothing
of the sentimentality of the works of Mary
Cassatt or Berthe Morisot but are consistently
confrontational, suggesting the boredom of sitting,
the deep concentration required to maintain a
pose, and the close, trusting relationship between
mother and child.

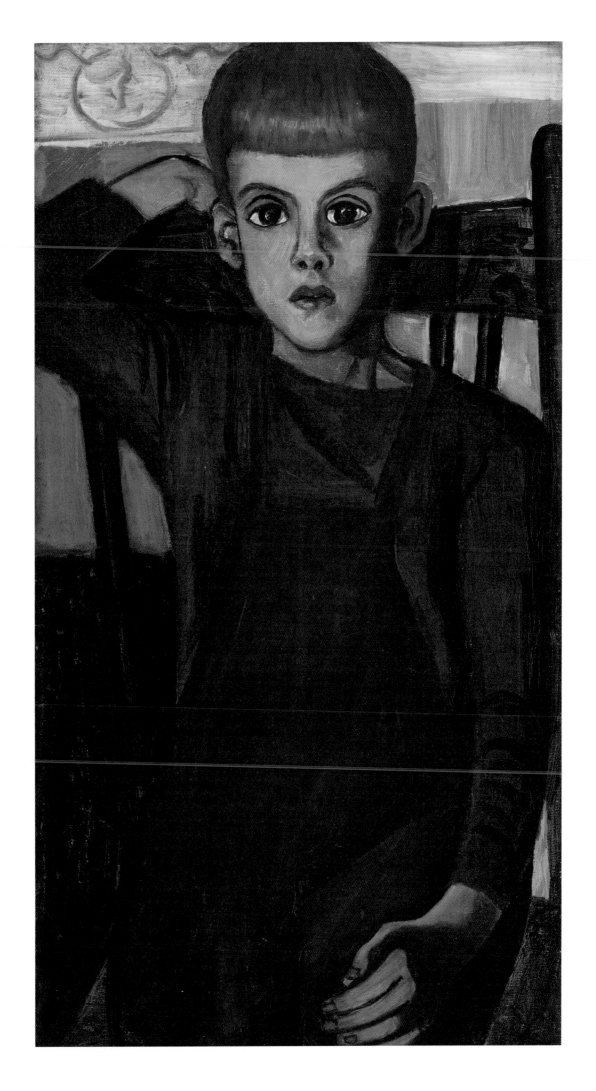

Dead Father, 1946

Oil on canvas, 50.2 x 71.4 cm.
Estate of Alice Neel.

George Washington Neel (1864-1946) was a clerk for the Superintendant Car Service of the Pennsylvania Railroad. He was a quiet man, rather dominated by his wife, Alice. Other than in a watercolour of the family (fig.30), Neel never painted her father during his lifetime, unlike her mother, but on seeing him in his coffin decided to rectify this oversight. It was perhaps his lack of personality that discouraged her from painting him earlier. *Dead Father* appears to make reference to Hispanic portraits of the dead as well as such memorial works by Communist luminaries as Käthe Kollwitz. It is a tender depiction of a man at peace. Neel executed it from memory the day after the funeral. She told Patricia Hills: "He was a good and kind man and his head still looked noble. I didn't set out to memorize him, because I was too affected. But the image printed itself".[1] Death was ever-present in Neel's mind following the demise of her first child, as it had been in the mind of her mother following the death of her child, Hartley, from diphtheria before Alice was born.

Note

1 Patricia Hills, *Alice Neel*, (New York, 1983), 81.

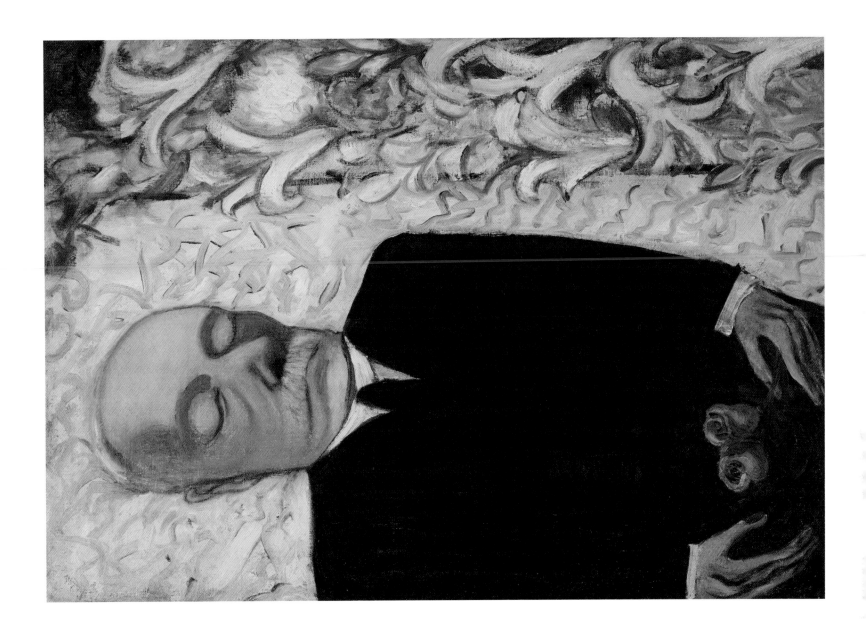

Fire Escape, 1948

Oil on canvas, 86.7 cm x 63.7 cm.
Estate of Alice Neel.

One of a small number of Neel's paintings depicting outside views from her various dwellings, *Fire Escape* shows washing hanging between buildings, and possibly one garment that has come loose from its moorings. The upward thrust of the painting towards the small triangle of blue sky evinces Neel's sense of confinement, while at the same time suggesting an interest in the architectural photographs of New York that frequently depicted buildings at a sharp angle. Neel gives emphasis to the shadows at the bottom of the painting but the way in which the shadow deviates around the window towards the lower left is curious, suggesting an unusual roofline opposite. Neel painted this from her kitchen, which was the final room in her "railroad" apartment, thus a dead end.

Art Shields, 1951

Oil on canvas, 81.3 x 55.9 cm.
Private Collection.

Art (Thomas Arthur) Shields was born 1888 in Barbados, the son of a Moravian preacher. He became a supporter of Soviet Russia at the time of the revolution and never wavered in that support in spite of the atrocities of Joseph Stalin. He signed up for the US Army in 1918, not to fight in Europe but to organise resistance to the war. As a machinist in the shipyards in Seattle he was a political activist. Moving to New York in 1920 he wrote in defence of Nicola Sacco and Bartolomeo Vanzetti, who were executed on trumped-up charges to discourage left wing affiliation. He then became a labour reporter and in 1924 joined the staff of the Communist *Daily Worker*. In 1939 he arrived in Spain to cover the last stand of the Republicans, ending up in a Nationalist prison. After repatriation he continued to work for the *Daily Worker* and then *Masses & Mainstream* (published between 1948 and 1963), for which Neel's friend, Phillip Bonosky, also wrote. Since Neel, at times, provided illustrations for this magazine, she more than likely met Shields there or through Bonosky (whom she also painted). Late in life Shields wrote a two-volume autobiography: *My Shaping-Up Years* and *On the Battle Lines 1919-1939*. Neel depicts Shields in three-quarters profile gazing ahead with zeal redolent of the pioneers depicted by Soviet photographers. The simply constructed portrait recalls such paintings by Van Gogh as *L'Arlésienne* (1888), bequeathed to the Metropolitan Museum by Sam A. Lewisohn in 1951, the year Neel painted this portrait. There had been retrospective exhibitions of Van Gogh at the Museum of Modern Art in 1935-36 and at the Metropolitan Museum in 1949-50. Communist Party members revered Van Gogh as an exemplary, humanist artist. Shields's date of death is not known but he is said to have died in his nineties.[1]

Note

1 Further information on Shields can be found in the online article "Art Shields: Labor's Great Reporter" by Tim Wheeler in *People's World* (18 May 2007) on which this entry in part relies. Accessed 27 February 2016, http://www.peoplesworld.org/art-shields-labor-s-great-reporter/

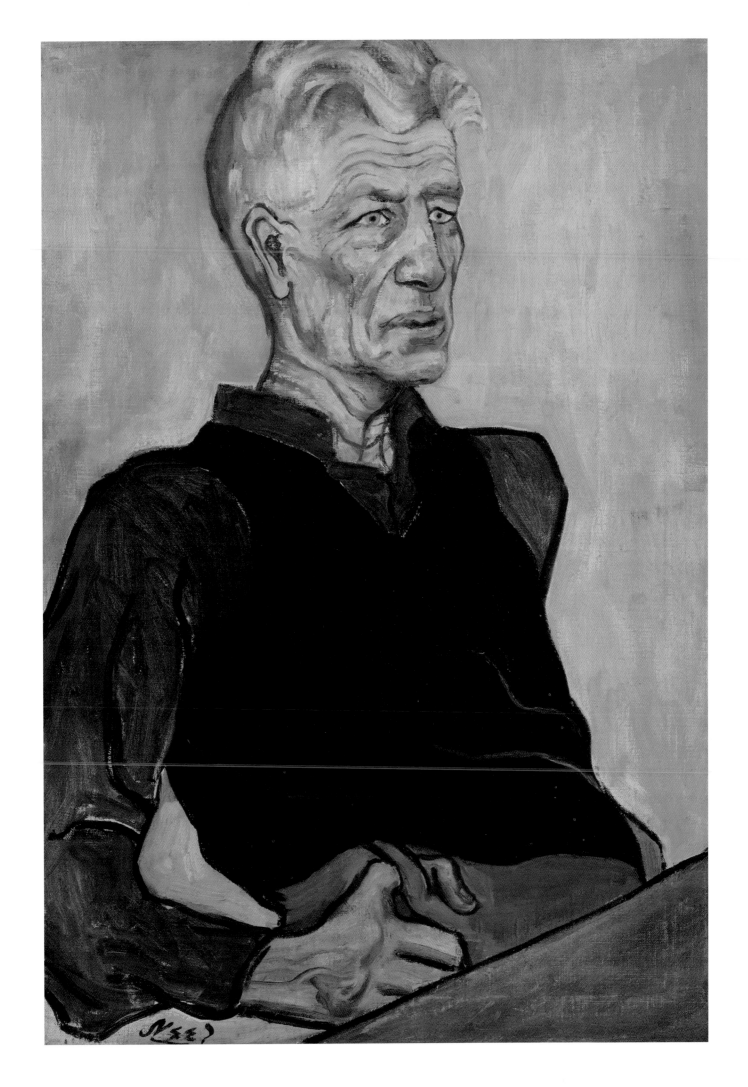

Last Sickness, 1953

Oil on canvas, 76.2 x 55.9 cm.
Philadelphia Museum of Art, 125th Anniversary
Acquisition, Gift of Hartley S. Neel and Richard
Neel, 2003.

Although she never painted her father during his
lifetime, Neel painted her mother at least four
times, of which this is the final example. Alice
Concross Hartley was a powerful figure in the Neel
family and Neel's psychiatrist suggested at one
point that her interest in portraiture came from
always having to study her mother's responses
closely to gauge her feelings. In March 1953, with
deteriorating health, Alice senior came to live
with Neel in Spanish Harlem with the effect that
Neel was now caring for two children and a dying
mother. As with her children, an efficient way
of keeping an eye on her as well as continuing
to paint was to have her sit. If the painting bears
some resemblance to Mary Cassatt's portrait of
her mother it is unlikely that this would have been
on Neel's mind, since she disliked Cassatt's work.
Perhaps more pertinent were photographs of
elderly women by August Sander. Neel confronts
her mother's frailty head on, inscribing her infirmity
and age into the surface of the painting itself. The
thinly brushed dressing gown appears threadbare,
her grey hair is wispy and fine with unprimed
canvas indicating both colour and absence of
hair, while the braiding along the edge of the
gown and the belt that circumscribes her body
appear to anchor Neel's mother safely to the chair.
The sharp coloured lemons in the background
may simply add an accent of light or make a
covert reference to the acerbic nature of the
matriarch's temperament.

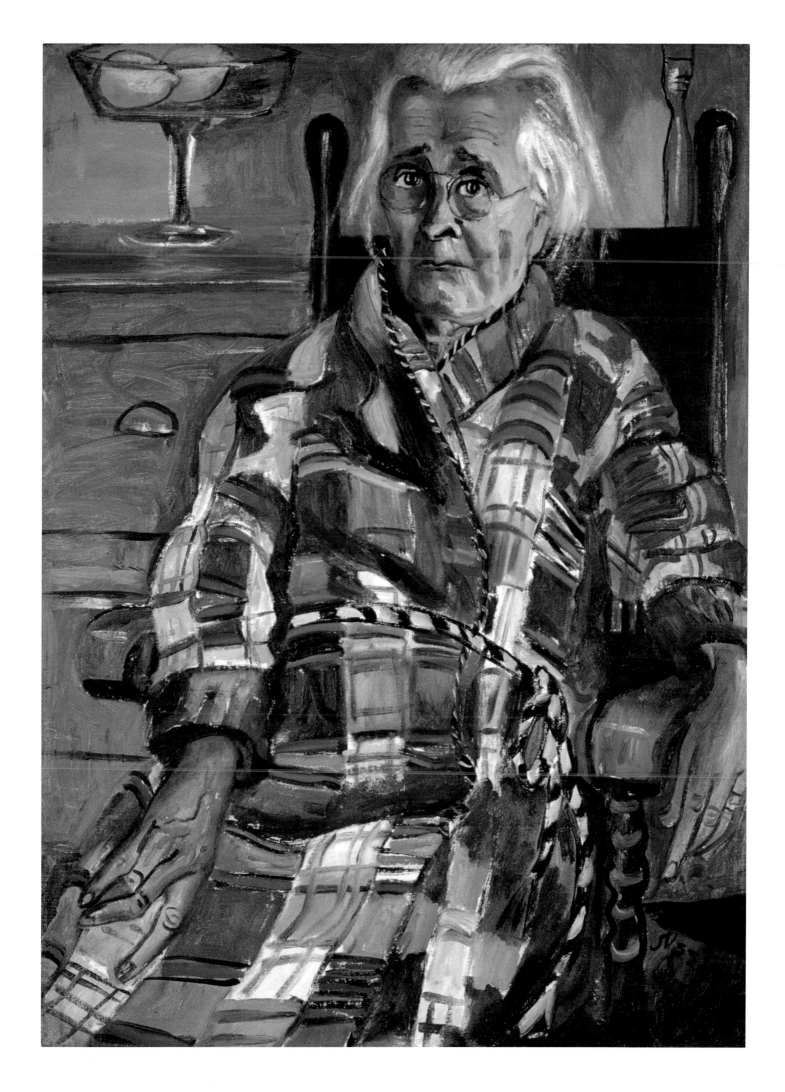

Rita and Hubert, 1954

Oil on canvas, 86.4 x 101.6 cm.
Defares Collection.

Neel painted the Communist writer Hubert
Satterfield on two occasions, once on his own and
the other with his girlfriend Rita. Little is known
about Satterfield, other than he was a writer and
his brother was a boxer. In 1954 American society
was still strongly racist, with the southern states
particularly badly affected. Segregation and
discrimination, though not sanctioned by law, were
carried out in practice. Rosa Parks's refusal to give
up a seat at the front of a bus in 1955 leading to
a bus boycott, and black students' attempts to
desegregate a school at Little Rock in 1957 were
to be symptomatic of the burgeoning struggle for
civil rights. Thus to portray an African-American
man with his Caucasian or Hispanic girlfriend
in 1954 was a statement of solidarity with a
cause. The Communist Party had for a long time
defended and campaigned for the civil rights
of African-Americans and as an affiliate it was
natural for Neel to make such a stand. There is a
marked contrast in the visibility of Rita and Hubert,
conveying the impression Neel was aware of the
suggestion that African-Americans were invisible,
enshrined in Ralph Ellison's novel *Invisible Man*
(published 1952) that described the rising tide of
Black Nationalism and examined the relationship
between black identity and Marxism. Neel could
hardly have avoided knowing about this novel,
which won the US National Book Award for Fiction
in 1953. But for the whites of his eyes and the
flashing highlights on his skin, Hubert fades into the
background, his intricately patterned shirt being
the focus of attention. Hubert lurks in the shadow
while Rita stands out. As a statement of political
conviction as well as political reality, this was a
powerful message.

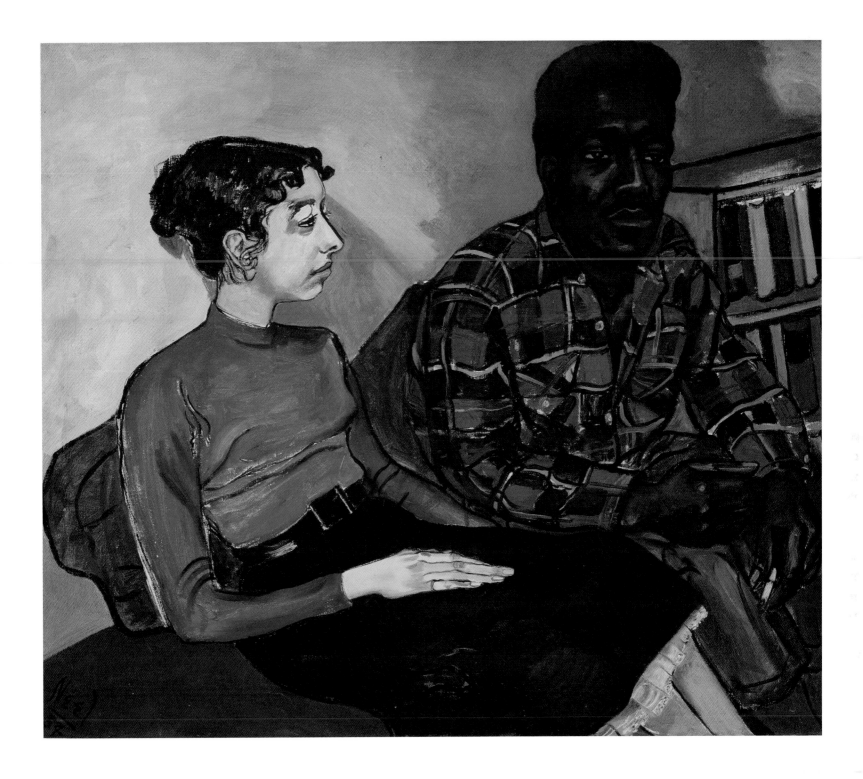

Sam, 1958

Oil on canvas, 81.3 x 56.2 cm.
Estate of Alice Neel.

By 1958 Neel's two sons had left home for boarding school and college, leaving her with more time to paint. It was also the moment when her intimate relationship with Sam Brody ended although they remained friends for life. In 1958 Brody married Sondra Herrera and they had a son, David, born in June that year. David, like Brody's other two children – Julian and Mady – sat for Neel. In some sense painting Brody's children was a way of infiltrating his life more fully. Here Brody is portrayed with a rather pained expression, his arms folded as though to defend him from Neel's insistent gaze, putting a barrier between himself and his former lover. Tired and sad, it is the final portrait of many that Neel painted of Brody. But it indicates the new direction that her painting had taken, incorporating strategies of mark-making adopted by her Abstract Expressionist contemporaries in the painterly background as well as in her emphasis on the facticity of paint.

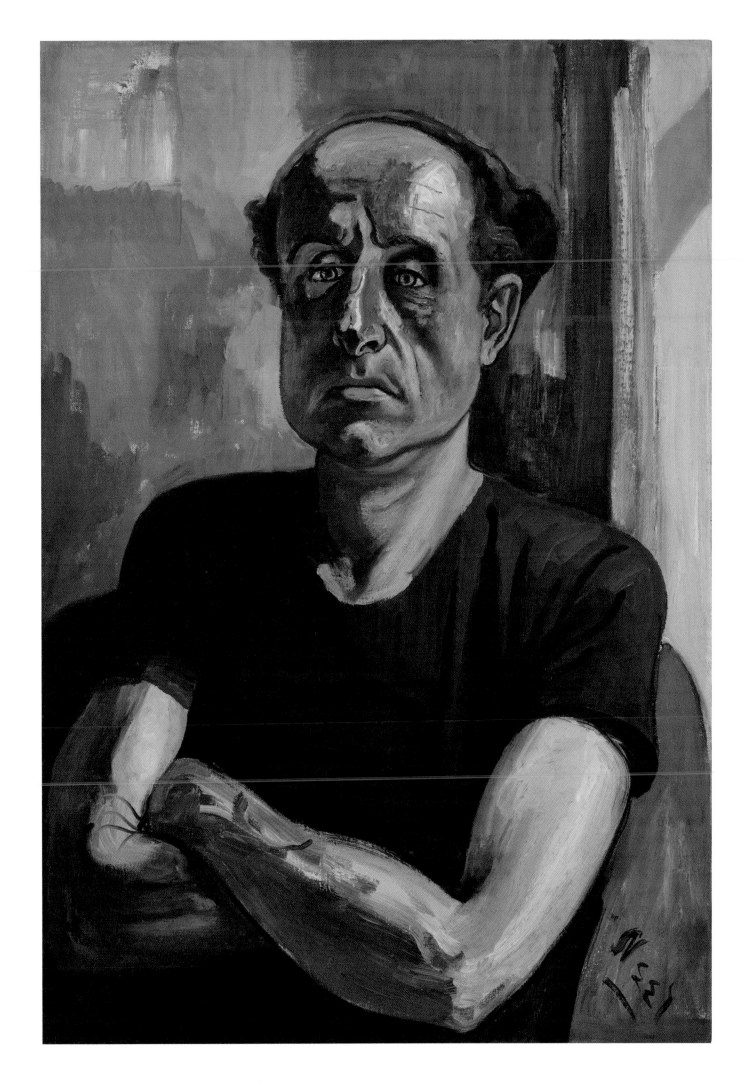

Night, 1959

Oil on canvas, 81.6 x 46.4 cm.
Estate of Alice Neel.

Looking out the window at night, seeing a light
burn brightly in a neighbouring apartment
indicates a sense of longing and loneliness.
Painted from the room where her mother lived out
her last year, the painting evinces loss, with life
closing in as the dark shadows encroach. There
is a suggestion of a person in the lower window
frame, someone with whom contact is tantalisingly
close but impossible. While the painterly address
of this work posits an admiration for Clyfford Still,
Neel uses abstraction in the service of narrative
without losing any sense of her radical use of paint.
The subject of the painting is the demons of the
night and it is the late work of Goya to which its
darkness probably refers. One work by Goya, from
slightly before what is regarded as his late period,
suggests it might have had a bearing on Neel's
painting. *The Plague Hospital* was completed
in 1800 when he was 54. In the background of
this sombre, deathly scene, two windows burn
with bright intensity. Like the windows in Neel's
painting, they propose the energy of the outside
world as a contrast to the sickness (physical or
in Neel's case, psychological) within. Goya was
among the artists Neel most admired.

Georgie Arce, 1959

Oil on canvas, 91.4 x 63.5 cm.
Estate of Alice Neel.

Neel made a number of paintings of Arce as a youth. A Puerto Rican, he became a con artist and in 1974 was convicted on two counts of murder and one of conspiracy to commit murder. He was sentenced to a term of 25 years at the Auburn Correctional Facility, Auburn NY. Arce lost an appeal on his conviction and his subsequent petitions for a writ of *habeas corpus* were also dismissed, the last one in 1989. Neel got to know Arce well during his childhood and Arce evidently enjoyed posing for her. There are paintings of him acting tough with a knife in hand, and others of him lurching around the streets. Arce clearly enjoyed the masquerade as much as Neel. In this painting Arce looks pensive. It is probably Neel's last painting of him and he appears as an adolescent with multiple rings on his fingers, aware perhaps of his seductive charms. The painterly background may be a metaphor for mental instability, of the world crowding in on him, while Arce's twisted pose suggests that behind the impassive façade may be a certain amount of discomfort. Neel had a penchant for the Hispanic population that always reminded her of her first love, Carlos.

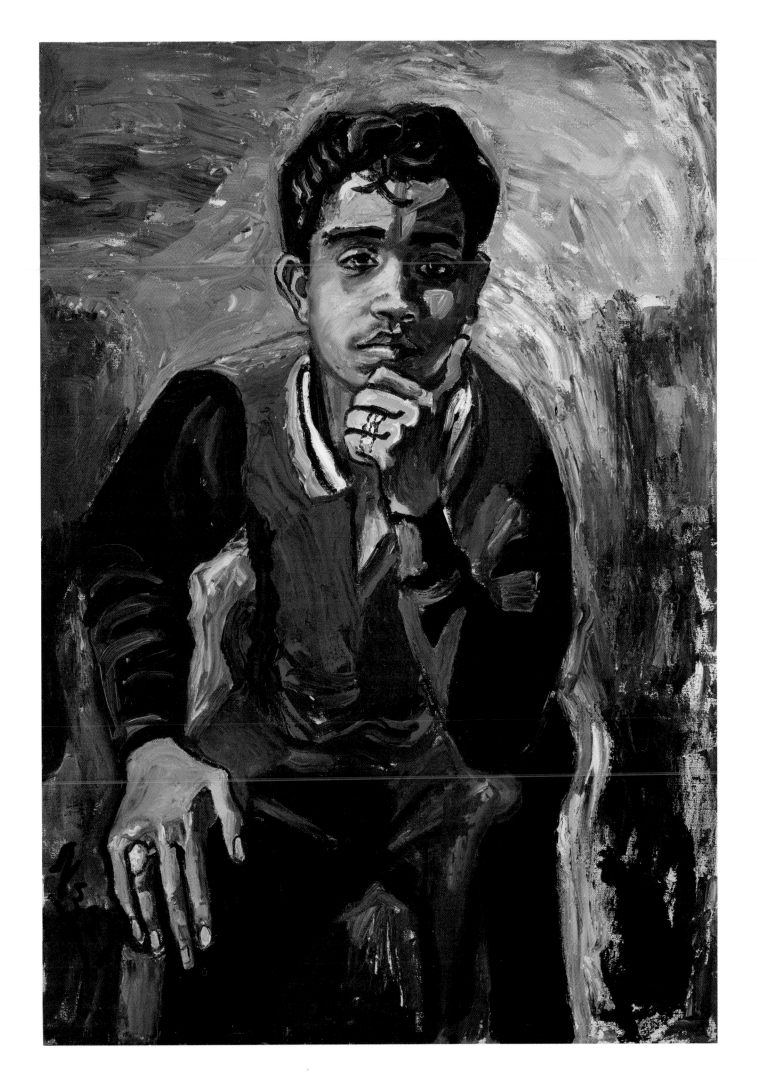

Alvin Simon, 1959

Oil on canvas, 97.2 x 46 cm.
Private Collection.

The year after Neel painted him, Alvin Simon became a member of the Organization for Young Men (founded 1960) and On Guard for Freedom (with which it merged), an African-American nationalist literary organisation founded the same year. Two years later he would join Umbra, a collective of young black writers established in 1962, which also had a number of white members. He became a co-founder and "editorial assistant" of *American Dialog*, which, according to James Smethurst "was never really a 'black magazine' ... but was far more consistently engaged with the new black cultural radicals, especially writers, visual artists, and free jazz musicians" than had been *Masses & Mainstream*.[1] Simon was a writer and photographer who also contributed to the Communist newspaper, the *Daily Worker*, and *New Horizons for Youth*. A man of leftist sympathies, as many African-Americans were in this period owing to the support given to their cause by the Communist Party, Simon was part of the Lower East Side artistic and literary community. It is not known how Neel met him. She shows him leaning on a *guéridon* table as though seated in a café waiting to be served, although he is actually depicted in her Spanish Harlem apartment. The *guéridon* was a prop often used in Cubist painting, particularly by Georges Braque.

Note

1 James Smethurst, *The Black Arts Movement. Literary Nationalism in the 1960s and 1970s*, (Chapel Hill and London, 2005), 140.

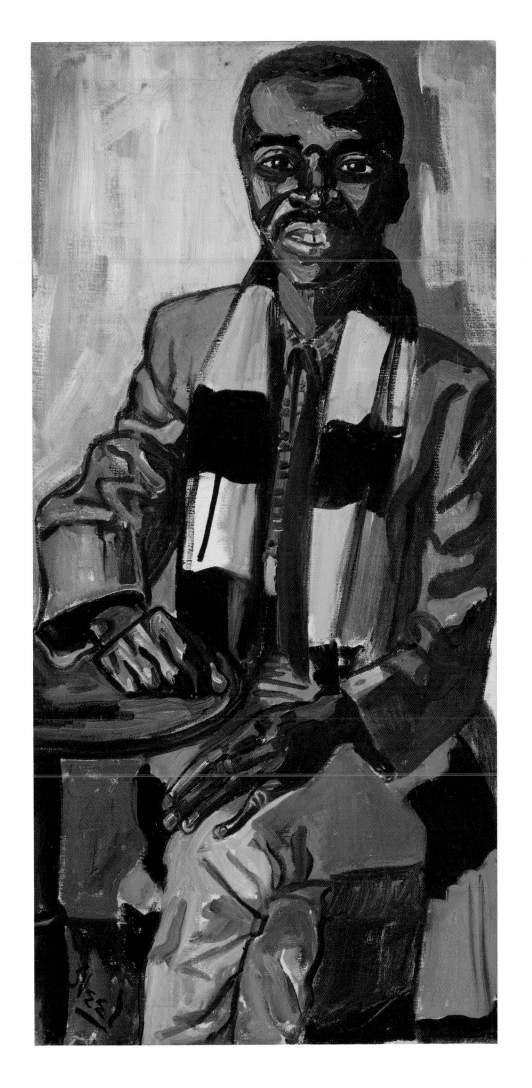

Frank O'Hara, No. 2, 1960

Oil on canvas, 96.5 x 61.1 cm.
Estate of Alice Neel.

Neel painted two portraits of the poet and curator
Frank O'Hara (1926-1966), one in profile, with the
nobility of a Roman emperor, and this one in which
he looks anxious, his teeth, as Neel put it, looking
like "tombstones", the lilacs that had been so vivid
in the first portrait, now withered. The first painting
had taken four sittings, this second only one.
O'Hara was an influential and powerful curator at
the Museum of Modern Art where he championed,
among others, Jackson Pollock whose major
showing at Documenta in Kassel he organised
in 1959 and whose European retrospective he
selected the previous year. Neel relates how she
painted O'Hara shortly after the exhibition of
Spanish art he mounted at MoMA (*New Spanish
Painting and Sculpture*) so the sitting must have
taken place in the latter part of the year. Neel met
O'Hara at the Club and her psychiatrist suggested
she paint him, almost as a way of coming out into
the art world. O'Hara was keen on figurative work
as well as Abstract Expressionism, especially the
paintings of Larry Rivers, but he never took up
Neel's cause, omitting her from *Recent Painting
USA: The Figure* held in 1962, selected by
William Lieberman, Dorothy Miller and O'Hara.
O'Hara's poems were somewhat casual, written
fast and with informality and were replete with
observations of life going on around him. In some
respects his poems were a literary equivalent to
Neel's paintings, for O'Hara was a poet of modern
life. He described what he thought and saw.

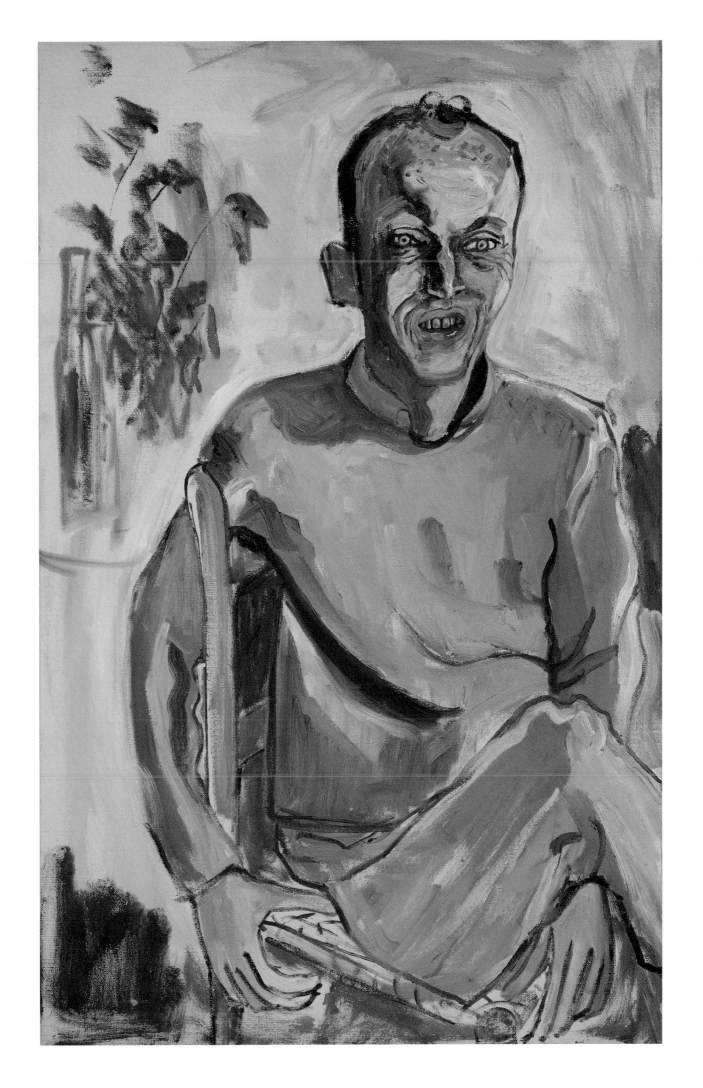

Randall in Extremis, 1960

Oil on canvas, 91.4 x 71.1 cm.
Estate of Alice Neel.

Little is known about Randall Bailey other than that he was born in Texas, was a guard at the Metropolitan Museum of Art and was also a painter. Perhaps Neel met him on one of her many visits to the museum. Neel painted two portraits of him, one in a relatively calm but intense state, wearing a beret and with a clenched fist, and this one, the second, where he appears het up, wracked by the intensity manifested in the first portrait, as though his world was falling apart. "This era, if you read statistics," Neel is reported as saying, "you know what the mental condition is. So why not show it? He was frightfully repressed! Look at those tearing teeth! He was in such an extreme state! But it is something that could be lost. That's why I wanted to paint him. And I know how he feels. I myself am inhibited. That's why he interested me so much."[1] Neel would often identify with, or enter into her sitters and her portraits would result from a process of transference. Neel stated in a lecture in 1981: "I believe in getting under the skin if possible. I believe in having the outside and as much of the inside as you could include but mine, they're always recognisable ... it's just that they may be a little extreme."[2] *Randall in Extremis* is closely related to *Frank O'Hara, No. 2* in Neel's desire to penetrate beyond the public persona presented by the sitter. In this painting, as in the O'Hara portrait, Neel uses bare canvas as a highlight, as well as a relatively thick application of paint with swirling brush strokes to indicate his anguish. Even the white, serpentine brush marks on the left side of Bailey's jacket, floating free, contribute to the strong feeling of restlessness that he imparted to the room. Talking about herself in relation to the Russian painter Chaïm Soutine, Neel remarked: "I am a feeling painter and a psychological painter. I deliberately want to be psychological and I want to feel. I don't want the picture to fall apart because of my feeling. I love Soutine but it's too subjective even though I love it. I could never be a follower of that ..."[3]

Notes

1 Quoted in Ted Berrigan, "The Portrait and Its Double", *ARTnews*, January 1966, 32.

2 Neel Estate archive.

3 Interview on 12 September 1975, Neel Estate archive.

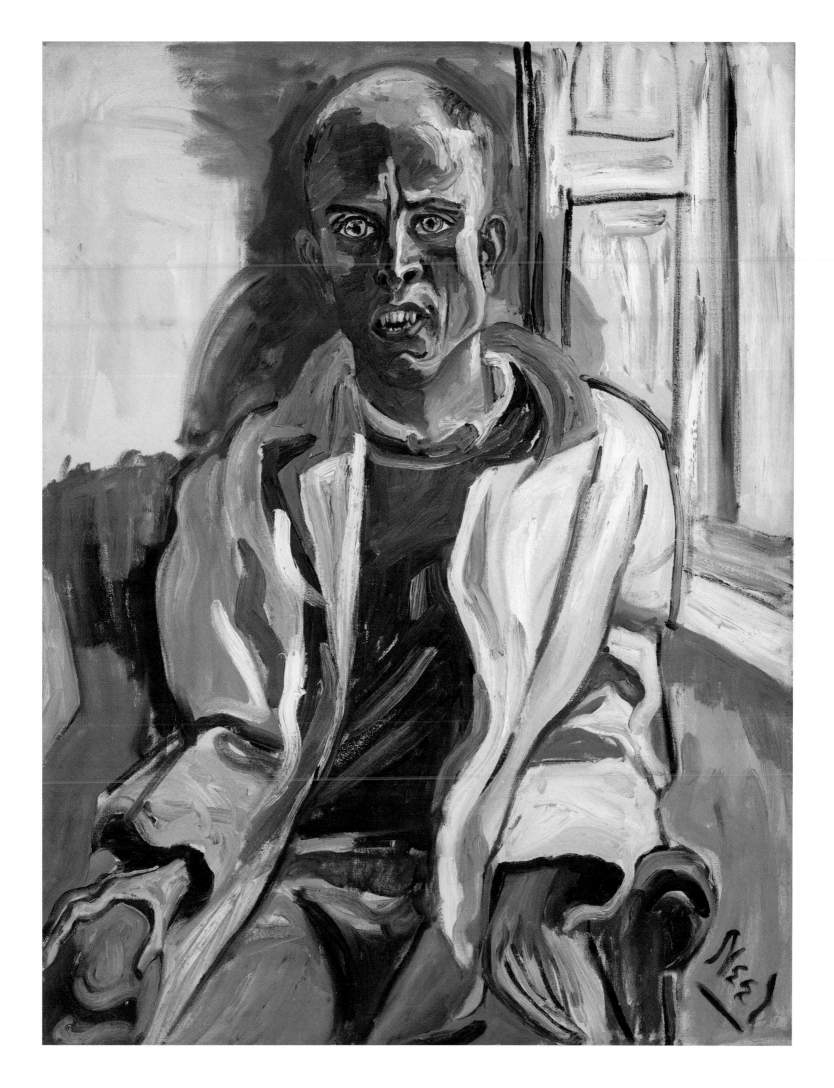

Max White, 1961

Oil on canvas, 101.9 x 71.6 cm.
Collection Kim Manocherian.

This is Neel's final painting of White, whom she had known for more than 25 years. Here he appears ravaged by time, one hand resting crab-like on the arm of his chair, the other swollen, all indications of arthritis. Half of White's head is in shadow, painted with vertical strokes that endow it with a wooden look as though paralysed; the other side, bathed in light, has deep sculptural folds and a swelling under his eye. Although White still has a powerful face, his body has shrunk and decayed. No longer directly facing the artist, in an upright pose, White writhes in the chair, leaning to one side unable to be comfortable. Everything about the painting suggests the discomfort of infirmity, from his hands to the restless background. In addition to being an author – a novelist, a biographer and a cookery writer - White was acquainted with Gertrude Stein (to whom he dedicated his book, *The Man Who Carved Women from Wood*, published 1949) and Alice B. Toklas. His papers are held in the library of Princeton University.

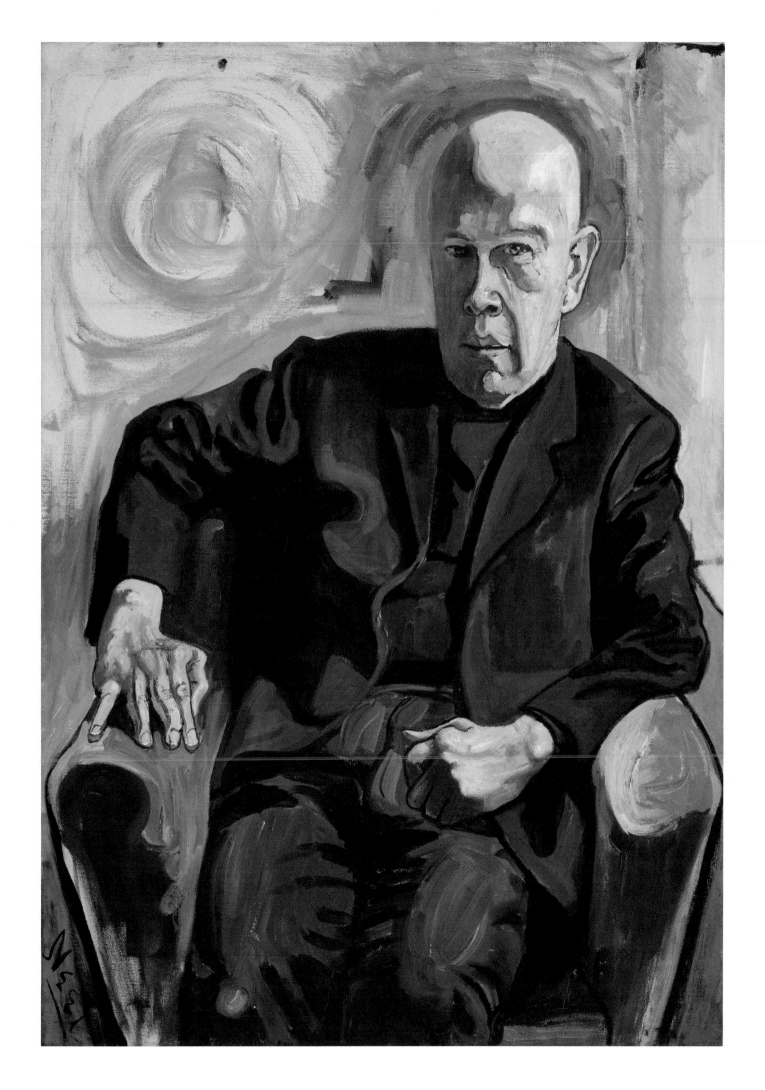

Robert Smithson, 1962

Oil on canvas, 101.6 x 61.6 cm.
Locks Foundation, Philadelphia.

One of the last paintings Neel executed in Spanish Harlem, as is obvious from its darkness, Neel portrayed Robert Smithson (1938-1973) before he had achieved fame as a land artist. At this point he was a painter of images of the human body, sometimes with Christian iconography, and mythical images that appear to have been strongly influenced by the Scottish artist Alan Davie, who had been showing in New York since 1956. This aspect of Smithson's career is often excluded from recent official accounts. He had held a solo show of paintings at Galleria George Lester in Rome in 1961 and an exhibition of assemblages at Richard Castellane Gallery in New York the year Neel painted him. In 1964, however, after a break from painting he launched himself as an artist who worked in the space between architecture and landscape, particularly the post-industrial landscape. He was perhaps better known for his theoretical writings as he did not actually complete many projects. The most celebrated completed project was *Spiral Jetty* (1970), in the Great Salt Lake, which has become a site of pilgrimage. Neel claimed that at the time she painted him, Smithson visited her shows. Neel captures a dreaming young artist beset by acne, who apparently asked her to tone down the bloody ravages on his cheeks because they embarrassed him. Ironically many of his paintings were quite gory. Because she chose a small canvas she required Smithson to fold his legs to give an impression of his full height.

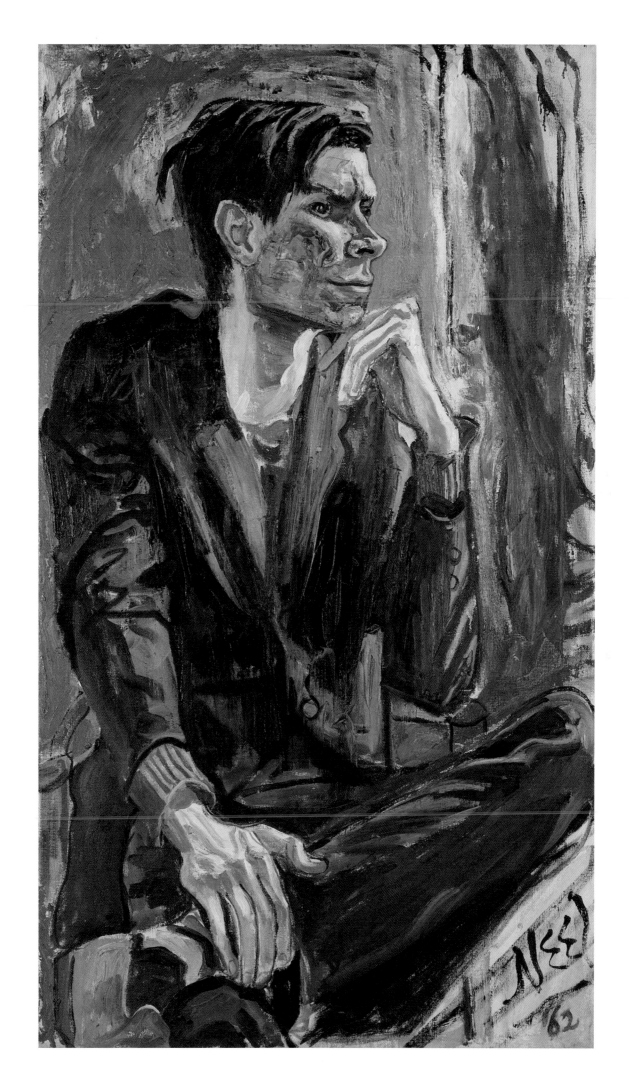

The Upper West Side

In September 1962 Neel moved to 300 West 107th Street, near to the junction of Broadway and West End Avenue. The neighbourhood was close to Columbia University and the Cathedral of St John the Divine (both a few blocks north), with Lincoln Center at the southern end, which opened that year. It was bisected by Broadway, on to which Neel's apartment had a view, and West End, Columbus and Amsterdam Avenues ran through it. Central Park West was at its eastern edge and Riverside Drive on the west. Effectively her apartment was at the same level as the one in Spanish Harlem but on the other side of the park on the northern edge of the Upper West Side.

Although often seen as a Jewish neighbourhood, there was a heavy influx of African-Americans, Russians, Dominicans, Puerto Ricans, Haitians and Ukrainians in the forties and fifties, and in the fifties and sixties Cubans and other Latin nationalities joined them. Neel felt right at home there. In addition, with the University a few blocks up the road, academics and students began to fill the apartment buildings that replaced the row houses. The Upper West Side underwent major urban renewal in the sixties beginning in 1959 with the slum clearance that made way for Lincoln Center. It was not a classy area but was popular with artists, writers and young families on account of its low rents and community feel. The area below 86th Street was also populated by large numbers of gay men arriving in the city looking for jobs.

Neel's apartment had two large reception rooms, one with windows looking on to West End Avenue and Broadway and the other with windows on two sides looking onto West End Avenue and 107th Street. Compared with the Spanish Harlem apartment, it was flooded with light. Although for a brief moment she worked in Elaine de Kooning's studio, for the rest of her life she painted, as before, at home.

Moving to the Upper West Side marked her emergence into a new world. At the end of the year the artist and critic Hubert Crehan published a major article on Neel in *ARTnews*, the first to appear in any art magazine. This newfound credibility would have helped her gain sitters within the art world and, indeed, that is what she set out to do. Meeting artists and writers at openings or trawling around the galleries on 57th Street, she would lure them back to her apartment to sit. Communism had had its day, particularly after the Treaty of Detroit, in 1950, when organised labour gave up the right to strike and bargain in exchange for certain social and welfare benefits, and even more so following the crushing of the Hungarian Uprising in 1956. Although she always remained loyal to its cause Neel began to move in other circles. The political activists were dropped. The tone of her paintings changed – they were lighter, brighter and less "finished" – and she revised the subjects of her painting – artists, art critics, art historians, visiting salesmen and student friends of her sons who were studying at Columbia University. Now that her sons were off her hands, Neel reintegrated herself into the art world. The success of this move was finally translated into her retrospective at the Whitney Museum of American Art in 1974, although so unfashionable was her art in elite circles that the curators for contemporary art, James Monte and Marcia Tucker, declined to organise it and it was left to the curator of prints, Elke Solomon. The result, according to the celebrated former Guggenheim Museum curator, Lawrence Alloway, then reviewing for *The Nation*, was a poorly hung and incoherently selected show.[1] Alloway, married to the figurative painter Sylvia Sleigh, was a qualified supporter of Neel and he was shocked by her treatment. The catalogue was an eight-page brochure and the show emphasised the last ten years. Landscapes were excluded and such major works as the paintings of Frank O'Hara were missing. It was not the first show of a woman artist at the Whitney – it followed in a line of exhibitions given to Helen Frankenthaler (1965), Louise Nevelson (1967) and Georgia O'Keeffe (1970) but they were still rare. For feminists it represented the breach of the citadel, for Neel was not considered a modernist artist but one who dealt with women's issues.

Neel lived and worked in the apartment for the remainder of her life. Unable to sell many works, notwithstanding her exhibitions at Graham Gallery and then Robert Miller Gallery, the works were stacked in rooms and along the corridor. In the absence of her sons, the paintings became her family.

‹ Neel in her apartment at 300 West
107th Street, New York, c. 1975.
Photograph by Sam Brody.

Note
1 Lawrence Alloway, "Art", *The Nation*, 9 March 1974.

Cat. 39

Ellie Poindexter, 1962

Oil on canvas, 76.2 x 61 cm.
Private Collection.

Born in Montreal but raised on Staten Island, Elinor Poindexter (1906-1994) worked at the Weyhe Gallery in the thirties and after a break to have children joined Charles Egan Gallery in 1953 where she met a number of the Abstract Expressionist artists. In 1955 she founded the Poindexter Gallery at 21 West 56th Street where she showed such artists as Richard Diebenkorn, Al Held, Jules Olitski, Willem de Kooning and Milton Resnick, the latter painted by Neel in 1960, as well as some figurative artists. The gallery continued to operate until 1978. Neel met Poindexter through the critic Hubert Crehan whose article on Neel appeared in *ARTnews* in October 1962. With a clear penchant for abstraction, Poindexter must have seemed an unlikely candidate to take up Neel's cause. The resulting first painting was relatively conventional with Poindexter sitting stiffly in a lilac dress with a red rose pinned to it and sporting a black and white hat. Behind her is a highly abstracted background making reference to her interests. Neel clearly did not enjoy the sittings, and Poindexter did not buy the portrait, for immediately after she left, as an act of catharsis, Neel swiftly executed a savage, second work, from memory, which is the present painting. Summarising her dislike of Poindexter she depicts her as an elderly woman with masculine facial features but enormous breasts, a snake-like fur coiled around her neck. Behind her the New York traffic drives up and down Broadway. There may be an element of parody of de Kooning's *Woman* paintings, which would be appropriate

for Poindexter who admired and sold his art. This is one of the first paintings Neel painted in her Upper West Side apartment at 300 West 107th Street into which she moved in September. Neel's palette would become much brighter from now on. Unlike her Spanish Harlem apartment, this one was flooded with natural light.

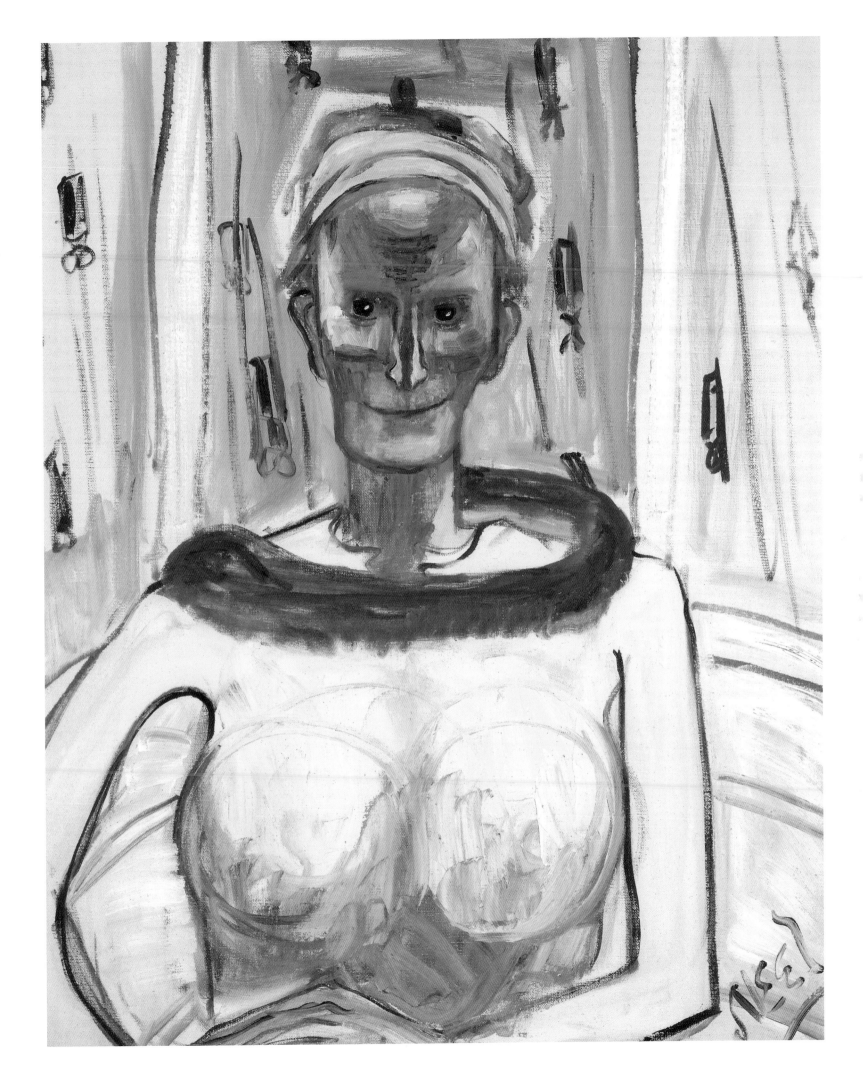

Cat. 40
Still Life, 1964

Oil on canvas, 116.8 x 101.6 cm.
Private Collection.

Neel's earliest known still life was painted in Havana in 1926. Artists have often employed still life as a means to address issues of mortality. The *vanitas*, a Latin word, with a literal meaning of vanity, suggests the meaningless of life and all that humans assemble or do as merely transient. In the hands of artists there was a tendency over the centuries for *vanitas* paintings to become increasingly morbid and for them to make overt references to death by the inclusion of skulls, rotting plants and vegetables, and time pieces. These were known as *memento mori*. Neel herself painted a still life of a skull and depicted herself as a skull in a drawing of 1958. Some aspects of this tradition enter Neel's 1964 *Still Life*. The presence of a portrait bust of Neel's deceased mother is a reminder of the fate that befalls every human being, and the artist's palette leaning against the wall proposes either the lack of inspiration – artist's block – or looks forward to the day the artist will not be able to paint. Once life is over, the rampant plants, currently encroaching on the interior space, will take over. In addition to the *vanitas* theme, however, is the rather more familiar one of confinement. While the fire escape is an exit from this interior life, the vertical bars suggest it may be no more than an illusion. Cooped up in her apartment, with a tantalising glimpse of life taking place on the street in her absence, the artist is trapped. When Neel painted people, her interiors were spare, uncluttered and clean but in reality her apartment was uncared for and crowded with objects and paintings stacked deep. Painting people permitted her removal from the difficulties of her own life; painting still life returned her to that reality.

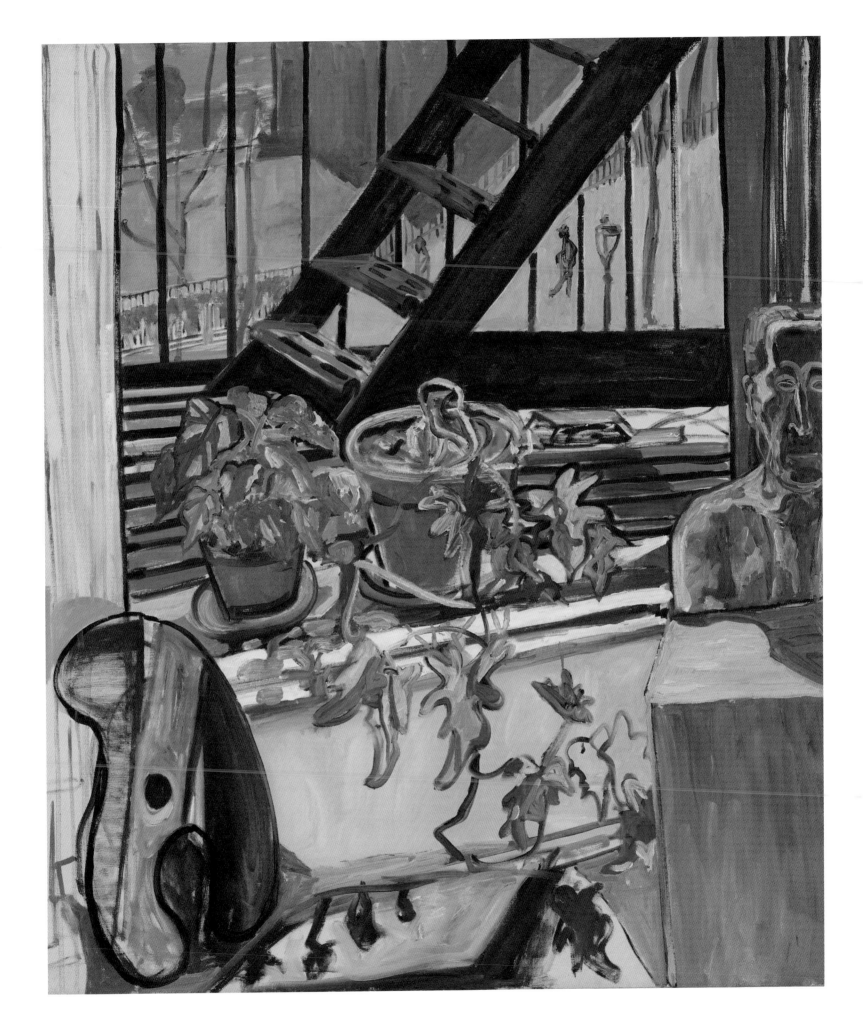

Ruth Nude, 1964

Oil on canvas, 102.2 x 121.9 cm.
Estate of Alice Neel.

Aside from the early nudes of the early 1930s, Neel did not return to the theme until the war period when she painted a fairly conventional, Titianesque, naked image of Sue Seely (1943) lying on a bed with a plush red cover set against a partially clouded, blue sky. The aggression of the previous decade's nudes had dissipated. In 1947, however, the gentle quality of *Sue Seely, Nude* was abandoned for the more confrontational *Pat Ladew* where Ladew, propped on one elbow, turns her body towards the viewer, one knee raised, the other flat, and places her sexual organs on open display. Ladew was so concerned about this that she asked Neel to paint on some underwear, but even that did not satisfy her and she returned the work to Neel, who promptly scraped off her addition. The presence of the cat in that painting makes obvious reference to Manet's *Olympia* (1863, first exhibited 1865) implying that Ladew was a courtesan, but in fact she was a fellow painter who had a love of cats. *Ruth Nude* takes the display of female attributes further. Seated in an indeterminate space, perhaps a landscape, or, since there is an evident shadow behind Ruth, an interior with a view beyond to the right, Ruth sits with splayed, bent legs exhibiting a gaping vagina. At once provocative and declarative, Neel stakes a claim for the depiction of the female body that eschews the erotic, discounts the ideal, and makes a feminist grab for historically male territory.

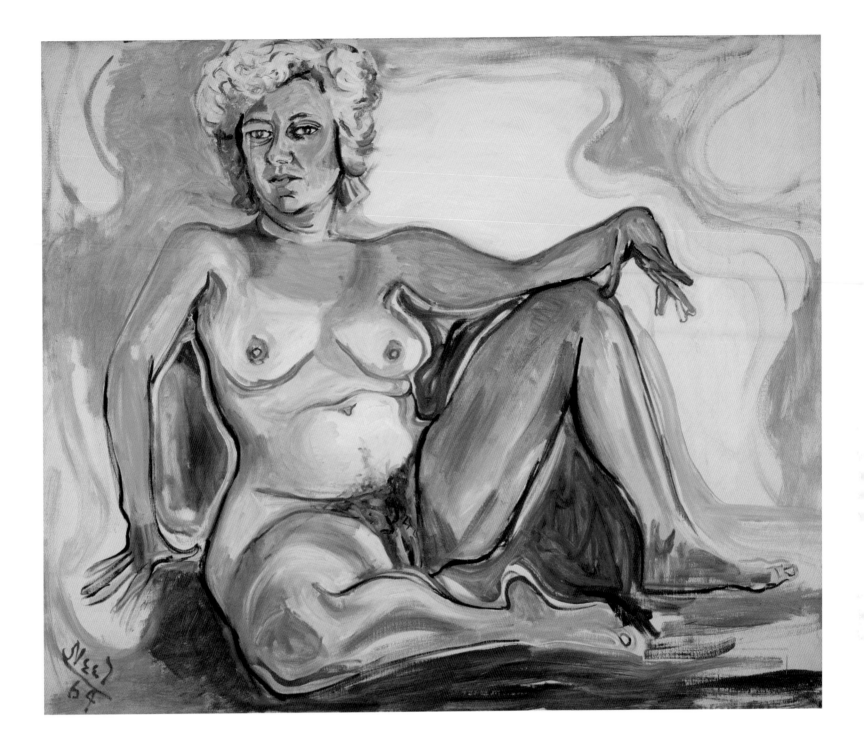

Thanksgiving, 1965

Oil on canvas, 76.2 x 61 cm.
Private Collection.

Thanksgiving is a sacrosanct celebration in the American calendar when families come together. Originally it was a harvest festival rooted in the English Protestant tradition but now it is a secular festival taking place on the fourth Thursday of November (in Canada it takes place on the second Monday of October). Normal fare for this festival is turkey but Neel recounted that a capon lies in the sink. "I painted *Chicken in the Sink* because Hartley was there and I felt happy. It was really a capon. I called it *Thanksgiving*. That's satiric: 'Thanksgiving' for everybody but the turkey, or bird, because that bird looks wretched," she told Patricia Hills.[1] There is a bleak quality to the painting which, when viewed alongside the contemporaneous *Hartley* (cat. 43), suggests that mortality was a key issue for the Neels at the height of the Vietnam War, as it was for many American families. The capon is no more than a lump of meat, not dissimilar to Francis Bacon's figures expressing the horror of living in the world in the post-war era.

Note
1 Hills, 1983, 169.

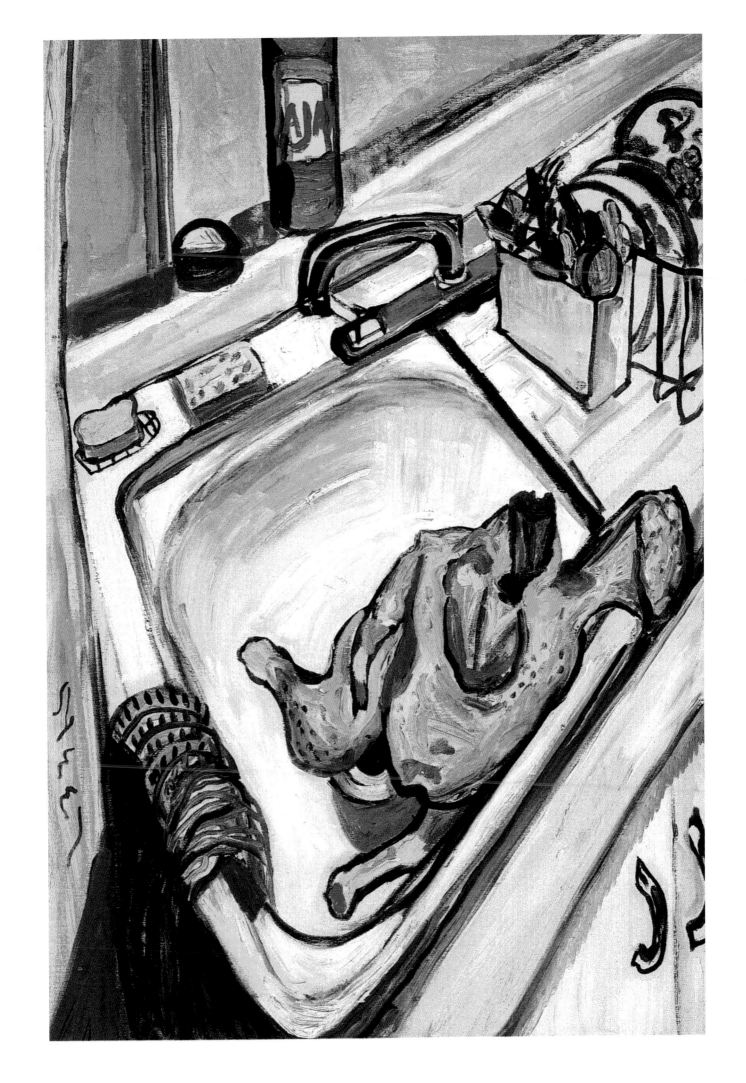

Hartley, 1966

Oil on canvas, 127 x 91.5 cm.
National Gallery of Art, Washington D.C.,
Gift of Arthur M. Bullowa, in Honor of the 50th
Anniversary of the National Gallery of Art,
1991.143.2..

Returning home from Tufts University during
his first year at medical school Hartley sits in an
Indian red chair, looking despondent. All around
him his contemporaries are being called up to
fight in Asia while he dissects corpses as part
of his training. Neel portrays his uncertainty and
depression. His indecision is signified by the
interlinking of hands above his head, removing
himself from any possible action. Hartley's crisis
is the crisis of everyman. *Hartley* is one of Neel's
most "unfinished" paintings to date. Large areas of
the canvas are left unpainted with the result that
the primary areas of focus are the face, the arms
and the shirt. This approximates the way in which
vision works with items on the periphery of vision
being a hazy presence rather than mapped out in
detail. Furthermore by not "finishing" the painting
Neel draws the viewer into the work and invites
her to collude in its creation, thereby keeping the
creative process alive. Neel must have begun the
painting in 1965 as it was included in an exhibition
at Graham Gallery, New York that opened on
4 January 1966.

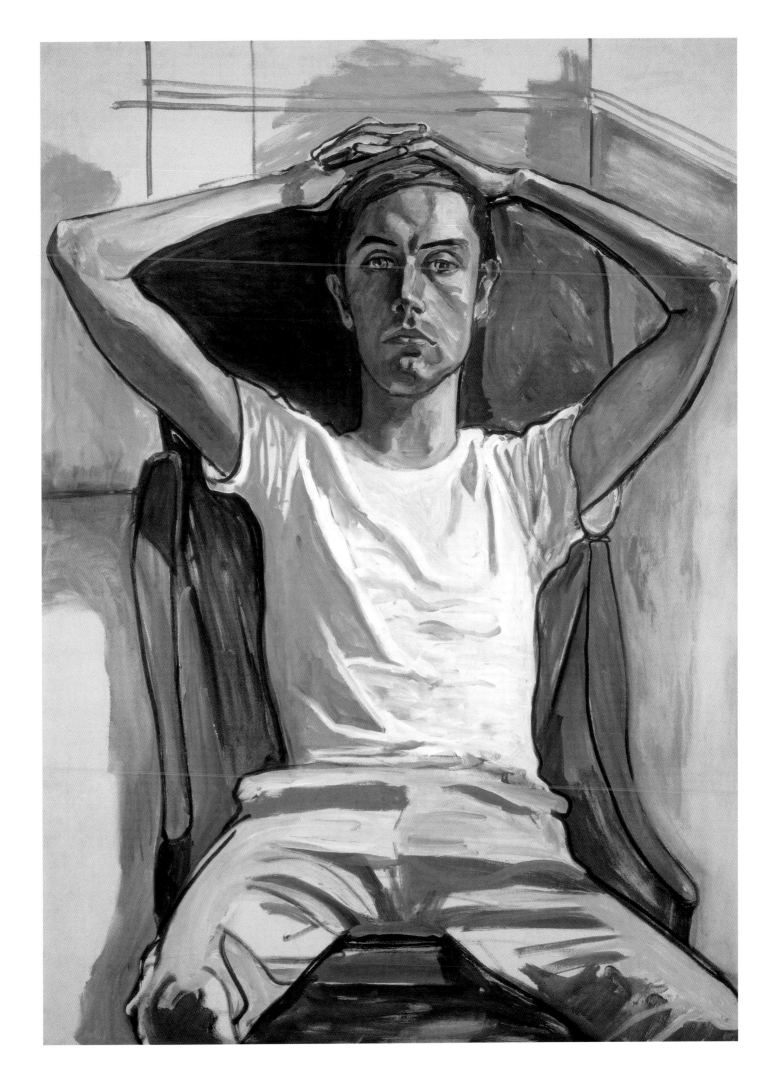

Henry Geldzahler, 1967

Oil on canvas, 127 x 86 cm.
Metropolitan Museum of Art, New York,
Anonymous Gift, 1981, 1981.407.

Henry Geldzahler (1935-94) was born in Antwerp into a Jewish family that emigrated to New York in 1940. An alumnus of Yale and a graduate of Harvard, he took up an appointment at the Metropolitan Museum where he became Curator of American Art and then, in 1967, Curator of Twentieth Century Art. When Neel painted him, he was about to embark on the organisation of what was to be his best-known exhibition, *New York Painting and Sculpture: 1940-1970*. This was the museum's first incursion into the field of contemporary art and inaugurated the formation of a new department of contemporary art. Geldzahler was highly socialised and mixed with many artists of the gay community including Jasper Johns, Larry Rivers, Andy Warhol and David Hockney. Later he became Commissioner for Cultural Affairs for the City of New York, appointed by Mayor Ed Koch, whom Neel also painted. The fact that Neel summoned Geldzahler in 1967 was probably not fortuitous but rather her attempt to curry favour and to be included in his exhibition. Geldzahler, however, never took her seriously. He was patronising, probably because she was a woman, as his short essay of 1991 testifies: "Her portraits of friends and family had a homemade, knitted quality, that reminded us of primitive painting, but they were always so trenchant, so well-observed that one knew that a keen intelligence and a lot of psychological savvy were at work."[1] In this portrait, probably the first by Neel of anyone from Andy Warhol's circle, she identifies Geldzahler's discomfort as he grips the chair back and seems to sit as far into the chair as he can while his proper left hand writhes in agony. The large stone on his pinkie was an open declaration of his homosexuality. One of the last interviews Neel gave before she died was to Geldzahler, in July 1984.

Note

1 Henry Geldzahler, *Alice Neel*, Bridgehampton, NY, 1991,4.

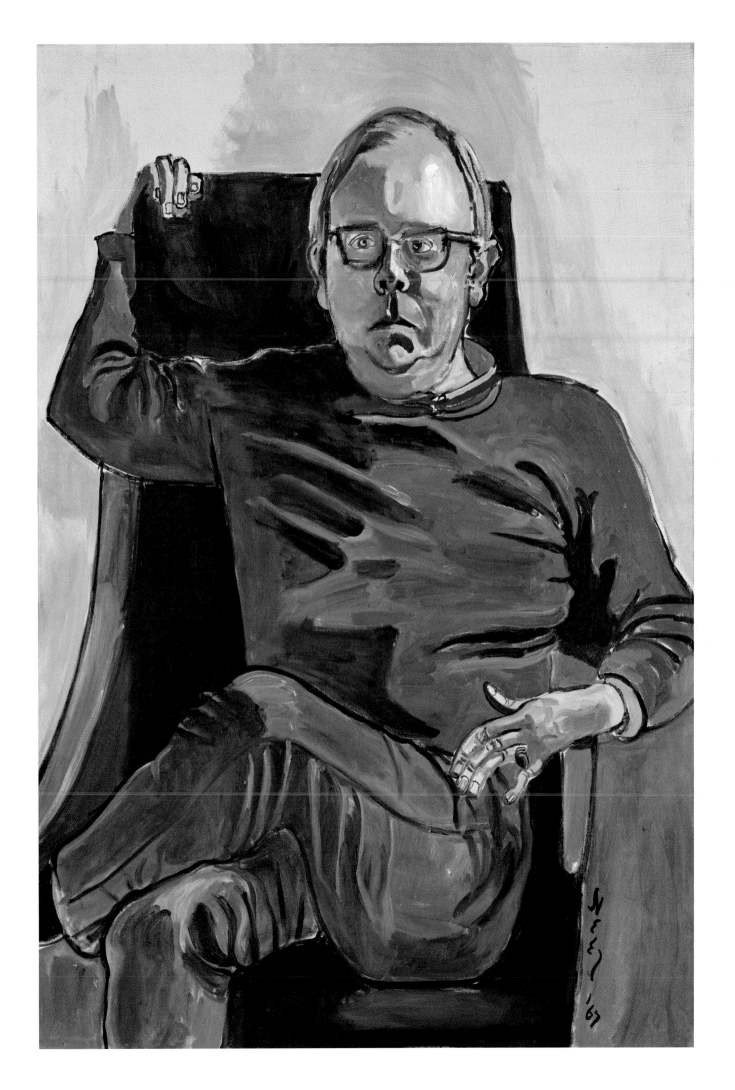

Joey Skaggs, 1967

Oil on canvas, 203.5 x 91.1 cm.
Private Collection.

When Neel painted Skaggs (born 1945) he had just set out as a multimedia artist, combining the making of objects with performance. His first documented work was a crucifixion sculpture he erected in Tompkins Square Park on the Lower East Side of Manhattan on Easter Sunday 1966. Attracting police attention, he was ordered to remove it. In 1967 he dragged it through the streets of New York and showed it in an exhibition at New York University called *Angry Artists: Artists Against the War in Vietnam*, where it was broken into many pieces. He remade it and erected it in Central Park on Easter Sunday 1968. At the time he met Neel, however, he was exhibiting abstract landscape paintings. In 2010 Skaggs wrote about sitting for Neel whom he met while he was wandering around galleries on 57th Street. "She said she'd like me to pose for her, that she'd like to do a really big painting, 6 feet tall, full figure. I agreed and she asked me to pick up the stretchers and the canvas. She never reimbursed me, but I figured, okay, she's a little old lady... And that began my friendship with Alice Neel."[1] Neel clearly wanted to accentuate Skaggs's height by making one of her tallest paintings while keeping it narrow. She was not immune to the seductive charms of her male sitters and painted Skaggs with particularly prominent male equipment. His shirt bears witness to the kinds of clothes made popular by proponents of flower power, a movement born out of protest at the Vietnam War.

Note

1 Joey Skaggs, *Alice Neel Remembered*, 9 July 2010, accessed 26 February 2016, http://artoftheprank. com/2010/07/09/alice-neel-remembered/.

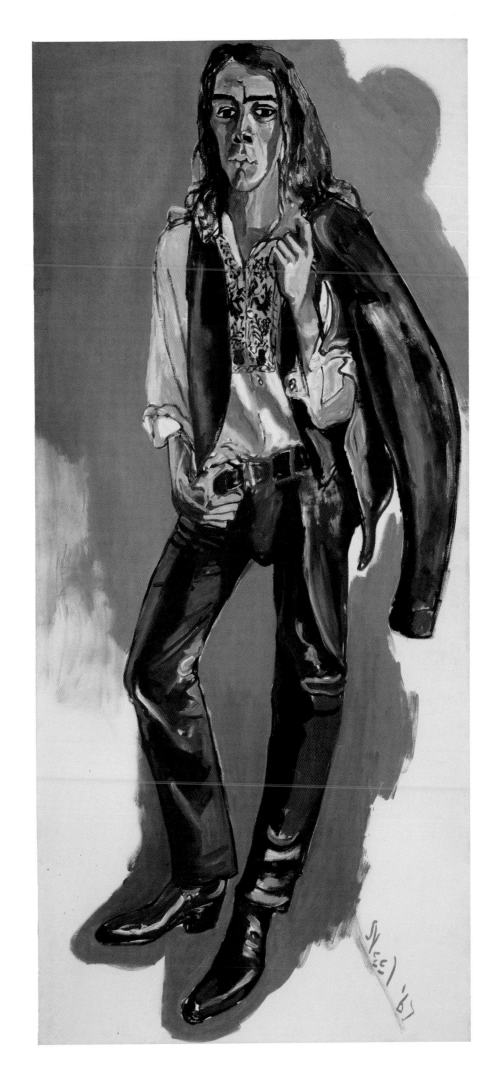

Mother and Child (Nancy and Olivia), 1967

Oil on canvas, 99.7 x 91.4 cm.
Collection of Diane and David Goldsmith.

Olivia, Neel's first grandchild (aside from the children of Isabetta whom she never met), was born the year Neel executed this painting. She is the daughter of Richard Neel and his first wife Nancy. It was difficult for Nancy to keep Olivia still and she clutches her anxiously to prevent her from falling off her lap. Nancy Neel has written: "The [painting] of Olivia and me was done in Spring Lake [New Jersey]. I remember Olivia was a very active child; she was about three months old. Olivia was always jumping around, and she didn't like to sit still. Alice would say, 'Keep that baby still'. I wasn't very successful in keeping her quiet, but the painting did get painted. But of course the way people interpret the picture is I was a scared mother. She was my first child, and I knew nothing about taking care of kids. I thought the uncomfortable look I have in the portrait was just me trying to keep Olivia still, but what Alice picked up on is that I didn't know what I was doing."[1] The birth of grandchildren gave Neel immediate access to new sitters whom she could observe not solely during a formal sitting but around her as they played. Neel's family became increasingly the subjects of her endeavour, particularly when she left New York for her house at Spring Lake where Richard and his family would spend the summer with her. In depicting other people's children, rather than her own, she was relieved of the responsibility of childminding and could take a more detached view than she had with her own children. Her paintings of mothers and children became feminist icons, showing a "truthful" side to motherhood that earlier, more conventional painters had ignored. Neel's world of mothers was not peopled by nannies that dealt with the difficult and messy aspects of childcare. She portrayed it as it was. This approach was anticipated by Edvard Munch when he wrote in a notebook around 1889: "No longer should you paint interiors with men reading and women knitting. They must be living beings who breathe and feel and love and suffer."[2] Neel must have seen the Munch exhibition at the Museum of Modern Art in 1950 for which Frederick Deknatel wrote the catalogue, where Munch's comment was cited.

Notes

1 Quoted in Edith Newhall, "Neel Life Stories", *New York Magazine* , accessed 26 February 2016, http://nymag.com/nymetro/arts/features/3409/

2 Quoted in Frederick B. Deknatel, *Edvard Munch*, exh. cat., (New York, 1950), 18.

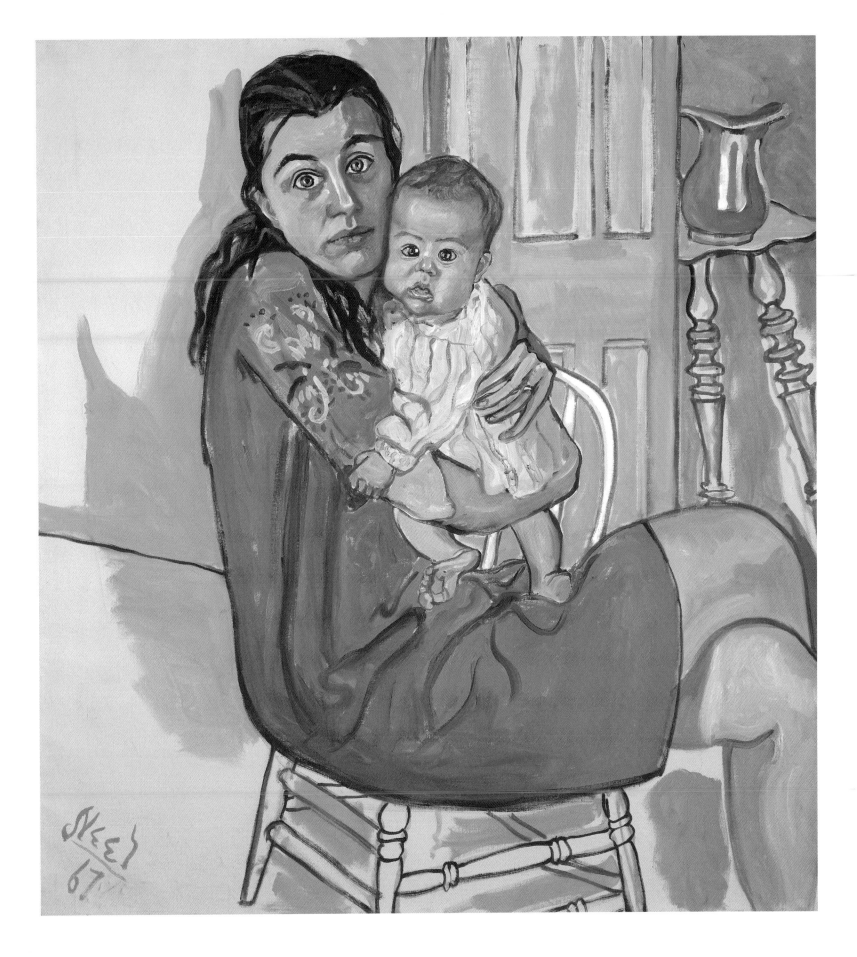

Pregnant Julie and Algis, 1967

Oil on canvas, 107.6 x 161.9 cm.
Estate of Alice Neel.

Daniel Algis Alkaitis was studying chemistry at Dartmouth University when Hartley Neel met him, but this painting was painted when Algis was studying for a doctorate at Berkeley, California. Neel was visiting San Francisco for her show at the Maxwell Galleries. She painted at least three works depicting Algis, including this one with his pregnant wife Julie Hall, whom she painted on multiple occasions. As Neel narrates it, her original intention was to paint Julie naked but Algis walked in at one point and lay down next to her. She particularly enjoyed the compression of one head above the other so adapted the work to the new theme. This was not her first treatment of the theme of the pregnant woman but during the sixties and seventies she made a number of such paintings. Pregnancy was a motif that male artists had avoided but as with her portraits of mothers and children, Neel's portrayals of women in a pregnant state were seen as representing females as they wished to be represented, not with idealised, contained bodies but as fully functioning human beings. With one hand protectively around his wife, Algis acts as both guard and proprietor, while Julie looks somewhat suspiciously at the artist. By apparently foreshortening his torso and legs, however, Neel diminishes him and undermines his role. The combination of a naked woman and a clothed man recalls the controversy surrounding the exhibition of Manet's *Le Déjeuner sur l'herbe* in 1863 at the *Salon des refusés* in Paris.

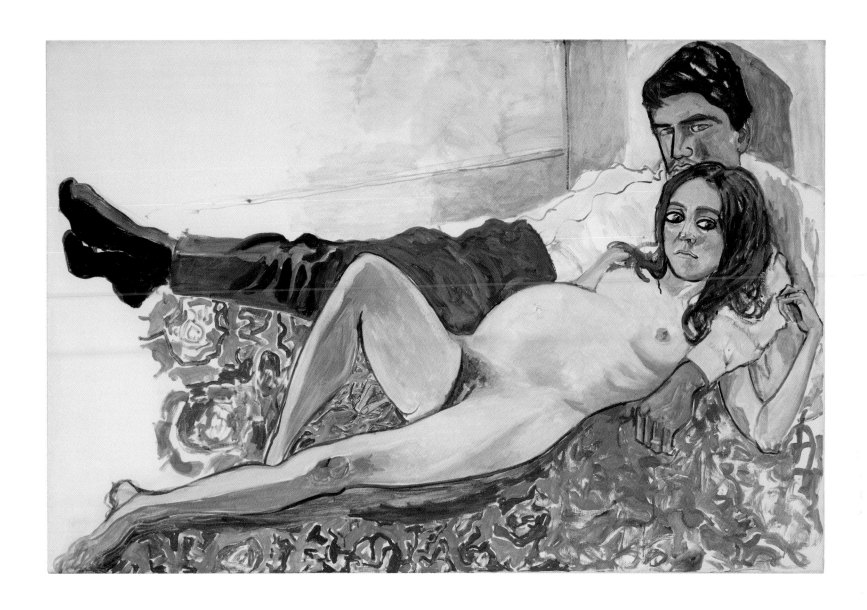

The Family (Algis, Julie and Bailey), 1968

Oil on canvas, 152.1 x 87 cm.
Charlotte Feng Ford Collection.

There are few occasions when Neel can be said
to have painted sequential works but this is one
of them. Having painted Julie Hall pregnant lying
beside her husband Algis, Neel painted them
again with their newborn child, Bailey. Whereas
Algis had been in the background of the earlier
painting here he is in the foreground proudly
clutching his son with Julie, somewhat diminished,
behind, looking more like a daughter than a wife.
Algis's height in this painting reinforces the view
that Neel reduced his stature in the earlier double
portrait or at best took a pragmatic view in order
to squeeze him in. Some of this painting must
have been done from memory as maintaining
such a pose with a newborn would have been
difficult over a long period of time. Moreover it
was probably executed swiftly. Large areas of the
canvas are left unpainted, Neel capturing enough
to satisfy her interest and to make the painting a
convincing whole.

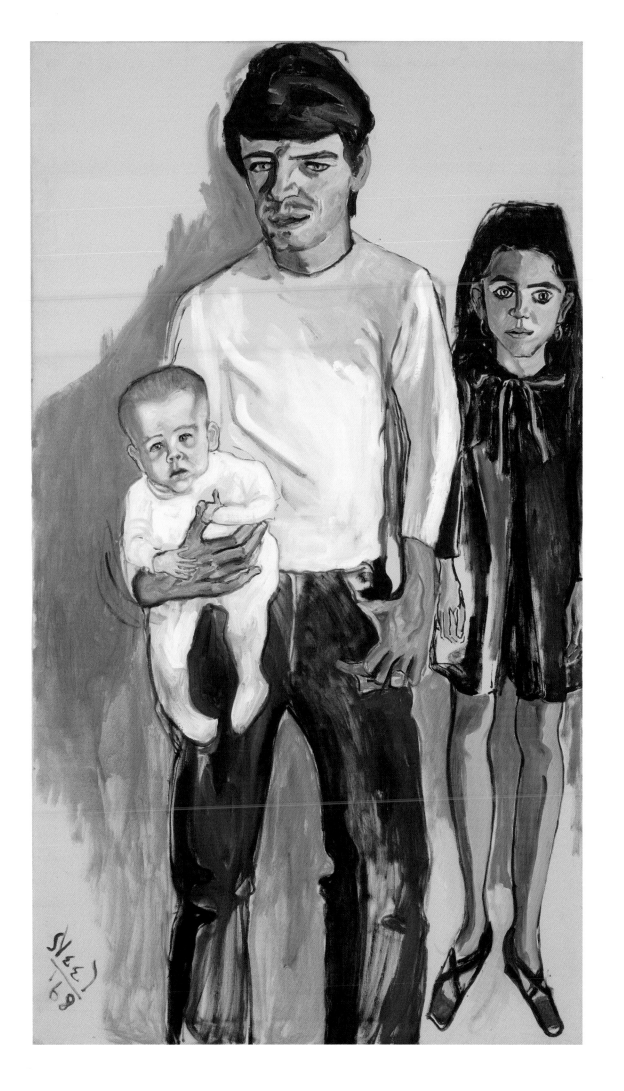

Gerard Malanga, 1969

Oil on canvas, 152.4 x 101.6 cm.
Locks Foundation, Philadelphia.

Gerard Joseph Malanga (born 1943) is a poet,
photographer and filmmaker. He was born in
the Bronx, the son of Italian immigrants. He
began working for Andy Warhol in 1962 at a
disused firehouse and moved with him when
Warhol took on a lease of a disused factory at
East 47th Street, which became known as the
Silver Factory. Malanga had technical expertise
in screen printing and helped Warhol with
this and filmmaking, also appearing in many of
Warhol's films. He choreographed the music of
the Velvet Underground for Warhol's multimedia
presentation, *The Exploding Plastic Inevitable*
(1966-67). With Warhol and John Wilcock he was
also a founding editor of *Interview* (1969). As a
photographer he has taken many photographs
of artists and poets. By the time Neel painted
Malanga he had more or less left the Factory but
was about to or had started up *Interview*. Malanga
recalled he first met her in 1962 through the
underground filmmakers Willard Maas and Marie
Menken at a literary party. Neel had a wide circle
of acquaintances. When he eventually sat for her
she required only about three sittings of about
two hours each. When the painting was finished
he was shocked by his demonic appearance.[1]
The casual way in which Neel has left apparent an
early delineation of his proper right arm endows
him with the mythic quality of a severally armed
creature like Lakshmi, the Indian goddess of
wealth and prosperity, while his chiselled features
and tousled hair are like those of a Roman statue.

1 See "Undergoing Scrutiny: Sitting for Alice Neel",
in Ann Temkin (ed.), *Alice Neel*, exh. cat., (Philadelphia,
2000), 68.

172 **The Upper West Side**

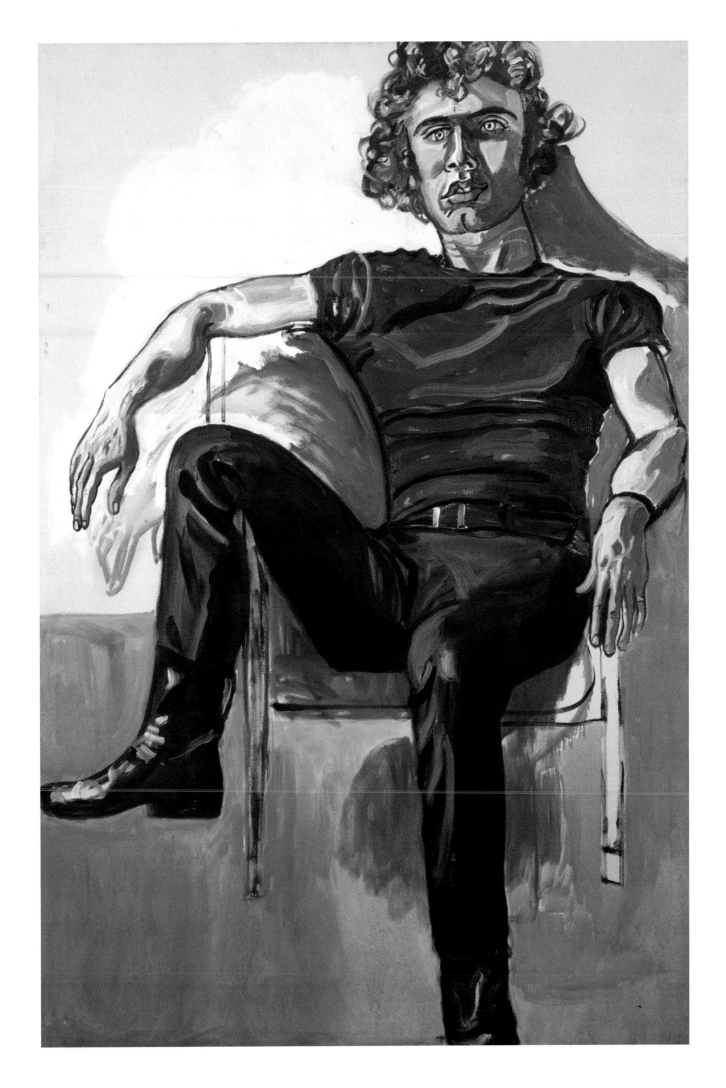

Still Life Spring Lake, 1969

Oil on canvas, 75.6 x 101.6 cm.
Estate of Alice Neel.

Neel initially bought a small cottage at Spring Lake, New Jersey, in 1935 but in 1959 she was able to purchase a larger one. This still life was executed there. The painting is unusual for the deep space Neel has depicted. Indeed the spatial construction is complex with various different depths and vanishing points. The group of fruits and vegetables on the table – pear, tomato, onion, shallot, and others unidentified – are an index of a modest lifestyle betokened also by the empty, solid earthenware vase. The furniture is Spartan and the refrigerator utilitarian rather than modern. The still life of ordinary fruits and vegetables inevitably recalls the work of Jean-Baptiste-Siméon Chardin and Paul Cézanne, who were masters of this genre. Like Cézanne in a number of his still life paintings, Neel examines the fruits and vegetables from multiple angles: side on, from above and straight on. But Neel's work has its own look of simplicity and purity. It is redolent of a life that values the handmade over the mechanistic and practicality over ostentatiousness.

Andy Warhol, 1970

Oil and acrylic on linen, 152.4 x 101.6 cm.
Whitney Museum of American Art, New York,
Gift of Timothy Collins, 80.52.

(Exhibited at Fondation Vincent van Gogh
Arles and Deichtorhallen Hamburg only)

Andy Warhol (1928-87) was arguably the most famous artist of his day and a leading practitioner of Pop Art. Initially working as a graphic artist in the advertising industry, he burst onto the New York art world in 1962 having already held a show at the Ferus Gallery in Los Angeles. He soon built up an entourage of assistants and hangers-on, as his silkscreen paintings of Coca-Cola bottles, greenbacks, soup cans, "Disasters" and electric chairs, and simulacra of Brillo boxes and boxes of Del Monte canned foods made him the talk of the town. He groomed various people in a world of counter-culture and Bohemia whom he called "Superstars" including, among others Nico, Ultra Violet and Jackie Curtis (cat. 52 and 57). Warhol also made films that redefined the nature of artist's film. In addition, he made celebrity portraits by taking photographs and printing them on a large scale in lurid colours using silkscreen painting. On 3 June 1968 radical feminist writer, Valerie Solanas, shot him. She had been a minor member of the Factory scene and on the day she shot him had been turned away from the Factory after asking for the return of a script she had given Warhol, which he had apparently misplaced and maybe had not read. Warhol was seriously injured and almost did not survive, the surgeons having to open his chest and give him heart massage. In a 1981 lecture[1] Neel recounted that she met Warhol in 1963, at Castelli Gallery at 4 East 77th Street, while her painting of Richard as a law student (fig. 41) was hanging at the Museum of Modern Art, next to a Warhol *Jackie* (no record of this event has been found). Warhol may have seen her 1963 Graham Gallery exhibition, however. Neel stated that Warhol asked her to paint him but she did not get around to it. However after he was shot he rang her again and she relented. Neel depicts him two years after this incident, the wounds from surgery sewn together, his muscles limp, his enlarged breasts sagging and making him look androgynous. With eyes closed, he disengages from Neel's gaze. The blue shadow on the wall appears like wings. In Neel's hands Warhol becomes a modern-day martyr. The South African artist, resident in the Netherlands, Marlene Dumas, has acknowledged the influence of this work on her painting, *The Painter* (1994).

Note

1 Neel Estate archive.

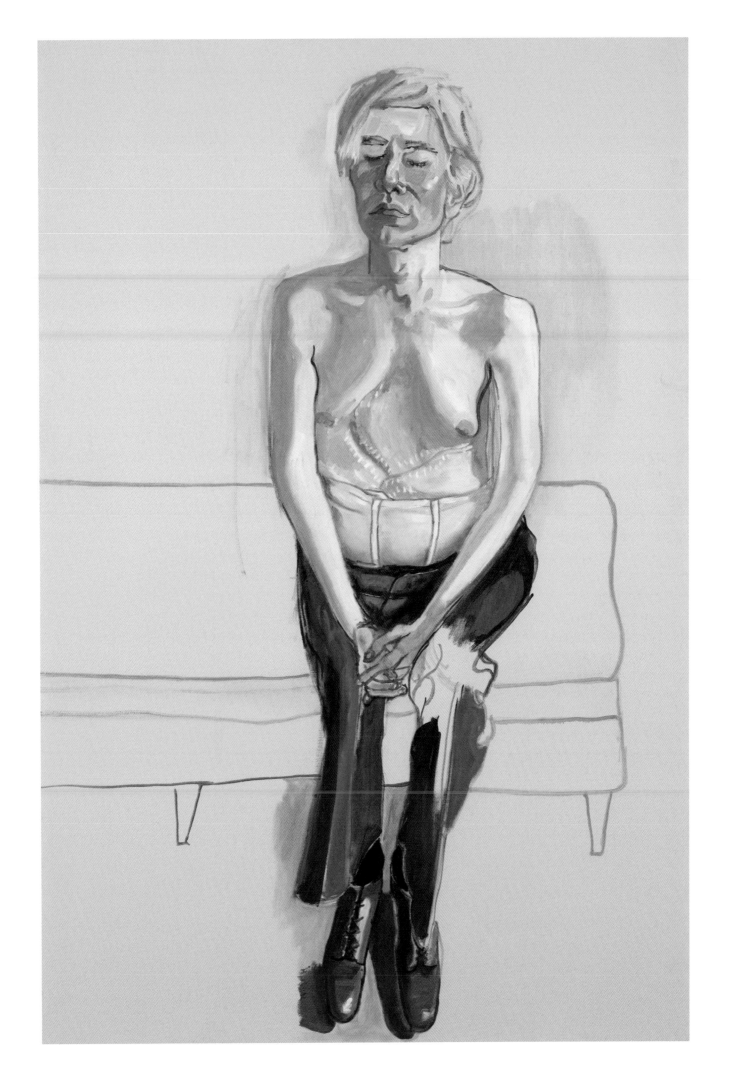

Jackie Curtis and Ritta Redd, 1970

Oil on canvas, 152.4 x 106.4 cm,
The Cleveland Museum of Art, Leonard C. Hanna,
Jr. Fund, 2009.345

Jackie Curtis (1947-1985), one of Warhol's "Superstars", here dressed in drag on the right, was a playwright, cabaret singer, poet and theatre director. Born John Curtis Holder Jr, Curtis performed as both a man and a woman but as a woman pioneered the combination of trash and glamour – lipstick, bright red hair, and ripped clothing. Curtis was also the subject of one verse of Lou Reed's "Walk on the Wild Side" from his 1972 hit LP *Transformer*:

Jackie is just speeding away
Thought she was James Dean for a day
Then I guess she had to crash
Valium would have helped that bash

Ritta Redd was no "Superstar" but in a relationship with Curtis and appeared in several films with him. Neel captures the contrast between Curtis's glamour and Redd's dowdy demeanour. The latter's horizontally striped top, painted like a Frank Stella, looks ordinary beside Curtis's vertically striped or ruched blouse, which seems almost sheer the way Neel has painted it. Their contrasting footwear further indicates their different approaches to life. Neel had always taken a keen interest in clothing, seeing it, as Charles Baudelaire wrote in "The Painter of Modern Life" (1863), as an index of the contemporary. Make-up and fashionable clothing were major themes in Baudelaire's essay, where he remarked that make-up improved upon nature and should stand out from it. But if make-up is a form of embellishment it also provides a disguise. Womanliness, psychoanalyst Joan Riviere argued in 1929, was a masquerade to conceal or subvert the masculine aspects of women. If in the era of second-wave feminism make-up was seen as disempowering, in Curtis's case it was the reverse. He uses the masquerade to mask his masculinity, to empower himself as a woman. He has in effect, already created a work of art, his face. Thus Neel's work is a painting of a painting. In applying make-up and adopting his pose and expression, it is as though Curtis has become the artist himself. It is he who forms the image that Neel is obliged to paint. Neel depicted this homosexual couple the year after the Stonewall riots. The Stonewall Inn was a working class gay and lesbian bar in Greenwich Village frequently raided by police. On 29 June 1969 the police raided the bar but the regulars locked them in, leading to three days of rioting. From then on the gay and lesbian movement became militant, leading eventually to important reforms of the legislation. By showing such paintings publicly as well as painting many gay men and women, Neel openly declared her allegiance to their cause.

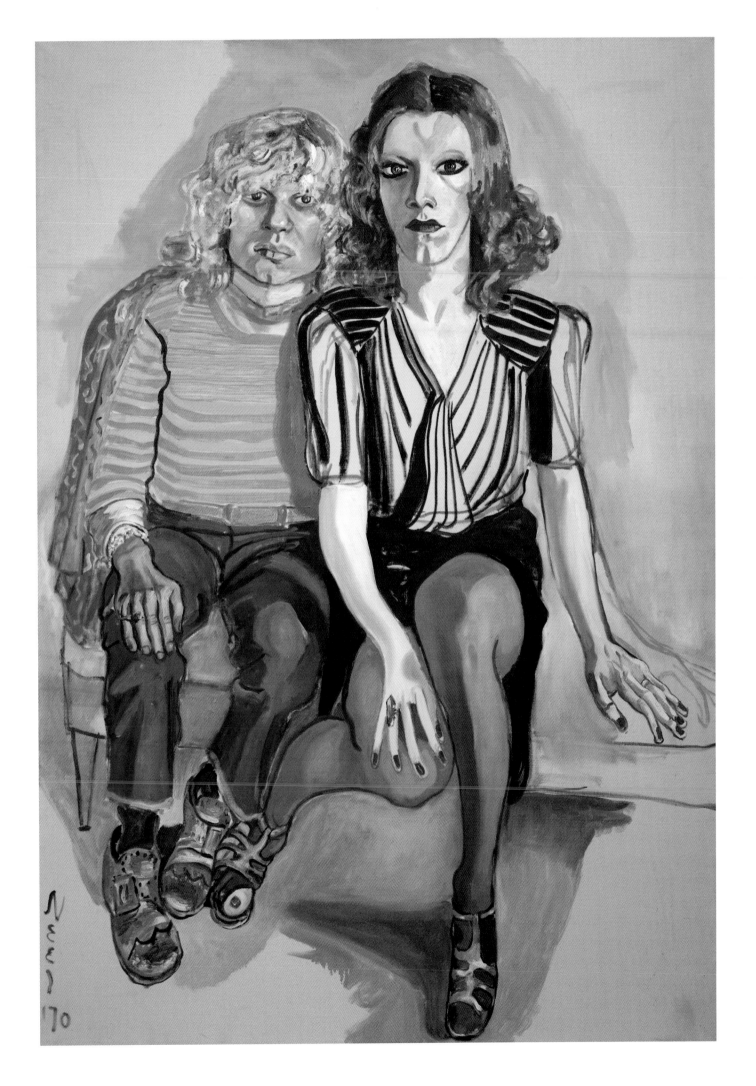

The Family (John Gruen, Jane Wilson and Julia), 1970

Oil on canvas, 153 x 147.3 cm.
The Museum of Fine Arts, Houston, Museum
purchase funded by the Caroline Wiess Law
Accessions Endowment Fund.

John Gruen (born 1926) is a photographer who
regularly wrote reviews on dance, music and
art for the *New York Herald Tribune*, *Vogue*,
ARTnews and the *New York Times*. His wife,
Jane Wilson (born 1924) is a painter while Julia
(born 1958) is Executive Director of the Keith
Haring Foundation, having been a student at
The School of American Ballet at the time Neel
painted this work. In 1966 Gruen had published a
review in the *New York Herald Tribune* of Neel's
show at the Graham Gallery, New York. In 1972
he would publish his memoir of the New York
art world, *The Party's Over Now*. This is one of
Neel's largest paintings and was the first work
of hers to be included in a Whitney Biennial.
Capturing three different expressions, all
directed at the artist, the painting suggests three
different attitudes to being depicted. While
Gruen is engrossed, Wilson is enigmatically aloof,
perhaps uninterested in Neel's stories and wary
of her beguiling approaches to men, while Julia
looks shy and awkward, her pose reminiscent
of the young girl in Edvard Munch's *Puberty*
(1895), seen by Neel in Oslo the previous year.
However Gruen and Wilson told Phoebe Hoban
that they were fascinated by the experience
of being painted by Neel and looked forward
to each session.[1] As film of Neel working on
other paintings testifies, she began the portrait
outlining the figures in blue but soon became
enchanted by the fact they were all three wearing
patent leather shoes and focused on those.
The contrast between their footwear and that in

Jackie Curtis and Ritta Redd (cat. 52) could not
be more marked. Neel had hoped Gruen would
buy the painting but he declined for lack of
money and space to accommodate it.

Note
1 Hoban, 2010, 272-73.

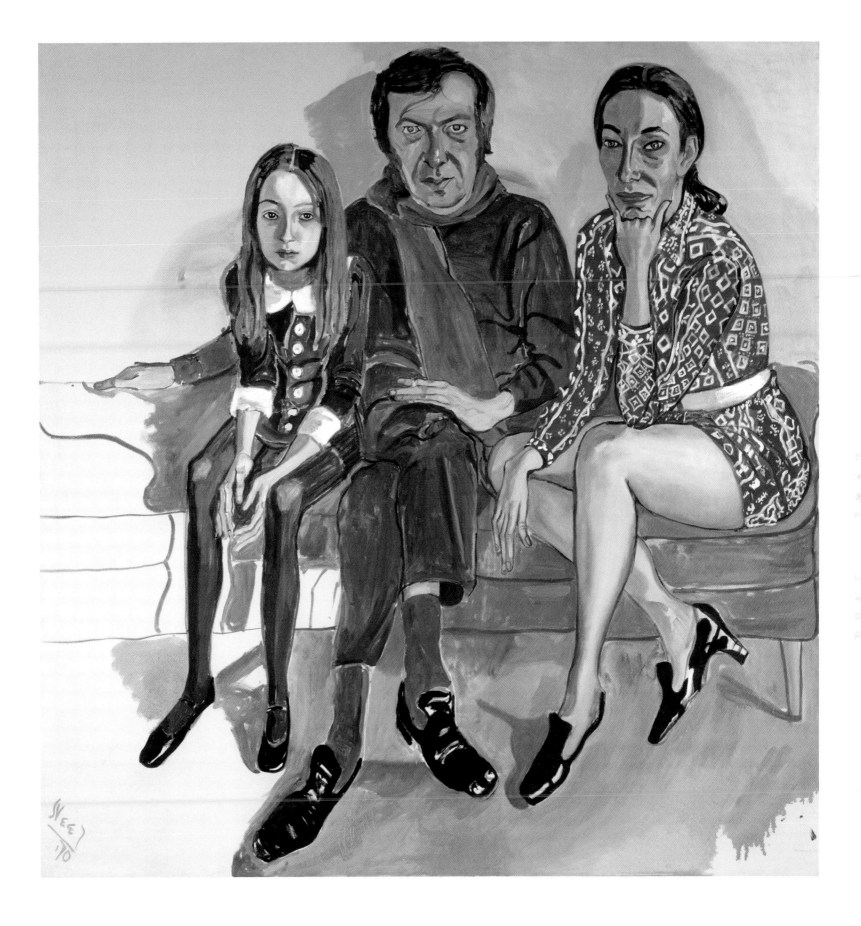

Loneliness, 1970

Oil on canvas, 203.2 x 96.5 cm.
National Gallery of Art, Washington D.C.,
Gift of Arthur M. Bullowa, in Honor of the 50th
Anniversary of the National Gallery of Art.

In August 1970 Hartley married Virginia Taylor.
Although he had lived away from home since
1963, marriage represented for Neel the end of a
phase of their lives. She regarded the empty chair,
in which she had painted Hartley in 1966 (cat. 43),
as representing her feelings of emptiness, but it
makes a clear reference to *Gauguin's Chair* and
Van Gogh's Chair painted by Van Gogh in 1888
that celebrated their short collaboration. More
than simply a personification of her desolation,
however, the empty chair signifies Hartley's
absence. The black blind is drawn halfway as a
sign of mourning. The sitters she welcomed to
her apartment, and in their absence her children,
animated Neel's life. This painting, like some of
the still life paintings, communicates how she felt
without that human interaction. Trapped inside,
with only an impersonal façade of unpopulated
windows beyond, Neel is left with the most
mundane, but the most poignant of subjects.

Pregnant Woman, 1971

Oil on canvas, 101.9 x 153 cm.
Estate of Alice Neel.

Nancy Neel was expecting twins when Neel
painted her naked on the sofa, the fact of which
Nancy was only aware late on. Unusually, Neel
did not title the work with Nancy's name but
depersonalised it representing her experience
as that of everywoman. Pregnancy itself, she
seems to suggest, was what defined Nancy at
the time rather than her personality. Nancy's self-
absorption is total as she raises her arm above
her head as a barrier to ward off the observing
eye of her husband Richard, represented by
a painting in the background. The fact that he
was not physically present but only as an image
suggests her aloneness in this state. Diagnosed
with toxaemia, the final weeks before delivering
twins must have been stressful for Nancy. The
green cast to her skin is an index of mental and
physical sickness, the same colour Neel had
employed in *Hartley* (cat. 43) in 1966 to suggest his
mental anguish. Nancy gave birth one week later
to Alexandra and Antonia, three weeks before
term. Pregnancy was not a subject often treated
by feminist artists in this period who tended
to work with themes connected to strength,
menstruation, violence or the politics of male
attitudes to the female body. Pregnancy was seen
as a distortion of the body, something monstrous,
as well as a sign of oppression, tying women to the
home and child-rearing, but Neel shows it to be a
natural state of being and concentrates as much
on the psychological state that accompanies it
as the form of the body itself.

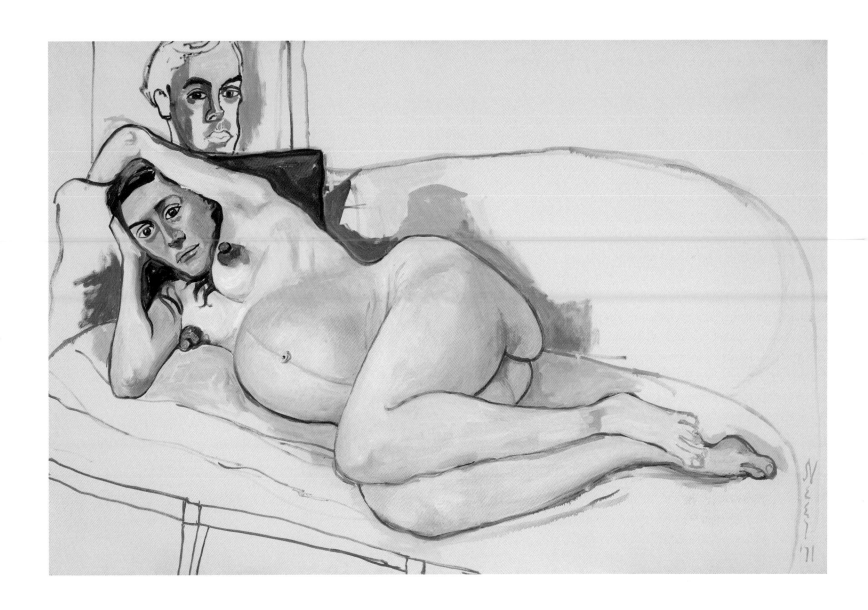

Nancy and the Twins (5 Months), 1971

Oil on canvas, 112.1 x 152.7 cm.
Estate of Alice Neel.

Five months after giving birth to twins, Neel
portrayed Nancy and her two daughters,
Alexandra and Antonia, on a bed at Spring
Lake. Nancy reclines like some Mexican god,
Chacmool for example, keeping a watchful eye
on the twins who advance towards the painter.
Neel took liberties with the delineation of form,
extending the bed at the back of the painting
and elongating Nancy's proper right arm, almost
dislocating her shoulder in the process. When
painting children, Neel would often make strange
noises to attract their attention. The way in which
the children raise their heads suggests that she
has caught such a moment. It is more than likely
that Nancy was painted substantially from life
but the sessions with the children must have been
quick leaving Neel to work a lot from memory on
their likenesses.

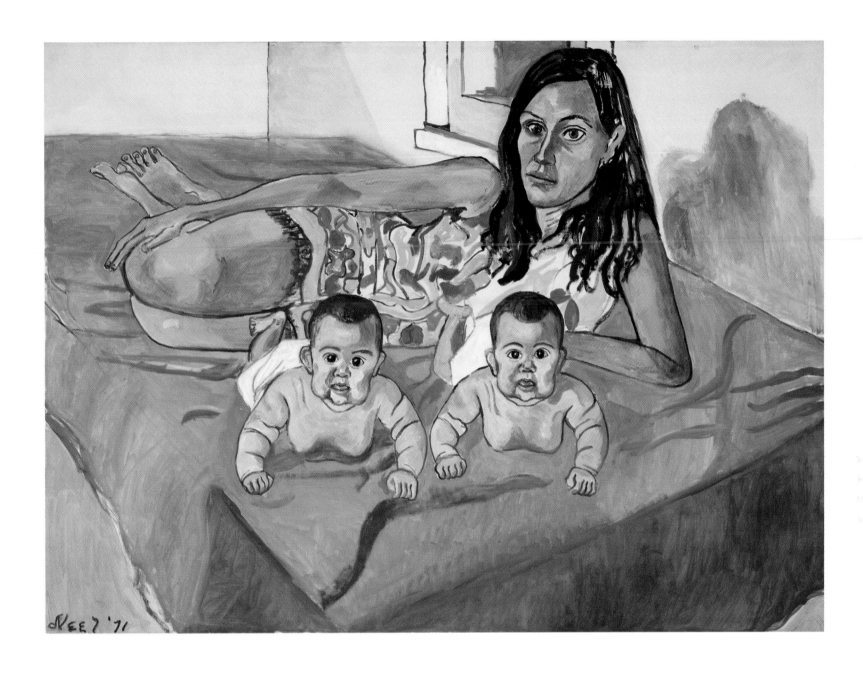

Jackie Curtis as a Boy, 1972

Oil on canvas, 111.8 x 76.2 cm.
Collection John Cheim.

Curtis returned to be painted again two years after the first portrait (cat. 52), this time in men's clothing and without the feminine mask. Without a role to play he is left somewhat unsure of himself. Curtis did in fact perform both as a man and a woman, as Lou Reed suggested in his lyric "thought she was James Dean for a day", thereby melding the genders. The rather Baconesque twist to his nose that turns back on itself as the line continues into his forehead echoes the phallic motif that snakes down from his collar to his crotch, suggesting a certain limpness to his sexuality. The colours Neel employed here, clear blues and deep reds, transform him into some kind of Piero della Francesca martyr.

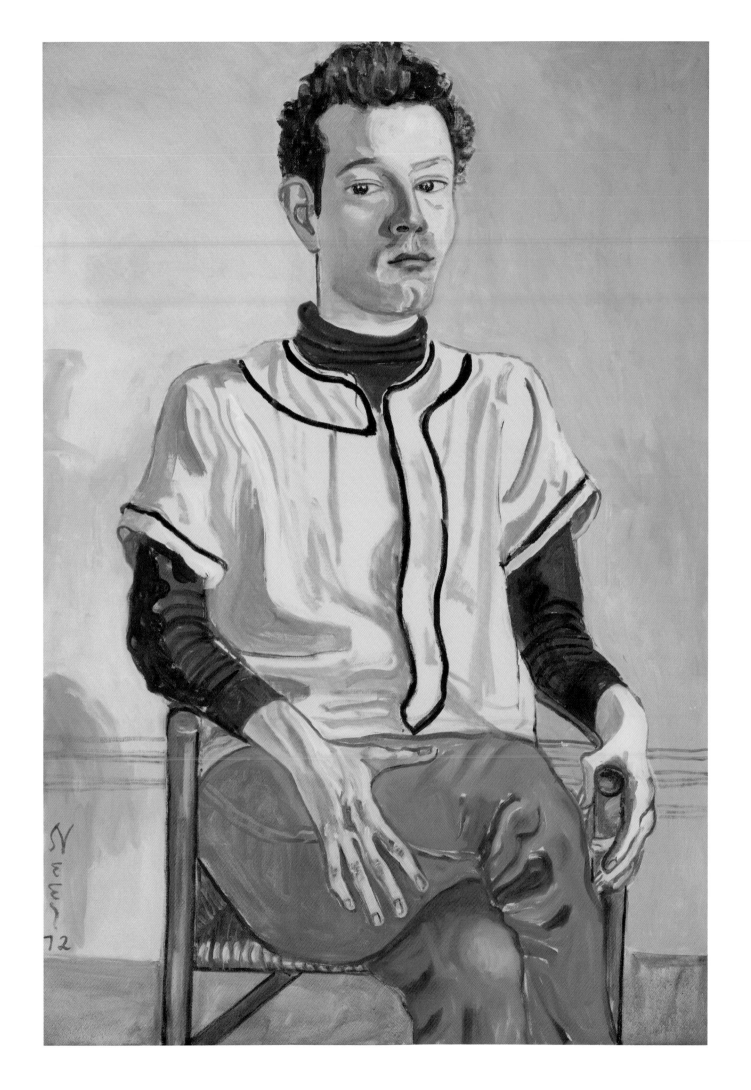

Benny and Mary Ellen Andrews, 1972

Oil on canvas, 152.2 x 127 cm.
Museum of Modern Art (MoMA), New York, Gift
of Agnes Gund, Blanchette Hooker Rockefeller
Fund, Arnold A. Saltzman Fund and Larry Aldrich
Foundation Fund (by exchange), 27.1988.

Benny Andrews (1930-2006) was an African-American artist raised as one of ten children by sharecropping parents in Georgia in the era of segregation. He married Mary Ellen Smith in 1957 but they divorced in 1976, four years after Neel painted them. He had known Neel since the early sixties and shared exhibitions with her twice. In 1969 Andrews founded the Black Emergency Cultural Coalition, an organisation that protested against the *Harlem on My Mind* exhibition at the Metropolitan Museum. One of only four white artists to do so, Neel joined that protest about the fact that no African-Americans were involved in organizing the show and no works of art by members of the thriving Harlem community were included. In an interview Andrews described the process of sitting for Neel:

"If you are a painter and you look at another painter working, you're always fascinated because it's almost like they are playing cards and you don't know the game. Their palette is somewhat similar to that. If you look at their palette, it makes no sense with the palette that you know, that you work from. I still swear today that Alice had only about three kinds of grays that she kept digging into – just little dirty spots of paint. And she would talk. She was still in her night robe. She would sit there, and she'd be digging in these three or four little piles of mud, painting away and talking and telling stories, and telling us how sexy she was. She'd say, 'I am cursed to be in this Mother Hubbard body. I am a real sexy person.' And she'd keep talking like that. It was so beguiling. She lulled you. And you can see it in my portrait. I am just lying in that chair. And she's continually working away, with this little mud, painting and sitting there with her house shoes on, talking about how sexy she is, telling sex stories, one after the other. ... She'd say: 'Now look at my earlier photographs, I used to be a beautiful woman'".[1]

Aside from providing evidence of Neel's display of narcissistic vanity and mourning for the loss of youth, this experience translated into a painting of Andrews whose pose indicates beguilement, while his prim wife remains upright with knees locked together, unimpressed by the seduction scene taking place before her.

Note

1 "Undergoing Scrutiny: Sitting for Alice Neel", Temkin (ed.), 2000, 73.

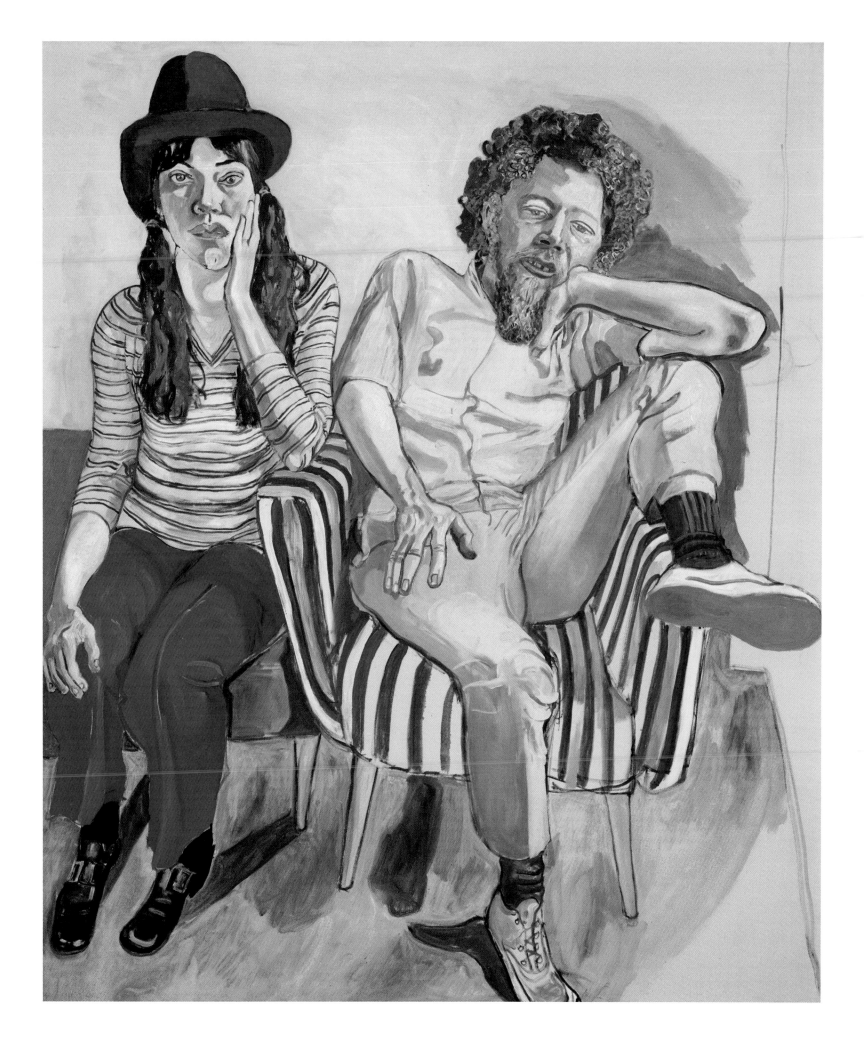

John Perreault, 1972

Oil on linen, 96.5 x 162.2 cm.
Whitney Museum of American Art, New York.
Gift of anonymous donors, 76.26.

John Perreault was only the second solo male nude Neel had painted in oils, the first being *Joe Gould* (cat. 8). At the time she painted him, Perreault (1937–2015) was chief art critic for the *Village Voice* and a painter but he was also a poet and curator. He went on to become the senior art critic and art editor of *Soho News*. He approached Neel to borrow *Joe Gould* for an exhibition on the theme of the male nude at the School of Visual Arts, New York. Neel enquired who else would be in the show and when she found out that all the work, other than hers, would be recent she agreed to lend the painting as long as she could paint Perreault nude and have the painting included as well. It took 17 sittings to complete, an unusually long time. She left the genitals until last and depicted them large but flaccid. Turned to face the viewer, Perreault is the equivalent of Goya's *Nude Maja* (1797–1800) or Manet's *Olympia* (1863). His penis offers disinterest and his gaze nonchalance. The paintings of Curtis and Perreault were of homosexual men at a time when homosexuality was still illegal and open display of homosexual behaviour was considered transgressive. The following year the American Psychiatric association finally conceded that homosexuality was not a mental illness. Only since 2003 has consensual sex between same-sex adults been legal throughout the US. For Neel, who had always painted homosexuals without hesitation, it was just another subject. Unlike the artists of the *Neue Sachlichkeit*, Neel did not seek to satirise homosexuals, but accepted them as they were.

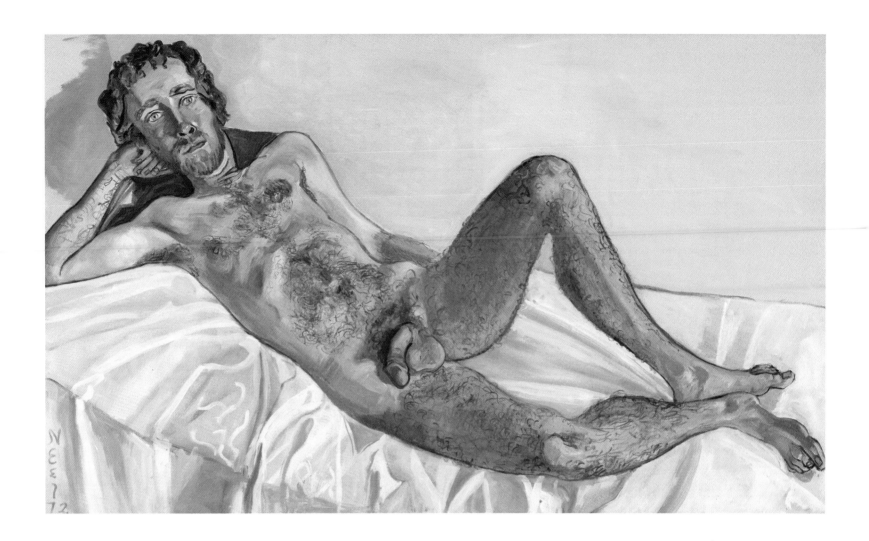

Carmen and Judy, 1972

Oil on canvas, 101.6 cm x 76.2 cm.
Oklahoma City Museum of Art,
Westheimer Family Collection.

Carmen Gordon was Neel's Haitian cleaner, who
also worked for Nancy Neel as a baby-sitter. Judy
was Carmen's sick daughter. The painting shows
Judy unable to take the breast while Carmen looks
on with quiet dignity and sadness. A few months
after the painting was completed Judy died of cot
death. Neel had painted a number of immigrant
mothers with their babies but mostly in Spanish
Harlem. After moving to the Upper West Side,
Neel was not exposed as much to the immigrant
community so this is a rare example of the reprise
of an earlier theme. Judy's inability to feed and
Carmen's sagging breast recall the plight of the
child in *Degenerate Madonna* (cat. 3). The theme
of malnourishment in that painting recurs here.
The exposure of Judy's vaginal slit also recalls
the treatment of the baby's diaper in *The Spanish
Family* (cat. 22). Like many a Madonna and Child,
this painting is inscribed with death.

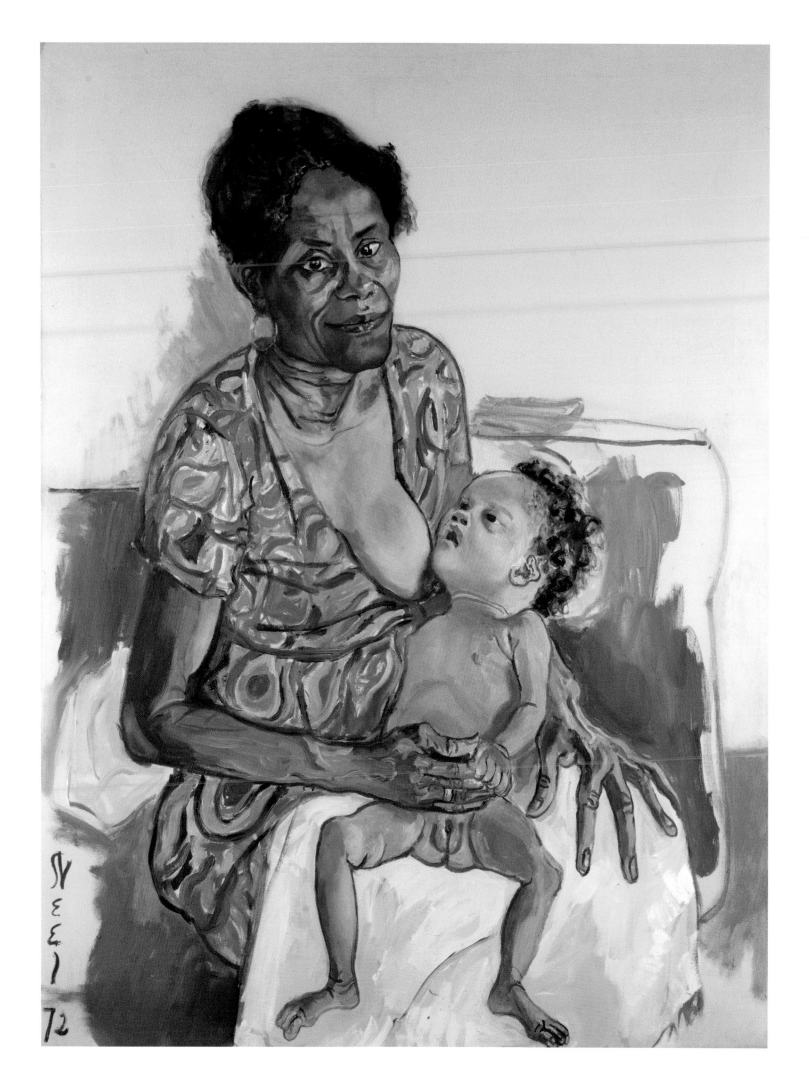

The Soyer Brothers, 1973

Oil on canvas, 152.2 x 117.3 cm.
Whitney Museum of American Art, New York,
Purchase, with funds from Arthur M. Bullowa,
Sydney Duffy, Stewart R. Mott and Edward
Rosenthal, 74.77.

Neel had known Raphael (1899-1987) and Moses Soyer (1899-1974) since the thirties as fellow artists of the left. They had emigrated with their parents from Russia in 1912 and became painters of social realist subjects. Moses studied under Robert Henri and George Bellows, while Raphael studied with Guy Pène du Bois. Both were influenced by the Ashcan School. Both also painted notable portraits, on rare occasions of the same subjects that Neel treated, for example Allen Ginsberg (depicted by Raphael Soyer). Neel painted the twins only on this occasion, towards the end of their lives. With time running out, they had proposed themselves as subjects. In the event they were correct, as Moses died the following year. Neel explained in a 1981 lecture[1] that the Soyer brothers suffered from Paget's disease, which can result in enlarged or misshapen bones. Raphael, on the left, has one shoe with a substantial heel and Moses's head had grown larger. Neel was only one year younger than the Soyer brothers. Therefore in painting them she could see a reflection of her own aging process. She also described how they sat on the "couch" and spoke about art in Russian and she began to feel superfluous. While it was her practice to begin by drawing in paint she did not always complete the whole composition before beginning to apply colour. In this case however she did. Colours were placed side-by-side rather than blended, as became her custom from the early sixties. In his review of the Paris Salon in 1859, Baudelaire had remarked presciently that colours that are

not blended but placed side by side will merge at a distance and will retain energy and freshness, as indeed the Impressionists and Cézanne later demonstrated. Neel understood the power of colour and its potential for autonomy (see for example *Hartley* (cat. 43), *Andy Warhol* (cat. 51) and *Meyer Schapiro* (cat. 71)).

Note

1 Neel Estate archive.

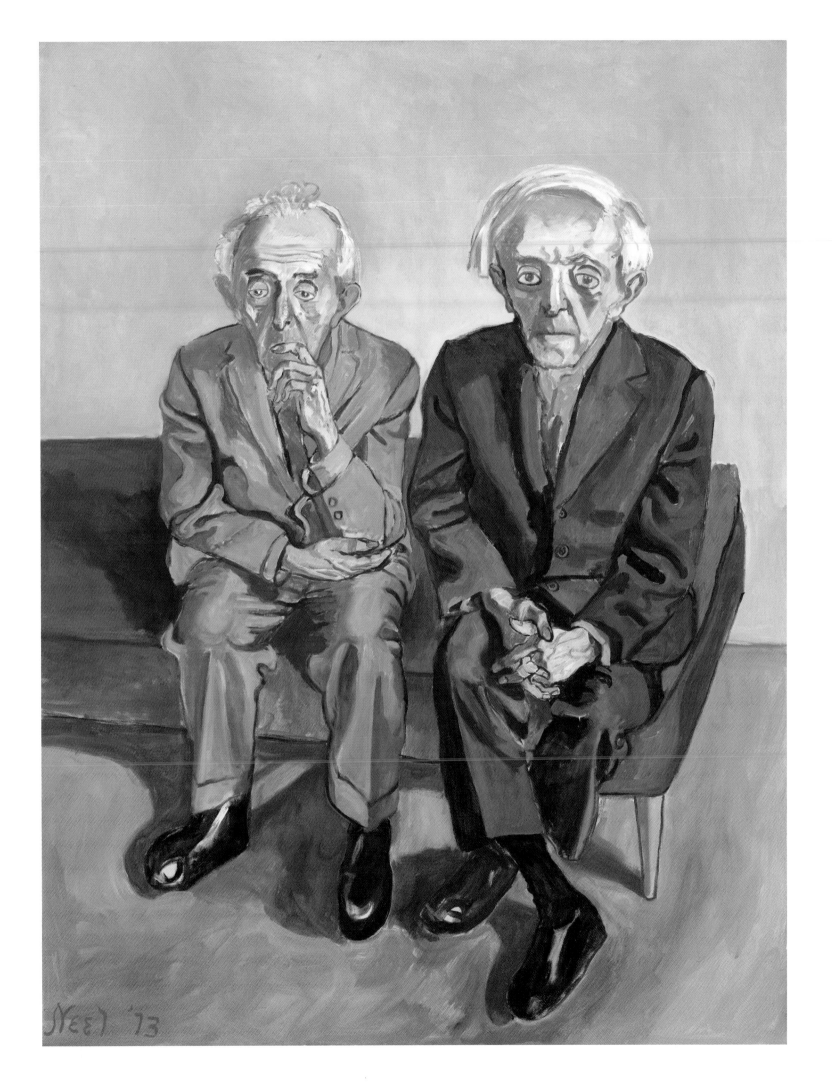

Ginny and Elizabeth, 1975

Oil on canvas, 106.7 cm x 76.2 cm.
Estate of Alice Neel.

Ginny and Hartley Neel had a daughter, Elizabeth, in January 1975. As with Nancy and Olivia, Neel made a point of making a number of paintings of mother and first child. Here Ginny sits displaying Elizabeth whom she holds in the crook of her arm at an angle mirrored by the angle of the sideboard, where the jug is in danger of sliding off. She exists in the topsy-turvy world of new motherhood. Dressed in dungarees, workmen's clothing fashionable in the seventies among the middle classes, she looks somewhat bewildered while Elizabeth appears fascinated, it seems, by being observed so intently. It is through looking that children read the emotions of their parents, and indeed Neel herself once stated that her interest in painting people derived from her need to read her mother's expressions to see whether or not she gained her approval. Looking and being looked at are as fundamental to child development, as they are to Neel's work. It was rare for Neel to paint objects in the background but she had done so in *Mother and Child (Nancy and Olivia)* (cat. 46) where a vase seems about to slide off a *guéridon* table. Clearly for Neel, if not for the two mothers concerned, motherhood was a destabilising experience. There are fewer paintings of Ginny and her children than of Nancy and her brood for the simple reason that Ginny and Hartley lived in Vermont, whereas Nancy and Richard lived in New York, and Nancy came daily to Neel's apartment to help out. Family, by now, had become a major late subject for Neel and she viewed it with a dispassionate eye.

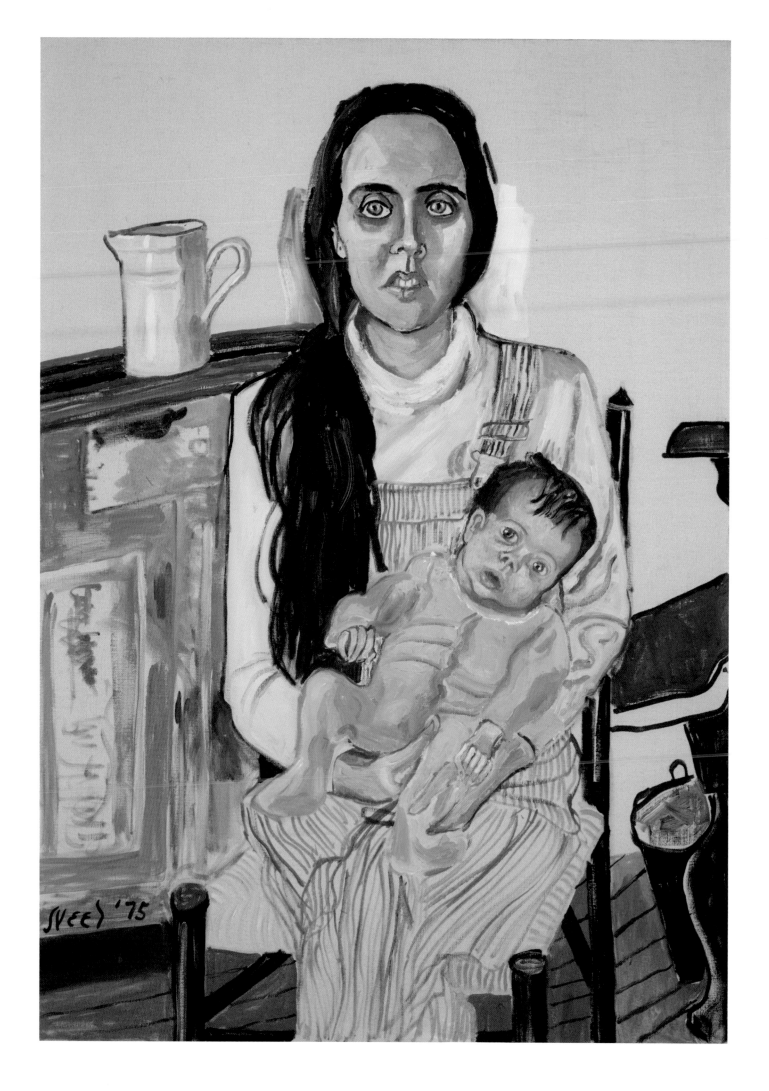

107th and Broadway, 1976

Oil on canvas, 152.4 cm x 86.4 cm.
Private Collection.

This was not the first view Neel had painted out of the window but it is one of the most detailed. Neel tended to paint from a seated position so she obviously could not see down to street level. While the dominant motif is the white façade interspersed with windows and blind openings, Neel introduces accents of colour through the depiction of labels on the shop window and the [Coca]Cola sign over the awning. As with other painted views out the various windows of her dwellings, the spectator has the feeling that life is passing Neel by, taking place without her active presence. Life for her was what took place in the apartment when people visited. Neel admitted that the shadow was a representation of the encroachment of death. Mortality was never far from her thoughts. Neel clearly enjoyed painting the rooftop cornices and architectural details around the windows and, at top right, her composition of chimneys and parapets made for a sophisticated area of abstraction.

Sari Dienes, 1976

Oil on canvas, 152.1 x 96.5 cm.
Hirshhorn Museum and Sculpture Garden,
Smithsonian Institution, Washington DC,
Museum Purchase, 1976.

Sari Dienes (1898-1992) was an émigré Hungarian artist who worked in a wide range of media. Her large-scale rubbings of pavements and street furniture between 1953 and 1955 are regarded as a rejection of the gestural approach to image making of the Abstract Expressionists in favour of an appropriation of the urban environment that would be further developed by Pop artists. Her work had an impact on Jasper Johns, who assisted her at times, and Robert Rauschenberg. Married to Paul Dienes in 1922, she fled Hungary to settle first in Vienna, then Paris and soon in the United Kingdom, where Paul ended up as professor of mathematics at Birkbeck College, London. In the late twenties and early thirties Dienes studied in Paris with Fernand Léger and Amédée Ozenfant and became assistant director of the Ozenfant Academy of Fine Art in London in 1936. Travelling to New York for a brief visit in September 1939, she was unable to return following the outbreak of war, so she helped Ozenfant establish a new academy in New York, where she taught till 1941. Paul meanwhile remained in England and, unable to find an academic job in the US after the war, died in London in 1952. In addition to Johns and Rauschenberg, Dienes was friendly with John Cage and Merce Cunningham and, in the sixties, with members of Fluxus. She also designed fabrics one of which consisted of circles. Neel presents her in old age, eccentrically dressed in a colourful dress ornamented with circles (perhaps a reminder of Dienes's own fabric, if it is not one of hers) and psychedelic socks, which appear to have individual, big toes. Her face and hands are ravaged by time, her hair is a frizzy mop of dyed blond and grey, her neck muscles are pronounced and her veins pop out of her arthritic hand. But she puts on a brave and happy face. Seventy-eight at the time, Dienes would live another fourteen years. Neel told Patricia Hills: "old age by itself is poignant. But the struggle."[1] Dienes was one of a series of major women artists and art historians Neel painted including Isabel Bishop, Faith Ringgold, Louise Lieber, Marisol, Linda Nochlin, Ellen Johnson and Ann Sutherland Harris. Louise Bourgeois declined to be painted by her.

Note
1 Hills, 1983, 144.

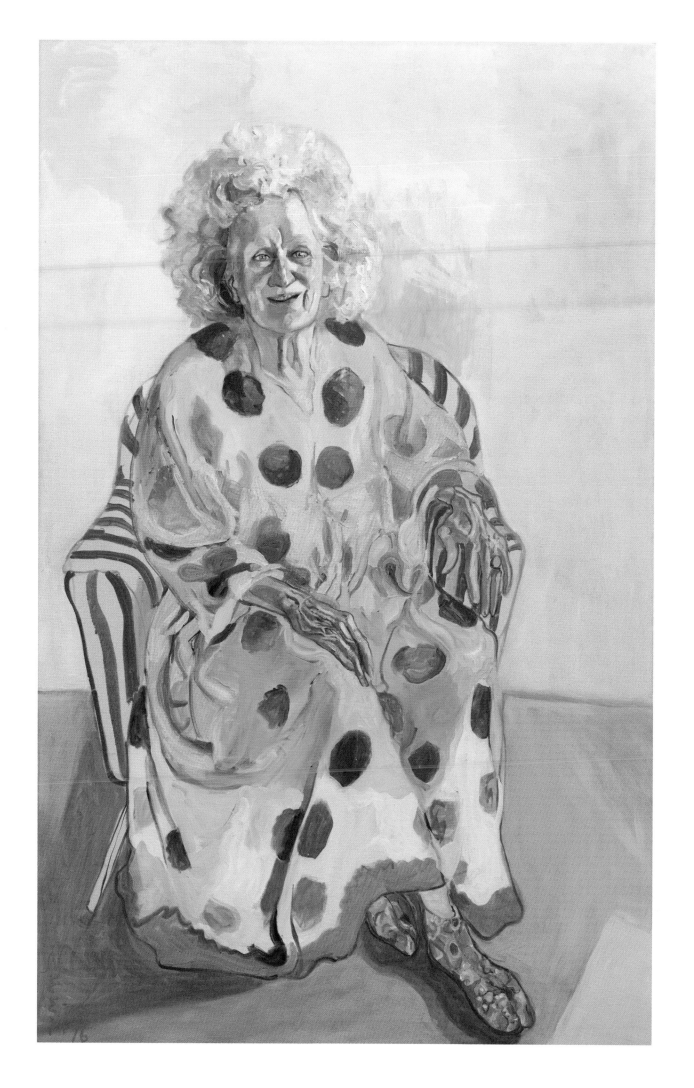

Margaret Evans Pregnant, 1978

Oil on canvas, 146.7 x 96.5 cm.
Institute of Contemporary Art, Boston

Margaret Evans, the wife of the painter, John Evans, was expecting twins when she sat for this painting. Neel tried her out on various different seats and ended up posing her on one of the smallest, causing a striking contrast between the sitter and her support and emphasising the enormity of her inflated womb. Evans looks as though she is full to the neck and grips the side of the seat so as to remain stable. Various different interpretations have been given to the possible meaning of the mirror reflection in which Evans appears older than her years. Some have seen this as implying the period post separation, while others have seen it as a conflation of Evans and Neel who would have seen her own reflection in the mirror, thus an identification between sitter and artist. It remains a conundrum. Although barely perceptible in this painting, the mirror actually ran across the corner of the room at a diagonal, so Neel took liberties with its placement here, bringing it far more into play than it otherwise would have been. There is also a disjunction between the left and right of the wall behind Evans, reminiscent of the spatial dislocations in Cézanne's *Madame Cézanne in Yellow Chair* (c. 1888-90). In another portrait, *Madame Cézanne in a Red Dress* (c. 1888-90) in the collection of the Metropolitan Museum that Neel would have known well, a painting, or possibly a mirror, sits above the fireplace and appears at a similar angle to Neel's mirror, behind Hortense Cézanne. Its presence is equally incongruous. While Neel may not have sought consciously to emulate this composition, when she arrived at the pose on the yellow chair she may unconsciously have recognised something familiar. Four circles dominate the composition: the large extended stomach, the two areolas and the head. Neck and legs seem to be extending away from the centre as though ready to detach or trying to create further space.

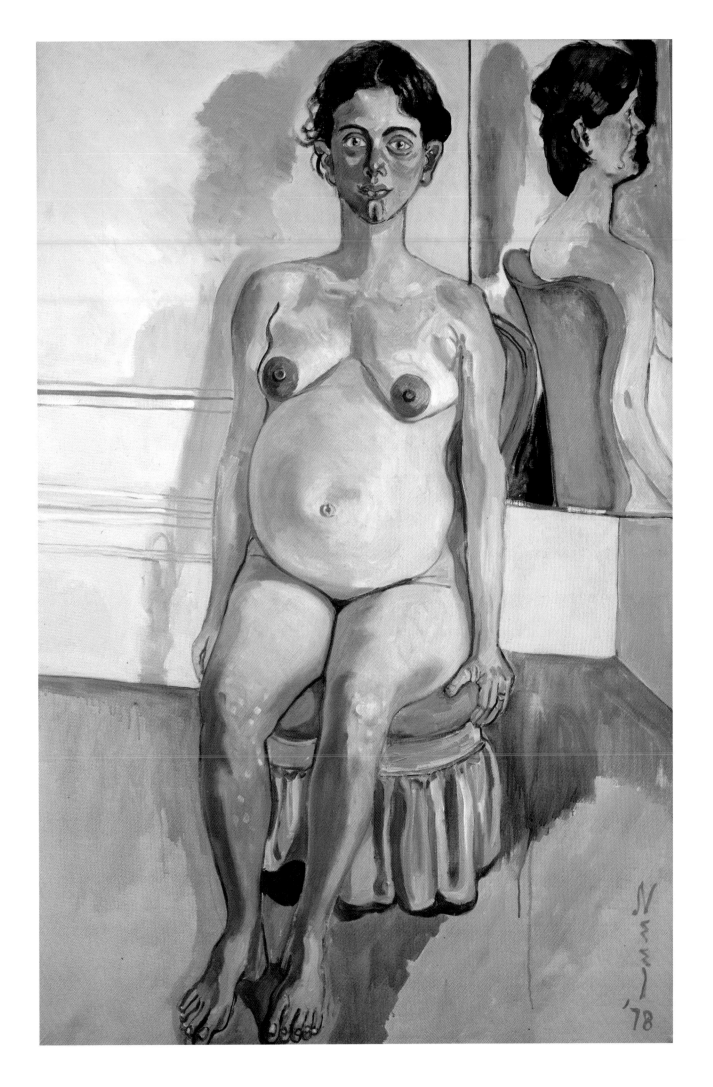

Self-Portrait, 1980

Oil on canvas, 135.3 x 101 cm.
National Portrait Gallery, Smithsonian
Institution, Washington DC

(Exhibited at Ateneum Art Museum, Helsinki
and Gemeentemuseum Den Haag only)

Neel began this painting, her first immediately recognisable self-portrait, in 1975 but abandoned it. It had been intended for her exhibition at the Georgia Museum of Art, *Alice Neel: The Woman and Her Work*. She was encouraged by Richard Neel to continue with it in 1980 so that she could participate in an exhibition of self-portraits at Harold Reed Gallery, New York. Neel was, in general, uninterested in self-portraits, preferring to project herself into others; thus in some senses her portraits of other people contain elements of her own character. If accusations of brutality are sometimes applied to her depictions of other people, none could be more candid than this painting, which anticipates Lucian Freud's naked self-portrait, holding a brush, by thirteen years. Unlike Freud's portrait that seeks to elevate the artist to mythical hero, Neel's is fully grounded. Her description of herself as having a Mother Hubbard body (see the entry for *Benny and Mary Ellen Andrews*, cat. 58) could not be more accurate. Neel's body is ravaged by time, birthing children and indulgent eating habits. Her feet had for many years given her problems and she is not concerned to hide them. Her grandmotherly glasses and white hair complete the picture of a woman unafraid of truthful exposure. Neel was left handed so even her depiction of herself in the mirror is frank for she is seen holding the brush apparently in her right hand. Throughout the seventies women artists had made their bodies a battleground for the feminist cause, reclaiming them with purpose and investing them not so much with erotic charge,

although some artists maintained that approach, but with meanings pertaining to bodily function. Neel's quiet self-portrait is eloquent on the nature of old age and femaleness and suggests that the grotesque distortion of the body during the course of the life cycle is nothing but normal and not to be ignored. In her acceptance of old age and her drawing attention to its consequent malfunctions she sits alongside Picasso for whom this was a major theme. Pierre Bonnard and Lovis Corinth also stand out among twentieth-century artists as having faced their mortality. Corinth's *Self-Portrait with Palette* (1924), painted after he had had a stroke (1911), entered the collection of the Museum of Modern Art in 1950 as a gift of Curt Valentin. Neel's *Self Portrait* and other works have had an impact on a number of women artists, not least the Austrian, Maria Lassnig.

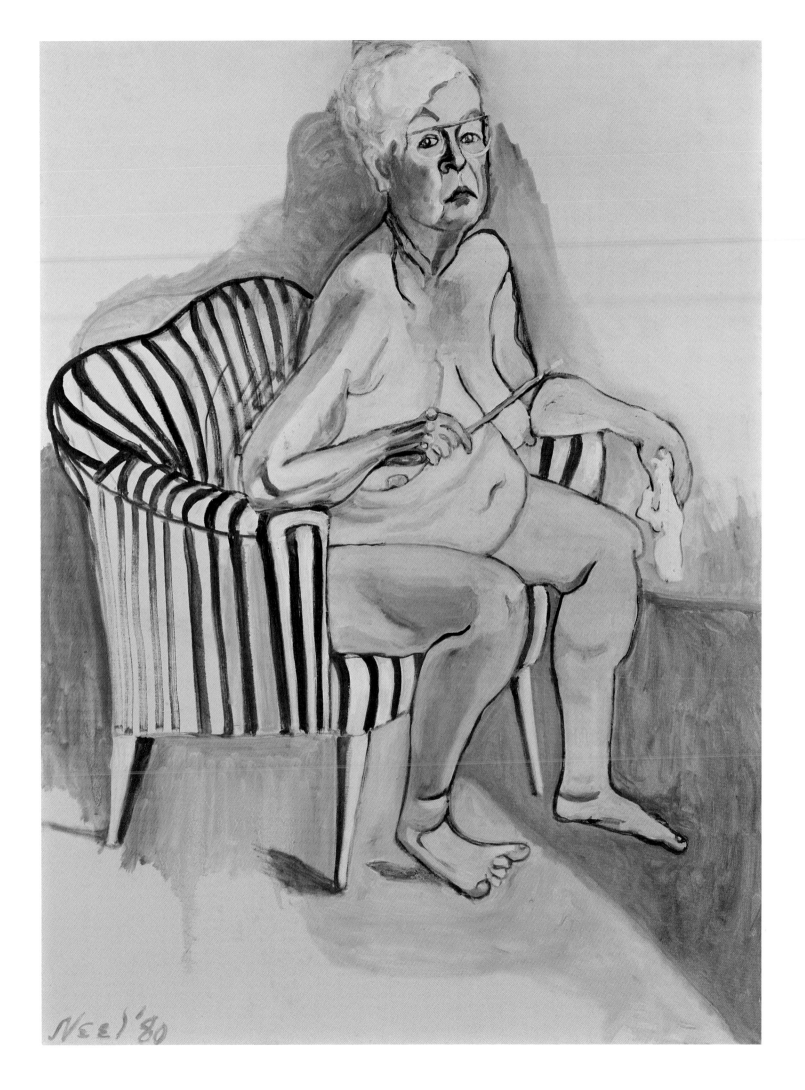

Michel Auder, 1980

Oil on canvas 127 x 101.6 cm.
Estate of Alice Neel.

Michel Auder was born in Soissons, France, in 1945 and began his career as a filmmaker with the Zanzibar group, part of France's New Wave of underground filmmakers. He moved to New York in the late 1960s and acquired one of the first portable video cameras. Since then he has never stopped filming. Auder is a special kind of documentary filmmaker, his camera constantly turning and recording his life and the lives of people with whom he comes into contact. An observer of and member of Warhol's crowd – his first wife was Viva – his filmmaking reflects the *zeitgeist* of that era. While his films bear some of the influence of Warhol, they also relate to the diary films of Jonas Mekas. Fundamentally he is a visual chronicler whose cinéma-vérité style memoirs are predicated on the informality of home movies and offer glimpses of personal situations, unexpected gestures and bizarre coincidences. Auder filmed Neel on a number of occasions, even accompanying her to Bermuda to stay with a patron, Stewart Mott, but his most famous film of Neel recorded her painting *Margaret Evans Pregnant*. Neel made a number of drawings of Auder and this one, late painting. She thus turned the tables and recorded the recorder. Typical of Neel's later work, this painting has an unfinished look yet the intensity of his face would be diminished by any further paint added to what surrounds it. The image remains fresh and Neel has judged it just right when to stop painting, allowing the viewer to fill in the missing information. In these lightly painted works it is possible to assess the importance of drawing in Neel's painting process, for much of the work's success derives from her delicate use of the brush in outlining the contours of Auder and the sideboard in the background, as well as the circular marks that pass for his knees. The background is unusually deep for a Neel painting thus giving greater emphasis to the close scrutiny under which she placed Auder. While there is release for the viewer's eye there is none for Auder. Auder recalled that he was suffering from poison ivy when Neel painted his portrait and sat three or four times. Neel specified that he should wear the white fabric jacket he had purchased at a flea market. Auder reminisced that Neel directed him into a particular chair stating "'You're going into that chair because your body goes in there'. She had a whole account, a scenario. She had to put that person where she wanted in order to paint what she wanted, because she had a number of references for people in her place, and they were all well defined for her. I think that for anybody, it would be natural enough to say, 'Oh, no, I want to go sit in that chair.' But you could tell this was a painter. Forget it."[1]

Note

1 "Undergoing Scrutiny: Sitting for Alice Neel", Temkin (ed.), 2000, 75.

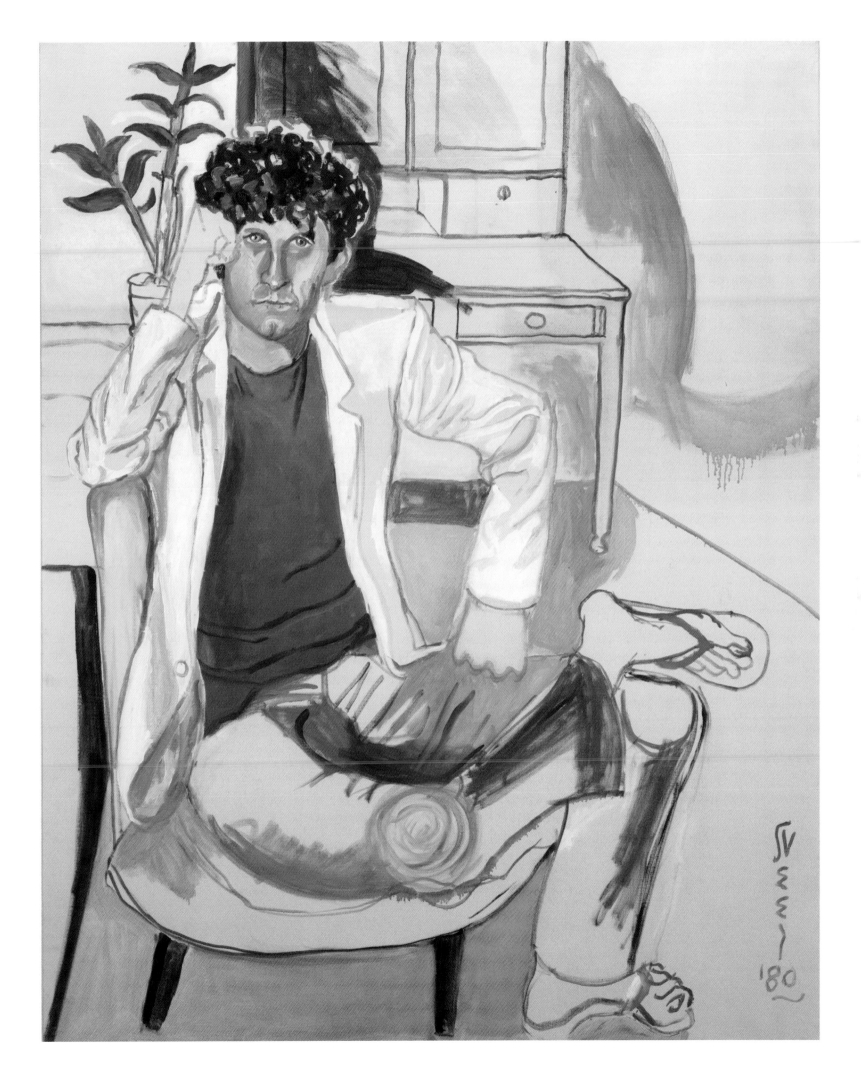

Victoria and the Cat, 1980

Oil on canvas, 101 x 65.4 cm.
Honolulu Museum of Art, Bequest of
Frederic Mueller, 1990, 6003.1.

Richard and Nancy Neel's fourth daughter, Victoria, was born in 1974 so is depicted here age six, 18 months older than when Neel depicted Isabetta naked in 1934. Apparently Victoria would often hold the cat in this way but clearly could not hold the pose for long, so much of the painting must have been done from memory. Just like *Isabetta*, *Victoria and the Cat* is a candid rendering of her granddaughter. Neel's gaze is unrelentingly sharp on this podgy, awkward little girl. Set against a stark white ground, like the contemporaneous photographs by Richard Avedon, there is no escape from scrutiny, nothing to divert the viewer's attention other than the cat whose tail extends into a cascading torrent of colour where Neel walks the tight rope between representation and abstraction. One of Neel's preoccupations throughout her life had been the vulnerability of children, not least her own sons as they were growing up. *Victoria and the Cat* is perhaps the acme of this theme.

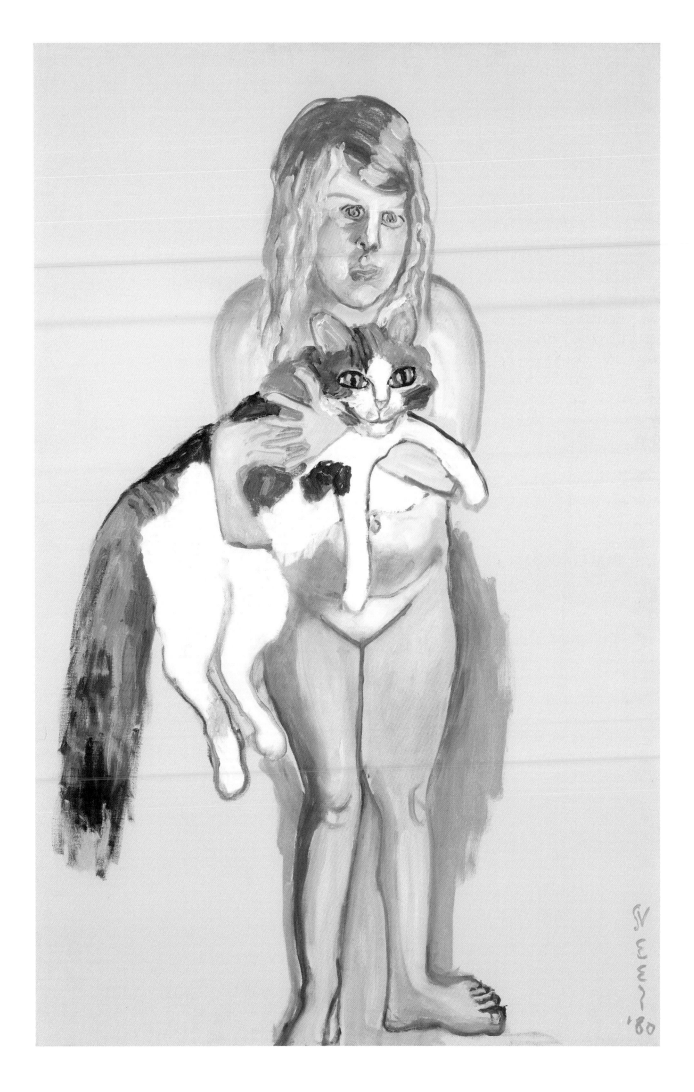

Gus Hall, 1981

Oil on canvas, 119.4 x 83.8 cm.
Estate of Alice Neel.

Gus Hall (1910-2000) was a lifelong communist who stood for election as President of the United States on the Communist Party ticket on four occasions. He was born Arvo Kustaa Hallberg to Finnish parents who were founding members of the Communist Party USA. By the time Neel painted him he had run for election three times, his last attempt being in 1984. Communism was a spent force by the late fifties although Hall, as Chairman of the Party, continued to advocate its cause, later lending support to the regime of Leonid Brezhnev and frequently appearing on Soviet television. Although there had been a resurgence of interest in Communism after the Second World War among intellectuals, by the mid fifties, and certainly after 1956, Communist interest metamorphosed into liberalism, not simply as a result of the brutal pursuit of Communists by Senator McCarthy and the House Un-American Activities Committee, but by the denunciation of Stalin by Nikita Khrushchev, Premier of the Soviet Union, and the widespread condemnation of Soviet repression of the Hungarian Uprising. Hall sits in his bearskin hat, blue eyes burning bright but with a jaw set hard and a mouth grimacing determinedly. Events appear to have overtaken him but he clings to the wreckage of his dream. After the dissolution of the Soviet Union in 1991, Hall stood against *glasnost* and *perestroika*, remaining a hardliner to the end. The shadow behind him intimates mortality, the presence of his double. This is another of Neel's candid portrayals of people in old age. It seems that as she herself anticipated the end of her life so she felt the need to record that process by observing fellow travellers and painting pictures of people who perhaps had eluded her thus far. The painting of Hall represents an acknowledgement of her past allegiance to a cause and a taking leave of it. The thick impasto of Hall's face is not unlike the facture of Munch's *Self-Portrait by the Window* (c.1940) in which the artist anticipated his own death. Munch depicts his mouth in the same downturned expression adopted later by Neel for this portrait. When Neel held an exhibition in Moscow in 1981 (arranged by Phillip Bonosky) Hall asked her not to exhibit his portrait, not wanting to encourage any sense of a cult of personality.

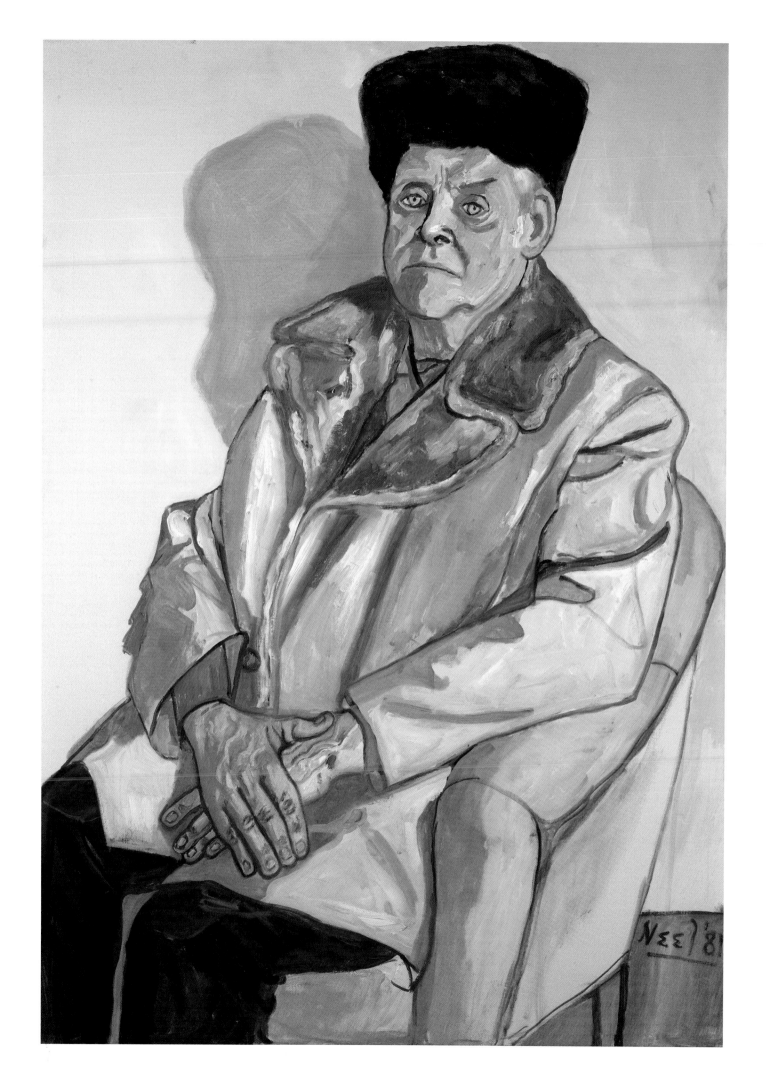

Don Perlis and Jonathan, 1982

Oil on canvas, 106.7 x 76.3 cm.
Moderna Museet, Stockholm,
Acquistion 2009.

Don Perlis (born 1941) is a figurative painter specialising in landscape and figure compositions, urban scenes and mythical narratives. He first showed in New York in the 1970 exhibition *22 Realists* at the Whitney Museum of American Art. The same year Graham Gallery, where Neel showed her work, mounted a solo show of Perlis's. He studied at the Art Students League and taught at the Fashion Institute of Technology. He continues to paint from his loft in Tribeca. Perlis met Neel at the Graham Gallery and, like Neel, attended meetings of the Alliance of Figurative Artists in the seventies, where Neel was vocal and often outspoken. The Alliance was a group of artists who felt isolated by the dominant modes of abstract and Pop art. Neel painted Don Perlis with his son, Jonathan, who was born with cerebral palsy. Neel tuned into Perlis's fatigue and depression while at the same time capturing Jonathan's wide-eyed innocence. She had a strong sympathy for victims. Depicting a traditional Madonna and Child pose, Neel's painting also reveals the impact of the feminist movement in encouraging fathers to take a greater role in the care of their children. The background is bare, laying all emphasis on the subject and revealing changes Neel made to the outline of Perlis's proper left shoulder. Perlis fills the frame from edge to edge, a massive brooding presence. The only edge he does not touch is the top one where the air appears to push his body downwards in an act of compression. The paint is laid on broadly. Perlis's face consists largely of horizontal marks that give his face a lifeless, wooden feel but the emotion comes through strongly by way of the dark shadows under his sunken eyes and the gash of black to the left of his nose that opens up his face like an infected wound. Jonathan, dressed in a white shirt that seems ethereal and evanescent, is grounded by his red dungarees, a sign of mortal flesh in a depiction that otherwise suggests, perhaps, a passing presence.

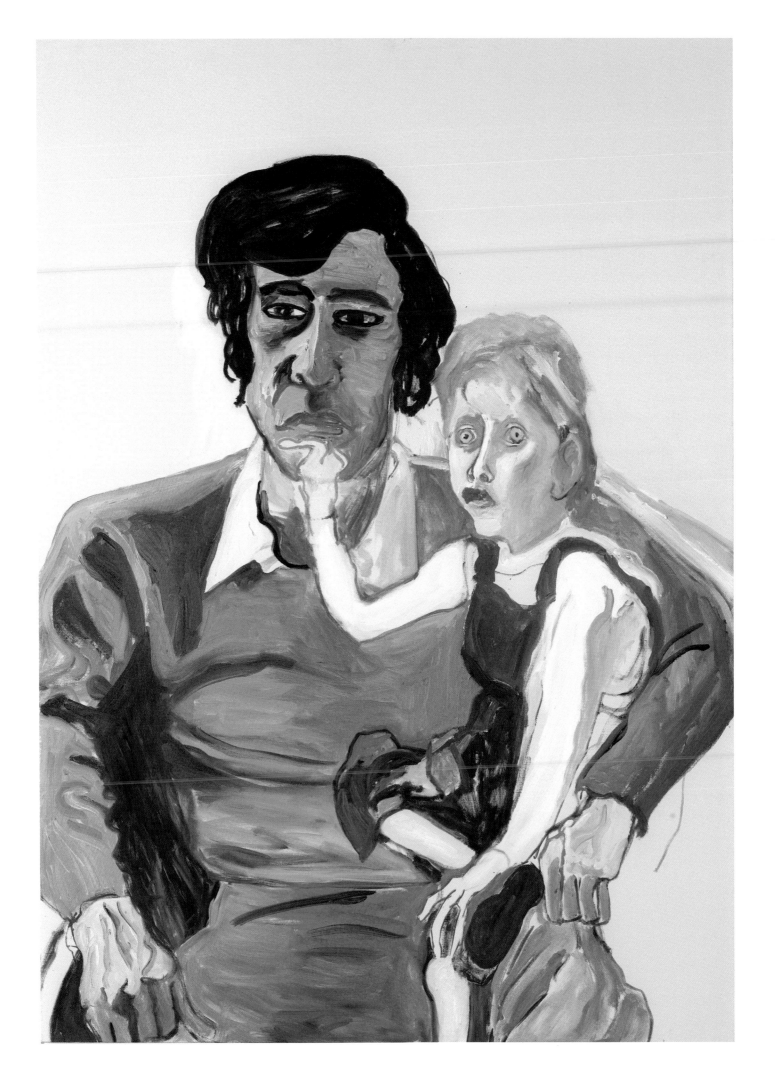

Meyer Schapiro, 1983

Oil on canvas, 106.7 x 81.7 cm.
The Jewish Museum, New York, Purchase:
S. H. and Helen R. Scheuer Family Foundation
Fund, 1995-111.

Meyer Schapiro (1904-1996) was one of the most influential art historians of the twentieth century. For much of his life he taught at Columbia University, not far from where Neel lived from 1962 onwards, and where her sons attended college. Born in Lithuania, Schapiro was a Marxist art historian who began his career as a medievalist but also became an expert in Christian and modern art. He was a pioneer of interdisciplinary ways of working. His father arrived in New York when Schapiro was two and sent for his family in 1907, once he had found a job teaching in a Yeshiva on the Lower East Side. Schapiro's work on Cézanne and Van Gogh was groundbreaking and would have been known to Neel. His support of Abstract Expressionism in the fifties, extending to presenting talks on BBC Radio, was also considered immensely supportive in the propagandising of that movement. Particularly influential was his discourse on style and the way in which it represents both an epoch and an artist, while acknowledging that the way in which contemporaries analyse style bears witness to the way in which their own epoch acts on them. Neel first painted Schapiro from memory in 1947 after she had attended one of his popular lectures at New York's New School for Social Research, a place where many of the Abstract Expressionist artists went to hear him speak. This late portrait, however, was the only time she painted him from life and has an entirely different feel. Here, instead of a remote but revered lecturer, Neel sees the human, vulnerable side of him, his discoloured teeth, wispy grey hair, thick on the sides but sharply receded, his wrinkled forehead and slightly watery eyes. However, Schapiro's expression is animated and for once, it seems, the sitter talks back to Neel, regaling her perhaps with art historical observations or perhaps sharing left-wing memories. This is a compassionate painting of an admired fellow traveller, an intellectual whose mind does not recognise retirement. The window behind Schapiro presented Neel with the opportunity to do what she liked best, divide up the canvas, but in a way that had not given such emphasis to geometry since she painted *Elenka* in 1936. She turned it into a grid, a sign of modernity. Schapiro was a firm supporter of modernism in spite of his Marxist background. Finally, seen through the window is glowing sunlight, enshrouding his head in a divine, Turneresque, aureate glow. Schapiro is portrayed as a wise, god-like figure.

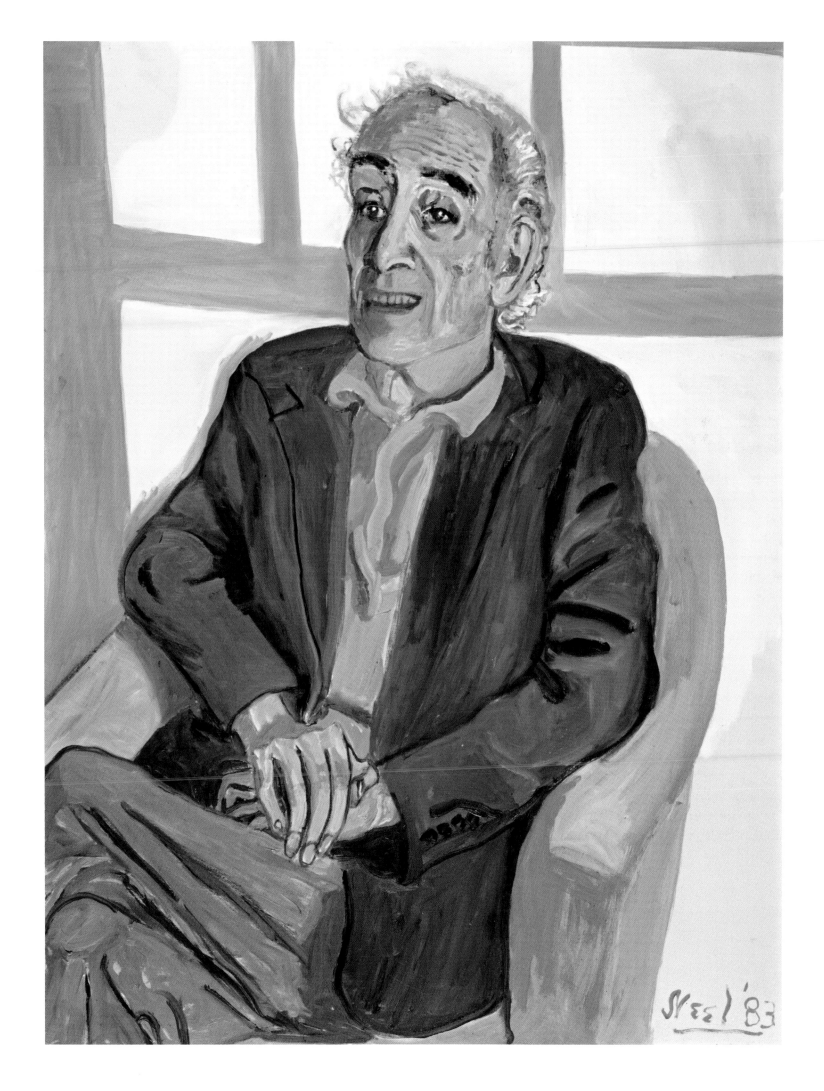

Ginny, 1984

Oil on canvas, 111.8 x 76.5 cm.
Private Collection.

This was one of the last paintings Neel completed before her death in 1984. Painted during the winter in Vermont, it depicts Ginny in mourning for her mother who died the previous year, and was painted at a time when Neel knew her number was up, for she had recently been diagnosed with terminal cancer. The painting for Neel was thus a glimpse into how her family might respond after her death. In this way she confronts her own mortality. Ginny sits grief-struck with her long, slowly greying hair draped around her shoulders, slightly slumped, her face an index of sadness. Behind her in a deep space lie the snowy landscape and the gable end of the barn that served as Neel's Vermont studio when staying with Hartley and Ginny, a pyramid shape reminiscent of a great necropolis. Space is indeterminate; there is no window frame, as though the outside chill has entered the room. The painting is reminiscent, probably serendipitously, of Alfred Stieglitz's celebrated photograph of Georgia O'Keeffe (1918) as well as possibly alluding to late paintings by Munch. It is clearly an expression of endings, and made in the knowledge that it would be the last in a long line of portraits of Ginny. Although she continued to paint, *Ginny* was, in effect, a signing off, an image of such power and subtlety that it appeared to subsume the knowledge of a lifetime of painting.

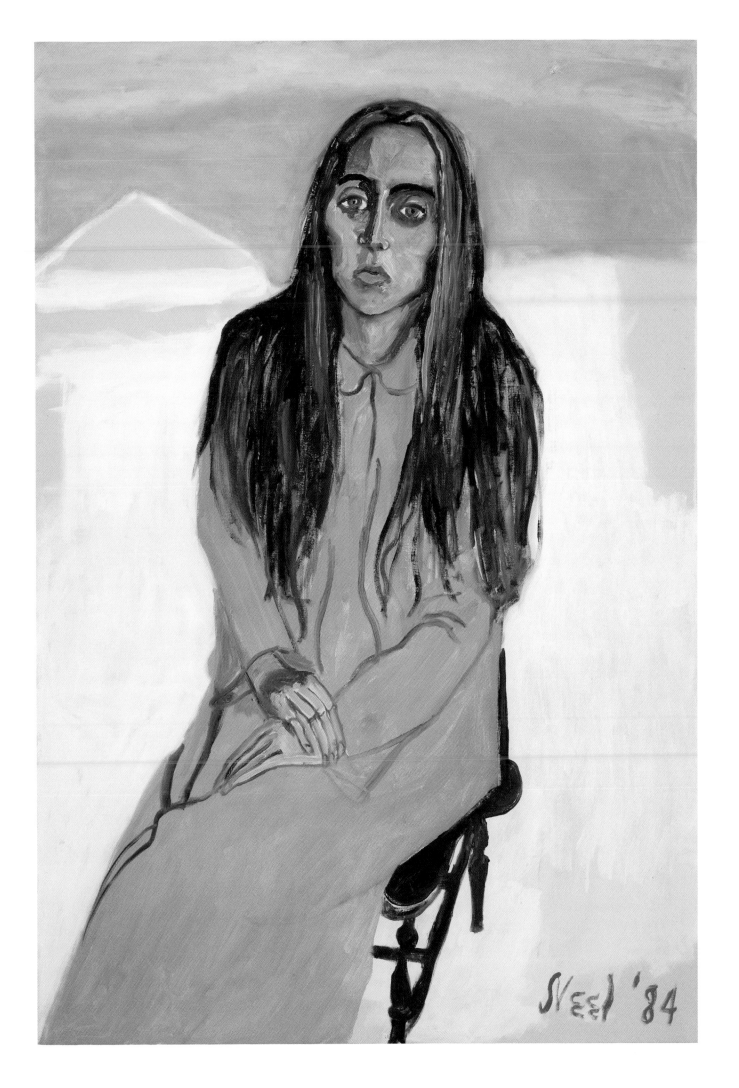

Alice Neel Chronology

1900

January 28 Alice Hartley Neel is born in Gladwyne, Pennsylvania (formerly known as Merion Square), to Alice Concross Hartley, a descendant of a signatory of the Declaration of Independence, and George Washington Neel, an accountant in the *per diem* department of the Pennsylvania Railroad. Her father's family is variously described as owners of a steamship company and as a family of opera singers. Neel is the fourth of five children (Hartley, Albert, Lillian, Alice, and George Washington, Jr.), the eldest of whom will die of diphtheria at the age of eight. In mid-1900 when Neel is about three months old, her family moves to nearby Colwyn, a small town outside Philadelphia in Darby Township.

1914–18

Neel attends Darby High School.

1918

June 28 Graduates from Darby High School, afterwards taking a business course that teaches her typing and stenography. Upon completing the course, she takes the civil service exam.

1918–21

Holds a secretarial job with the Army Air Corps, working for Lieutenant Theodore Sizer, who will later become a Yale University art historian. She takes evening art classes at the School of Industrial Art, a division of the Pennsylvania (later Philadelphia) Museum and School of Industrial Art.

1921

November 1 Enrols in the fine art programme at the Philadelphia School of Design for Women (now Moore College of Art & Design), although she is listed as a student in illustration for a brief period during the 1922–23 school year. She uses her savings to pay the first year's tuition but receives Senatorial (state-funded) scholarships for the next three years, according to school records. Among her instructors are Paula Balano, who teaches drawing and anatomy and designs stained glass; Henry Snell, who teaches landscape painting; and Rae Sloan Bredin, her teacher for life class and portraiture. Harriet Sartain is Dean of the school.

1923

Receives honourable mention, the Francisca Naiade Balano Prize, in her portrait class.

1924

Again wins honourable mention, the Francisca Naiade Balano Prize, in her portrait class.

Attends the Chester Springs summer school of the Pennsylvania Academy of the Fine Arts, which offers an outdoor portrait class and landscape drawing and painting classes. Here she meets the Cuban artist, Carlos Enríquez (1900–1957), son of a prominent family in Havana.

1925

Wins the Kern Dodge Prize for best painting in life class at the Philadelphia School of Design for Women.

Spring Graduates from the Philadelphia School of Design for Women.

June 1 Marries Enríquez in Colwyn, Pennsylvania, but anxieties prevent her from travelling to Havana with him. Enríquez eventually leaves for Havana, where he takes a job with the Independent Coal Company and participates in his first exhibition, the *Salón de Bellas Artes 1925*, with Eduardo Abela, Victor Manuel, Marcelo Pogolotti, and Amelia Peláez. This group of young artists, along with Enríquez, will be among the leaders of the Cuban *vanguardia* movement.

1926

Enríquez returns to Colwyn in February to convince Neel to join him in Cuba. She travels with him to Havana. In Cuba, the couple lives with Enríquez's parents in their house in El Vedado, later moving into their own apartment on the waterfront and then to a rented house in the neighbourhood of La Víbora. Neel's parents visit in the later summer.

Has her first solo exhibition in Havana, according to Neel's later remarks (dates and location unconfirmed).

December 26 Gives birth to a daughter, Santillana del Mar Enríquez.

1927

March–April Exhibits in Havana with Enríquez in the *XII Salón de Bellas Artes*.

May 7–31 Exhibits in Havana with Enríquez in *Exposición de Arte Nuevo*, a show sponsored by *revista de avance*. Two of Enríquez's nudes are removed from the exhibition for being "too exaggerated."

May Neel returns to Colwyn, Pennsylvania, with Santillana.

Autumn Enríquez arrives in Colwyn. The family moves to an apartment on West 81st Street in New York City. Neel finds a job at a Greenwich Village bookstore run by Fanya Foss whom she will paint in a formal portrait, *Fanya*, as well as in a nude double portrait *Bronx Bacchus*.

Meets Nadya Olyanova, a graphologist, who will become one of her closest friends and a frequent subject in her work of the late 1920s and early 1930s.

Winter Moves with Enríquez and their daughter to 1725 Sedgwick Avenue in the Bronx.

December Santillana dies of diphtheria and is buried on 9 December in the Neel family plot at Arlington cemetery in Pennsylvania.

1928

November 24 Gives birth to Isabella Lillian Enríquez (known as Isabetta) in New York City.

1930

May 1 Enríquez leaves for Cuba with Isabetta. He plans to leave Isabetta with his parents and travel with Neel to Paris. After his departure, Neel sublets her apartment in New York and goes back to her parents' house in Colwyn. She travels every day to Philadelphia, where she works at the Washington Square studio of friends from art school, Ethel Ashton and Rhoda Myers.

July Enríquez, finding there is not enough money for two to travel, goes on to Paris without Neel, and leaves Isabetta in Cuba in the care of his two sisters. Neel spends a summer of exhaustingly intense painting.

August 15 Neel returns to Colwyn from a day of painting at Myers and Ashton's studio and suffers a nervous breakdown.

October Neel is hospitalised at Orthopedic Hospital in Philadelphia, where she stays until Christmas of that year.

1931

January Enríquez returns to the United States. He visits Neel a few times in the hospital and takes her home to Colwyn where her family can look after her. Shortly after Neel is back home, she attempts suicide by turning on the gas oven in her parents' kitchen. She is hospitalised at Wilmington Hospital in Delaware. After a few days she is returned to Orthopedic Hospital in Philadelphia, where she smashes a glass with the intention of swallowing the shards; attendants are able to prevent her from harming herself. She is sent to the suicidal ward at Philadelphia General Hospital the following day, where she stays until Easter. At some point during this time, Enríquez returns to Paris.

Late spring A social worker recommends Neel's transfer to the suicidal ward of Gladwyne Colony, a private sanatorium in Gladwyne. After a period of time there, she is allowed to leave the suicidal ward and live with the other patients in the main house. She is encouraged to continue drawing and painting, in contrast with the conventional treatment of nervous conditions at this time, which prescribes that a patient cease all activities related to professional life.

September Psychiatrist Seymour DeWitt Ludlum discharges Neel from the sanatorium and she returns to Colwyn. She visits Olyanova and her Norwegian husband, Egil Hoye, a sailor in the merchant marine in Stockton, New Jersey. Through them she meets Kenneth Doolittle, also an able-bodied seaman.

1932

Early in the year, moves with Kenneth Doolittle to 33 ½ Cornelia Street in Greenwich Village.

May 28–June 5 Participates in the *First Washington Square Outdoor Art Exhibit*, in New York. She is forced to withdraw *Degenerate Madonna* following protests by the Catholic Church. At the exhibition she meets John Rothschild, a Harvard graduate from a wealthy family, who runs a travel business. Their friendship will last throughout their lives.

November 12–20 Participates in the *Second Washington Square Outdoor Art Exhibit*.

1933

January Participates with Joseph Solman in an exhibition at the International Book and Art Shop on West Eighth Street. Solman will be a founding member of the abstract art group The Ten and will include Neel in a number of group shows over the years.

March 16–April 4 Exhibits in *Living Art: American, French, German, Italian, Mexican, and Russian Artists* at the Mellon Galleries in Philadelphia, organised by J. B. Neumann.

December 26 Enrols in the Public Works of Art Project (PWAP), a government-funded programme run under the auspices of the Whitney Museum of American Art and its director Juliana Force.

Paints Joe Gould, a well-known Greenwich Village bohemian who claims to be writing "An Oral History of Our Time".

1934

January Enríquez returns to Cuba from Spain. His mother has died. He writes to Alice expressing a desire to get back together. She, however, is in a relationship with Kenneth Doolittle, and being pursued by John Rothschild. Although she and Enríquez never obtain a divorce or annulment, they never meet again.

April 17 Neel is discharged from the PWAP payroll.

Summer Rents a house with her mother on the New Jersey shore, in Belmar. Her mother and father come to spend the summer with her. Isabetta, now almost six years old, comes from Cuba to visit her. It is here that Neel paints a nude portrait of Isabetta, later destroyed by Doolittle and subsequently repainted.

December Doolittle, in a rage, burns more than 300 of Neel's drawings and watercolours and slashes more than 50 oil paintings at their apartment on Cornelia Street. Neel moves in with Rothschild.

1 Neel at age five, 1905.

2 Carlos Enríquez c. 1924–26.

3 Neel and Santillana at Belmar, New Jersey, 1928.

4 Neel and one-month-old Isabetta, probably at Neel's parents' house in Colwyn, Pennsylvania, December 1929.

5 Neel and Kenneth Doolittle, c. 1933.

6 John Rothschild, c. 1940.

1935

With some help from her parents, Neel buys a modest cottage in Spring Lake, New Jersey. Although in 1959 she will sell this house and buy a larger one, Spring Lake will be where she spends part of each summer for the rest of her life.

September 30 Neel is entered on the payroll of the Works Progress Administration (WPA; later the Work Projects Administration), which replaced PWAP, at $103.40 per month, in its easel division.

Neel moves to 347¹⁄² West 17th Street, New York.

About this time, she meets José Santiago Negrón (1910-1992), a nightclub singer. Negrón abandons his wife and infant child to move in with Neel.

1936

January 28 Receives notice of a WPA pay adjustment to $95.44 per month.

September Exhibits at the ACA Gallery, New York, in a show of the winners of honourable mention in a contest held by the American Artists' Congress. This organisation was founded in 1935 by a group of artists that included Stuart Davis, Louis Lozowick, and Moses Soyer. ACA Gallery, co-founded by Herman Baron and artists Stuart Davis, Adolf Dehn and Yasuo Kuniyoshi in 1932, favours artists of social conscience who depict the reality of American life.

1937

July Neel is hospitalised for a miscarriage in the sixth month of her pregnancy. Negrón temporarily abandons her and returns briefly to his wife

July 10 Receives notice of another WPA pay adjustment to $91.10 per month.

1938

Moves to Spanish Harlem (East Harlem), 8 East 107th Street, with Negrón.

May 2–21 Exhibits 16 paintings in her first solo exhibition in New York City, at Contemporary Arts, 38 West 57th Street.

Neel is included in at least three group shows at Contemporary Arts this year.

May 23–June 4 Shows four paintings in the exhibition *The New York Group* at the ACA Gallery. Also in the show are Jules Halfant, Jacob Kainen, Herb Kruckman, Louis Nisonoff, Herman Rose, Max Schnitzler, and Joseph Vogel.

1939

February 5–18 Exhibits three paintings in the second exhibition of the New York Group at the ACA Gallery.

July 18 Receives notice of a WPA pay adjustment to $90.00 per month.

Summer Isabetta travels from Havana to Spring Lake for a visit with Neel

August 17 Neel is terminated from the WPA.

September 14 Birth of Neel's and Negrón son, Neel, later called Richard.

October 24 Alice Neel is reassigned to the WPA.

December Negrón leaves Neel and their three-month-old son.

1939–40

Winter At a WPA meeting Neel meets Sam Brody (1907–1985), a photographer and filmmaker who was one of the founding members of the Film and Photo League, a radical filmmaking cooperative. Brody is married to Claire Gebiner. Neel and Brody begin a relationship. They will live together on and off for much of the next two decades.

1941

February 28 Neel is terminated once again from the WPA.

March 19 Reassigned to WPA.

September 3 Birth of Neel's and Brody's son, Hartley Stockton Neel.

Autumn Moves to 10 East 107th Street in Spanish Harlem.

October 14 A letter from the Federal Works Agency, a branch of the WPA, notifies Neel that an appointment has been made for her with Miss Grace Gosselin, Director of East Side House, explaining that there is "a solution for the older youngster to be placed at Winifred Wheeler Day Nursery, where you will teach" (Neel Archives). Neel will teach painting at the school for two years.

December Brody's marriage annulled.

1942

November Moves to a third-floor apartment at 21 East 108th Street, between Fifth Avenue and Madison Avenue in Spanish Harlem, where she will live and work for the next 20 years. The apartment features a large living room with two windows that face south; this is where Neel will do most of her painting.

1943

The WPA is terminated by Congress, and Neel begins to collect public assistance which she will continue to do until the mid-1950s.

1944

March 6–22 Exhibits 24 paintings in a solo exhibition at Rose Fried's New York gallery, Pinacotheca.

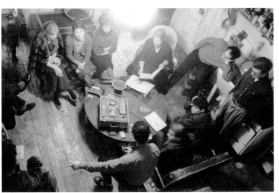

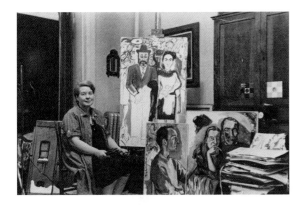

7 José Santiago Negrón (second from the right) with his band, c. 1938.

8 Neel and Sam Brody, c. 1940.

9 Neel with her sons Richard and Hartley at 21 East 108th Street, 1943. Photograph by Sam Brody

10 Neel and her son Richard, c. 1955. Photograph probably by Sam Brody.

11 John Cohen, The cast of *Pull My Daisy*, 1959.

12 Neel in her Spanish Harlem apartment at 21 East 108th Street with paintings (left to right): *Rag in Window* (1959), *Milton Resnick and Pat Passlof* (1960), *Frank O'Hara No. 1* (1960) and *Poet Mark McCloskey and His Girl* (c. 1960). Photograph by Sam Brody.

April 17 *Life* magazine, in an article titled "End of WPA Art", reports that Henry C. Roberts, a bric-a-brac dealer, bought WPA paintings from a Long Island junk dealer who had obtained them for four cents a pound. Neel's painting *New York Factory Buildings* is illustrated. She is able to buy back a few of her paintings from Roberts.

1946

May 3 Neel's father dies at the age of 82.

May Illustrations published in *Masses and Mainstream*, a Communist magazine. This was the first of a number of commissions Neel carried out for this journal.

Both sons attend the Rudolph Steiner School on full scholarships.

1950

December 26–January 13, 1951 Has her first solo exhibition in six years, showing 17 paintings at the ACA Gallery.

1951

April 23–May 23 Exhibits 24 paintings in a solo show at the New Playwrights Theatre, New York.

1953

March Neel's mother comes to live with her in Spanish Harlem.

Autumn Richard Neel enters High Mowing School in Wilton, New Hampshire, which he attends on a full scholarship until his graduation in 1957. High Mowing is affiliated with the Rudolf Steiner School.

1954

March 1 Neel's mother dies at the age of 86 from complications brought on by a broken hip.

August 30–September 11 Exhibits 18 paintings in *Two One-Man Exhibitions: Capt. Hugh N. Mulzac, Alice Neel*, at the ACA Gallery. This is Neel's last show until 1960.

1955

Autumn Hartley Neel enters High Mowing School, which he will attend on a full scholarship until his graduation in 1959.

October 11 and 17 Neel is interviewed by FBI agents, whose files show that she has been under investigation from as early as 1951 owing to her periodic involvement with the Communist Party. The files describe her as a 'romantic Bohemian type Communist.' According to her sons, Neel asks the agents to sit for portraits. They decline.

Sometime this year Brody meets photographer Sondra Herrera and begins a relationship with her by the following year.

1957

Spring Richard Neel graduates from High Mowing School. In the autumn he enters Columbia College, New York, on a full scholarship.

1958

Brody's and Neel's relationship ends but they remain friends until her death.

Neel begins counselling sessions with Dr. Anthony Sterrett.

1959

Appears with Gregory Corso, Mary Frank, Allen Ginsberg, Jack Kerouac, and Peter Orlovsky in Robert Frank and Alfred Leslie's film *Pull My Daisy*, the major art film of the Beatnik era.

Spring Hartley Neel graduates from High Mowing School and in the autumn begins Columbia College on a full scholarship.

Neel buys a larger house in Spring Lake, New Jersey.

1960

Spring Paints Frank O'Hara, poet, critic, and curator at the Museum of Modern Art, over the course of five sittings, producing two portraits. She had met O'Hara at meetings of The Club in the 1950s.

September 4–17 Has a solo exhibition at Old Mill Gallery, Tinton Falls, New Jersey.

December Participates in a four-person show at the ACA Gallery, *Alice Neel, Jonah Kinigstein, Anthony Toney, Giacomo Porzano*.

1961

Autumn Richard Neel begins law school at Columbia University, having graduated from Columbia College in the spring.

1962

January 21–February 3 Hubert Crehan, an artist and art critic, organises an exhibition of 15 of Neel's paintings at Reed College in Portland, Oregon. To avoid controversy *Joe Gould* is hung in a janitor's closet.

Spring Critics Thomas Hess and Harold Rosenberg visit Neel to consider her for the Longview Foundation Purchase Award from Dillard University, New Orleans, which is given to under-recognised artists. Neel receives the award later this year.

May 21–June 15 Exhibits three paintings in the group show *Figures* at the Kornblee Gallery, New York, organised in response to the Museum of Modern Art's show *Recent Painting USA: The Figure* (May 23–September 4). The Kornblee's roster of figure painters ignored by MoMA includes, among others, Milton Avery, Alex Katz, Philip Pearlstein, Fairfield Porter and George Segal.

June 4–30 Participates in the group exhibition *Portraits* at the Zabriskie Gallery, New York.

September Moves to 300 West 107th Street, near the corner of Broadway. It is a much larger apartment, with a front room with north and east-facing windows (one of them rounded) where she will do the majority of her painting for the rest of her life.

October "Introducing the Portraits of Alice Neel" by the critic, Hubert Crehan, is published in *ARTnews*. It is the first major feature article to examine her work.

1963

Spring Hartley Neel graduates from Columbia College and in the autumn begins a teaching fellowship and master's programme in chemistry at Dartmouth College, Hanover, New Hampshire.

October 1–26 Has her first exhibition at Graham Gallery, New York, which will represent her until 1982.

December 21 Richard Neel and Nancy Greene, are married. They live with Neel for two years.

1964

Spring Richard graduates from Columbia Law School.

Neel begins receiving a yearly stipend of $6,000 from an Amercian heiress and philanthropist, the psychiatrist Dr. Muriel Gardiner, whom she had met through John Rothschild. The stipend will continue until Neel's death.

1965

January 12–28 Hartley arranges an exhibition of paintings and drawings by Neel at the Hopkins Center at Dartmouth College.

February 5–21 Exhibits *Max White* (1935) in the *Exhibition of Paintings Eligible for Purchase under the Childe Hassam Fund* at the American Academy of Arts and Letters in New York. This fund places works of art in public collections. Neel will participate in four of these exhibitions over the next decade.

Summer Travels to Europe with Hartley. They visit Paris, Rome, Florence, and Madrid.

Fall Hartley begins medical school at Tufts University in Medford, Massachusetts.

1966

January Has her second solo exhibition at Graham Gallery, which is reviewed in the *New York Post* (January 16) and the *Herald Tribune* (January 9), as well as in *Newsweek* (January 31) and the March issue of *Arts Magazine*.

1967

February 11 A daughter, Olivia, is born to Richard and Nancy in New York.

June 9–30 Peter Homitzky, a fellow artist and neighbour, arranges an exhibition of Neel's work at Maxwell Galleries in San Francisco.

1968

January 6–February 3 Graham Gallery presents a solo exhibition of Neel's paintings.

Participates in the protest decrying the absence of women and African-American artists in the Whitney Museum of American Art's exhibition *The 1930's: Painting and Sculpture in America*.

1969

Hartley graduates from medical school and begins his internship at the University of California in San Francisco.

January 16 Neel participates in demonstrations against the Metropolitan Museum of Art's exhibition *Harlem on My Mind*. The protest is organised by the Black Emergency Cultural Coalition, of which Benny Andrews, Neel's close friend and fellow artist, is a co-chair and organiser. Raphael Soyer, John Dobbs and Mel Roman are the only other white artists in attendance.

April Travels to the Soviet Union with John Rothschild.

May 21 Receives a $3,000 Award in Art from the National Institute of Arts and Letters, New York.

Summer Travels to Mexico with Richard and Nancy. While there, they visit Richard's father, José Santiago Negrón, now an Episcopal minister, and the Mexican mural painter David Alfaro Siqueiros.

From Mexico, Neel travels to San Francisco to stay with Hartley and Virginia (Ginny) Taylor, Hartley's future wife. While there, Neel paints more than ten paintings, including one of the Nobel Laureate, Linus Pauling, as well as one of his wife, Ava Helen Pauling, and a portrait of them together.

November–December Travels to Denmark, Norway, and Spain with Richard and his family. In November she visits Jonathan Brand and his wife, Monika, Pennsylvania collectors of her work, who are living in Copenhagen. Brand's father, the novelist Millen Brand, had been a close friend of Neel's in the 1930s.

1970

August 15 Hartley Neel and Virginia (Ginny) Taylor are married at Ginny's home in Sherman, Connecticut. Hartley and Ginny move to Cambridge, Massachusetts, where Hartley begins his three-year medical residency at Harvard's Massachusetts General Hospital.

Rothschild moves into the guest room in Neel's apartment, where he will live until his death in 1975.

August 31 Neel's portrait of Kate Millett appears on the cover of *Time* magazine in an issue dedicated to "The Politics of Sex". Rosemary Frank, the art editor of *Time*, periodically asks Neel to paint portraits of public figures including Ted Kennedy and Franklin Roosevelt for possible inclusion in the magazine.

October Paints Andy Warhol. Brigid Berlin photographs the sitting.

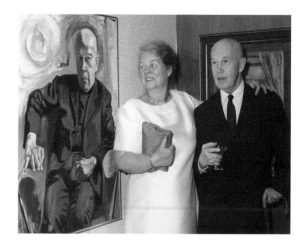

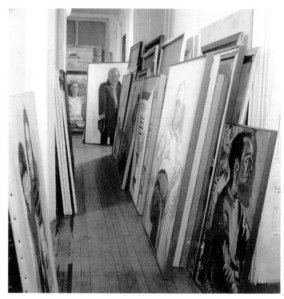

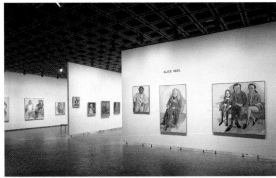

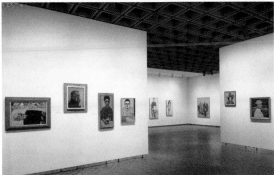

13 Neel with Max White in front of his 1961 portrait at Neel's exhibition at Maxwell Galleries, San Francisco, June 1967.

14 Neel's apartment at 300 West 107th Street, c. 1971.

15 Neel participating in the protest against the Whitney Museum of American Art's exhibition Contemporary Black Artists in America, April 1971.

16 Two installation views of *Alice Neel* (February 7–March 17, 1974). Whitney Museum of American Art, New York. Photograph by Geoffrey Clements.

17 Neel painting a portrait of Edward Weiss at 300 West 107th Street, c. 1976.

October 13–November 7 Has a solo exhibition at Graham Gallery.

1971

January 15–February 19 Moore College of Art & Design in Philadelphia, formerly the Philadelphia School of Design for Women, Neel's *alma mater*, gives her a solo exhibition.

January 29 Participates in a panel of 19 women who had taken over the floor to demand their own session at one of the weekly meetings of the Alliance of Figurative Artists in New York, which had a long tradition of having only male speakers.

February 25–March 21 Participates in the National Academy of Design's *146th Annual Exhibition* and receives the Benjamin Altman Figure Prize for $2,500.

February 28 Twin daughters, Alexandra and Antonia, are born to Richard and Nancy in New York.

May Joins a demonstration against the Whitney Museum of American Art's exhibition *Contemporary Black Artists in America*, curated by Robert Doty. The exhibition is widely criticised by artists as being hastily organised and ill-conceived.

June 1 Received an honorary doctorate in fine arts from Moore College of Art & Design.

September Participates in a protest against the Museum of Modern Art organised by the Black Emergency Cultural Coalition and Artists and Writers Protest Against the War in Vietnam. The protestors oppose Governor Nelson Rockefeller's handling of the Attica Prison riot and the museum bookstore's refusal to sell their *Attica Book* (1971). Rockefeller is a trustee of MoMA and previously its President.

Winter Neel's doctoral address from Moore College is published in the journal *Women and Art*. The same issue announces the circulation of two petitions, one by the Alliance of Figurative Artists (initiated by Noah Baen) and the other by Women in the Arts (initiated by Cindy Nemser), demanding the inclusion of Neel's work in the Whitney's upcoming annual exhibition.

1972

January 25–March 19 Neel's painting *The Family (John Gruen, Jane Wilson, and Julia)* (1970) is included in the Whitney's annual exhibition.

June Travels to Greece and Africa with Hartley and John Rothschild.

Late summer Spends a week at the Skowhegan School in Maine as a visiting artist.

1973

February 15–March 13 John Perreault, art critic and instructor, organises the exhibition *The Male Nude* at the School of Visual Arts Gallery in New York. *Joe Gould* (1933) is included, as is *John Perreault* (1972), which was painted for the exhibition.

Spring Hartley finishes his residency and opens a private practice in St. Johnsbury, Vermont. Hartley and Ginny move to Stowe, Vermont, where Neel will spend several weeks a year for the rest of her life.

Neel is awarded a $7,500 grant from the National Endowment for the Arts.

Between 1973 and 1975 Neel will participate in at least eight exhibitions devoted to the work of women artists, organised by the Women's Interart Center and Women in the Arts, among others.

1974

February 7–March 17 The Whitney Museum of American Art presents the first retrospective exhibition of Neel's work, *Alice Neel*, curated by Elke Solomon. Fifty-eight paintings are included, and an eight-page brochure accompanies the exhibition. Although Neel's admirers consider it an inadequate tribute, Neel herself views it as a triumph.

April 17 A daughter, Victoria, is born to Richard and Nancy in New York.

1975

January 23 A daughter, Elizabeth, is born to Hartley and Ginny in Stowe, Vermont.

Summer Neel helps Hartley and Ginny renovate space on their property in rural Vermont to serve as Neel's studio during her visits.

September 7–October 19 The Georgia Museum of Art in Athens, Georgia, presents *Alice Neel: The Woman and Her Work*, which includes 83 paintings and is accompanied by a catalogue with an introduction by Nemser. Neel has six other solo exhibitions this year and participates in 16 group exhibitions.

An interview with Neel is included in Nemser's book *Art Talk: Conversations with 12 Women Artists* (New York: Charles Scribner's Sons, 1975).

November 2 Participates in a panel discussion at the Brooklyn Museum, New York, "Women Artists, Seventy Plus."

1976

Neel is inducted into the National Institute of Arts and Letters, New York (now the American Academy and Institute of Arts and Letters).

February 26 Receives the International Women's Year Award (1975–76) "in recognition of outstanding cultural contributions and dedication to women and art."

December Neel's *T. B. Harlem*, 1940, is included in the ground-breaking exhibition *Women Artists, 1550–1950*, organised by Linda Nochlin and Ann Sutherland Harris, first presented at the Los Angeles County Museum of Art.

1977

Among many other exhibitions this year, Neel participates in two shows focusing on WPA artists of the 1930s, one at the Parsons School of Design, New York, and the other a travelling exhibition organised by the Gallery Association of New York.

1978

May 18 A son, Andrew, is born to Hartley and Ginny in Stowe, Vermont.

November 1–25 Graham Gallery organises *Alice Neel: A Retrospective Exhibition of Watercolors and Drawings*, the first show dedicated to her works on paper.

1979

January 30 Receives the National Women's Caucus for Art award for outstanding achievement in the visual arts, along with Isabel Bishop, Selma Burke, Louise Nevelson, and Georgia O'Keeffe. President Jimmy Carter presents the award.

An interview with Neel is included in Eleanor Munro's book *Originals: American Women Artists* (New York: Simon & Schuster, 1979).

1980

After several incidents where she loses consciousness, and on the insistence of her sons, Neel undergoes tests at Massachusetts General Hospital in Boston. It is discovered that she has sick sinus syndrome leading to episodes of bradycardia. A pacemaker is immediately inserted to regulate her heart rate.

1981

February 5–March 1 *Alice Neel '81: A Retrospective, 1926–1981* is held at Grimaldis Gallery in Baltimore.

July Travels to the Soviet Union with her sons and daughters-in-law and several grandchildren for a solo exhibition of her work at the Artists' Union in Moscow. It is organised by Phillip Bonosky, who is *Daily Worker* correspondent in Moscow and a friend of longstanding.

1982

March 29 New York City Mayor Ed Koch hosts a dinner at Gracie Mansion in honour of Neel, showcasing the portrait of him she has recently completed and showing a few of her other paintings.

Signs on with Robert Miller Gallery, New York. Her first exhibition there is *Alice Neel Non-Figurative Works* (May 4–June 5).

1983

March 17–April 17 Participates in the National Academy of Design's *158th Annual Exhibition* and receives the Benjamin Altman Figure Prize for $3,000.

Receives a $25,000 artist fellowship from the National Endowment for the Arts.

Patricia Hill's book *Alice Neel* (New York: Harry N. Abrams, 1983), the first fully illustrated monograph on Neel's work, is published. It features Neel's own account of her life, gathered from interviews with Hills.

1984

February Has a solo exhibition at Robert Miller Gallery, exhibiting 40 paintings representing her work from the 1930s to the present.

February 21 Appears on Johnny Carson's "The Tonight Show" and proves herself a skilled entertainer.

On a routine visit to the Massachusetts General Hospital to have her pacemaker checked, X-rays indicate that she has advanced colon cancer, which has already spread to her liver. She immediately undergoes surgery and afterwards returns to Vermont to stay with Hartley and Ginny and their children while she recuperates.

Spring-summer Despite her poor health, in April, she returns to New York and, with the help of Richard and Nancy, continues her busy schedule. Among her many commitments, she is interviewed during the summer by Judith Higgins of *ARTnews* for an upcoming article and, on June 19, makes a second appearance on "The Tonight Show" during which she insists that Johnny Carson visit her in New York to sit for a portrait.

July She returns to Vermont to spend time with Hartley and his family and to lecture at the Vermont Studio School.

Receives chemotherapy treatment for her cancer. Much debilitated, she spends the end of the summer in Spring Lake with Richard and his family. Despite her weakened condition, she continues to paint.

Early autumn She returns to her apartment in New York.

October Appears on the cover of the *ARTnews* issue that features the article by Judith Higgins, "Alice Neel and the Human Comedy". Robert Mapplethorpe visits early in October to photograph Neel. Neel plans to return to Vermont to visit Hartley and his family and to attend a lecture in her honour at the Fleming Museum in Burlington, Vermont. However, she is too weak to travel, and on October 13, she dies, with her family at her side, at her apartment in New York.

18 Neel painting *Stephen Shepard* at 300 West 107th Street, 1978.

19 Neel, Selma Burke and Isabel Bishop with President Jimmy Carter at the first National Women's Caucus for Art Lifetime Achievement Award Ceremony, 1979.

Exhibitions History

Selected Solo Exhibitions

Alice Neel
1 January 1926
Havana, Cuba
Full dates and location unknown

Alice Neel
New York, Contemporary Arts
2 May – 21 May 1938

Neel
New York, The Pinacotheca
6 March – 22 March 1944

Paintings by Alice Neel
New York, New Playwrights Theatre
23 April – 23 May 1951

Paintings by Alice Neel
New York, ACA Gallery
26 December 1950 – 13 January 1951

Alice Neel
Tinton Falls, New Jersey, Old Mill Gallery
4 September – 17 September 1960

Alice Neel
Portland, Oregon, Reed College
21 January – 3 February 1962

Alice Neel
New York, Graham Gallery
1 October – 26 October 1963

Recent Paintings and Drawings from the Thirties
New York, Graham Gallery
5 January – 29 January 1965

Paintings by Alice Neel
Hanover, New Hampshire, Beaumont-May Gallery, Hopkins Center Dartmouth College
12 January – 28 January 1965

Alice Neel
Bronx, New York, Fordham University
1 September – 30 September 1965

Alice Neel; A One Man Exhibition of Oil Paintings
San Francisco, Maxwell Galleries
9 June – 30 June 1967

Alice Neel
New York, Graham Gallery
6 January – 3 February 1968

Alice Neel
Toronto, Nightingale Galleries
13 November – 4 December 1969

Alice Neel
New York, Graham Gallery
13 October – 7 November 1970

Alice Neel. A Comprehensive Exhibition of Paintings, 1930-1970
Philadelphia, Moore College of Art &Design
15 January – 19 February 1971

Alice Neel
Bowling Green, Ohio, The School of Art Gallery, Bowling Green State University
16 February – 14 March 1972

Alice Neel: Portraits
Bloomsburg, Pennsylvania, Haas Gallery of Art, Bloomsburg State College
7 March – 28 March 1972

Alice Neel
Nairobi, Kenya, Paa Ya Paa Art Gallery and Studio
1 June – 30 June 1972

Alice Neel: Recent Paintings
New York, Graham Gallery
13 September – 13 October 1973

Alice Neel
New York, Whitney Museum of American Art
7 February – 17 March 1974

Alice Neel: The Woman and Her Work
Athens, Georgia, Georgia Museum of Art, The University of Georgia
7 September – 19 October 1975

The Eye of Woman: Alice Neel
Geneva, New York, Houghton House Gallery, Hobart and William Smith Colleges
23 February – 28 March 1975

Alice Neel Paintings
Northampton, Massachusetts, Smith College Museum of Art
8 April – 11 May 1975

Alice Neel: Recent Paintings
New York, Graham Gallery
31 January – 28 February 1976

Alice Neel
Wallingford, Connecticut, The Paul Mellon Arts Center, Choate Rosemary Hall
1 November – 30 November 1976

Paintings by Alice Neel
Hagerstown, Maryland Washington County Museum of Fine Arts
9 January – 30 January 1977

Alice Neel: Thirty-Six Paintings from 1935-76
Oshkosh, Wisconsin, University of Wisconsin
24 February – 3 March 1977

Alice Neel: Drawings and Paintings
New York, Graham Gallery
4 October – 29 October 1977

Alice Neel
Fort Lauderdale, Florida, Fort Lauderdale Museum of Art
8 February – 26 February 1978

Alice Neel: A Retrospective Exhibition of Watercolors and Drawings
New York, Graham Gallery
1 November – 25 November 1978

Alice Neel: Recent Paintings
Plattsburg, New York, Plattsburg State Art Museum, Plattsburg State University
1 November – 30 November 1978

Alice Neel Paintings
Saratoga Springs, New York, New Art Center, Skidmore College
16 November – 12 December 1978

Alice Neel
Akron, Ohio, Akron Art Institute
9 December 1978 – 28 January 1979

Alice Neel: A Retrospective Showing (an exhibition in two parts)
New Canaan, Connecticut, The Silvermine Guild of Artists March 18-April 8; travelled to Madison, Wisconsin, Madison Art Center.
25 February – 11 April 1979

Paintings by Alice Neel
Williamstown, Massachusetts, Williams College Museum of Art
7 March – 28 March 1979

Alice Neel
Upper Montclair, New Jersey
Montclair State College, Montclair State College (now University)
6 April – 27 April 1979

Alice Neel
Fort Wayne, Indiana, Fort Wayne Museum of Art
14 September – 1 November 1979

Alice Neel: Paintings of Two Decades
Boston, Boston University
9 October – 2 November 1980

Alice Neel: Recent Paintings
New York, Graham Gallery
8 November – 13 November 1980

Alice Neel '81: A Retrospective, 1926-1981
Baltimore, C. Grimaldis Gallery
5 February – 1 March 1981

Alice Neel
Storrs, Connecticut
Jorgensen Gallery, University of Connecticut at Storrs
22 March – 10 April 1981

Alice Neel 1981
Moscow, Moscow Artists' Union
9 July – 31 July 1981

Alice Neel
Washington, DC, National Academy of Sciences
12 November – 28 January 1982

Non-Figurative Works: Still Lifes, Cityscapes, Landscapes, Interiors
New York, Robert Miller Gallery
4 May – 5 June 1982

Alice Neel: Paintings 1933-1982
Los Angeles, Art Gallery, Loyola Marymount University
29 March – 7 May 1983

Alice Neel: Premiering Works from the 20's, 30's, 40's, and 50's
Annandale-on-Hudson, New York, Edith C. Blum Art Institute, Bard College
17 July – 28 August 1983

Alice Neel: Five Decades of Painting
Baltimore, C. Grimaldis Gallery
29 September – 30 October 1983

Alice Neel
New York, Robert Miller Gallery
31 January – 25 February 1984

Alice Neel: Paintings Since 1970
Philadelphia, Pennsylvania Academy of the Fine Arts
26 January – 17 March 1985

Perspectives 1: Alice Neel
Portland, Oregon, Portland Art Museum; travelled to Berkeley, California, University Art Museum
29 January – 10 March 1985

Alice Neel: Paintings and Drawings
Roslyn, New York, Nassau County Museum of Fine Art
16 March – 18 May 1986

Alice Neel: Paintings, Drawings, Watercolors
San Francisco, Gallery Paule Anglim
18 September – 31 October 1987

Revealing the Spirit: Paintings by Alice Neel
Lewiston, Maine, Museum of Art, Olin Arts Center, Bates College
8 October – 13 December 1987

Alice Neel: Drawings and Watercolors
New York, Robert Miller Gallery
2 December – 3rd January 1987

Alice Neel in Spanish Harlem
Bridgehampton, New York, Dia Center
for the Arts; travelled to Santa Monica,
California, Linda Cathcart Gallery
29 June – 28 July 1991

**Fire and Ice: Painting and Drawing
by Alice Neel**
Reno, Nevada, Nevada Museum of Art
13 September – 17 November 1991

Exterior/Interior: Alice Neel
Medford, Massachusetts, Tisch Gallery,
Aidekman Arts Center, Tufts University
1 October – 20 December 1991

**Alice Neel: The Years in Spanish Harlem,
1938–1961**
New York, Robert Miller Gallery
15 February – 19 March 1994

The Pregnant Nudes of Alice Neel
New York, Robert Miller Gallery
9 January – 3rd February 1996

Kinships: Alice Neel Looks at the Family
Tacoma, Washington, Tacoma Art Museum;
travelled to six venues
12 March – 16 June 1996

Alice Neel: Paintings from the Thirties
New York, Robert Miller Gallery
11 March – 12 April 1997

Alice Neel: Men in Suits
New York, Cheim & Read Gallery
Travelled to New Orleans
3rd March – 25 April 1998

Alice Neel
New York, Whitney Museum of American
Art. Travelled to Andover, Philadelphia,
Minneapolis and Denver
29 June 2000 – 30 December 2001

Duos. Alice Neel's Double Portraits
Naples, Florida, Naples Museum of Art
17 January – 24 March 2002

Alice Neel: Black and White
New York, Robert Miller Gallery
14 February – 30 March 2002

Alice Neel Drawings
Chicago, Arts Club of Chicago
19 September – 8 November 2003

**Alice Neel: A Chronicle of New York
1950–1976**
London, Victoria Miro Gallery
1 June – 31 July 2004

Alice Neel
Philadelphia, Locks Gallery
4 March – 9 April 2005

Alice Neel's Women
Washington DC, National Museum
of Women in the Arts
28 October 2005 – 15 January 2006

Alice Neel: The Cycle of Life
London, Victoria Miro Gallery
23 May – 21 July 2007

Alice Neel: Pictures of People
Berlin, Galerie Aurel Scheibler
27 September – 3 November 2007

Exhibition of Drawings
Philadelphia, Moore College of Art & Design
28 August – 6 December 2008

**Moderna Museet Now:
Alice Neel Collector of Souls**
Stockholm, Moderna Museet
6 September – 7 December 2008

Alice Neel: Nudes of the 1930s
New York, Zwirner and Wirth Gallery
1 May – 20 June 2009

Alice Neel: Selected Works
New York, David Zwirner Gallery
14 May – 20 June 2009

Alice Neel: Painted Truths
Houston, Museum of Fine Arts; travelled
to Whitechapel Gallery, London and
Moderna Museet, Malmö, Sweden
21 March 2010 – 2 January 2011

Alice Neel: Paintings
Los Angeles, L A Louver Gallery
20 May – 26 June 2010

Alice Neel: Paintings and Drawings
Berlin, Gallerie Scheibler Mitte
29 October 2010 – 14 January 2011

Alice Neel: Men Only
London, Victoria Miro Gallery
8 June – 29 July 2011

Alice Neel: Family
Dublin, Douglas Hyde Gallery
8 September – 16 November 2011

Alice Neel: Late Portraits and Still Lifes
New York, David Zwirner Gallery
4 May – 23 June 2012

**Alice Neel: People and Places.
Paintings by Alice Neel**
Seoul, Gallery Hyundai
2 May – 2 June 2013

Alice Neel: Intimate Relations
Skärhamn, Sweden, Nordiska Akvarellmuseet
26 May – 8 September 2013

Alice Neel. My Animals and Other Family
London, Victoria Miro Mayfair
14 October – 19 December 2014

**Alice Neel Drawings and Watercolours
1927–1978**
New York, David Zwirner Gallery
19 February – 18 April 2015

Alice Neel
Brussels, Xavier Hufkens
27 February – 11 April 2015

Alice Neel
Zürich, Thomas Ammann Fine Art
1 June – 23 October 2015

Selected Group Exhibitions

XII Salón de Bellas Artes
Havana, Cuba, Asociación de Pintores
y Escultores,
1 March – 30 April 1927

Exposición de Arte Nuevo
Havana, Cuba
7 May – 31 May 1927

**First Washington Square Outdoor
Art Exhibit**
New York, Washington Square Park
28 May – 5 June 1932

Washington Square Outdoor Art Exhibit
New York, Washington Square Park
12 November – 20 November 1932

**Living Art: American, French, German,
Italian, Mexican, and Russian Artists**
Philadelphia, Mellon Galleries
16 March – 14 April 1933

**Exhibition & Sale of Pictures by Needy
New York Artists**
New York, Hotel Brevoort
1 March – 8 March 1933

Exhibition of Pictures for Sale or Rental
New York, Hotel New Weston
28 September – 1 November 1933

**New York Artists Who Have Participated
in the Washington Square Outdoor Art
Exhibitions**
New York, International Art Center of Roerich
Museum
17 March – 8 April 1934

The New York Group
New York, ACA Gallery
23 May – 4 June 1936

Open Exhibition
New York, Contemporary Arts
19 September – 1 October 1936

**Paintings for the Five to Fifty Christmas
Budget**
New York, Contemporary Arts
5 December – 25 December 1938

The New York Group
New York, ACA Gallery
5 February – 18 February 1939

Mid-Season Retrospection
New York, Contemporary Arts
26 February – 16 March 1940

**Two One-Man Exhibitions: Capt. Hugh
N. Mulzac, Alice Neel**
New York, ACA Gallery
30 August – 11 September 1954

**Alice Neel, Jonah Kinigstein,
Anthony Toney, Giacomo Porzano**
New York, ACA Gallery
1 December – 31 December 1960

Figures
New York, Kornblee Gallery
21 May – 15 June 1962

Portraits
New York, Zabriskie Gallery
4 June – 30 June 1962

Tenth Street, U.S.A
New York, Camino Gallery
1 October – 30 October 1962

**Some Contemporary American
Figure Painters**
Hartford, Connecticut, Wadsworth Atheneum
7 May – 31 May 1964

The West Side Artists
New York, The Riverside Museum
28 September – 8 November 1964

The Emotional Temperatures of Art
New York, Schenectady Museum Association;
travelled to ten venues
10 October – 31 October 1964

**Exhibition of Paintings Eligible for
Purchase under the Childe Hassam Fund**
New York, American Academy of Arts & Letters
Neel was also included in this exhibition in
1972, 1973, and 1976
5 February – 21 February 1965

**The Art Work of Benny Andrews,
Alice Neel, Tecla (Selnick)**
New York, New York Public Library, Countee
Cullen Regional Branch
18 April – 13 May 1966

Social Comment in America
Appleton, Wisconsin, Lawrence University;
travelled to eight subsequent venues.
Exhibition circulated by Museum of Modern
Art, New York
25 February – 9 June 1968

**Exhibition of Work by Newly Elected
Members and Recipients of Honors
and Awards**
New York, American Academy of Arts & Letters
and National Institute of Arts & Letters
21 May – 15 June 1969

146th Annual Exhibition
New York, National Academy of Design
Neel was also included in the 1975 and 1983
annual exhibitions
25 February – 21 March 1971

**Annual Exhibition of Contemporary
American Painting**
New York, Whitney Museum of American Art
25 January – 18 February 1972

Women Choose Women
New York, The New York Cultural Center
12 January – 18 February 1973

The Male Nude
Hempstead, New York, Emily Lowe Gallery,
Hofstra University; travelled to New York,
School of Visual Arts, Visual Arts Gallery,
School of Visual Arts
1 November – 12 December 1973

Women: Self Image
New York, Women's Interart Center
8 March – 18 April 1974

In Her Own Image
Philadelphia, Samuel S. Fleisher Art Memorial
5 April – 10 May 1974

**Tokyo International Biennial, 1974:
New Image in Painting**
Tokyo, Osaka
Hanshin Department Store
6 September – 18 September 1974

**New Images: Figuration in
American Painting**
Flushing, New York, The Queens Museum
16 November – 29 December 1974

Sons and Others: Women Artists See Men
Flushing, New York, The Queens Museum
15 March – 27 April 1975

**Figure as Form: American Painting
1930–1975**
Saint Petersburg, Florida, Museum of Fine Arts
25 November 1975 – 4 January 1976

**From Pedestal to Pavement: The Image
of Women in American Art, 1875–1975**
South Hadley, Massachusetts, Mount Holyoke
College
5 December 1975 – 30 January 1976

American Family Portraits: 1730–1976
Philadelphia, Philadelphia Museum of Art
28 February – 30 June 1976

**Paintings by Three American Realists:
Alice Neel, Sylvia Sleigh, May Stevens**
Syracuse, New York, Everson Museum of Art
17 September – 31 October 1976

Women Artists: 1550–1950
Los Angeles County Museum of Art
21 December 1976 – 13 March 1977

**New Deal for Art: The Government Art
Projects of the 1930s with Examples from
New York City and State Oswego**
Oswego, New York, Tyler Art Gallery,
State University of New York; travelled to
seven venues
25 January – 13 February 1977

New York WPA Artists Then and Now
New York
New York, Parsons School of Design Exhibition
Center
8 November – 10 December 1977

The Sister Chapel
Queens, New York, P.S.1; travelled to Stony
Brook, New York, The Fine Arts Center Gallery,
State University of New York
15 January – 19 February 1978

American Painting of the 1970s
Buffalo, New York, Albright-Knox Gallery;
travelled to six venues
8 December – 14 January 1979

As We See Ourselves: Artists' Self-Portraits
Huntington, New York, Heckscher Museum
2 March – 1 April 1979

**Six Painters of the Figure: Alex Katz,
Diana Kurz, Alfred Leslie, Alice Neel,
Philip Pearlstein, Sylvia Sleigh**
Boulder, Fine Arts Gallery, University of
Colorado
5 March – 7 April 1979

**Selected 20th-Century American
Self-Portraits**
New York, Harold Reed Gallery
1 October – 1 November 1980

American Figure Painting 1950–1980
Norfolk, Virginia, Chrysler Museum
17 October – 30 November 1980

Inside Out: Self Beyond Likeness
California, Newport Harbor Art Museum
22 May – 12 July 1981

**Contemporary American Realism Since
1960**
Philadelphia, Pennsylvania Academy of the
Fine Arts; travelled to five venues in the United
States and Europe
18 September – 13 December 1981

**Realism and Realities, The Other Side
of American Painting 1940–1960**
New Brunswick, New Jersey, Rutgers University
Art Gallery; travelled to two venues
17 January – 26 March 1982

**Five Distinguished Alumni:
The WPA Federal Art Project**
Washington, DC, Hirshhorn Museum and
Sculpture Garden, Smithsonian Institution
21 January – 22 February 1982

**Five Artists and the Figure: Duane
Hanson, Alex Katz, Philip Pearlstein,
Alice Neel, George Segal**
Stamford, Connecticut, Whitney Museum
of American Art, Fairfield County
9 April – 9 June 1982

Focus on the Figure: Twenty Years
New York, Whitney Museum of American Art
15 April – 13 June 1982

Homo Sapiens: The Many Images
Ridgefield, Connecticut, The Aldrich Museum
of Contemporary Art
9 May – 5 September 1982

**Das Andere Amerika: Kunst, Kultur und
Geschichte der Amerikanischen Arbeiter
Bewegung**
Berlin, Staatliche Kunsthalle Berlin
13 March – 24 April 1983

**Social Concern and Urban Realism:
American Paintings of the 1930s**
Boston, Boston University Art Gallery; travelled
to other venues
1 April – 30 October 1983

The Painterly Figure
Southampton, New York, The Parrish Art
Museum
24 July – 4 September 1983

American Still Life: 1945–1983
Houston, Texas, Contemporary Arts Museum;
travelled to four venues
20 September – 20 November 1983

**The Human Condition:
SFMOMA Biennial III**
San Francisco, San Francisco Museum
of Modern Art
28 June – 26 September 1984

The Surreal City: 1930s–1950s
New York, Whitney Museum of American Art
at Philip Morris; travelled to four venues
3 May– 11 July 1985

**The Figure in 20th-Century American
Art: Selections from the Metropolitan
Museum of Art**
New York, The Metropolitan Museum of Art
and the American Federation of Arts; travelled
to seven venues
9 February – 8 June 1986

**The Expressionist Landscape:
North American Modernist Painting,
1920–1947**
Birmingham, Alabama, Birmingham Museum
of Art; travelled to four venues in the United
States and Canada
11 September – 4 November 1987

**Making Their Mark: Women Artists Move
Into the Mainstream 1970–85**
Cincinnati, Cincinnati Art Museum;
travelled to three venues
22 February – 2 April 1989

Alice Neel, Diane Arbus: Children
New York, Robert Miller Gallery
25 April – 20 May 1989

Figuring the Body
Boston, Museum of Fine Arts
28 July – 28 October 1990

**American Realism and Figurative Art:
1952–1990**
Sendai, Japan, The Miyagi Museum of Art;
travelled to four venues in Japan
1 November – 20 December 1991

The Portrait Now
London, National Portrait Gallery
19 November 1993 – 6 February 1994

Face-Off: The Portrait in Recent Art
Philadelphia, Institute of Contemporary Arts,
University of Pennsylvania; travelled to two
venues
9 September – 30 October 1994

Féminin-Masculin: Le sexe de l'art
Paris, Centre Georges Pompidou
24 October 1995 – 12 February 1996

Poet Rebels of the 1950s
Washington, DC, The National Portrait Gallery,
Smithsonian Institution
26 January – 2 June 1996

**Views from Abroad: European
Perspectives on American Art 3:
American Realities**
New York, Whitney Museum of American Art
10 July – 5 October 1997

Body
Sydney, Australia, The Art Gallery of New
South Wales
12 September – 16 November 1997

**Faces of Time: 75 Years of Time Magazine
Cover Portraits**
Washington, DC, The National Portrait Gallery,
Smithsonian Institution
20 March – 2 August 1998

**In Memory of My Feelings: Frank O'Hara
and American Art**
Los Angeles, The Museum of Contemporary
Art
11 July – 14 November 1999

**The American Century: Art & Culture
1950–2000**
New York, Whitney Museum of American Art
26 September 1999 – 13 February 2000

WACK! Art and the Feminist Revolution
Los Angeles, The Geffen Contemporary at
MOCA; travelled to Washington DC, National
Museum of Women in the Arts, Long Island
City, New York, PS1, Vancouver, British
Columbia, Vancouver Art Gallery
4 March – 4 July 2007

The Naked Portrait
Edinburgh, Scottish National Portrait Gallery
and Warwick, England, Compton Verney Art
Gallery
6 June – 2 September 2007

Paint Made Flesh
Nashville, Frist Center for the Visual Arts;
travelled to Phillips Collection, Washington
DC, and Memorial Art Gallery, University of
Rochester
23 January – 10 May 2009

Self-Consciousness
Berlin, VeneKlasen/Werner
30 April – 26 June 2010

In the Company of Alice
London, Victoria Miro Gallery
22 June – 30 July 2010

**Face Value: Portraiture in the Age
of Abstraction**
Washington DC, National Portrait Gallery,
Smithsonian Institution
18 April – 11 January 2015

Forces in Nature
London, Victoria Miro Gallery
13 October – 14 November 2015

**The Great Mother: Women, Maternity,
and Power in Visual Art and Culture,
1900–2015**
Milan, Palazzo Reale
26 August – 15 November 2015

Rabenmütter
Linz, Austria, Lentos Kunstmuseum
23 October 2015 – 21 February 2016

Unfinished: Thoughts Left Visible
New York, Met Breuer
18 March – 4 September 2016

For a full list of exhibitions consult
http://www.aliceneel.com/exhibitions/

Notes

Alice Neel: Painter of Modern Life

1 "la peinture des mœurs du présent". Charles Baudelaire, "Le Peintre de la vie moderne", *Curiosités esthétiques. L'Art romantique et autres œuvres critiques*, (Paris: Editions Garnier Frères, 1962), 454. All quotations are taken from this edition and translated by the present author.

2 "Le plaisir que nous retirons de la représentation du présent tient non seulement à la beauté dont il peut être revêtu, mais aussi à sa qualité essentielle du présent." 454.

3 "la morale et l'esthétique du temps." 454.

4 "Le beau est fait d'un élément éternel, invariable, dont la qualité est excessivement difficile à déterminer, et d'un élément relatif, circonstanciel, qui sera, si l'on veut, tour à tour, ou tout ensemble, l'époque, la mode, la morale, la passion. Sans ce second élément, qui est comme l'enveloppe amusante, titillante, apéritive du divin gâteau, le premier élément serait indigestible, inappréciable, non adapté et non approprié à la nature humaine." 455–56.

5 "Il s'agit, pour lui, de dégager de la mode ce qu'elle peut contenir de poétique dans l'historique, de tirer l'éternel du transitoire." 466.

6 "La modernité, c'est le transitoire, le fugitif, le contingent, la moitié de l'art, dont l'autre est l'éternel et l'immuable." 467.

7 "J'ai dit que chaque époque avait son port, son regard et son geste." 468

8 "Si un peintre patient et minutieux, mais d'une imagination médiocre, ayant à peindre une courtisane du temps présent, s'inspire (c'est le mot consacré) d'une courtisane de Titien ou de Raphael, il est infiniment probable qu'il fera une œuvre fausse, ambiguë, et obscure. L'étude d'un chef-d'œuvre de ce temps et de ce genre ne lui enseignera ni l'attitude, ne le regard, ni la grimace, ni l'aspect vital d'une de ces créatures que le dictionnaire de la mode a successivement classées sous les titres grossiers ou badins d'*impures*, de *filles entretenues*, de *lorettes* et de *biches*." 468.

9 "Ce mot barbarie ... pourrait induire quelques personnes à croire qu'il s'agit ici de quelques dessins informes que l'imagination seule du spectateur sait transformer en choses parfaites." 468.

10 "Il s'établit alors un duel entre la volonté de tout voir, de ne rien oublier, et la faculté de mémoire qui a pris l'habitude d'absorber vivement la couleur générale et la silhouette, l'arabesque de contour." 470.

11 "... chaque dessin a l'air suffisamment fini". 471.

12 Meyer Schapiro, *Paul Cézanne* (New York, 1952),10.

13 P. G. Konody, *The Painter of Victorian Life. A Study of Constantin Guys*, Geoffrey Hone (ed.) (London and New York, 1930). I am grateful to Michèle Hannoosh for this information.

14 In Norman Cameron, *My Heart Laid Bare and Other Prose Writing*, with an introduction by Peter Quennell (London and New York, 1950).

15 *The Painter of Modern Life and Other Essays*, trans. Jonathan Mayne (London, 1964).

16 *The Art Spirit* is a collection of Henri's lectures, lecture notes, fragments of letters and teachings that he collected together and published in 1913. Henri taught at the Philadelphia School of Design for Women but left before Neel began to study there. Nevertheless the school's curriculum was strongly influenced by him even after he left.

17 Quoted in Patricia Hills, *Alice Neel* (New York, 1983), 134. Moore College of Art & Design is the renamed Philadelphia School of Design for Women.

Painting Crisis

1 See for example Jeremy Lewison, "Showing the Barbarity of Life: Alice Neel's Grotesque", in Jeremy Lewison and Barry Walker, eds., *Alice Neel. Painted Truths*, exh. cat., Museum of Fine Arts, Houston (Houston, 2010), 34–63.

2 "I had a conscience about going to art school... Because when I'd go into school, the scrubwomen would be coming back from scrubbing the office floors all night. It killed me that these gray-headed women had to scrub floors and I was going in there to draw Greek statues." Neel quoted in Eleanor Munro, *Originals: American Women Artists* (New York, 1979), 124.

3 In this essay I refer to the sitter's actual appendages rather than the viewer's perspective.

4 See Petra Gördüren's essay in this volume for a discussion of Neel's relationship to German painting.

5 For further discussion of the impact of Van Gogh see Barry Walker, "Dividing Up the Canvas", in Lewison and Walker, eds., 2010, 82 and Andrew Hemingway, *Artists on the Left. American Artists and the Communist Movement 1926–1956* (New Haven and London, 2002), 247 and 251.

6 For example, Kirsty Bell writes that in her Harlem apartment Neel was in a neighbourhood "far removed from the cut and thrust of artistic activity in the city." *The Artist's House, from Workplace to Artwork* (Berlin, 2013), 88. Such a statement ignores the lively literary and artistic movements in Harlem with which Neel undoubtedly had contact.

7 *Hound & Horn*, Oct–Dec 1931.

8 Hemingway, 2002,15–16.

9 Film and Photo League programme notes, 22 Dec 1934, quoted in Russell Campbell, *Cinema Strikes Back. Radical Filmmaking in the United States 1930–42* (Michigan 1982), 107.

10 Neel revealed this in an interview with Ted Castle. Ted Castle, "Alice Neel", *Artforum*, October 1983, 36–41.

11 See Jeremy Lewison, "Allegory" in Lewison and Walker, eds., 2010, 100.

12 Hine had previously had a solo show at the Yonkers Museum, Yonkers, NY in 1931.

13 For further discussion on the relationship of Neel's work to contemporary American photography see Susan Rosenberg, "People as Evidence" in Ann Temkin, ed., *Alice Neel*, exh. cat., Philadelphia Museum of Art (Philadelphia, 2000), 33–51.

14 In fact Nadar did not photograph Balzac but owned an anonymous daguerreotype portrait of him (now well known), which is presumably to what Neel refers.

15 Jonathan Brand, "Fire and Alice", unpublished typescript, 1969.

16 Quoted in James H. Rubin, *Nadar* (London and New York, 2001), n.p.

17 Henry Geldzahler, "Alice Neel by Henry Geldzahler", *Alice Neel*, exh.cat., Dia Center for the Arts (Bridgehampton, 1991), 4.

18 Brand. In 1930 Bourke-White became the first photographer to be permitted to take photographs of Soviet industry.

19 There is some dispute as to when Brody left Neel. According to Brody's son David (born June 1958) (see http://www.sambrody.com/ Brief Bio, Alice, accessed 27 February 2016) Brody's relationship with Neel terminated in 1955 when Brody began a relationship with Sondra Herrera (herself a married woman), who would become his wife in 1958. However, Hartley Neel believes that Brody maintained his relationship with Neel at the same time and continued to be Neel's partner until 1958 (email of 30 December 2015).

20 Irving Sandler does not mention Neel in his book about the Club, *A Sweeper-Up After Artists. A Memoir* (London 2004).

21 Ralph Ellison, *Invisible Man* (New York, 1952, reprinted London 2014), 3.

22 Patricia Hill, *Alice Neel* (New York, 1983), 55.

23 Umberto Eco, *The Open Work*, trans. Anna Cancogni (Cambridge, MA, 1989), accessed 27 February 2016, http://monoskop.org/images/6/6b/Eco_Umberto_The_Open_Work.pdf

24 Conversation with the author.

25 "My son Hartley represented all the youth of that day. In this portrait of him in 1966 he was twenty-five and threatened with Vietnam and with everything else that threatened the youth of that day". Neel, quoted in Cindy Nemser, *Conversations with 12 Women Artists* (New York, 1975), 132.

26 Mark Greif, *The Age of the Crisis of Man: Thought and Fiction in America, 1933-1973*, (Princeton and Woodstock, 2015)

27 Quoted in Hills, 1983, 89.

28 *Alice Neel*, exh. cat., Whitney Museum of American Art, (New York, 1974), n.p.

29 Greif, 2015, 8.

30 Greif, 2015, 9 cites the following as examples: Ernst Cassirer, *An Essay on Man: An Introduction to the Philosophy of Human Culture* (New Haven, 1944); Lewis Mumford, *The Condition of Man* (New York, 1944); Martin Buber 'What is Man' in *Between Man and Man* (New York, 1948).

31 Mumford, 1944, 393.

32 Judith Higgins, "Alice Neel and the Human Comedy", *ARTnews*, October 1984, 75.

33 In an unpublished interview on 12 September 1975 Neel stated that she had read José Ortega y Gasset's *The Dehumanisation of Art* (1925), translated from the Spanish at her request by her husband Carlos Enríquez. Interview in the archive of the Estate of Alice Neel.

34 Robert Penn Warren, "William Faulkner", in *Selected Essays* (New York, 1958), p.65, quoted in Greif 2015, 119.

35 Michael Leja, *Reframing Abstract Expressionism. Subjectivity and Painting in the 1940s* (New Haven and London, 1993).

36 Trilling's influential essay "Art and Fortune", published in *Partisan Review* in 1948, was widely read. Greif 2015 discusses it at length, 104–07.

37 William Faulkner, "I Decline to Accept the End of Man", *Perspectives USA*, Pilot Issue, January 1952, 5–6, quoted in Greif 2015, 121–22.

38 Published in New York in 1960 this was quoted in the pamphlet that served as a catalogue for Neel's exhibition at the Whitney Museum of American Art in 1974.

39 Peslikis was an artist and feminist activist and founder of the New York Feminist Art Institute. She was also the co-founder of the journal *Women & Art*, which promoted Neel.

Emotional Values

This essay was written in the summer of 2015, during a research residency at the Getty Research Institute, Los Angeles. I would like to thank Thomas W. Gaehtgens, Director of the GRI, and A. Alexa Sekyra, Head of Scholars Program, for the opportunity to utilise the extraordinary holdings of the library and special collections.

1 See *Post-War and Contemporary Art: Evening Sale,* auction cat., Christie's, 8 November, 2005, (New York, 2005), 156, lot number 41.

2 See Patricia Hills, *Alice Neel* (New York, 1983), 60. The communist painter Sid Gotcliffe is marching on the right in the first row, wearing a suit and tie. Except for him, none of the demonstrators have been identified by name. Neel executed a drawing of the same person in 1953 which was untitled but which has been attributed a title of *Portrait of Welsh Poet Sid Gottcliff* [sic] by its present owner, the William Louis-Dreyfus Foundation. Since the author

has found no record of such a poet, it is likely that it is the American painter (born in England in 1899, died USA 1969) who is represented.

3 This group exhibition gathered a whole series of artists who had received honourable mentions from the American Artists' Congress. The congress met to oppose war and Fascism and was held in the New York Town Hall from 14-16 February,1935; approximately 500 artists participated. See Serge Guilbaut, *How New York Stole the Idea of Modern Art: Abstractionism, Freedom and the Cold War* (Chicago, 1984), 19-21; Andrew Hemingway, *Artists on the Left: American Artists and the Communist Movement 1926-1956* (New Haven and London, 2002), 123-30.

4 Emily Genauer, "New Fall Exhibits Feature by Tyros' Promising Efforts", *New York World Telegram*, 12 September, 1936.

5 *Christ's Entry into Brussels in 1889* was one of the best-known paintings by Ensor in the US; see E. M. Benson, "James Ensor", *Parnassus* vol. 6, no. 2 (1934), 1-3. The journal *Parnassus* was published by the New York College Art Association.

6 Hills, 1983, 60.

7 See Hills, 1983, 60; Pamela Allara, *Pictures of People: Alice Neel's American Portrait Gallery* (Hanover and London, 1998), 66-67; Phoebe Hoban, *Alice Neel: The Art of Not Sitting Pretty* (New York, 2010), 86, 118, 344. To date, her membership of the Communist Party, as stated by Hoban, has not been confirmed by any documentary proof (see Hoban, 2010, p. 116). Because of her contact with the Communist Party, Neel was kept under surveillance by the FBI until at least 1951 (see Hoban, 2010, p. 425, n. 82).

8 Thus, for example, the *New York Times* reported on 11 May, 1933, about demonstrations against the Hitler regime in New York, Chicago, and Philadelphia. In New York, the Upper East Side's Yorkville neighbourhood was inhabited by many German-Americans, and it formed a centre of protest where many rallies were held (see, e.g. *New York Times*, 10 September 1933; 11 May, 1934; 9 March, 1935; 10 October, 1935). The articles mostly contain information about the economic sanctions against the Jewish population. Reports on the concentration camps - in which Jewish émigrés returning to Germany were imprisoned along with Socialists and Communists - appeared, for example, in the *New York Times* on 9 March and 10 October, 1935. Another mass demonstration against the Nazi regime took place in the period leading up to the participation of the US in the 1936 Olympic Games in Germany (see *New York Times*, 13 November, 1935; 19 November, 1935; 22 November, 1935).

9 Anonymous, "Bernhard Says Now Crush All Jews", *New York Times*, 20 June, 1936.

10 Hills, 1983, 184. In actual fact, Neel had an opportunity to see paintings by Munch in early 1928 at the exhibition *Carnegie International* at the Brooklyn Museum; see Michael Parke-Taylor, "'The Scarlet Trail of the Serpent': The Reception of Edvard Munch in America", in *The Symbolist Prints of Edvard Munch: The Vivian and David Campbell Collection*, eds. Elizabeth Prelinger and Michael Parke-Taylor, exh. cat., Gallery of Ontario (Toronto, 1996), 23-48.

11 Grosz's 1927 version of the portrait of the writer Max Herrmann-Neiße was exhibited in 1931 at the exhibition *German Painting and Sculpture* at the Museum of Modern Art and reproduced in the catalogue; see *German Painting and Sculpture,* exh. cat., Museum of Modern Art (New York, 1931), 22, cat. 19.

12 See Cindy Nemser, "Alice Neel: Teller of Truth", in *Alice Neel: The Woman and Her Work,* exh. cat., Georgia Museum of Art, University of Georgia (Athens, GA, 1975), n. p.; Ronald A. Kuchta, "Foreword", in *Paintings by Three American Realists: Alice Neel, Sylvia Sleigh, May Steven,* exh. cat., Everson Museum of Art (Syracuse, NY, 1976), 4; Phyllis Derfner, "Introduction", in ibid., 7-15, and 7; Ellen H. Johnson, "Alice Neel's Fifty Years of Portrait Painting", in *Studio International* vol. 193, no. 987 (1977), 174-179; Allara, 1998, 8; Pamela Allara, "Object as Metaphor in Alice Neel's Non-Portrait Work", in *Alice Neel: Exterior - Interior,* exh. cat., Tufts University Art Gallery (Medford, MA, 1991), 5-38, and 6 ff.; Eleanor C. Munro, *Originals: American Women Artists* (Boulder, 2000), 121.

13 See Hills, 1983, 184; Lawrence Alloway, "Review of *Alice Neel*, by Patricia Hills", *Art Journal* 44, 2 (1984), 191-92 (typescript of the article, Los Angeles, Getty Research Institute, Special Collections, Lawrence Alloway Papers, Box 26, Folder 4).

14 Hills, 1983, 90.

15 See Hills, 1983, 13; Munro, 2000, 123. On the School of Design, see Gerald L. Belcher and Margret L. Belcher, *Collecting Souls, Gathering Dust: The Struggles of Two Women Artists; Alice Neel and Rhoda Medary* (New York, 1991), 9 ff.

16 See Mark Hain, "Coming into Focus: Two Hundred Years of Building a Collection", in *Pennsylvania Academy of the Fine Arts, 1805-2005* (Philadelphia, 2005), 29-41. In 1920, the exhibition *Painting and Drawings by Representative Modern Masters* was held there; in 1921, *American Modernists*; and, in 1923, *Contemporary European Painting and Sculpture.*

17 Hills, 1983, 13.

18 Karl E. Fortess and Alice Neel, "When I Was Very Small" (Audio Interview, 12 September, 1975), Smithsonian Archives of American Art, Washington, DC, "Karl E. Fortess taped interviews with artists [1963-1985]", cited in Hoban, 2010, 20.

19 Alice Neel, "Bloomsbury State College Lecture", 21 March, 1972 [typescript], Washington, DC, Smithsonian Archives of American Art, Alice Neel Papers, Series 2: Writings and Notes, circa 1960-1979, Box 1, Folder 2, Mf 4964.

20 See Hills, 1983, 13 ff.; Munro, 2000, 124.

21 See Allara, 1998, 18.

22 The first edition of Robert Henri's *The Art Spirit* was published in Philadelphia in 1923. In Cuba, Alice Neel gave a copy to the writer Alejo Carpentier; see Hoban, 2010, 24.

23 Cited in Paul Avrich, *The Modern School Movement, Anarchism and Education in the United States* (Princeton, 1980), 146.

24 Cited in Belcher and Belcher, 1991, 51.

25 See Juan A. Martinez, *Cuban Art and National Identity, 1927-1950* (Gainesville, FL, 1994), 5 ff.

26 *Revista de avance* vol. 3, no. 22 (1928), 112 for Max Ernst and 124 for George Grosz; vol. 4, no. 33 (1929), 101 for Egon Schiele. No information on the works is provided with the illustrations.

27 See Stephanie Barron, "The Embrace of Expressionism: The Vagaries of Its Reception in America", in *German Expressionist Prints and Drawings: The Robert Gore Rifkind Center for German Expressionist Studies,* exh. cat., Los Angeles County Museum of Art, 2 vols. (Los Angeles, 1989), vol. 1, 131-49; Pamela Kort, "The Myths of Expressionism in America", in *New Worlds: German and Austrian Art 1890-1940,* ed. Renée Price, exh. cat., Neue Galerie (New York, 2001), 260-93; Gregor Langfeld, *Deutsche Kunst in New York: Vermittler - Kunstsammler - Ausstellungsmacher* (Berlin, 2011).

28 Ruth L. Bohan, *The Société Anonyme's Brooklyn Exhibition: Katherine Dreier and Modernism in America* (Ann Arbor, 1982).

29 See Margaret Sterne, *The Passionate Eye: The Life of William R. Valentiner* (Detroit, 1980).

30 See Anja Tiedemann, *Die "entartete" Moderne und ihr amerikanischer Markt, Karl Buchholz und Curt Valentin als Händler verfemter Kunst*, Schriften der Forschungsstelle "Entartete Kunst", vol. 8 (Berlin, 2011), 156; Katrin Engelhardt, *Ferdinand Möller und seine Galerie: Ein Kunsthändler in Zeiten historischer Umbrüche,* PhD thesis., Universität Hamburg, 2013, 44-46 (http://ediss.sub.uni-hamburg.de/volltexte/2013/6507/, accessed September 14, 2015).

31 Anonymous, "Modern German Art", *New York Times*, 7 October, 1923, p. X12.

32 See Sterne 1980, 143-144; regarding the reviews, see Langfeld, 2011, 62 ff.

33 William R. Valentiner, "Introduction", in *A Collection of Modern German Art,* exh. cat., Anderson Galleries (New York, 1923), 2-9, and 2.

34 The catalogue of the 1912 *Sonderbund* exhibition, for example, still emphasises Expressionism's international orientation; see *Internationale Kunstausstellung des Sonderbundes westdeutscher Kunstfreunde und Künstler zu Cöln,* exh. cat. (Cologne, 1912) 3-5, 3; Ashley Bassie, *Expressionism* (New York, 2008), 7; Uwe Fleckner, "Die internationale Avantgarde des Expressionismus", in *Gauklerfest unterm Galgen: Expressionismus zwischen "nordischer" Moderne und "entarteter" Kunst,* eds. Uwe Fleckner and Maike Steinkamp (Berlin, 2015), 3-9, and 2.

35 See Henry Brennecke, "Germany's New Storm and Stress", *New York Times*, 16 April, 1922, 49; Herman George Scheffauer, *New Visions in the German Arts* (New York, 1924); Hermann Bahr, *Expressionism* (London, 1925) trans. R. T. Gribble of the German edition of 1916. Both are early and important books on expressionism, not necessarily visual arts, in English.

36 See Penny Bealle, "J. B. Neumann and the introduction of Modern German Art to New York, 1923-1933", *Archives of Art Journal* vol. 29, no. 1/2 (1989), 2-15; Karl-Heinz Meißner, "Israel Ber Neumann: Kunsthändler - Verleger", in *Avantgarde und Publikum: Zur Rezeption avantgardistischer Kunst in Deutschland 1905-1936,* ed. Henrike Junge (Cologne, 1992), 215-224.

37 See Anabelle Kienle, *Max Beckmann in Amerika* (Petersberg, 2008), 14 ff.; Gesa Jeuthe, *Kunstwerte im Wandel: Die Preisentwicklung der deutschen Moderne im nationalen und internationalen Kunstmarkt 1925 bis 1955,* Schriften der Forschungsstelle "Entartete Kunst", vol. 7 (Berlin, 2011), 238.

38 Henry McBride, "First Exhibition by Max Beckmann", *New York Sun*, 16 April, 1927, cited in Kienle, 2008, 15.

39 Anonymous, "Beckmann's Art Portrays German Post-War Disillusion", *New York Times*, 17 April, 1927, X8.

40 Anonymous, "German Art Hailed", *New York Times,* 3 September, 1927, 15.

41 See *Twenty-Sixth Annual International Exhibition of Paintings*, exh. cat., Carnegie Institute (Pittsburgh, 1927). The German artist, Karl Hofer, was also a member of the exhibition's international jury that year. The exhibition was shown in Pittsburgh from 13 October to 4 December, 1927, as well as in New York from 9 January to 19 February, 1928, and in San Francisco from 2 April to 13 May, 1928.

42 Elisabeth L. Cary, "Portraiture in Variety", *New York Times*, 15 January, 1928. Otto Dix's portrait of Hugo Erfurth was not reproduced, but his child portrait *Nelly in Blumen (Nelly among Flowers*, 1924, private collection) was.

43 Helen Appleton Read, "National Characteristics in the Art Are Emphasized at Carnegie International", *Brooklyn Daily Eagle*, 15 January, 1928, 61; regarding Helen Appleton Read, see Carol Lowry, *A Legacy of Art: Paintings and Sculptures by Artist Life Members of the National Arts Club* (Hudson Hills, 1927), 179.

44 See Valentiner, 1923 (Introduction), 2.

45 See Edward Alden Jewell, "Dusseldorf a Mecca", *New York Times*, 24 June, 1928, p. X7; Anonymous, "German Cartoonist Fined", *New York Times*, 11 December, 1928, 5.

46 See Alfred Kuhn, "German Art of the Present Day", *Survey Graphic* vol. 14, no. 5 (1929, special edition: The New Germany), 591-95; Anonymous, "Modern German Art", *New York Times*, 3 February, 1929, 117.

47 See Lina Goldschmidt, "Aspects of Current Art Season in Berlin", *New York Times*, 23 March, 1930. In 1932, George Grosz led a summer course at the Art Students League of New York that aroused substantial attention because conservative voices within the organisation spoke out against him. He emigrated to the US in 1933. See Jeuthe, 2011, 73 f.

48 See Anonymous, "Buy German Art Works", *New York Times*, 3 September, 1929, 7.

49 See Lina Goldschmidt, "From Rembrandt to Nolde", *New York Times*, 25 May ,1930; Edward Alden Jewell, "Eleven Nations Show their Art", *New York Times*, 10 August, 1930, p. X7. Dix's painting was printed with the title *Girl Resting.*

50 See *German Painting and Sculpture*, 1931; Langfeld, 2011, 72 ff.

51 There was a flyer for the exhibition, which listed the participating artists and their works, but did not provide any more detailed information; see *Living Art Exhibition*, exhibition flyer, Mellon Galleries (Philadelphia, 1933), Washington, DC, Smithsonian Archives of American Art, Alice Neel Papers, Series: Printed Material 1933-1983, Box 1, Folder 24, Mf 4964. Among the works exhibited by the German artists, it has so far been possible to identify only Max Beckmann's *Künstler am Meer (Artists by the Sea*; 1930, oil on canvas, 36.5 x 24 cm, private collection).

52 It is possible that *Red Houses* refers to the painting *Classic Fronts*, 1930, oil on canvas, 61 x 50.8 cm (Estate of Alice Neel).

53 See Belcher and Belcher, 1991, 163 and 174.

54 See Munro, 2000, 128: "I never followed any school. I never imitated any artist. [...] I believe what I am is a humanist. That's the way I see the world, and that is what I paint."

55 For Social Realism in American art see *Social Concern and Urban Realism: American Painting of the 1930s*, ed. Patricia Hills, exh. cat., Boston University Art Gallery (Boston,

1983); *American Scene Painting and Sculpture: Dominant Style of the 1930's and 1940's,* exh. cat., D. Wigmore Fine Art (New York, 1988); *American Impressionism and Realism: The Painting of Modern Life, 1885-1915,* exh. cat., Metropolitan Museum (New York, 1994); Bram Dijkstra, *American Expressionism: Art and Social Change 1920-1950* (New York, 2003).

56 See Hoban, 2010, 135.

57 Sheldon Cheney, *A Primer of Modern Art* (New York, 1924), 192 and 194.

Alice Neel, A Marxist Girl on Capitalism

1 In her article '"The human race torn to pieces"; The Painted Portraits of Alice Neel' Tamar Garb describes a number of developments in art that caused Neel's style to be regarded as old-fashioned. In Jeremy Lewison and Barry Walker, eds., *Alice Neel Painted Truths,* exh. cat. (New Haven and London, 2009), 16-33.

2 The dominance of Abstract Expressionism was related to America's 'cultural cold war' against Socialist ideas. For a discussion of just how far this went, see Frances Stonor Saunders, *Who Paid the Piper?: The CIA and the Cultural Cold War* (London, 2000).

3 Neel's time in La Víbora, Havana, and the events that occurred soon after are described in detail in Gerald Meyer, Alice Neel: The Painter and Her Politics, in: *Columbia Journal of American Studies,* Volume 9 (Spring?, 2009), 154, 155.

4 Andrew Hemingway, *Artists on the Left, American Artists and the Communist Movement 1926-1956* (New Haven and London, 2002), 248.

5 Joseph Mitchell, *Joe Gould's Secret* (New York, 1965), 1-12. In this book, Mitchell portrays Gould as a fraud, the writer with the "empty notebooks". In response, several people sent him notebooks that had belonged to Gould which together contained several chapters of his "Oral History".

6 The WPA (Works Progress Administration) also ran a Federal Arts Project, established during the Great Depression to support artists. Alice Neel received a grant from the WPA from 1933 to 1943. She also became a member of the 'easel-painting' division of the WPA, where she could obtain materials in exchange for one painting every six weeks.

7 One chapter was published in 1923 in *Broom: An International Magazine of the Arts*

8 Information on the portrait of Joe Gould can be found in: Lewison and Walker, 2009, 204 and Pamela Allara, *Pictures of People, Alice Neel's American Portrait Gallery* (Waltham, 1998), 79-82.

9 See for example Hemingway, 2002, 249-251.

10 Allara, 1998, 142-145 and Meyer, 2009, 160-161.

11 This insinuated that the Beats were pro-Communist, whereas they were in fact apolitical. Communist sympathisers did tend to be drawn to the Beats' counterculture, however.

12 This was in fact simply another way of keeping countercultures in check.

13 Two years later the same magazine would publish an article by Hubert Crehan titled 'Introducing the Portraits of Alice Neel', in connection with a retrospective of Neel's work at the Reed Gallery in Oregon. It was Neel's first review in a national publication.

14 This move was precisely consistent with her vision: "I love to paint people torn by all the things that they are torn by today in the rat race of New York." Quoted in Patricia Hills, *Alice Neel* (New York, 1983), 100.

15 Gerald L. Belcher and Margaret Belcher, *Collecting Souls, Gathering Dust, The Struggles of Two American Artists, Alice Neel and Rhoda Medary* (New York, 1991), ix.

16 Phoebe Hoban, *The Art of Not Sitting Pretty* (New York, 2010), 273.

17 For further information on the encounter: Allara, 1998, 179-184.

18 Susan Sontag, 'Notes on Camp', in: *Partisan Review* (Spring, 1964), 515.

19 Allara, 1998, 184.

20 Allara, 1998, 141.

21 It is at any rate clear that he saw uniformity as a consequence both of the product-driven culture of Capitalism and the state repression of the Soviet Union. "I want everybody to think alike...Russia is doing it under government... Everybody looks alike and thinks alike, and we're getting more and more that way." Andy Warhol, interview with Gene Swenson, "What is Pop Art?" in *ARTnews* (November 1963), 25.

22 The word Redstocking is a combination of 'bluestocking' - which referred to an intellectual (i.e. unsexy) woman - and the colour red's association with Socialism.

23 In the year that Peslikis was added to Neel's 'Visual History' she also contributed to the Archives of American Art's "Oral History Project: Art World in Turmoil".

24 Allara, 1998, 195-196.

25 Motherhood is an important theme in Neel's work, which includes many portraits of pregnant women. For further information see Jeremy Lewison, "Showing the Barbarity of Life: Alice Neel's Grotesque." in Lewison and Walker, eds., 2009, 34-63.

26 For the context of Neel's slideshows, see Meyer, 2009, 174.

27 Balzac's *Comédie* was among the literary favourites of Marx and Engels.

28 Lewison and Walker, 2009, 252.

"I hate the use of the word *portrait*."

1 Alice Neel in *Alice Neel*, documentary film by Andrew Neel, 2007.

2 Ibid.

3 In Cindy Nemser, "Alice Neel - Teller of Truth", Georgia Museum of Art, *Alice Neel: The Woman and Her Work,* exh. cat. Georgia Museum of Art (Athens, Georgia, 1975), unpaginated, cited in Patricia Hills, *Alice Neel,* (New York,1983), 105.

4 Hills, 1983, 184.

5 In the film *Alice Neel* and the bonus track on the DVD.

6 As elegantly summed up in the title of a book by Phoebe Hoban, *Alice Neel. The Art of Not Sitting Pretty* (New York, 2010).

7 Hills, 1983, 141.

8 Bonus track on the DVD of the film *Alice Neel.*

9 Hills, 1983, 134.

10 Jeremy Lewison cites Pamela Allara in "Showing the Barbarity of Life: Alice Neel's Grotesque" in Jeremy Lewison and Barry Walker (eds.), *Alice Neel, Painted Truths,*

exh. cat., Museum of Fine Arts, Houston (Houston, 2010), 43 who "maintains that pregnancy was not considered an appropriate subject by feminists because it threatened to provide evidence for the charge - certain to send women back to their suburban prisons - that 'anatomy is destiny'." In Pamela Allara, '*Mater*' of Fact: Alice Neel's Pregnant Nudes, *American Art* 8, no. 2 (Spring 1994): 6-31.

11 The then art critic of the *Village Voice.*

12 Brigid Berlin in *Polaroids* (London, 2015), 144. In fact Neel's apartment by then was in the Upper West Side three blocks south of Harlem.

13 Hills, 1993, 49. Joe Gould, a down-and-out writer, a beatnik, a tramp, who was writing an "Oral History of Our Time". Dubbed Professor Seagull, he also called it "the shirt-sleeved multitude". See: Joseph Mitchell, "Joe Gould's Secret", *New Yorker*, September 19, 1964, 61, and Jill Lepore, "Joe Gould's Teeth", *New Yorker*, July 27, 2015.

14 Hills, 1983, 183.

15 In: Pamela Allara, *Pictures of People: Alice Neel's American Portrait Gallery* (Hanover, 1998), 75.

16 See Robert Frank's Film, *Pull My Daisy*, 1959, in which Neel appears along with Allen Ginsberg, Jack Kerouac, Gregory Corso and others of mythical renown.

17 Lewison and Walker, 2010, 94.

18 Leo Steinberg disconcerted part of the art historical community in 1983 when he first published his essay "The Sexuality of Christ in Renaissance Art and in Modern Oblivion" (2nd revised edition, University of Chicago Press, 1997). Questions of body and history have since flooded art theoretical discourse.

19 Klaus Theweleit and Rainer Höltschl, *Jimi Hendrix: Eine Biographie* (Berlin, 2008), 16. Speaking of the "electrified body" in their conversation, they used Jimi Hendrix as an example, for he extinguishes "the ideological body of the 20th century, the obeying body of the fascist blocs and the preparing body of the socialist guard of convictions."

20 "Transformer: Aspekte der Travestie" (17 March - 15 April, 1974). Katharina Sieverding was the only woman artist in the show, which included Urs Lüthi, Jürgen Klauke, Luciano Castelli, Luigi Ontani, Pierre Molinier, Tony Morgan, Walter Pfeiffer, Andrew Sherwood, Alex Silber, The Cockettes and Andy Warhol.

21 Hills, 1983, 134.

A Modern Woman's Social Conscience

1 Linda Nochlin, "Why Have There Been No Great Women Artists?" *ARTnews,* January 1971: 22-39, 67-71.

2 Not to be confused with the Los Angeles County Museum of Art, which has the same acronym (LACMA).

3 Phoebe Hoban, *Alice Neel. The Art of Not Sitting Pretty* (New York, 2010), 266.

4 Quoted in Hoban, 2010, 7.

5 Annamari Vänskä, "Gender and Sexuality, 1920-2000s". In Alexandra Palmer (ed.): *Bloomsbury Series on Cultural History of Fashion & Dress, Vol. 6: Fashion in the Modern Age (1920-2000).* London and New York, to be published in 2016.

6 Quoted in Hoban, 2010, 20.

7 Quoted in Hoban, 2010, 27.

8 Quoted in Eleanor Munro, "Alice Neel" in *Originals: American Women Artists* (New York, 1979), 124, cited in Hoban, 2010, 27.

9 Quoted in Hoban, 2010, 21.

10 Annamari Vänskä, *Fashionable childhood: Children in fashion advertising,* London and New York, to be published 2016.

11 Andrew Neel, *Alice Neel.* SeeThink Productions, 2007.

12 Jeremy Lewison, "The Detached Gaze". In Jeremy Lewison and Barry Walker, eds., *Alice Neel: Painted Truths,* exh. cat. (Houston: Museum of Fine Arts, Houston and New Haven: Yale University Press, 2010), 234.

Concise Bibliography

Writings by Alice Neel

"A Statement" in *The Hasty Papers: A One-Shot Review*. Alfred Leslie and Robert Frank (eds.), New York: Alfred Leslie, 1960, 50.

Lecture in *Alice Neel: Paintings 1933-1982*. Los Angeles: Loyola Marymount University, Los Angeles, 1983.

Books

Allara, Pamela. *Pictures of People: Alice Neel's American Portrait Gallery*. Hanover, NH, and London: Brandeis University Press, 1998.

Belcher, Gerald L., and Margaret L. Belcher. *Collecting Souls, Gathering Dust: The Struggles of Two American Artists, Alice Neel and Rhoda Medary*. New York: Paragon House, 1991.

Bell, Kirsty. *The Artist's House from Workplace to Artwork*. Berlin: Sternberg Press, 2013, 86-97.

Carr, Carolyn. *Alice Neel: Women*. New York: Rizzoli, 2002.

Hemingway, Andrew. *Artists on the Left. American Artists and the Communist Movement 1926-1956*. New Haven, and London: Yale University Press, 2002

Hills, Patricia. *Alice Neel*. New York: Harry N. Abrams, 1983.

Hoban, Phoebe. *Alice Neel: The Art of Not Sitting Pretty*. New York: St Martin's Press, 2010.

Leppert, Richard. *The Nude. The Cultural Rhetoric of the Body in the Art of Western Modernity*. Boulder, CO: Westview Press, 2007, 149-51, 153-55, 191-93.

Munro, Eleanor V. "Alice Neel" in *Originals: American Women Artists*. New York: Simon and Schuster, 1979, 120-30.

Nemser, Cindy. "Alice Neel" in *Art Talk: Conversations with 12 Women Artists*. New York: Charles Scribner's Sons, 1975, 97-122.

Nochlin, Linda. *Bathers, Bodies, Beauty. The Visceral Eye*. Cambridge, MA: Harvard University Press, 2006, 224-30.

Wagner, Anne Middleton. *Mother Stone. The Vitality of Modern British Sculpture*. New Haven and London: Yale University Press, published for the Paul Mellon Centre for Studies in British Art, 2005, 76-80.

Solo Exhibition Catalogues

Alice Neel: Black and White. New York: Robert Miller Gallery, 2002.

Allara, Pamela. *Exterior/Interior: Alice Neel*. Medford, MA: Tisch Gallery, Aidekman Arts Center, Tufts University, 1991.

Bell, Kirsty. "Her Family and Other Animals" in *Alice Neel. My Animals and Other Family*. London: Victoria Miro Gallery, 2014.

Castle, Ted. *Alice Neel: Paintings Since 1970*. Philadelphia: Pennsylvania Academy of the Fine Arts, 1985.

Cheim, John. *Alice Neel: Drawings and Watercolors*. New York: Robert Miller Gallery, 1986.

Geldzahler, Henry. *Alice Neel in Spanish Harlem*. Bridgehampton, NY: Dia Center for the Arts, 1991.

Gold, Mike. *Paintings by Alice Neel*. New York: New Playwrights Theatre, 1951.

Griffin, Tim. "A Scene of Her Selves". *Alice Neel. Late Portraits and Still Lifes*. New York and Santa Fe, NM: David Zwirner and Radius Books, 2012.

Harris, Ann Sutherland: *Alice Neel: Paintings 1933-1982*. Los Angeles, CA. Loyola Marymount University, Los Angeles, Art Gallery, 1983.

Koestenbaum, Wayne. *Alice Neel: Paintings from the Thirties*. New York: Robert Miller Gallery, 1997.

Lebovici, Elisabeth. *Alice Neel*. Brussels: Xavier Hufkens, 2015.

Lewison, Jeremy. *Alice Neel: A Chronicle of New York 1950-1976*. London: Victoria Miro Gallery, 2004.

Lewison, Jeremy and Barry Walker (eds.). *Alice Neel. Painted Truths*. Houston: Museum of Fine Arts and Yale University Press, New Haven and London, 2010.

Lewison, Jeremy. "Alice Neel and her Legacy" in *Alice Neel: People and Places. Paintings by Alice Neel*. Seoul: Gallery Hyundai, 2013.

Lewison, Jeremy and Claire Messud. *Alice Neel Drawings and Watercolours 1927-1978*. New York: David Zwirner, 2015.

Nordal, Bera (ed.). *Alice Neel: Nära Relationer (Intimate Relations)*. Skärhamn, Sweden: Nordiska Akvarellmuseet, 2013.

Paul, William D., Jr. and Cindy Nemser. *Alice Neel: The Woman and Her Work*. Athens, GA: Georgia Museum of Art, The University of Georgia, 1975.

Peyton, Elizabeth. "On Alice Neel" in *Alice Neel: Pictures of People*. Berlin: Galerie Aurel Scheibler, 2007.

Phillips, Adam. "Sitting Targets" in *Alice Neel: Family*. Dublin: The Douglas Hyde Gallery, 2011.

Scheibler, Aurel. *Alice Neel. Paintings and Drawings*. Berlin: Aurel Scheibler, 2010.

Solman, Joseph. *Paintings by Alice Neel*. NewYork: ACA Gallery, 1950.

Solomon, Elke M. *Alice Neel*. New York: Whitney Museum of American Art, 1974.

Storr, Robert. "Interview" in *Alice Neel: The Cycle of Life*. London: Victoria Miro Gallery, 2007.

Temkin, Ann (ed.). *Alice Neel*. New York: Harry N. Abrams in association with Philadelphia Museum of Art, 2000.

Group exhibition catalogues

Baum, Kelly, Andrea Bayer and Sheena Wagstaff. *Unfinished: Thoughts Left Visible*. New York: Met Breuer, 2016.

Butler, Cornelia and Lisa Gabrielle Mark (eds.). *WACK! Art and the Feminist Revolution*. Los Angeles: The Geffen Contemporary at MOCA, 2007.

Cullen Deborah (ed.). *Nexus New York. Latin/ American Artists in the Modern Metropolis*. New York and New Haven: El Museo del Barrio in association with Yale University Press, 2009.

Fortune, Brandon Brame, Wendy Wick Reeves and David C Ward. *Face Value. Portraiture in the Age of Abstraction*. Washington D.C.: National Portrait Gallery, Smithsonian Institution in association with D Giles Limited, London, 2014.

Gioni, Massimiliano (ed.). *The Great Mother. Women, Maternity, and Power in Art and Visual Culture, 1900-2015*. Milan: Fondazione Nicola Trussardi and Skira, 2015.

Hammer, Martin. *The Naked Portrait 1900-2007*. Edinburgh: National Galleries of Scotland, 2007.

Harris, Ann Sutherland and Linda Nochlin. *Women Artists, 1550-1950*. Los Angeles: Los Angeles County Museum of Art, 1976.

Hills, Patricia (ed.). *Social Concern and Urban Realism: American Paintings of the 1930s*. Boston: Boston University Art Gallery, 1983.

Nowak-Thaller, Elisabeth (ed.). *Rabenmuetter. Zwischen Kraft und Krise: Muetterbilder von 1900 bis heute*. Linz: Lentos Kunstmuseum, 2015. Scala, Mark W. (ed.). *Paint Made Flesh*. Nashville: Frist Center for the Visual Arts, 2009.

Weinberg, Adam (ed.). *Views from Abroad: European Perspectives on American Art 3: American Realities*. New York: Whitney Museum of American Art, 1997.

Periodicals

Allara, Pamela. "'Mater' of Fact: Alice Neel's Pregnant Nudes", *American Art*, vol. 8, no. 2 (Spring 1994), 6-31.

Alloway, Lawrence. Review of *Alice Neel*, by Patricia Hills. *Art Journal*, vol. 44, no. 2 (Summer 1984), 191-92.

Alloway, Lawrence. "Art", *Nation* (New York), 9 March, 1974, 318.

Bauer, Denise. "Alice Neel's Feminist and Leftist Portraits of Women", *Feminist Studies*, vol. 28, no. 2 (summer 2002), 375-95.

Bauer, Denise. "Alice Neel's Portraits of Mother Work", *NWSA Journal*, vol. 14, no. 2 (summer 2002), 102-20. Reprinted in Mesropova, Olga and Stacey Weber-Fève, (eds.). *Being and Becoming Visible. Women, Performance and Visual Culture*. Baltimore: The Johns Hopkins University Press, 2010, 26-43.

Bauer, Denise. "Alice Neel's Female Nudes" *Woman's Art Journal*, vol. 15, no. 2 (Fall 1994-Winter 1995), 21-30.

Bell, Kirsty. "Alice Neel". *Frieze*, September 2007, accessed 27 February 2016, http://www.frieze.com/issue/review/alice_neel1/.

Berrigan, Ted. "The Portrait and Its Double", *ARTnews*, vol. 64, no. 9 (January 1966), 30-33, 63-64.

Bochner, Mel. "In the Galleries: Alice Neel", *Arts Magazine*, vol. 40, no. 5 (March 1966), 55.

Campbell, Lawrence. "Reviews and Previews: Alice Neel, Jonah Kinigstein, Anthony Toney, Giacomo Porzano", *ARTnews*, vol. 59, no. 8 (December 1960), 13-14.

Castle, Ted. "Alice Neel", *Artforum*, vol. 22, no. 2 (October 1983), 36-41.

Crehan, Hubert. "Introducing the Portraits of Alice Neel", *ARTnews*, vol. 61, no. 6 (October 1962), 44-47, 68.

Geldzahler, Henry. "Alice Neel" *Interview*, vol. 15, no. 1 (January 1985), 86-87. Reprinted in Henry Geldzahler, *Making It New: Essays, Interviews, and Talks* (New York: Turtle Point Press, 1994), 232-41.

Gold, Mike. "Alice Neel Paints Scenes and Portraits from Life in Harlem", *Daily Worker* (New York), 27 December, 1950.

Gruen, John. "Collector of Souls", *New York Herald-Tribune*, 9 January, 1966. Reprinted as "Alice Neel" in John Gruen, *Close-Up*. New York: Viking Press, 1968, 144-46.

Halasz, Piri. "Alice Neel: 'I Have This Obsession with Life'", *ARTnews*, vol. 73, no. 1 (January 1974), 47-49.

Harris, Ann Sutherland. "A Note on Alice's Greatness", *ARTnews*, vol. 75, no. 11 (November 1977), 113.

Hess, Thomas B. "Art: Sitting Prettier", *New York Magazine*, 23 February, 1976, 62-63.

Higgins, Judith. "Alice Neel, 1900-1984", *ARTnews*, vol. 83, no. 10 (December 1984), 14.

Hope, Henry R. "Alice Neel: Portraits of an Era", *Art Journal*, vol. 38, no. 4 (Summer 1979), 273-81.

Johnson, Ellen H. "Alice Neel's Fifty Years of Portrait Painting", *Studio International*, vol. 193, no. 987 (March 1977), 174-79.

Lawrence, M. "Alice Neel Remembered", *Art in America*, vol. 89, no. 5 (May 2001), 39.

Lewison, Jeremy. "Beyond the Pale: Alice Neel and her Legacy". *Art & Australia*, vol. 48, no. 3, 2011, 502-13.

McEvilley, Thomas. "Reviews: Alice Neel", *Artforum*, vol. 32, no. 9 (May 1994), 97-98.

MacKenzie, Suzie. "Heroes and Wretches", *Guardian Weekend* (London), 29 May 2004, accessed 27 February 2016, http://www.theguardian.com/artanddesign/2004/may/29/art.

Mainardi, Pat. "Alice Neel at the Whitney Museum", *Art in America*, vol. 62, no. 3 (May-June 1974), 107-08.

Nedo, Kito. "Ihre visuelle Chronik der New Yorker", *Berliner Zeitung*, 23 October 2007, accessed 27 February 2016, http://www.berliner-zeitung.de/archiv/ihre-visuelle-chronik-der-new-yorker,10810590,10513586.html.

Nemser, Cindy. "Alice Neel: Portraits of Four Decades", *Ms.*, vol. 2, no. 4 (October 1973), 48-53.

Nochlin, Linda. "Some Women Realists: Painters of the Figure", *Arts Magazine*, vol. 48, no.8 (May 1974), 29-33. Reprinted in Linda Nochlin, *Women, Art, and Power and Other Essays* New York: Harper & Row, 1988, 86-108.

Perreault, John. "Catching Souls and Quilting", *Village Voice*, 27 February, 1974.

Princenthal, Nancy. "About Faces: Alice Neel's Portraits", *Parkett* (Zurich), no. 16 (1988), 6-17.

Rubinstein, Raphael. "Eros in Spanish Harlem", *Art in America*, vol. 88, no. 12 (December 2000): 102-09, 131.

Saltz, Jerry. "Alice Neel", *Village Voice*, 25 July 2000, 65.

Saltz, Jerry. "Notes on a Painting: Alice Neel, Painter Laureate", *Arts Magazine*, vol. 66, no. 3 (October 1991), 25-26.

Schjeldahl, Peter. "Wild Life. Alice Neel's People", *New Yorker*, 25 May 2009, 86-87.

Schor, Mira. "Some Notes on Women and Abstraction and a Curious Case History: Alice Neel as a Great Abstract Painter", *Differences: A Journal of Feminist Cultural Studies*, vol. 17, no. 2 (2006), 132-60.

Williams, Gilda. "Alice Neel. Whitechapel Gallery", *Artforum*, October 2010, 286-87.

Silberman, Robert. "Alice Neel, Walker Art Center, Minneapolis", *Burlington Magazine*, vol. 143, no. 1181 (August 2001), 518-19.

Stevens, May. "The Non-Portrait Work of Alice Neel", *Women's Studies* (New York), vol. 6 (1978), 61-73.

Temkin, Ann. "Double Exposure", *ARTnews*, vol. 99, no. 5 (May 2000), 138, 140.

Voss, Julia. "Chuck Close! Ich hasse Ihr Werk!", *Frankfurter Allgemeine Zeitung*, 29 September 2007.

Weinstein, Jeff. "Alice Neel", *Artforum*, September 2000, accessed 21 April 2016, https://artforum.com/inprint/issue=200007&id=32174

Wullschlager, Jackie. "Familiar and unfamiliar visions of American art", *Financial Times* (London), 2 June 2004.

For a full bibliography visit http://www.aliceneel.com/bibliography/?mode=display

Index

Contributors

Bice Curiger is artistic director of the Fondation Vincent van Gogh Arles. From 1993 to 2013 she was curator at the Kunsthaus Zürich, organizing such exhibitions among others as "Birth of the Cool" (1997), "Hypermental" (2000), and "Riotous Baroque" (2012). In 2011 she was the director of the 54th Venice Biennale. She is also co-founder and editor of *Parkett,* published in Zurich and New York. She has written extensively on art.

Petra Gördüren, Ph.D., is an independent art historian and researcher based in Berlin. Being author and editor for DeGruyter Allgemeines Künstlerlexikon she is a specialist in American art of the 19th and early 20th century. She publishes on the relationship of art and sciences and on contemporary art, especially on portraiture of the late 20th century.

Jeremy Lewison is an independent curator as well as advisor to the Estate of Alice Neel. Previously Director of Collections at Tate, he organises exhibitions and writes on modern and contemporary art with a particular interest in American art. He has written books and catalogues on Jackson Pollock, Barnett Newman and Brice Marden among others.

Laura Stamps is curator of modern art at the Gemeentemuseum Den Haag organizing exhibitions and writing texts principally relating to works in the collection. Her most recent exhibition was *Constant New Babylon,* which toured to the Reina Sofia, Madrid after being shown in the Hague. She is currently researching a Lee Bontecou exhibition to take place in 2017.

Annamari Vänskä PhD is Adjunct Professor of Art History and Gender Studies at the University of Helsinki where she was named Adjunct Professor of the Year in 2012. Vänskä currently works as Collegium Researcher at Turku Institute for Advanced Studies. She has published widely on art, fashion and visual culture. Her book, *Muodikas lapsuus. Lapset muotikuvissa* (Fashionable Childhood. Children in Fashion Advertising, Gaudeamus, 2012), was awarded the "The Best Scientific Book of the Year Honorary Mention 2012" and will be published in English by Bloomsbury Publishing in 2016.

Photo credits
and Copyrights

Photo credits

All images © Estate of Alice Neel with the following exceptions:

Art + Commerce / Mapplethorpe Foundation

Nancy Baer

Bridgeman Images

Brigid Berlin Courtesy / Vincent Fremont Enterprises, Inc.

Brian Buckley

Camera Press, London

Cathy Carver, New York

Centre Pompidou, MNAM-CCI, Dist. RMN-Grand Palais / Jean-Claude Planchet

Cheim & Read, New York

Christie's Images / Bridgeman Images

The Cleveland Museum of Art

John Cohen, Courtesy L. Parker Stephenson Photographs, New York

Giorgio Colombo, Milan

David Zwirner, New York

De Agostini Picture Library / G. Nimatallah / Bridgeman Images

Estate of Alice Neel

The Estate of Diane Arbus LLC Howcroft, Will

Lee Fatherree

Honolulu Museum of Art

J. Paul Getty Trust

Locks Gallery, Philadelphia

The Metropolitan Museum of Art / Art Resource / Scala, Florence 2015

The Metropolitan Museum of Art / Art Resource / Scala, Florence (Copy Photograph) 2016

Joseph Mills

Moderna Museet, Stockholm

Musée d'Orsay, Dist. RMN-Grand Palais / Patrice Schmidt

Museum of Fine Arts, Boston

The Museum of Fine Arts, Houston

The Museum of Modern Art, New York / Scala, Florence

National Gallery of Art, Washington D.C.

National Gallery in Prague 2016

National Museum of Women in the Arts / Lee Stalsworth

National Portrait Gallery / Smithsonian Institution / Scala, Florence

Ethan Palmer

John Parnell (1995-11) / The Jewish Museum / Art Resource / Scala, Florence 2015

Philadelphia Museum of Art

Private Collection

Rheinisches Bildarchiv, Köln

The Richard Avedon Foundation

RMN-Grand Palais (Musée d'Orsay) / Hervé Lewandowski

Paul Rogers

The Royal Library, Denmark

Smithsonian Museum of American Art, Washington D.C.

Tate, London 2015

Walker Evans Archive, The Metropolitan Museum of Art / Scala, Florence

Whitney Museum of American Art, New York

Malcolm Varon, New York

Victoria & Albert Museum, London

Victoria Miro Gallery, London

Simon Vogel

Copyrights

© Estate of Alice Neel, with the following exceptions:

The Andy Warhol Foundation for the Visual Arts, Inc. / Kuvasto 2016 p. 45 (below)

Art + Commerce / Mapplethorpe Foundation

Brigid Berlin Courtesy / Vincent Fremont Enterprises, Inc.

John Cohen, Courtesy L. Parker Stephenson Photographs, New York

The Estate of Diane Arbus LLC

Camera Press, London

Kuvasto

The Richard Avedon Foundation

Walker Evans Archive, The Metropolitan Museum of Art

Publisher
Mercatorfonds, Brussels
Managing Director: Bernard Steyaert

Coordination of the exhibition and catalogue
Ateneum Art Museum, Finnish National Gallery
Museum Director: Susanna Pettersson

Chief Editor
Jeremy Lewison

Co-Editor
Anu Utriainen, Ateneum Art Museum, Finnish National Gallery

Picture research and editing
Anna Luhtala, Finnish National Gallery

Production
Tijdsbeeld & Pièce Montée, Ghent
Managing Directors: Ronny Gobyn and Rik Jacques

Coordination
Ann Mestdag, Mercatorfonds
Barbara Costermans, Tijdgeest, Ghent

Translations
Finnish to English: Wif Stenger (Annamari Vänskä's article)
German to English: Catherine Schelbert (Bice Curiger's article),
Michael Wetzel (Petra Gördüren's article)
Dutch to English: Sue McDonnell (Laura Stamps' article)

Text editing
Wif Stenger

Graphic design
Yanne Devos, Tijdsbeeld & Pièce Montée, Ghent

Typeset in Lyon Text (Kai Bernau) and Larsseit (Type Dynamic)
Printed on LuxoArt Samt 150 gsm

Colour separations, printing and binding
Graphius, Ghent

© **2016**
Mercatorfonds, Brussels
Ateneum Art Museum, Finnish National Gallery, Helsinki
Deichtorhallen Hamburg
Fondation Vincent van Gogh Arles
Gemeentemuseum Den Haag

www.mercatorfonds.be
www.ateneum.fi
www.deichtorhallen.de
www.fondation-vincentvangogh-arles.org
www.gemeentemuseum.nl

Ateneum Publications Vol. 80
ISSN 1238-4712

Distributed in Belgium, the Netherlands and Luxembourg by
Mercatorfonds, Brussels
ISBN 978-94-6230-138-2
D/2016/703/22

Distributed outside Belgium, the Netherlands and Luxembourg by
Yale University Press, New Haven and London
www.yalebooks.com/art – www.yalebooks.co.uk
ISBN 978-0-300-22007-0
Library of Congress Control Number: 2016939150

Front cover: Alice Neel, *Jackie Curtis and Ritta Redd*, 1970 (cat. 52)
Back cover: Alice Neel, *The Family (Algis, Julie and Bailey)*, 1968 (cat. 48)
Page 2: Brigid Berlin, Polaroid of Alice Neel painting Andy Warhol, c. 1970.
Pages 6-7: Alice Neel, *Mother and Child (Nancy and Olivia)*, 1967 (cat. 46)
Pages 64-65: Neel in her Spanish Harlem apartment, c. 1940. Photograph by Sam Brody.

The main partners of the Ateneum Art Museum: